Errata for *Anything but a Still Life*

p. 187. *Poppies* is in the collection of Dwight Kostjuk, not Gallery 78.

p. 204. Credit for *London Pub* should read as follows:
Molly Lamb Bobak, *London Pub*, 1962
Oil on canvas, 115.5 x 135.9 cm.
(Collection of Allan and Marjory Donaldson. Photograph by Jason Nugent.)

p. 208. Credit for *Massey's Funeral* should read as follows:
Molly Lamb Bobak, *Massey's Funeral*, 1968
oil on masonite, 121.9 x 101.6 cm
(Gift of Dorothy and Edgar Davidson. Collection of Owens Art Gallery, Mount Allison University, Sackville, NB. Photograph by Roger Smith.)

p. 214. Credit for *The Lighting of the Christmas Tree* should read as follows:
Molly Lamb Bobak, *The Lighting of the Christmas Tree*, 1982
oil on canvas, 76.2 x 101.6 cm
(Collection of Inge Pataki. Photograph by Jason Nugent.)

p. 321. William McCain should read Billie McCain.

Anything but a Still Life

Also by NATHAN GREENFIELD:

The Reckoning: Canadian Prisoners of War in the Great War

*Missionnaires en terre barbelée : Des Oblats prisonniers
de guerre (1941-1945)* (with Bill Rawling)

The Great War Album

The Forgotten: Canadian POWs, Escapers and Evaders in Europe, 1939-45

*The Damned: The Canadians at the Battle of Hong Kong
and the POW Experience, 1941-45*

*Baptism of Fire: The Second Battle of Ypres and
the Forging of Canada, April 1915*

The Battle of the St. Lawrence: The Second World War in Canada

Anything but a
Still Life

The Art and Lives of
Molly Lamb and Bruno Bobak

NATHAN M. GREENFIELD

Edited by James Harbeck.
Cover and page design by Julie Scriver.
Cover image: Photograph of Molly Lamb Bobak
and Bruno Bobak in London, England, by Joseph
McKeown for the *Montreal Star and Standard*.
Printed in China by MCRL Overseas Group.
10 9 8 7 6 5 4 3 2 1

Goose Lane Editions acknowledges the generous support
of the Government of Canada, the Canada Council for
the Arts, and the Government of New Brunswick.

Goose Lane Editions
500 Beaverbrook Court, Suite 330
Fredericton, New Brunswick
CANADA E3B 5X4
gooselane.com

Library and Archives Canada Cataloguing in Publication

Title: Anything but a still life : the art and lives of
Molly Lamb and Bruno Bobak / Nathan M. Greenfield.
Names: Greenfield, Nathan M., 1958- author.
Description: Includes bibliographical references
and index.
Identifiers: Canadiana (print) 20200210521 | Canadiana
(ebook) 2020021053X | ISBN 9781773100920 (hardcover) |
ISBN 9781773100937 (EPUB) | ISBN 9781773100944
(Kindle)
Subjects: LCSH: Bobak, Molly Lamb, 1920-2014. |
LCSH: Bobak, Bruno, 1923-2012. | LCSH: Bobak,
Molly Lamb, 1920-2014—Marriage. | LCSH: Bobak,
Bruno, 1923-2012—Marriage. | LCSH: Artist couples
—New Brunswick—Fredericton—Biography. | LCSH:
War artists—Canada—Biography. | LCSH: Painters
—Canada—Biography.
Classification: LCC ND249.B554 G74 2021 | DDC
759.11—dc23

To Micheline Dubé, who helped me see the world through Molly's eyes, and is there to share the places my writing takes us to,

and

To Pierre Ezra Lowrie, our first grandchild, who joined our world while this book was nearing completion.

Every artist dips his brush in his own soul, and paints his own nature into his pictures.
—Henry Ward Beecher (American minister, 1813-1887)

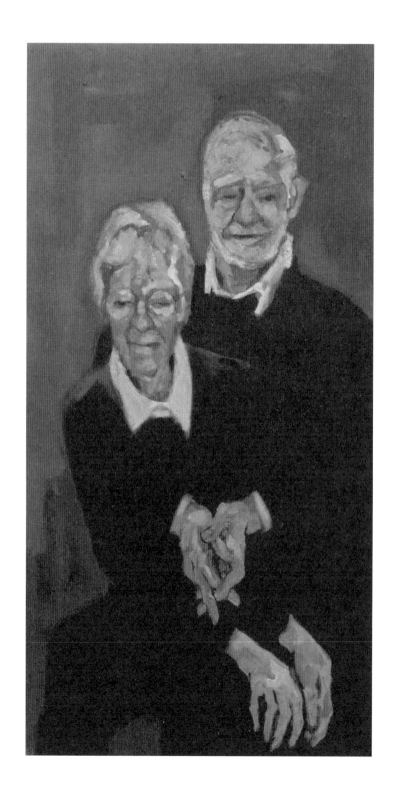

Contents

(opposite) Bruno Bobak, *Anniversary*, 2000
oil on linen, 121.6 x 60.8 cm

A Note to the Reader

Since the central figures of this book, Molly Joan Bobak (née Lamb) and Bruno Bobak, shared a surname after their marriage in December 1945, I cannot follow the usual practice of a non-fiction writer and refer to each as "Bobak." For a short time, I considered referring to Molly as Molly Lamb. But after a while that began to seem clunky. Although I generally find that non-fiction authors sound overly chummy if, after finishing with their subjects' youth, they continue to use their first names, I have decided to refer to my subjects as Molly and Bruno. As well, I refer to their children, Alexander Bobak and Anny (née Bobak) Scoones, by their first names.

In order to contextualize financial information, I have provided the dollar figure as it was in the period and the 2019 equivalent in parentheses, for example, "In 1969, the painting sold for $1,000 ($6,600)."

Unless otherwise indicated in the text, I have cited each reference to Molly's thirty-two-year long Diary in the endnotes following this format: Molly Diary, 24 February 1975. Unless indicated by date in the text, references to Molly's (Canadian Women's Army Corps–era) "War Diary" (hereafter, War Diary) in the endnotes are to the digital version available at Library and Archives Canada and appear in this format: Molly War Diary, 21.

Although I have reached out to both of Molly and Bruno's children, Alexander and Anny, each has declined to be interviewed for the project.

I thank Alexander Bobak for his permission to reproduce many of the images in this text. Accordingly, since I could not present their side of, say, an argument, I have refrained from using much of what Molly wrote about each of them in her letters and Diaries. I can only hope that they find my rendering of their parents' lives and art rings true to their memories of their parents, who, as public figures, also belong to Canadians.

As indicated in the endnotes and bibliography, I have been able to use letters held in the University of New Brunswick Archives, the archives of UNB's Art Centre, as well as letters held at the University of British Columbia. While I have been able to consult letters held in Library and Archives Canada from and to Molly from Molly's mother and father, from A.Y. Jackson, Jack Shadbolt, Joseph (Joe) Plaskett, and a number of Molly's other friends, I am enjoined from quoting them or summarizing their content. Needless to say, some of the particulars in these letters are fascinating; their absence does not materially alter the story told here.

Prelude
A Scene from Their Marriage

We have art in order not to die of the truth. —Friedrich Nietzsche

Near 4:00 p.m. on 16 February 1996, Molly Lamb Bobak and Bruno Bobak sat with several hundred other well-dressed men and women in the ornate ballroom in Rideau Hall, the Ottawa residence of the Governor General. After His Excellency Roméo LeBlanc gave a short speech about the importance of service to the nation and the nation's duty to recognize that service, Molly and Bruno heard their names called. Together, the couple —who two months earlier had passed their fiftieth wedding anniversary and were fast approaching the same anniversary of their demobbing from the army, in which they had both been war artists (she the only official female war artist and he the youngest)—walked to the front of the room. They stopped and stood in front of the man who, back in Fredericton, was known simply as Roméo. One of his aides opened the box containing Molly's white-and-gold medal, showed it to her, and then pinned it over her heart. Then he did the same with Bruno's. And as quickly as that, the first formal investiture of married artists into the Order of Canada was complete.

It was a near-run thing that Bruno was there—and not only because he would not drive to Ottawa in February. Or because he hated flying. Indeed, it had been so long since he last flew that at the Ottawa airport he was surprised and unnerved by how far the disembarking passengers had

to walk from the Dash 8 to the baggage pickup. The well-travelled Molly was amused by this and gently led him to the baggage carousel.

Though nominations to the Order of Canada are anonymous, Molly had a pretty good idea who had nominated them. The previous December, retired chief justice of the Supreme Court of Canada Antonio Lamer wrote her, saying that both she and Bruno, who had painted his official portrait four years earlier, should be awarded the Order of Canada. Accordingly, Molly was not surprised in early 1995 when she received a letter from Rideau Hall with the news that the Governor General intended to name her to the rank of Officer of the Order of Canada. She was, however, shocked that Bruno did not receive a similar letter.

"The thought that Bruno would not be honoured greatly upset Molly," says retired art historian Stuart Smith, who was a colleague of Bruno's at the University of New Brunswick for almost three decades and a friend to both Bobaks. "Molly told me that without Bruno receiving the honour she would refuse it."[1]

Molly's intent might surprise a casual reader of the coming pages, which — drawing from her Diary and letters — tell of the difficulties in her marriage, Bruno's towering rages, the number of times she wrote of permanently separating, and her escapes to meetings in Ottawa, Montréal, and Toronto as well as months-long visits to her beloved Galiano Island. Nor, as we will see, did Molly think much of Bruno's recent work. None of this mattered, however, when Molly was offered the Order of Canada's second-highest honour.[2] "Whatever my personal feelings: body of work from Bruno from the 60s, 70s, 80s is stunning. Amazing strength of colour.... Not by any remote chance could I compare with this stuff," she believed.[3]

Smith, who himself had been awarded the Order of Canada fifteen years earlier for his role in helping to save Fredericton's historic downtown, contacted a number of people in Ottawa, explaining that Molly intended to refuse admission to the order because Bruno was not being so honoured. "There was a rough and ready rule that as a smaller province, New Brunswick was allocated one officer and several members each year,"

Smith explains. "Accordingly, after some discreet strings were pulled, it was arranged that Molly and Bruno would both be admitted to the order at the level of Member of the Order of Canada."[4]

Molly's allegiance to Bruno's work is all the more striking given its distance from her own. "Where her mature work on flowers and crowds [is] formed from loose, Impressionistic, brush strokes and [is] oriented toward eliciting or recording fleeting moments of energy and joie de vivre, Bruno's most important works are indebted to Expressionists like Oskar Kokoschka. His presentation of the human condition is brooding and, one can say, almost defeated," says Smith.

At the investiture, Molly thoroughly enjoyed meeting Louis Applebaum, who received the order's highest honour, Companion, as well as physicist Bertram N. Brockhouse, who had won the Nobel Prize the previous year, and National Film Board producer Colin Low. Garth Drabinsky, the most famous name on the 1995 list announced on 30 June, took a pass on the ceremony. At the buffet dinner, "quite the best" she'd ever seen, Molly sat next to LeBlanc and another man and had a great time. Even Bruno, who did not like large parties, had "done awfully well."[5]

The next day, Molly solved the problem of Bruno's gouty leg that flared up on their way home by finding him a wheelchair with which to traverse the airport. She wasn't able, however, to do anything to relieve the tension caused by the "very rough flight" back to Fredericton.[6]

Back in Fredericton on the eighteenth, an "ugly sky" from which corn snow fell both triggered and reflected the end of the idyll. Like an inverted version of Cinderella, the day after the night before found both Molly and Bruno "in foul moods" that felt to her like a "mental breakdown," the effect of returning to the world of "anger and resentment."[7]

Introduction

I'm a painter. I wake up every morning and get to work. It's my little contribution to civilization. — Philip Pearlstein

Molly Lamb and Bruno Bobak came to artistic maturity in a much different context than did many of their teachers, who found it necessary to follow the footsteps of the late-nineteenth-century artists like Marc-Aurèle de Foy Suzor-Coté and James Wilson Morrice and pursue formal studies in Europe. Lawren Harris and Emily Carr, two of the artists who attended the salon-like gatherings hosted by Molly's father, Harold Mortimer-Lamb, studied in England, Belgium, and Germany. Jack Shadbolt, Molly's most influential teacher at the Vancouver School of Art, returned to his native England to study at Euston Road School before moving on to Paris, while Frederick Varley studied at the *Académie Royale* in Antwerp, Belgium; both were habitués of Mortimer-Lamb's hospitality. The British-born Arthur Lismer, who taught Bruno at the Art Gallery of Toronto in the late 1930s, studied at the Sheffield School of Art and at the *Académie Royale* in Antwerp before coming to Canada, where he worked at Grip Ltd., the commercial art firm in Toronto that served as a hothouse for the Group of Seven — five of its members had worked there.

Nor did the Canada in which Molly and Bruno learned about art lack for a distinct artistic identity as, for example, the editor of the *Canadian Magazine* believed it did in 1908, when he published Mortimer-Lamb's article lamenting the fact that no painter had yet come to terms with Canada's northern reality. At that time, Canada's best-known painters

were Cornelius Krieghoff (d. 1872), Homer Watson (d. 1936), and Horatio Walker (d. 1938). In addition to paintings of waterfalls and frontier life, Krieghoff's bread and butter was wintery scenes of Quebec *habitants* at work and play. Watson basked in Oscar Wilde's praise as the Canadian Constable. Walker painted Quebec's fields and villages with Jean-François Millet's sentimental brush.

By the end of the 1920s, Canada had produced two major schools: one that included both men and women who painted both urban and rural scenes, and an exclusively male outdoors-based one. The first of the two, the Beaver Hall Hill Group (BHHG) — named for the tony Montréal street where the artists rented space — produced mainly figurative paintings imbued with a modernist, though not, to at least one critic's relief, "secessionist" aesthetic.* After getting over the fact that most of the portraits displayed in 1922 were by women, the *Montreal Star*'s critic praised the "loud, brilliant, glaring colours — passionate reds, indigo blues, greens — [that] dominate and triumph."[1] Completed a few years after the BHHG's breakup following bankruptcy in 1922, Adrien Hébert's *Montreal Harbour* exemplifies other aspects of the group's modernist interests; it depicts the (now abandoned) Grand Trunk Railway concrete grain elevator and, before it, steamers moored, oddly, perpendicular to each other. As one historian notes, Hébert "highlights the rectilinear enormity of the port buildings as seen from close up, [the port] is framed by the geometry of the grain elevators, conveyors [belts] and ship masts." Though there would be other influences that nudge Molly and Bruno in this direction, both knew Hébert's work and how he pushed "natural elements," including the sky, clouds, and even the water, "to the very edges" of his work.[2] Other works by Beaver Hall Hill artists borrowed from Art Nouveau and Jazz Age aesthetics.

* In this context, "secessionist" does not refer to Quebec politics but to the secession movements in the late 1890s in Munich, Berlin, and Vienna that saw dozens of artists withdraw from mainstream or state-sponsored artists' associations and strike out in ways not approved of by the academicians. The Vienna secession movement included both Gustav Klimt and Oskar Kokoschka.

The Group of Seven and Tom Thomson (who died three years before the Group's founding in 1920), on the other hand, famously focused on the Canadian landscape.³ In contradistinction to Krieghoff's scenes that were seemingly transported from a seventeenth-century Dutch workshop, Harris served up stylized razor-sharp mountains in a vista that emphasized snow and ice. Before painting what became the iconic *The Jack Pine*, Thomson primed his canvas with vermilion red, which "gives the tree forms a throbbing vitality and force" and makes the granite of the Canadian Shield stand out.⁴ A.Y. Jackson's paintings were made "with vivid colours in a loose, sketchy manner, eliminating detail and applying his paint in thick layers"; they were derided as "Hot Mushes" and prompted questions about whether he had become a dope fiend under the influence of both Van Gogh and Impressionism while he was in Europe in 1913.⁵ Ten years later, Jackson, Harris, and Lismer were making regular trips to Algonquin Park, and later Algoma, to paint the "North." Eric Brown, the first director of the National Gallery of Canada, and the Art Gallery of Toronto, defended the Group of Seven against its early critics and purchased a number of their works.

This North established itself as a mythos in Canadian art. But it was also a mythical construct, or at least one that ignored core Canadian realities. At the same time as Jackson and the others were tramping through Algoma, nearby Sudbury was a major mining town — during the First World War, its nickel, incidentally, reversed Lismer's and fellow Group of Seven member Frederick Varley's trajectory and went to Sheffield, where it was turned into steel and fashioned into guns and shells by the city's famous armoury. And this North involved erasure and replacement: the Group's work has a complete absence of Indigenous men, women, and children, or even traces of their absence. This erasure was, of course, so common at the time as to be unthinking, but its effect, as Anne Clendinning notes, was the creation of "a central Canadian regionalism that was Anglophone, white and male."⁶ Neither the members of the Group of Seven nor its supporters twigged to the irony in such paeans as F.P. Housser's claim that their "task demands a new type of artist; one who

divests himself of the velvet coat and flowing tie of his caste, puts on the outfit of the bushwhacker and prospector;* closes with his environment: paddles, portages and makes camp: sleeps in the out-of-doors under the stars; climbs mountains with his sketch box on his back."[7] Even as the Group ignored First Nations peoples (as well as the *voyageurs*), they arrogated to themselves numerous traits of the people they did not depict.

Though both Molly and Bruno studied with members of the Group, and through her father, Molly knew some from when she was a young girl, neither was an acolyte; however, both show influences. In a few of Bruno's war artist works, it is easy to see his debt to the Group in the interlocking trees—their fullness all the more noticeable because they are set off against blasted tree stumps that do more than simply echo paintings from Algoma and Algonquin Park. And decades later, when he painted New Brunswick rivers with a brush borrowed from the Group, he, too, was uninterested in the lands' original inhabitants. At least one of Molly's early postwar works was so obviously indebted to the Group that Jackson ribbed her about it. Her signature works, both flowers and crowds, are animated by the same concern for movement made famous in Thomson's *The Jack Pine*. Perhaps most importantly, although much of their work was far from either the BHHG's or the Group of Seven's concerns (Bruno's Expressionist-inspired nudes being the furthest), the two groups bequeathed to Molly and Bruno a nationalist artistic consciousness.

Though it can sometimes be easy to forget, the development of Canada's artistic identity did not end with the Group of Seven. As the Depression of the 1930s deepened, the works of artists like Yvonne McKague Housser and Paraskeva Clark pointed beyond the "nation building" narrative associated with the Group of Seven and toward an avowed socialist artistic mindset. McKague Housser's *Cobalt*, for example, is more than a colourful rendering of the town of Cobalt, Ontario, with yellow, green, blue, red, and ochre two- and three-storey clapboard houses running down and then up a hill. Her clear delineation of the brown rocks

* Given the number of photos of Harris, et al. painting in three-piece suits, one might say that the Group didn't get the memo.

that poke through the deep green of the grass and the sinuous sky in the distance show her debt to the Group of Seven. The wooden towers that rise above the mine heads echo Harris's mountains. Two things make this picture of the town in 1930 stand out, however. The first is the almost total absence of people in a town where, in 1911, more than thirty mines produced 30 million troy ounces (937 tons) of silver. The second is the dilapidated state of the homes, symbolic of the depths of the Depression.

The Petrograd-born Clark answered her own call for Canadian artists to "come out from behind the pre-Cambrian Shield" with works like *Petroushka*, which owes less to the 1910 ballet about puppets coming to life (to Igor Stravinsky's music) than to her reaction to the killing of five steel workers by Chicago police in May 1937.[8] In a space between a tall yellow brick and squatter red brick buildings (two others are visible behind a fence), stands a short tower made of red corrugated iron boxes. On top of it is a top-hatted figure who resembles Monopoly's Rich Uncle Pennybags holding bags of money, while in front of him a cartoony policeman holds a Punch and Judy–like figure whose body is bent downward as if his legs were broken. "The viewer looks down on the scene in a cobblestoned yard between apartment blocks. The crowd responds to the performance with catcalls and clenched fists—an anti-fascist symbol of unity, strength, and resistance used here to indicate the artist's support for their cause," notes art historian Christine Boyanoski.[9]

Two other artists (who would be major influences on Bruno) gave a stark portrait of the times in a 1932 painting. *The Young Canadian* shows a male figure sitting on the ground between a farm on the left and an ominously quiet factory on the right, his arms draped over his legs. Charles Comfort was the painter; his model was another artist, Carl Schaefer. But this "young Canadian" does not have an artist's judging, probing gaze; instead, Comfort gave him what approaches a "thousand-yard stare," though his shock is not from the Western Front fifteen years earlier but rather from the economic crisis of the 1930s, which damaged millions in mind and body. By denying Schaefer, who looks out toward us, any knowledge of the light that glints off what is probably Lake Ontario

and the deep blue sky reminiscent of Van Gogh, Comfort all but cancels out the symbolism of these colours while taking full advantage of how they, and especially the white glint, push Schaefer's drained body forward. The angular figure in *The Young Canadian* anticipates the degradation of labourers John Steinbeck would soon depict in *The Grapes of Wrath*. Not only does Schaefer's muscular right hand hang uselessly, his left is positioned so that several fingers hang below the picture's bottom, thus all but obscuring the productive tool he holds: a paintbrush.

Comfort's decision to paint *The Young Canadian* in watercolour also fit with the work's theme and the times, when watercolours were popular because they were inexpensive.[10] Watercolours also have a certain spontaneity that is only partially the result of the fact that they must be completed swiftly, since the colour dries quickly. Years later, Molly spoke of wetting the page and then "draw[ing] with water," which, as we all know well, runs on its own, its natural spread producing an immediacy quite unlike the exactitude oil paints allow.[11] But at the same time, measuring almost a metre high and just over a metre wide, *The Young Canadian* pushes the limit of the medium and set a standard of colour handling that Bruno, especially, looked to. Comfort drew on his studies of Japanese watercolours and knowing how they used blotting paper, he produced deeply blue skies with insets of grey clouds; Schaefer's face shifts from stark white on the left to deep beige with black highlights, and many gradations from black to brown on his jacket.

As war clouds gathered first over Spain and then the rest of Europe, these artists and others turned toward even more open politics. Several artists — including Jack Humphrey, whose self-portrait casts him as an out-of-work labourer, albeit one wearing his worker's cap on a rakish angle as if it were a beret — went to Spain. In late June 1941, with Nazi Germany triumphant in the West and advancing into Russia, dozens of politically engaged artists met at Queen's University in Kingston, Ontario. Neither Molly nor Bruno left a record of what they knew about the Kingston Artists' Conference. However, it was covered in newspapers and art magazines. Further, since Shadbolt, who chaired the conference's

resolution committee, and Lismer were both there, it is reasonable to assume that Molly and Bruno were aware of the gathering of artists who wanted to enlist their art in the fight against totalitarianism. Equally important to the attendees was their desire to cast themselves as Canadian equivalents of Woody Guthrie and question "the conventional wisdom that free-enterprise capitalism was the best way" to organize the nation's economy.[12] "We thought," the artist Lucy Jarvis recalled in 1974, "here are all these totalitarian countries trying to clamp down on creativity, and we are doing the opposite thing, and we really did think of it as war work."[13]

Conscious of the success of the *Britain at War* exhibit of British war artists then running at the National Gallery in Ottawa, and of works Jackson, Lismer, David Milne, Maurice Cullen, and seven other artists produced during the First World War under the auspices of the Canadian War Memorials Fund (sponsored by Lord Beaverbrook), the Federation of Canadian Artists (FCA) — founded at the Kingston Conference — called for the creation of an official Canadian war artists' program. An unofficial one had, in fact, existed since 1939. Indeed, on 8 September, two days *before* Canada officially declared war, Frederick B. Taylor, a Montréal painter and architect, contacted the Department of National Defence urging the creation of a war artists' program.[14] After much negotiation, Taylor received permission for himself and eight other artists "to paint unofficially in the factories that produced war equipment."[15] Some twenty-two painters donated war art to a poster program run by the Departments of National Defence and External Affairs. In 1940, the Department of National Defence commissioned works from a few artists on an ad hoc basis.

For months, Prime Minister William Lyon Mackenzie King gave the FCA the same cold shoulder he had given a more august Canadian, the Right Honourable Vincent Massey, Canada's High Commissioner to Britain, an art aficionado, who in 1939 sought to replay one of Lord Beaverbrook's First World War roles and shepherd into existence an official Canadian war artist program. One concern in the Prime Minister's Office was that the artists would produce modern art, which King did

not like. Nor did vagueness of the FCA's proposal and its artistic language do much to nudge open the prime minister's door. "Neither King nor his staff was interested in discussing the philosophy of art," deadpanned one historian.[16] Even though mandarins like Hume Wrong groused that the public relations campaigns were designed "as if national feeling were a commodity to be sold" like soap powder, paying artists to help Canadians "see past the immediate struggle to a new [socialist] world" was a bridge too far for Ottawa.[17]

In February 1942, the FCA shifted tactics. Instead of trying to meet with King, it sent him a petition signed by almost one thousand artists. Following his usual modus operandi (memorialized by the poet F.R. Scott, who was at the Kingston Conference, as "Do nothing by halves/Which can be done by quarters"),[18] the prime minster passed the petition on to John Grierson, the founding director of the National Film Board and manager of the Wartime Information Board. Though Grierson took a less jaundiced view of the need for a Canadian war artists' program, through most of 1942, each step forward seemed to be followed by two backward. Early in 1942, Major Charles P. Stacey, the Canadian Army's historical officer in London, had managed to "formalize the hiring of Hughes, Fisher and Ogilvie [as artists] and to obtain them commissions as officers with the rank of second lieutenant."[19] Then, records Stacey in his memoirs in April 1942, "we were told that Fisher . . . would not be coming, no more artists would be sent, and the appointment of [BHH alumnus] Mrs. Lillias Newton, whom Massey had asked for as a portrait artist, was rejected."[20] Stacey, however, remained committed to the "slightly illegal" program and in October 1942 added Lawren P. Harris Jr. to it.[21] Though the Minister of National Defence Colonel James L. Ralston, who happened to be colour-blind, was decidedly cool to the idea of an official war artists' program, he did not overrule Stacey. Late in the year, Massey tried again. Perhaps because of Grierson's support, King reversed himself and authorized what became the Canadian War Records program.

We don't know when Bruno learned that the war artists' program had been authorized. However, from Vancouver, Molly had been following

these developments carefully. On 21 October 1942, two months before joining the Canadian Women's Army Corps (CWAC), she ended a letter to Shadbolt with the words, "I'll be seeing you in the War Records Dept," which was both where the lieutenant Shadbolt worked and where the war artists' program was to be housed.[22]

This dual biography could not have been written without access to Molly's letters and Diary. Save for a lamentable gap from December 1942 through January 1946, while Molly was a member of the CWACs, partially filled by her comic War Diary of CWACs, the letters and Diary cover her youth through the early 2000s. The majority of the letters are to and from Shadbolt and the artist Joe Plaskett. There are a significant number to and from Jackson, and a few from Molly's mother, her father, and an assortment of other people, including the artist and curator Donald Andrus. The letters are in collections of the University of New Brunswick and the University of Victoria. Molly's Diary is housed at Library and Archives Canada. The letters to and from Andrus are in his possession.

There is little debate that diaries can be trusted for quotidian events, such as when Molly went fiddleheading or Bruno went fishing; there is no convincing reason to dissemble about such daily occurrences. Major events outside of one's personal life, such as the outcome of an election, can also be trusted—and can easily be checked. On emotional or highly personal questions, however, diaries must be taken with a grain of salt, for, no matter how much confidence one might have built up in the author, in this case, of her own life, we must always remember that she presents "a view." Or, as Molly herself underlined on 17 January 1975, when she quoted Morley Callaghan's discussion of diaries on CBC Radio, "People only write [in their diaries] what they want other people to find."

At first blush, it might be thought that the biographer's task would be easier if Bruno had left a corpus of writing of similar size and variety as Molly's. In fact, this would only have doubled the problem. For then we would have always had two contending written "views" to deal with, and

we would be well on the way to a diaristic version of the Gunfight at the O.K. Corral on the banks of the Saint John River.

Diaries, at least diaries kept by serious diarists, are a special type of text. They share a number of attributes with literary texts: most notably, notions of story structure, quotation, time, and narration strategies (e.g., flashbacks and giving backstory when a new person is named). The episodic nature of diaries and their first-person narration links them to the epistolary novel, of which Samuel Richardson's *Pamela* (1740) is the paradigmatic example. This is not to say that Molly is omniscient and cannot be wrong; indeed, more than once over the course of three decades, she asserts something only to later report that she was mistaken. Yet, at each moment—when she makes the original assertion and when she corrects it—Molly's prose leaves little doubt that she is absolutely sure of the probity of what she is writing at the kitchen table before making breakfast. Still, we must keep in mind Winston Churchill's boast-cum-warning: "History will say that the Rt. Hon. Gentleman [Prime Minister Stanley Baldwin] is wrong in this matter. I know it will, for I shall write that history."[23]

I judged what Molly wrote about her troubled marriage against a number of sources. The first is Molly's own words or, to be more precise, how she spoke about Bruno and her marriage over a period of time: weeks, months, years, decades. In other words, I looked to see if her story remained constant. Second, I looked to responses to her words, from her friends as she records them in her Diary. Third, I looked to Molly's letters to friends like Shadbolt; since he knew and visited the Bobaks, he had first-hand experience that Molly knew about when she wrote what can safely be considered *cri de cœur* letters. The fourth "database" I had access to were friends and professional colleagues of the Bobaks. In some cases, my interviewees were quite forthcoming with details—of events, fights, anguish—that they saw over decades. Others, remained tight-lipped, while still others, reticent about "telling stories out of school," only confirmed general trends about the Bobaks' "difficult" marriage.

As well, while reading Molly's letters, her War Diary, and Diary, I have kept in mind the lessons by feminist scholars, including Judith Butler,

Carolyn Heilbrun, Mary Kelly, and Verna Reid, about women's auto-
biographies. Briefly, the difference they have found between women's
autobiographies and men's is that the very form is defined by men. Think
of the great autobiographies and the first two names that are likely to
come to mind are Augustine and Rousseau. The autobiographical form is
perforce tilted toward a man's desire to present himself as a fully formed,
unitary, heroic self. Charles Dickens plays with this very notion at the
opening to *David Copperfield* when the eponymous protagonist asks,
"Whether I shall turn out to be the hero of my own life, or whether that
station will be held by anybody else, these pages must show."[24] The answer,
as is well known, is "Yes—the former."

A quarter century after first Structuralism and later Deconstruction
showed that even for male writers the idea of the unitary self is a fiction,
Judith Butler, borrowing from linguistic philosopher John Austin's speech-
act theory, argued that women's autobiographical writing is a performance
that occurs within rules and social structures defined by men.* Following
Butler, I view Molly's War Diary as a self-conscious performance that
makes manifest the fact that she is an artist to be reckoned with. Her
intent, as we will see, was to impress upon male artists like Jackson and
through him the military hierarchy that she wanted to perform the speech
act (in this case, the signing of an order) appointing her as Canada's first
official female war artist. Indeed, in a letter Molly wrote to Shadbolt on
28 December 1942, less than a month after she joined the CWACs, she
makes this plain, telling him that her "newspaper...went over big with
the officers."

When Molly began keeping her Diary in January 1969, she appears
to have considered it a rather private enterprise. By the end of the year,
however, she reconceptualized it as a public document that would set out
her views on two main issues: her art (as well as her views of other artists)
and her fraught relationship with her husband. Since Verna Reid's *Women
Between*, which examines the construction of the self in the works of four

* Austin argues that certain locutions, such as when an authorized person says, "I now
pronounce you man and wife," create a new reality that others must recognize.

artists, including Molly's younger contemporary Mary Pratt, was published in 2008, seven years after Molly stopped keeping her Diary, Molly could not use Reid's term "the marriage plot" to conceptualize her own roles.[25] Yet, even without the term, Molly is fully conscious that she speaks from a script that casts women in traditional roles that in large measure she rejects but in other areas, such as her unwillingness to break decisively from Bruno, she partially accepts. One of her explanations for this refusal, her worry about who will take care of Bruno, is, of course, part of the traditional view of a wife and mother, though, as we will see, Molly did not view herself as a mothering figure. In at least one work, we can note without getting ahead of ourselves, Bruno makes it clear that he wants to view Molly in precisely this role; the effect of her failure to inhabit this role is recorded in other works. When writing about art, Molly is also aware of the traditional male version of art history and how her still lifes belonged to what was usually considered a lesser genre. Molly chose to contest this ground and, as we will see below, did so largely on her own terms and was largely successful.[26]

While I interpret Molly's paintings in the light of her Diaries and orient the story of the Bobaks' marriage in concert with what Molly records about it over time, Bruno's paintings and drawings are the narrative of his life, as both he and more than one curator and commentator of his work have noted. This is not as contentious as it might first appear. While one could extend the intentional-fallacy logic (i.e., that a work of art exists beyond the "intention" of the author and that it is not a biographical statement) to paintings, perhaps because of the iconographic tradition in Western art (Erwin Panofsky's *Studies in Iconology* is only the most obvious example), art historians have been much less bothered than literary scholars by doubts about intention.

The author of a recent book on Picasso's *Les Demoiselles d'Avignon*, for example, declares without the slightest hint of a scare quote, "The Women themselves may be singularly unsexy, but the rhythmic push and pull to which space is subjected diffuses the erotic charge across the entire surface of the canvas—an instance of what Freud would term

polymorphous perversity. . . . The seduction/repulsion that is the thematic heart of the painting encompasses not only the whores but the world they inhabit. . . . Spatial compression replicated tumescence."[27] After noting the presence of the artist's paintbrush in Pegi Nicol MacLeod's nude self-portrait in *A Descent of Lilies*, Devon Smither, who is acutely aware of theoretical issues, writes in her recent doctoral dissertation "Bodies of Anxiety: The Female Nude in Modern Canadian Art, 1913-1945,"

> MacLeod disrupts the codes of the nude genre. . . . We can read in *Descent of Lilies* a kind of resistance: she is both subject and object, viewer and viewed. MacLeod's nude self-portraits follow the modern turn away from tradition of a woman veiled in history or mythology to portray a woman or model "as she is." . . . MacLeod was engaging with international developments in modern art, responding to the work of those European artists exploring Surrealism and psychoanalysis, and in a similar fashion to [Suzanne] Valadon, counters the eroticism of the conventional high art nude.

Accordingly, it should not be contentious to read Bruno's or Molly's works both as having determinable relationships to existing trends in art and as meaningful statements about their emotional lives.

Finally, as I read Molly's Diaries, although I came to see her as an abused woman — and she came to consider herself one — this was true only in the context of her relationship with Bruno. And then, only later and partly. Molly's Diary makes clear that she was almost preternaturally optimistic and supremely able to compartmentalize her life. To view her as a beaten-down woman is to allow the tragedy of the Bobaks' marriage — which, as we will see, was painful for both of the persons in it — to overdetermine both her life and Bruno's.

We must thus also view their art as art on its own terms and in a historical tradition. However much Molly's many paintings of flowers and

crowd scenes can be viewed as escapist, they are also important works of art in their own right and are fascinating documents in the history of producing pleasing art, an all-too-often forgotten aspect of art history and theory. Often derided for the speed with which she painted them, Molly's flowers evince an interest in some of the more complex issues in the philosophy of aesthetics. And her War Diary, in particular, is best understood not just as a comic take on CWAC life but as a polyvocal literary event formed from intertextual references that is a singular work in Canadian art. Molly's CWAC paintings do more than record what otherwise would have been largely forgotten; they show her developing a sense of rhythm that makes her crowd pictures fairly shimmer with movement.

Similarly, though I examine Bruno's works through the prism of their marriage, to see his art solely as a form of self-therapy — to see the pain and lashing contained in his art as defining Bruno *tout court* — is to ignore his singular contribution to Canadian figure painting. No other Canadian painter in the period tried to bring into the Canadian *weltanschauung* such diverse influences as J.M.W. Turner, Claude Monet, Oskar Kokoschka, Carl Schaefer, and even Wyndham Lewis. His encounter with the terrible violence of war forced him to aestheticize the horror he saw during the Second World War. And however much Bruno was a classic Eastern European tortured soul, he is also the author of a number of humorous works and a fascinating examination of sexuality in a group not usually associated with *eros*: larger women. Further, while not as adventurous as his nudes and taut works, Bruno's fishing-themed works should not be dismissed because the phrase "fishing buddies" seems flippant; these works are a singular contribution to the Canadian pastoral.

When compared to their contemporaries, Charles Comfort, Alexander (Alex) Colville, Christopher Pratt, and Mary Pratt, Molly's and Bruno's lives have received little comment. The essays in *Molly Lamb Bobak: A Retrospective/Une Rétrospective* published by Regina's MacKenzie Art Gallery in 1993 and in *Bruno Bobak: The Full Palette* in 2006 are

extremely useful. However, neither these two books nor curator Michelle Gewurtz's recent monograph *Molly Lamb Bobak: Life & Work* are full-dress biographies. Nor did the authors of these works or of the few scholarly articles on Molly's War Diary have access to Molly's Diary and letters. Accordingly, these works do not consider Molly's or Bruno's work in relation to the detailed chronicle of their lives available to me and which forms the backbone of the chapters that follow. *Anything but a Still Life* seeks to fill this void by telling the stories of their lives and situating Molly's and Bruno's work in the flow of their lives across more than eight decades of the twentieth century. *Anything but a Still Life* takes us from their birth, through their education, their war artist years, their early professional years, and after 1960, the decades they spent in New Brunswick, years of marital strife, and triumphant painting.

PART ONE

1920-1945

Chapter 1
Learning Their Trade

A drawing is an autobiographical record of one's discovery of an event—seen, remembered or imagined. A "finished" work is an attempt to construct an event in itself. —John Berger

Molly Lamb Bobak's father, Harold Mortimer-Lamb, was one of the better educated of the tens of thousands of Britons who came to Canada in the 1880s. His parents were Captain Henry L. Lamb of the Indian Navy and Emily (née Mortimer). Mortimer-Lamb's father's career, which culminated as the naval director at the High Commission for India in London, allowed Harold to receive a solid education that included a brief period of study in Bruges, Belgium. But once he was in Canada, Mortimer-Lamb's career could have come from Horatio Alger's pen.[1] Like so many other immigrants who had been promised they would be taught to farm, Mortimer-Lamb found that what the farmer he had been assigned to, Captain L.N. Agassiz, wanted was a set of hands on the cheap.

Three months after arriving in Canada in 1889, the almost penniless seventeen-year-old walked away from Agassiz's Fraser Valley farm. Stints as a day labourer and cook in Vancouver were leavened by Mortimer-Lamb's friendship with the rector of St. James Anglican Church, where Mortimer-Lamb served as a lay reader. In 1891, trusting to his ability as a wordsmith, Mortimer-Lamb struck out on his own and started the *Chilliwack Progress*. Three years later, the twenty-four-year-old founded the *Boundary Creek Times*, which by 1896 was doing well enough for him to marry Kate Lindsay, with whom he would have six children. The following year, on the strength of articles he wrote as the *Province*'s (part-time)

mining correspondent, Mortimer-Lamb became director and secretary of the Mining Association of British Columbia, and founded the *British Columbia Mining Record*.

Over the next two decades, Mortimer-Lamb moved from strength to strength. In 1905, he became secretary to the Canadian Mining Institute, headquartered in Montréal. Four years later, he represented the Dominion at an industrial conference in Düsseldorf, Germany. During the First World War, he chaired the Central Directing Committee of Technical Organizations charged with co-operating with the (British) Advisory Council for Scientific and Industrial Research.

Mortimer-Lamb's family did not escape the all-too-common sorrow of losing a child to illness. In 1895, ten-year-old Dolly, Mortimer-Lamb's favourite photographic model, died during a measles outbreak. Kate never recovered from Dolly's death and lived the rest of her life in semi-seclusion. In 1916, their son Private J. Haliburton Lamb was badly wounded on the Somme. Three years later, Mortimer-Lamb suffered a nervous breakdown, likely brought on by overwork, which resulted in a move back to Vancouver. Within a year—helped by a regimen that included caring for three cows, ten goats, and chickens, and some strenuous plowing with a horse named Fred—Mortimer-Lamb was again active at the highest levels of British Columbia's mining industry.

Mortimer-Lamb's social position inoculated him against the opprobrium that might otherwise have fallen upon him for having a child with the family maid, Mary Williams, in 1920.[2] While he rubbed shoulders with business and government leaders in Vancouver, Victoria, and Ottawa, their daughter, Molly, and her younger half-brothers

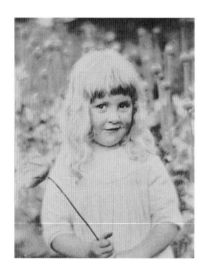

Molly Lamb as a child at Burnaby Lake, British Columbia, 1923.

(Photograph by Harold Mortimer-Lamb, Royal BC Museum and Archives, Victoria)

and half-sisters were effectively raised by Williams. "Gombo," as Molly called Kate from a childhood mispronunciation of "godmother," was kind to Mortimer-Lamb and Williams's daughter. As Molly grew up she recalled Kate Mortimer-Lamb seeking solace from the ministers at St. James Anglican Church and from another whose church was in Chinatown. Kate's last years were spent in a bed under a print of Christ taken from Leonardo da Vinci's *Last Supper*, which Molly would turn to much later as a model in something other than a religious context.

Bruno Bobak's father was also a writer, though as a poor Polish-speaking immigrant he could not support his family with his pen. The Bobaks' immigration to Canada in 1925 was, actually, the second time the families of Dziedzik Bobak and Bronislawa (née Wiewiorka) sought to better their lives by immigrating to North America. The first attempt began before the First World War when the Bobak and Wiewiorka families (which did not know each other) immigrated separately to New York. Dziedzik and Bronislawa married in 1917 and had two sons, but in 1921 dire poverty forced the four of them back to Poland, making theirs one of 678,000 Polish families to return to their homeland between 1919 and 1922. In 1925, likely after experiencing a certain amount of reverse culture shock, Dziedzik and Bronislawa, who had had another son while in Poland, decided to try their luck in Canada. At Pier 21 in Halifax, upon seeing the youngest Bobak's Christian name, Bronislaw, a Dominion immigration official "christened" the infant with a simpler name, Bruno.

After failing at farming in Saskatchewan and being unable to make a living in Windsor, Ontario, the Bobak family fetched up in Hamilton, Ontario. Their poverty was so great that even after reducing the family's mouths by one (by allowing Dziedzik's sister and her husband in Buffalo, New York, to "adopt" Henry, their eldest son), Bronislawa abandoned the family, moving to a town near Niagara. Sometime later, a woman named Mary, whom Bruno called Babi,[3] a "loving mother, the only mother I ever knew," joined the family.[4] We don't know whether Dziedzik, who

in addition to being a general labourer taught drama in Polish schools, considered how dramatic the moment would be when Babi entered the lives of Bruno and his older brother Ernie. The approach of a woman the boys did not know in their school playground, offering two-layered cookies with icing in the middle to entice them to come with her to the apartment that would be their new family home, was one of Bruno's most vivid childhood memories.

Likely because he was a cultural leader who published articles in the local Polish journal, the ultramontane Catholic Polish community accepted Dziedzik's irregular relationship with Mary. At some point, perhaps because of Mary, Bruno began considering himself a Baptist, which may explain why there is no record of the normal rites of passage for a Catholic boy: communion, confirmation, or consideration as an altar boy. Given Dziedzik's position in the community and Mary's religiosity later in life, we can assume that despite their poverty, Christmas and Easter were as special as the Bobaks' straitened circumstances permitted.

While Babi provided Bruno with warmth and nurturing that was absent from many Depression-era families, Dziedzik just managed to keep his family clad and fed. To help keep the home fires burning, Bruno and Ernie scrounged coal from the nearby Canadian Pacific Railway tracks. The brothers augmented the family's diet with potatoes corralled from Hamilton Harbour, where local farmers (following government directives) dumped them to create shortages designed to keep potato prices from collapsing. Such urban foraging meant learning to avoid police patrols. Bruno's school lunch often consisted of shredded cabbage sandwiches, at least one of which was eaten by another boy who traded his brown sugar and honey sandwich for Bruno's fare.

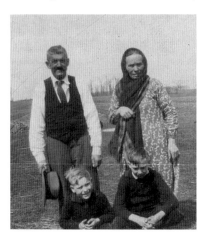

Bruno (left), his brother Ernie, and their grandparents, c. 1931.

Unlike Horatio Alger's heroes, Mortimer-Lamb was not interested solely in financial success. His true love was art. Were they to have spared a moment for aesthetics, the hard-bitten miners Mortimer-Lamb interviewed and photographed would likely have agreed that "no painter has yet experienced the spirit of the great northland: none perhaps has possessed the power of insight which such task would demand," as Mortimer-Lamb wrote in the November 1908 issue of *Canadian Magazine*.[5] The gifted amateur painter's support for such *avant-garde* painters as A.Y. Jackson, whose work, he assured his readers (with tongue planted firmly in his cheek) can in "no stretch of fancy . . . be classified as post-impressionist," was, however, hardly designed to appeal to miners and mining executives.[6] Mortimer-Lamb's words would have been even less welcome by the few Canadians interested in purchasing art in 1913, who, with visions of Krieghoffs hanging on their walls, considered the works produced by the men who later became the Group of Seven to be muddy canvases. Readers of mining journals appreciated the photographs that accompanied many of Mortimer-Lamb's articles. What they would have made of his pioneering work in night photography and gauzy (out-of-focus, Pre-Raphaelite-like) pictures of children can only be guessed at.

Though other critics derided the Group of Seven, Mortimer-Lamb's status as secretary-treasurer of the Canadian Mining Institute's BC Division, executive secretary of the Mining Association of British Columbia, and editor of the *British Columbia Miner* gave him the latitude to mount a full-throated defence of this burgeoning Canadian artistic form. In a seven-page article on Tom Thomson in the prestigious journal *The Studio*, published the year the Group was founded and three years after Thomson drowned on Canoe Lake in Algonquin Park, Mortimer-Lamb wrote that works like *The Jack Pine* were "remarkable chiefly in that they express a typical Canadian spirit, in a degree never before so concentrated and consistently maintained."[7]

Mortimer-Lamb also opened his home, a large house set on a one-hectare estate in what is now Burnaby, to artists such as A.Y. Jackson,

J.E.H. MacDonald, Frederick Varley (who, Molly recalled, did not like children), and Emily Carr. Their presence at soirées and lawn parties at which tables groaned with "eclairs, cakes, sandwiches, a big jug of milk and a bigger teapot of Nabob orange pekoe tea" kindled Molly's interest in art.[8] More than once in her letters and Diaries she says that she inherited much of her artistic skill from the man she always called Dada.

Save for the devotional paintings Bruno saw in churches or homes, his exposure to artistic images was restricted to what his teachers showed in class and what he saw in school texts. It's true Molly's mother had to rifle through Mortimer-Lamb's trousers for change that she used for taking Molly to see the British Guild Players at the Empress Theatre, but this means Mortimer-Lamb earned enough money that he could unthinkingly leave change in his pockets. By contrast, Bruno and his friends were so poor that they rarely had even the nickel that would have bought them admission to double features in which they might have caught glimpses of artworks in films.

From an early age, Bruno showed an interest in doodling. His teachers, graduates of Ontario's famed normal schools, saw little value in this practice. Indeed, combined with an inability to concentrate that seemed impervious to the strap, his doodling was taken as proof that Bruno possessed lower-than-average intelligence. His difficulty in concentrating was, in fact, due to a growling stomach and the trauma of being bullied by bigger boys.

Like Molly, Bruno appears to have inherited at least some of his artistic sense from his father. This, at least, was Molly's view after the decades-delayed reunion with Henry in 1984, a few months before Bruno's eldest brother died. But even as she thought that the wooden toys Henry made and proudly showed his brother and sister-in-law evinced "rare skill," she knew the Bobak brothers' painful past meant that neither could admit their design skills owed something to Dziedzik.[9]

Henry's memories of his parents were grievous. The mother who had

allowed him to be adopted out of the family was, he told Bruno and Molly, a "whore"; Henry remembered her "boyfriends," one of whom he claimed was Ernie's real father, though the fact that Henry could have been at most three years old when Ernie was born suggests he is remembering a later period.[10] Henry's memory of Dziedzik smashing the wooden toys that young Henry had made meshed with Bruno's memories. Bruno resented doing his father's bidding at Polish community festivals and picnics and, more importantly, his father's jealousy when, during Bruno's early teens, Dziedzik realized that his own talent had been surpassed by his youngest son.

The family's situation improved slightly in 1934, when they moved to Toronto, where Dziedzik worked as a manual labourer and Babi took in sewing. Bruno's continued poor grades prompted the principal of the neighbourhood school to recommend that the twelve-year-old transfer to Orde Street Public School. Standing at the intersection of College Street and University Avenue, the school was a model for underprivileged students, many of whom were Polish-Jewish emigres with whom Bruno could converse in the language spoken at home. Since hungry students could not learn, the school provided breakfast and lunch, and since sleepy students could not concentrate, it provided cots for naps.

Established in 1905 as a school for tubercular children, the school's classrooms differed greatly from those at Bruno's previous schools, where the desks and seats were bolted to the floor. Nor did the school follow the regimented pedagogy for which Ontario was famous (until after the Hall-Dennis Report of 1968). Instead, Principal Dr. D.D. MacDonald's school was loosely based on the theories of American education theorist John Dewey and emphasized discovery by the students. Under this permissive system, which saw value in skilful doodles, Bruno blossomed and began learning to draw. As William I. Thomas and Florian Znaniecki, authors of the five-volume *The Polish Peasant in Europe and America*, could have predicted, even though Dr. MacDonald's staff did not interfere in Bruno's home life, the interest and special supervision Bruno received at the Orde Street Public School fed the "culture war" in the Bobak home.

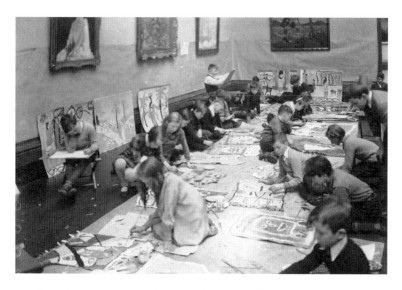

Saturday morning art classes at the Art Gallery of Toronto, 1936.
(City of Toronto Archive, Fonds 200, Subseries 2, Item 76)

Bruno's North American values of independence clashed with Dziedzik's traditional Polish values, the central pillar of which was the father's absolute authority over his family.[11]

At one point, likely when Bruno was thirteen, his equally poor school chum, Gerald Budner, invited Bruno to join him at the Art Gallery of Toronto (AGT, today's Art Gallery of Ontario) for Saturday-morning art classes that were directed by Group of Seven alumnus Arthur Lismer. Influenced by Franz Cižek (a Viennese teacher, artist, and follower of Freud) and John Dewey, Lismer believed that "true [art] education should aim at the harmonious development of native abilities, instead of using the child as an example of obedient response to professional or commercial demands."[12] Children were encouraged to explore their imaginations on paper, through metalwork, puppetry, and stage and costume design. In 1939, the *Christian Science Monitor* waxed poetic about an "Indian project" in which the children learned about West Coast First Nations and learned to make facsimiles of ceremonial robes.[13]

That same year, a reporter for the *Toronto Star* took on the task of explaining to the readers of Canada's most popular newspaper why, in the

midst of the Depression, children were "learning to think of light as an active thing, as a person who co-operates with them": lessons that stuck with Budner, a future National Film Board film director, and—as we will see in detail in the pages to come—the now aspiring artist Bruno.[14] Bruno later recalled what simply being in the building meant to his development. The "people I knew and rubbed shoulders with didn't go to movies. To see even a book with colour reproductions was a rare thing. So, coming face to face with real art on the wall was an incredible inspiration for me, for all of us."[15]

A follower of Blavatskian Theosophy, Lismer kept his heterodox religious views out of the classroom. Instead, he taught that painting was not a way of imparting facts and information. Rather, he encouraged Bruno and the others to express themselves boldly, using very few colours and big brushes.

In lieu of Algonquin Park or Algoma, Lismer and other AGT teachers took their charges to sketch outside at the Kensington Market and to Toronto's (still rural) Centre Island. The island was the source of *Untitled, Fishing Community* (p. 193), in which the seventeen-year-old Bruno confidently depicted a shorefront with three boathouses, one tumbling down, as if he were looking at them from the water. What would become one of the signature strategies of his early work, the use of the white of the under-canvas, is integral to the sky and water and to emphasize the sagging roof of the most run-down boathouse. The woodcut *Street Scene*, executed the same year, shows the influence of sketching factories and industrial plants as well as what Bruno learned by examining Lawren Harris's *Elevator Court, Halifax* and, especially, *The Gas Works*, both of which hung on the AGT's walls. The "dingy browns and greys" that modulate the light and make a social commentary on the "pollution-infested" workers' houses depicted by the scion of the heir to the Massey-Harris fortune are replaced in Bruno's woodcut by shadows—that feel less and less benign the longer one looks at them.[16]

While the AGT received funding from the Carnegie Foundation, students were required to pay a nominal tuition, which was beyond

Dziedzik's purse. Pushed by both his socialist political principles and belief in social improvement–rooted Theosophy, in lieu of tuition, Lismer made Bruno a monitor responsible for setting up easels. This arrangement did not end up as Tom Sawyer and fence painting *après la lettre*. Instead, the monitorship allowed the increasingly ambitious young man to mix with teachers and other staff.

The teachers at Central Technical School, the high school Bruno attended after graduating from the Orde Street Public School, may not have been imbued with the spirit of progressive education, but they knew their stuff. As befits the Collegiate Gothic architecture of the school that still dominates the corner of Bathurst and Harbord Streets, students followed the traditional educational program of reproducing in two dimensions three-dimensional copies of Roman and Greek busts as well as flowers, chairs, and buildings, skills that Bruno would put to good use "building" paintings, to use the word the Bobaks' long-time friend Stuart Smith chooses admiringly to describe how Bruno constructed his works.[17] At Central Tech, Bruno learned the essential skills of pen and ink, pencil, crayon, watercolours and oils, sculpture, and woodcutting. Bruno studied drawing under Charles Goldhamer, a "master of charcoal," who was president of the Canadian Society of Painters in Water Colour and had exhibited several watercolours at the Tate Gallery in London.[18] Decades later, after he had won numerous awards for his own graphic and design work, Bruno recalled that Goldhamer "was strict but reasonable and sympathetic."[19]

From the Toronto Board of Education's point of view, the measure that mattered most was job placement. And here, too, Bruno's school excelled; in 1937, in the teeth of the Depression, when unemployment in Toronto hovered around 30 per cent, every one of the printing, mechanical drafting, and architecture students found work. Bruno and his fellow students — including Budner (who remained a life-long friend), future NFB filmmaker Grant Munro, Aba Bayefsky (who became an air force war artist and was the only Jewish artist to record a concentration camp, Bergen-Belsen), and Edwy Cooke (director of the Beaverbrook Art Gallery

when Bruno's family moved to Fredericton, New Brunswick) — also benefited from the school's rigorous academic program, which included studying English history and essay writing. These last were graded by the Ontario Ministry of Education, the standards of which were legendary.

While in high school, Bruno held two jobs. At seventeen he graduated from monitor to teacher at the AGT. At around the same time, Goldhamer put Bruno on the road trod by Tom Thomson and five members of the Group of Seven by arranging for a part-time job with a commercial art firm. In addition to cleaning up the office, Bruno hand-lettered banknotes and bond and stock certificates. The poor boy parlayed this skill and his access to a perforating machine into a little petty larceny: making streetcar "tickets" that fooled the officials responsible for checking that riders had paid their transit fares.

Bruno learned other skills, as some of his friends discovered decades later, at a dinner at the Bobaks' in Fredericton. After someone asked Smith how he had become interested in art history, Smith recounted how his father, a rug salesman at the Canadian National Exhibition in 1941 or 1942, gave the young Smith a break so he could see some of the exhibits. He told his dinner companions that he walked into the Borden Dairy Company's installation nearby, which had a large refrigerated case, in which he saw a life-sized statue of Elsie the cow carved from butter. Barely had Smith said these last words when Bruno slapped the table so hard the empty wine glasses jumped. A smile spreading across his broad Eastern European face, Bruno said, "That's my cow! I sculpted it before I went into the army, while I was working for the commercial art company Wookey, Bush and Winter."[20]

Family lore has it that Molly's poor eyesight explains her poor performance in school. And it is true that she wore Coke-bottle glasses, and that starting in the 1970s she had severe eye problems, including surgery for a detached retina. But with her glasses she did well in art school, passed the physical to become a member of CWAC, saw well enough to drive (though she

did little), was a voracious reader, and become Canada's most successful female painter of her era. Accordingly, her poor school performance likely owed as much to the failure of British Columbia's rote curriculum and her teachers' failure to engage her as it did to poor eyesight. At all events, when Molly was in her mid-teens, Williams agreed to send her to Vancouver School of Art.

Whatever pride Molly took in going to the school her father had helped found vanished during her first year there when one of her teachers told her, "You're hopeless. You'll never become an artist."[21] She returned for the second year only because her mother insisted she do so. On the first day of class, instead of ripping into her in-class sketch of a classmate, a new teacher, Jack Shadbolt, said to her, "I like that line" before adding, "Now if you work on this, give me this structure, dig here, and understand the bones under this [skin?]."[22] Shadbolt not only turned around Molly's attitude toward school, she had a two-year-long crush on him.* Shadbolt soon became another artist who came to Mortimer-Lamb's home to talk about painting; he especially enjoyed, Molly recalled years later, fresh cream from the family's cow.

At a time when most art schools (including, surprisingly, Emily Carr's) had students copy reproductions of the great masters and draw from plaster casts, Shadbolt introduced his students to the Impressionists and *en plein air* drawing. While none of Shadbolt's lesson plans or class notes survive, an idea of what he taught about the formal principles of structure can be had by looking at *In Search of Form*, which, though published in 1968, contains many examples dating to when Molly was his student. One sequence of two sketches of his backyard in Victoria shows how treating the "space" between objects as being as important to the scene as the objects themselves and adding curvilinear lines that lead the eyes forward turn a factual presentation into a dramatic one.[23] In another, a stand of trees turns into a "whip lash of energy breaking from limb to limb" by departing from facticity.[24]

* Among Molly's other teachers were two artists she already knew: MacDonald and Varley.

Using Cézanne's works and others', Shadbolt taught that spatial progression could best be achieved by building up a scene plane by plane so that objects "link…their structures indissolubly into a firmly wrought dialogue between static and rhythmic elements."[25] While the rectangular plane on the mid-left of an untitled 1941 oil Molly completed while she was a student does not produce the depth-of-field effect intended, it nevertheless shows her incorporating Shadbolt's lessons. Nor do the people, who are obviously walking, drive forward to the fence. It is worth noting, however, that the bare tree on the left links with the slope of the roof, and how Molly uses the yellow street light and yellow light in the windows to unify the frame. Writing years later, Molly's words bespeak her amazement at another aspect of Cézanne's work that Shadbolt drew attention to: "One could see layers of watercolours [a particularly difficult technical feat since layered watercolour tends to run to muddy brown] over surfaces of taut blue strokes shattering around the edges, open, moving."[26]

Bruno left no record of his reactions to Adolf Hitler's rise to power, the events of the 1930s, or the gathering war clouds. From Lismer, friends like Bayefsky (who was Jewish), worries in the Polish diaspora community, and Matthew Halton's articles in the *Toronto Star* detailing the Nazi terror he saw in the Third Reich, Bruno would have known the broad outlines of what was happening in Germany. Events like the *Anschluss* (the incorporation of Austria into Nazi Germany in March of 1938) augured poorly for the peace of Europe.

Though an ocean and continent away from where Hitler and Joseph Goebbels harangued tens of thousands, Molly's home in Burnaby felt the effects of *Kristallnacht*, the pogrom on the night of 9 November 1938 during which the windows of more than 7,500 Jewish-owned shops were smashed and the stores vandalized, and 267 temples burned, following which 30,000 Jews were sent to Dachau, Buchenwald, and Sachsenhausen. At Williams's urging, Mortimer-Lamb welcomed Pamela Diamond (the daughter of famed British art critic Roger Fry); her husband, who was

a Romanian Jew; and their son Roger into the Lamb home. Pamela was afforded a singular honour: hanging her favourite Renoir, which Mortimer-Lamb did not like, over the living-room fireplace.[27]

Even Molly's taste in art, especially her reverence for Cézanne, can be seen as having political overtones. Despite Cézanne's well-known anti-Semitism, the Nazis lumped him in with the "degenerate" Impressionists, post-Impressionists, Cubists, and of course Jews, such as Marc Chagall. From the newspapers and certainly from the politically aware Shadbolt, Molly would have known that the Nazis removed "degenerate modern artists" from museums and mocked them in *Die Ausstellung „Entartete Kunst"* (*Degenerate Art Exhibit*): many in the rooms with "Madness becomes method" or "Nature as seen by sick minds" printed on the walls.

When war broke out in September 1939, Molly and Bruno might have joined with, and certainly knew of, the crowds that gathered in Vancouver's Robson Square and Toronto's Nathan Phillips Square, respectively, to sing "God Save the King," "The Maple Leaf Forever," and "O Canada." Given that in her youth Molly had read the entire *Times History of the War*, it's reasonable to assume that her nineteen-year-old mind filled with images of the Western Front and battles like Gallipoli. When she heard that military police and soldiers were now guarding Vancouver's docks, she would have had little trouble imagining their beats; during her tomboy days, she had spent many happy hours prowling the docks. The Anglican church, in which her favourite half-brother, Abby, was a parson, offered up its prayers for their British Empire.

Even after travelling to Poland in the late 1980s, when his work toured the country, Bruno was not known to speak longingly of the place as his "homeland." Yet, the young man living in the Polish-Canadian community, who spoke Polish at home and whose birth certificate gave his name as Bronislaw, could hardly have been unmoved by the radio reports and pictures in both English and Polish papers of the dive-bombing of Warsaw. At church and at home, he would have heard prayers for *Polska* and for family across the sea. Nor could he have escaped knowing that the empire to which he belonged—the pink graphic representation of it that

girdled the world map he saw every day in school—had gone to war to protect the land from which his family had twice emigrated.

Molly was aware enough of the war in May 1940 that when a friend asked her why she had burst into tears in the middle of an overnight camping/sketching trip, instead of saying it was because her heartthrob, Shadbolt, had gone off with a pretty girl (and not the acned Molly), Molly said, "Oh, those poor men at Dunkirk."[28] Two years later, in a letter to Shadbolt, Molly identifies the old soldier she was talking to (about the tartan skirt she was wearing) by his regiment, the Seaforth Highlanders, showing an uncommon knowledge for a young woman of things military. As seen from Arbutus Point Lodge on Salt Spring Island, owned my Molly's mother, where Molly was working in mid-1942, the war had a certain unreality about it, despite the fact that the Battle of the Atlantic raged, and in just seven months U-boats had sunk more than two dozen ships in the St. Lawrence River, as well as the recent disaster at Hong Kong, where the 2,000-man-strong C Force suffered 100 per cent casualties (killed, wounded, missing, and captured). At Arbutus Point, a certain Mrs. Blanchard worried loudly whether it was safe to go boating because of the mines she feared the Japanese had planted.

The rustic lodge sat on property filled with apple trees, mosses of different shades, and rock flowers such as blue lobelia and pink bells, all of which appealed to Molly's developing artistic sense and called to mind Henry David Thoreau's *Walden*, which Shadbolt had introduced her to. Mortimer-Lamb bought it for Williams in early 1942, after she turned down his offer of marriage; Harold's wife, Kate Mortimer-Lamb, had died three years earlier. Rather than agreeing to regularize their relationship, Williams suggested that to allow her to move out of the Mortimer-Lamb home and support herself, he should buy her the small summer resort on Salt Spring Island.[29]

Williams did think, however, that Mortimer-Lamb should marry. She urged him to propose to Grace Melvin, a long-time friend and teacher at the Vancouver School of Art, but Melvin, too, demurred. Aware that he had had an affair with Vera Weatherbie (which had upset Varley, since

she was his model and muse), the ever-practical Williams suggested that Mortimer-Lamb give her a try.[30] Given the more than thirty-year gap in their ages — Mortimer-Lamb was in his early sixties — he was not hopeful.

Though vaguely aware of this minuet, it wasn't top of mind one early May day in 1942 when Molly went to her father's house to surprise him. Since the door was not usually locked, she did not bring her key. Finding it locked, however, Molly reprised a childhood pastime and crawled through the air vent of the organ in the house's kitchen. Moments after jumping onto the kitchen floor, Molly saw her father and another person rushing in to see what was making so much noise.

"Dad," Molly said, catching sight of him, "you shaved off your beard!"

"Moll," he replied, "I was married today."

"To miss so and so?" Molly said, no doubt with a bit of sass in her voice.

But the other person who had rushed in was Vera, who stepped forward and said, "No. To me. Do you mind?"[31]

Somewhat later, alone in her old room, Molly shed a few tears — "Not because of the marriage, but because our old life was over," she wrote in her memoir, *Wild Flowers of Canada*. While Molly hastens to add that the marriage was the start of their "long and happy life together," in her Diary she recalls being upset by the marriage and that it took her some time to get used to it.[32]

After turning nineteen on 28 December 1942, Bruno had the choice of volunteering for the army, navy, or air force, or signing up for the home defence force under the National Resources Mobilization Act (NRMA). Not wanting to be a "Zombie," as the NRMA men were pejoratively known, Bruno joined the army in January 1943. He rather liked the cut of his army uniform, which fed into his view of himself as something of "a dandy." But, given how hard he had worked to lay the foundation for a career as some kind of artist, he must have found his first encounter with

the army's mentality as something of a shock. The recruiting officer filling out Bruno's attestation papers asked what his trade was. Bruno proudly answered that he was an artist who had just had three works accepted by the AGT for its *Painters Under Thirty* exhibition. Without missing a beat, the officer wrote, "No Trade."[33]

Although by 1942, tens of thousands of women were serving in the Canadian Women's Army Corps (CWAC), the Women's Division of the Royal Canadian Air Force, and the Royal Canadian Navy's Women's Royal Canadian Naval Service, Molly did not have to decide between one of the armed forces or being a Zombie.[34] Yet, pushed by the changes to her family, her undeniable patriotism, as well, perhaps, as her knowledge of her grandfather's military career and her half-brother's, and her hope to become the first official female war artist, by late October 1942 Molly had decided to join the CWACs. At the end of December 1942, she signed the papers that immediately provided her with the sort of alternative family depicted in the National Film Board film *Women are Warriors*, narrated by Lorne Greene's resonant voice. Given her art school training, it's hardly surprising that what struck her about her first moments in the army was the Vancouver Hotel's military décor: its ornate interior had been torn out and replaced with institutional grey walls and banisters. Decades later, she remembered the feeling of the "bare, bare, bare" barracks on the hotel's top floor and the glow of the naked light bulb above her bunk.[35]

Molly's expectations of military discipline, drawn from her childhood memories of having been made an honorary member of the crew of a freighter belonging to the Norwegian Skibs-A/S Fruit Express Line, did not quite match up with the reality. The raw recruit was nonplussed to learn that to go to dinner with her mother she needed a pass—and that she would have to be back by 11:00 p.m. At what was one of her favourite restaurants, Molly was so upset she could barely eat.

Thinking of Mortimer-Lamb's connections in Ottawa, Williams promised that they would go all the way to the prime minister to get her out of the army. Hope formed from these comforting words alternated

with the knowledge that since Molly was a twenty-two-year-old, her parents could do nothing to undo the signature that had formalized her taking the king's shilling.

But a few days later, she was so happy that nothing could have gotten her out of the army. Years later, the child born to privilege spoke of being "thrown in with all kinds of girls from different backgrounds." Of her military family, she told one interviewer, she "can honestly say that there wasn't a girl" she didn't like.[36]

Chapter 2

The Education of Two Artists
as Young Soldiers

The way in which I create myself is by means of a quest. I got out into the world in order to come back with a self. —Mikhail M. Bakhtin

The Bobaks told good stories of how they became war artists. When Ian Lumsden, director of the Beaverbrook Art Gallery, interviewed Molly for the booklet produced to accompany her paintings of Queen Elizabeth II's 1976 visit to New Brunswick, Molly told him that almost as soon as she attested into the army, she began "pestering to be a war artist."[1] Bruno's story is more dramatic, turning as it does on his being detached from his sapper unit just days before his 13th Canadian Infantry Brigade was set to storm Juno Beach. The call to Canada House may have saved Bruno's life, for most of the men in his platoon died on that Normandy beach.

It takes nothing away from Molly's and Bruno's patriotism that their future fields of glory were pieces of canvas. That each became an official war artist was due to their skill and drive—as well as to a network of powerful men in the arts world who were on the lookout for talented painters, and, importantly for Molly, were remarkably unconcerned with gender.

The guarantee of three squares a day was not enough to break Bruno of the habit of earning money where he could. Shortly after enlisting, he volunteered for the Canadian part of an international gas warfare study. Army doctors applied liquids infused with such agents as mustard gas to

unprotected skin to see how skins of different ethnic and racial groups reacted. The doctors then spent "days applying various ointments and medications" to the painful blisters to determine which, if any, helped healing.[2] As well, while based in Petawawa, Ontario, in addition to painting watercolours in his spare time, Private Bobak produced charcoal and pencil sketches of his friends for $5 ($75) each.[3] However, if we judge from what the curator Donald Andrus called the "heroic materialism" of *Still Life, Army Kit* that dates to the same period, in which the buckle of the belt is rendered carefully and the netting of the Brodie helmet shows wear, Bruno's portraits must have been seen as true to life by the sitters as well as their wives, girlfriends, and/or parents.[4]

In January 1944, Bruno's former teacher (and now RCAF flight officer and official war artist) Charles Goldhamer visited him at Petawawa. He left with five of Bruno's best watercolours and a covering letter in which Bruno introduced himself to H.O. McCurry, who, in addition to being the director of the National Gallery, chaired the Canadian War Artists Selection Committee. McCurry responded warmly. On the strength of what he had seen, he said he would speak to the authorities "and perhaps get you some opportunity to devote more time to painting."[5] McCurry's letter to Colonel A.F. Duguid can only be described as effusive, saying Bruno "appears to be something of a genius in water colour." He is, McCurry continued, "the kind of young man who should be given an opportunity to paint and I wonder if it could be arranged, at least for a short period of time, to see what he could do without actually giving him a commission at first."[6]

Molly came to the notice of the War Records Office at about the same time and through an equally personal route. In February 1944, while stationed in Ottawa, she arranged to meet her father's old friend A.Y. Jackson to show him part of what she called her War Diary, which she started within hours of joining the CWACs. "Uncle Alex," as she was soon calling him, was impressed and, under his other hat as an advisor to the selection committee, wrote McCurry in February 1944, saying,

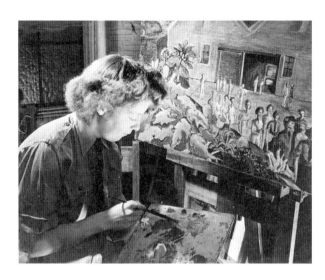

Molly Lamb Bobak painting, undated.
(National Film Board of Canada / Library and Archives Canada / PA-188549)

Captain Bruno Bobak at Cleve, Germany, 1945.
(War artists photo portraits collection - Bruno Bobak. CWM 20040082-012.
George Metcalf Archival Collection. Canadian War Museum.
Courtesy of Canadian War Museum)

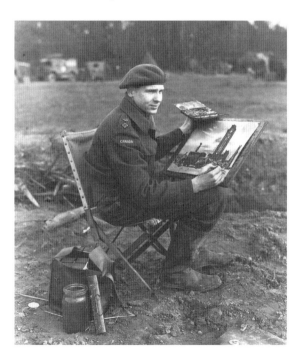

"Molly's stuff looks fine and I am for giving her the opportunity to do war records. I know of no one else in the country who is doing that kind of thing [recording CWAC life] as well."[7] In fact, Molly had been aware of Jackson's intent since the beginning of the previous December, when he told her that "the National Gallery wanted to send the stuff to London for the Canadian Artists Exhibition"; included in this consignment was an original of one of the pictures *New World* magazine had bought that Molly wanted to send to Shadbolt. After telling Shadbolt this, Molly shifted into the third-person voice of her War Diary: "Unconfirmed reports state that the Private [her] was near histeria [*sic*]" upon hearing the news.[8]

Molly had learned more than an appreciation of art from her father. She proved herself the consummate networker and soon was dining with McCurry and his wife, which, no doubt, provided much relief from the fried food (presumably from one of Ottawa's ubiquitous chip wagons) that Molly was eating so often with a military guard named Leo that she remarked on gaining weight. She also spent some weekends at McCurry's summer home, which abutted Mackenzie King's estate at Kingsmere (in the Gatineau Hills), where McCurry, his wife, and Molly walked among King's faux ruins. For his part, since Molly was a soldier, McCurry put her on the short list to become an official war artist and arranged for her transfer to the Canadian Army Show. As well, he arranged for the National Gallery to pay for her painting materials as it was already doing for civilian artists Paraskeva Clark and Pegi Nicol MacLeod, who were also painting CWACs and women's involvement in the war effort.

Her transfer to the Army Show in March 1944 put an end to a rather inglorious period in Molly's military career. After basic training in Vermilion, Alberta, in January 1943, the new recruit underwhelmed her instructors at NCO (non-commissioned officer) training, though she retained the rank of lance corporal. Noting her drawing ability, however, the army sent her for draftsman training. Next came a stint at the Trade Training unit in Ottawa, where she drew "universal joints, pinions and rear axels [*sic*]" — which, by her own admission, she was awful at, rulers not being one of the tools Shadbolt emphasized.[9] Worse, in July 1943, her

military career seemed to crater when, after being AWOL for two days (returning late from a furlough to Vancouver), she was busted down to private and transferred to the Canadian Army Trades School in Hamilton, Ontario. She summed up the experience of producing meat-cutting charts for the CWAC School of Cookery in one word: "hell."[10] She was restored to the rank of lance corporal in January 1944, a month before she called on A.Y. Jackson.

For the Canadian Army Show, Molly designed and produced three hundred costumes and fort sets, including those used in what she considered "a complete disaster" of a show put on for Prime Minister Winston Churchill and President Franklin D. Roosevelt at the 1944 Quebec Conference.[11] She had fonder memories of a show starring Wayne and Shuster because she was able to talk with Johnny Wayne about Cézanne.

<div align="center">✳</div>

In August 1943 the magazine *New World* purchased six of Molly's CWAC pictures and a month later the Art Gallery of Toronto bought three others, bringing her work to a mass audience for the first time. Each of these drawings was part of her War Diary, which ultimately totalled 226 pages. Molly's War Diary is neither a real war diary nor a diary like her personal one that runs from 1969 to 2001.[12]

The war diary kept, for instance, by Bobak's sapper unit was written for senior officers and, its authors knew, would be available to future historians. This does not mean, of course, that such diaries were free from bias: that generated by the fog of war or by officers covering up mistakes or preening. However, since men's lives (as well as awards) were at stake, on the whole, military war diarists strove for accuracy. Molly's War Diary was meant for public consumption: first by CWACs around her, then Jackson, the editors at *New World*, and finally, the war artists selection committee.

Molly's newspaper-cum-war diary was not her first foray into faux journalism. While working first at Hill Top Lodge and then at Arbutus Point, she produced the *Daily Chore Girl — Galiano's Dish Rag*. Drawing on what she learned about cartooning at art school, Molly filled the

Daily Chore Girl with stories and pictures derived from her experiences as a charwoman.[13] The *Daily Chore Girl* hints at Molly's playful attitude toward symbols as well as artists and famous writers that the War Diary develops fully. The final number, for example, pictures a heavily laden "slave" coming home, carrying a jacket, a float, and what looks like one of the serpents on the Rod of Asclepius (the medical symbol), as well as interviews with avatars "Freud Molly" and "Renoir Molly."

By placing *W110278*—Private Molly Joan Lamb's service number—in the newspaper-cum-diary's masthead of the War Diary, Molly slyly places both her text and pictures in the area defined by Huckleberry Finn when he says at the beginning of his "autobiography" that in *The Adventures of Tom Sawyer*, Mr. Mark Twain "told the truth, mainly."[14] Molly's subject, as others have noted, is "Private Lamb"—whose story unfolds like a *Bildungsroman*, charting the education of a raw recruit fumbling packages while trying to give a proper salute through the "calamity" of missing the train from Vancouver to Ottawa (resulting in her temporary demotion) to the purchase of her pictures by *New World*, her time with the Army Show and, ultimately, being named the "First Woman War Artist." According to art historian Tanya Schaap, satiric humour allows Molly to "criticize the institutional conventions to which she must adhere."[15] Thus the stories about a password, "The first two bars of 'Come All Ye Faithful,' three knocks, accompanied by 'Great Balls of Fire,'" and Molly's send-up of the military's penchant for initials:

> Private Caneul V.N. (Very Nice)
> Model Private O.W.K. (One Who Knows)
> Rookie Molly E.A.L. (Enjoys Army Life) E.D.F. (Except For Dirt)
> Corporal H. Pathetic (true name withheld) D.O.H.F. (Dead On Her Feet).[16]

Molly conceives of "Molly" in much the same way that she had seen the authors of the First World War trench newspapers, such as the *Wipers*

Times, and the cartoonist Bruce Bairnsfather do Tommy Atkins: that is, as something of a soldierly anti-hero. In the entry dated 3 August 1943, Molly tells of the "Horrible Fate of Innocent Private," who was silently attacked in violation of the Geneva Convention. The picture accompanying the story shows her badly pocked legs that prompted an erstwhile reporter to ask if the wounds were caused by mustard gas. Molly casts the medical officer as the scene's straight man when he answers "No, by Poison Ivy."

By focusing on herself or other CWACs, Molly presents servicewomen as more than just a "women's division" of the army. She viewed these women as what Schaap calls "cite[s] [*sic*] of agency" in their own right.[17] Their agency is not that of a soldier in battle, of course. Rather, their agency turns on Molly depicting them as women significantly more quotidian than the idealized images on CWAC recruitment posters.

Postwar sepia memories aside, the entry of hundreds of thousands of women into the workforce and almost a hundred thousand into the CWACs, WRENS, or the Royal Canadian Air Force's Women's Division worried moralists. They feared that women like the American Rosie the Riveter or the woman on the "We Can Do It" poster, who flexes her right arm's muscle like a boxer, were at once too muscular, too mannish, *and* overly sexual. By definition, the women who joined up were independent and willing to accept risk: ninety-nine Canadian servicewomen and nursing sisters were killed during the war. Further, as these eighteen- to twenty-five-year-old women grew to womanhood, traditional ideas about virginity were being challenged: as the authors of *New Girls for Old* put it, "The girl who makes use of the new opportunities for sex freedom is likely to find her experience has been wholesome," this last word having a different spin than the moralists would give it.[18] In 1943, to counter the whisper campaign that women who joined up were "patriatutes," to use the American term, the government launched a public relations campaign that stressed the probity of the Canadian servicewoman.[19] Even before that, military brass ensured that the cut of the servicewomen's uniforms struck a balance between expected gender appearance (i.e., the shape of their bodies) and a smart, professional look.

Some of Molly's CWACs, such as Alice in the eponymous sketch of her, the sketch of a CWAC on the train, or CWACs in the October 1944 montage of CWACs in basic training in Kitchener, Ontario, are well turned out. In the watercolour of Molly trying to style her hair, she is, quite frankly, frumpy. In another, Molly catches herself taking a moment's break from washing the floor, the effort of doing so having left her hair sticking out in all directions, as it is on the Molly who, holding a paintbrush, crouches before two works of "Rembrandt Lamb's."[20] Molly faces the patriatute whisper campaign head-on when she has "Pvt Molly L.R.R.H." (Little Red Riding Hiker) put the required distance between herself and her "wolfish" driver by placing her haversack between them and holding a potted plant in her left arm, "foil[ing] the enemy by camouflage."[21]

The real-life Molly was more adventurous than her hitchhiking avatar. In Ottawa in 1944, she drank enough at one party to end up "in a cathouse near King [Edward Avenue] with a fellow who didn't do anything but wet the bed," as she wrote decades later, recalling that dejected night in the nation's capital.[22] When, the following morning, she stumbled back to the home where she was billeted, Mrs. Maybelle Andisons, her landlady, with a rueful look, said, "Lamb, dear, you're beginning to look coarse."[23] Molly had spent the previous Christmas (unchaperoned) with fellow Vancouver School of Art alumnus Peter Aspell at the Château Frontenac in Québec City; after going to a Catholic Mass, they drank a bottle of champagne in the -20°F cold and then went to a "French movie."[24] After disembarking from the *Ile de France* in Scotland in 1945, instead of heading directly for the Canadian Army base at Aldershot, she spent a night near Glasgow—waiting in vain, alas, for two sailors she had met on the boat to join her. When she arrived at the Canadian base at Crewe near London, officialdom was less than impressed with her excuse for showing up late: her belief that since she was an officer she could do as she pleased.[25] Fortunately, this incident ended with a reprimand and not her demotion from the rank of 2nd lieutenant, which she had attained on 24 May 1944.

Another way Molly demonstrated women were individual agents was by how she drew them. Whether depicted cartoony or realistically, their faces are those not of women *qua* women. Rather, they are of women *qua* individuals who have their own stories — though, unlike Molly, not their own Boswells.[26] This interest in faces will be a primary feature of her mature war art ... and then, when the war is over, she will be turned away from them almost entirely.

Almost every picture in the War Diary depicts someone in uniform. Yet, while there are references to Dunkirk, the Battle of Midway, Dieppe, the assassination of the French collaborationist admiral François Darlan in November 1942, and the third Battle of Rostov (1943), in an odd way, the war itself seems very distant, somewhere over the horizon. Indeed, as Molly wrote in January 1943, "I keep forgetting there's a war on — because there is no time to read a paper."[27] This is especially true in the twenty-four-page section entitled "New York By Thumb," which tells of Molly's and her friend Corporal Jones's hitchhiking trip to New York in February 1944.

As entertaining as her trip to New York was — with visits to upstate New York diners, bars, and even an aviation factory — what mattered to Molly were visits to several art galleries, the Museum of Modern Art, the Art Students League, and the offices of *Life* magazine. At the Museum of Modern Art, she saw works by Cézanne, Degas, Renoir, and Picasso, and was especially impressed with Peter Blume's *Eternal City*, at the centre of which Mussolini's head pops out of a jack-in-the-box. She was significantly less impressed with a "great liquid, glue-like canvas of living things" on the other side of the room. "There were arms and fingers and soft babies' heads and they were all terribly red and raw and big blue veins and red veins stood out upon them. And there were trees of intense green with yellow veins and it smelt like the humid beginning of all the world. But I don't suppose that is what it meant."[28]

At the famed Art Students League, Molly was in her element, walking the halls where Morris Kantor (a Russian-American realist painter) and Reginald Marsh (an American social realist painter) taught and whose

works she knew from reading arts journals. A woman at the Arts Students League suggested that she call *Life* magazine to see if it would be interested in her CWAC pictures. After leaving several examples of her work with the magazine's arts editor, she had "visions of a future *Life* Magazine [issue] which said — Speaking of Pictures . . . A Canadian WAC draws Army Life" — and then added, "But I had better tell you that it never happened."[29]

From our distance, what is perhaps most striking about Molly's War Diary is its intertextuality, that is, how she incorporates and reinterprets existing texts, paintings, and images for her own purposes. A drawing made a few days after she joined up is divided into two parts. The medic on the top portion of a drawing made a few days after signing up stands before three very frightened-looking CWACs standing in the "Inoculation Parade." The lower half of the picture, entitled "This is a Blood Test," has him pulling the strap tight around a CWAC's arm while her face is distorted and hair sticking out in fright as he readies to jab in the needle. Just coming into view from behind this medic is another one holding the front of the stretcher on which another CWAC has passed out. Both the medic and distorted CWAC partake in what the Russian literary critic Mikhail M. Bakhtin called the "carnivalesque":[30] exaggerated bodies like those Molly would have known from works like William Hogarth's *Gin Lane*, replete as it is with animalistic drunken men and women; medieval façades showing sinners morphing into animals; or comics that Molly would have seen in the pages of her newspapers — her medic shares much with Dick Tracy's more porcine villains, for example. Rather than being frightening, the effect is humorous because both the artist and the viewer know how the body should look and the reference (for example, a pig) from which the caricature borrows.

Other examples of intertextuality are more audacious and show Molly mixing the sacred and profane, which, by generating laughter, as Bakhtin showed, punctures the sacred's claim to authority. The picture of Molly's first meal as an officer borrows heavily from Da Vinci's *Last Supper*. Molly groups the figures together as did Da Vinci and she gives each

CWAC the hands Da Vinci gave each apostle. The newly minted 2nd lieutenant occupies Jesus's position, though instead of his mournful face, hers resembles Tintin's, complete with his famous cowlick (p. 194).

Whether Molly actually undertook a painting that showed Christ and the Virgin visiting an army camp is doubtful. But she knew such a thing would have been contentious. She mocks her own imagined departure from tradition in a sketch in which a parson viewing Molly's (imagined?) work expostulates: "Christ in battle dress? Outrageous!"[31] Just as Bakhtin showed that intertextuality, references to the body, and coarse language allow an author to undermine established discourses, such as religious speech, Molly undercuts her own borrowing of sacred images in, for example, the sketch of the "New Saint Captain Smith." Even if we were to accept her Christ Pantocrator pose as a bit of visual hyperbole, the fact that Smith lifts her left, not right, hand means she is aping, not performing, a Christian blessing. Molly literally underscores her critique of her own images by having Captain Smith's feet run into the story underneath, which tells of fart jokes and Molly falling in with drunken soldiers in Montréal.

At home and at the Vancouver School of Art, Molly received such a thorough grounding in literature that "Homer Lamb,"* as she styled herself on 19 August 1943, rewrote Jesus's trial before Pilate (Matthew 27 and Luke 23):

> The chief priest arose from their beds as the sun rose over Jerusalem.
>
> And they blessed — and I, in camouflage mounted my Bren [gun] behind the olive leaves and waited quietly.
>
> They brought him to the governor and the people came out of the doorways into the sun — their brown dry feet in the sand. They waited in groups, ate and expected. I saw them from behind the olive leaves and trembled.

* Other literary avatars are "Renoir Lamb," "Rembrandt Lamb," "El Greco Lamb," "Hearst Lamb," and "Lambnova Lambofski."

He was now before the governor and the people came together—jostled into sound.

"Will ye that I release the King of the Jews?" And they cried out, "Crucify him" and my fingers trembled on the trigger.

The crowd began to go blind—like a lynching mob, crazy all together, "Crucify him!" From behind the olive leaves then I saw him crowned in thorns.

I set my eye and trained my steel-slugs spit from my Bren and the crowd screamed and fell in the dust. And Pilate, white, looked dazed and all lay trembling in the dust.

But he in the purple robe stood still. Still crowned with thorns.

CWAC training did not include learning to use a Bren gun, though Molly would have seen men training with it. The reference to "lynching mob" tells us, also, that Molly was well aware of the history of lynching of African Americans in the American South. Homer Lamb's desire to save Christ fails, but it tells us much about Molly's sense of justice.[32]

On 22 March 1944, Bruno won first prize, a $100 Victory Bond, at the *Army Art Show* at the National Gallery in Ottawa for the watercolour *Cross Country Convoy* (p. 195) painted in 1943. Bruno was stationed in England and so couldn't attend the awards dinner the following September, which meant that he missed the opportunity to meet both Princess Alice, who presented the awards, and the two artists who tied for second place, Lance Corporal Robert Bruce and 2nd Lieutenant Molly Lamb.[33] In lieu of a picture of Bruno before his winning painting, on 14 September the *Globe and Mail* ran a photo of a middle-aged couple, named as Mr. and Mrs. Joseph Bobak, looking proudly at the painting above the misleading title, "'New Canadian' Soldier Wins Army's Art Prize."[34]

Cross Country Convoy is informed by both his commercial art and sapper training; after enlisting, Bruno had been assigned to the Royal Canadian Engineers. The impact of the first can be seen in the rendering of details such as the hood of the truck climbing up the hill and the tread of the right rear wheel of the last truck in the convoy. It can also be seen in an aspect of the picture pointed out by artist William Forrestall, who knew both Molly and Bruno well beginning in the 1970s. "He gives us a little peek under the vehicle, exposing the mechanical language of the vehicle, reinforced by the back tailgate and other details of the Canadian Military Pattern Truck, which I'm quite sure the military brass who saw the picture recognized."[35]

The terrain may be imagined versions of the hills around Petawawa, but the imagination is that of a trained sapper, who had qualified as an "efficient driver" and had completed the Topographical Draughting course. Thus the feel for the difficulty of the terrain—and the care the driver of the truck cresting the hill takes in avoiding the tracks left in the muddy ground by the other trucks.

Molly's *Meal Parade, Hamilton Trades School*, which came in second, is a reworking of a sketch of "Quacks...standing in groups near Officer's building—a place with a red roof and snow quietly resting on it."[36] *Meal Parade* reveals a self-assured artist using the canvas white to form snow and the whites of the soldiers' eyes. The line of soldiers forms roughly a *C*, running from the mess hall door on the upper right to the midpoint of the left side of the frame, and then, with a short break filled by snow and the shadow of a small fence to the lower right. Though orderly, the line is not static. Despite being an amalgam of blacks and greys, the line of soldiers fairly hums with the expectation of eating, others joining the line, and especially, with talk, with some soldiers facing each other talking. The depiction of people speaking is a theme that runs through Molly's pictures of crowds and, indeed, was one she drew attention to in her December 1942 letter to Shadbolt in which tells him of an oil (a forerunner of *Meal Parade*) "of Quaks [CWACs] standing in groups near the Officer's building—a place with a red roof and snow quietly resting on it."

The headline for the 24 May 1944 number of *W110178* reads, "Lamb's Fate Revealed! 2nd/Lieutenant Reels in Street! To Be First Woman War Artist!" The first paragraph predicts that she "was going overseas within 3 or 4 weeks." In keeping with her somewhat guileless self-portrait, Molly has her avatar flub her first attempt at giving the reporter a quote, "I am confused," and then the second before remembering what an instructor taught her at Officer Training School: "Gentleman, I have now normalized the situation and you can quote me as saying, 'I am happy about everything — it's all wonderful.'"[37] Three weeks stretched to four, then five and...

Eleven days after Molly learned that she was going to become a war artist, a telegram arrived at the headquarters of the 13th Canadian Infantry Brigade in England. Bruno's brigade was sequestered, as were more than 150,000 men ready to storm the beaches of Normandy. What the telegraphist and the chain of officers the telegram passed through made of the curious order that one Lieutenant Bobak immediately report to London has been lost to history, but it meant that the closest Bruno got to D-Day was the BBC Radio report of it. A few weeks later, "a great mysterious hand [belonging to Vincent Massey, High Commissioner for Canada in London] reached out of the blue" and beckoned the young sapper to a meeting at Canada House.

In the ornate 128-year-old Greek Revival building, likely the fanciest that Bruno had ever been in, Massey told Bruno that he was impressed with his submissions to the *Army Art Show* and asked if he wanted to become an official war artist. Bruno's reply shows just how far the boy who had been bullied in a Hamilton schoolyard had travelled. Instead of politely answering, "Yes, Sir," the sapper told the highest ranking Canadian in Britain that since he was not an officer, he was ineligible. Massey's response no doubt confirmed what the poor have always suspected: that the great and the good have ways of getting things done. "That's not

a problem. We'll arrange for you to go to my old alma mater, Balliol College, Oxford."[38]

Some of the courses Bruno took over a two-week compressed semester might seem strange. With Allied forces fighting in France, Dr. J.B. Hanson's French history class was of obvious utility. The importance of studying Shakespeare is less clear, as was a course entitled Local Government, taught by the town clerk of Oxford, and the oddly named Knowing Ourselves, taught by the warden of All Souls College. Today, in the wake of the collapse of the "Great Man Theory of History" and the shattering impact of post-structuralist and post-colonial thought on what used to be called Western Civ, it is hard to remember how important the "Great Tradition" was in mobilizing Britain, Australia, and Canada. During the war, millions of copies of Shakespeare's works and other classics were sent to Canadian and other Commonwealth soldiers. Bruno's local government course would have stressed the history of property rights and local elections. Knowing Ourselves had nothing New Agey about it. It was a course in Whig political theory, which stressed the primacy of Parliament, the Bill of Rights of 1688, and no doubt, contrasts to Nazism. Drawing on his two books on Shakespeare, Mr. Maurice R. Ridley would have highlighted the plays that turned on opposition to tyranny.

Bruno doesn't record what he thought of these courses, but two conjectures are reasonable. Given the sense of drama in many of his paintings, studying Shakespeare and seeing a performance of *Hamlet* could hardly have been detrimental. And, given how well he writes in his War Diary, these courses can be credited with helping to polish the style developed at Central Tech. Bruno's depiction of a moment on 15 January 1945 when viewing the heavily damaged Dutch village of Empel has a touch of the poet to it: "It was an eerie sound to hear the 'Drum Boogie,'[39] being played on an undamaged piano in this deserted and ghostly village."

≠

As newly minted Captain Bobak waited to cross the English Channel, he studied the war artists' standing orders:

> You are expected to record and interpret vividly and veraciously, according to your artistic sense, (1) the spirit and character, the appearance and the attitude of the men, as individuals or groups of the Service to which they are attached, (2) the instruments and machines they employ, and (3) the environment in which they do their work. The intention of our productions shall be worthy of Canada's highest cultural traditions, doing justice to History, and as works of art worthy of exhibition anywhere at any time.[40]

Bruno's commercial art training dovetailed with the war artist's need for technical accuracy when depicting "instruments and machines of war." Indeed, while the artists were not told what subjects to sketch or paint, all their works produced in Europe were examined by historical officers who "assessed the compositions for accuracy and for any breach of censorship" before the works were sent to London for storage. The expectation was that the artist would later work watercolours and sketches up into oils.[41]

For months before he crossed to the continent on 15 December, Bruno honed his craft, producing hundreds of small and not-so-small sketches of tanks, universal carriers, and men in uniform in various poses—such as standing around tanks. A number of watercolours depict moving tanks. In at least one, *Training Area (Ram Tanks)*, Bruno set himself the difficult task of depicting uncoiled razor wire. He did so by intertwining circles that shift from flecked white to brown to black and back again. (We will see that decades later, when painting a faculty party, Bruno would again ponder how to paint numerous overlapping circles of high ball glasses.)

Meanwhile, Molly continued to wait, held up by what Duguid explained was "the Army's point of view that [a woman's] appointment

was not desirable as the artists were at the scene of combat."[42] While predictable for the time period, Duguid's decision to keep Molly in Canada is curious. As he well knew, three companies of CWACs were serving in Britain and were not withdrawn when the V-1 attacks began a week after D-Day. Further, as Molly cooled her heels in various postings, including, fatefully, Halifax, where she would paint one of her most famous works, CWACs belonging to the Army Show toiled in rear areas of Italy.

Whatever her disappointment at not shipping out, in addition to teaching first aid to artillerymen, Molly painted three important pictures. *Gas Drill* (p. 196) is based on a series of sketches made a few days after Lamb's draft of recruits arrived in Vermilion, Alberta, for basic training in late December 1942. However important it was deemed in 1942 for soldiers to know how to put on their gas masks, Molly the raw recruit was struck less by the urgency of the sergeant's instruction than by "the pattern of our black boots on the white snow" that two years later she reproduced on the canvas in order to create the feeling of movement.[43] The seemingly straightforward scene is replete with structural devices. The line of bricks at the bottom of the wall leads our eyes to the belt of the CWAC whose back is toward us and who is showing the recruits how to don their gas masks. The line continues to the left arm of the one CWAC, who, unlike the others, appears to be preening. Her left hand, stretched behind her hips, points toward another CWAC's belt, which directs the viewer's eye toward a CWAC far to the back right, close to the wall. Under other circumstances, the wall might have the effect of flattening the scene because it brings our vision up short. However, by having this CWAC kneeling over to pick up her dropped haversack, Lamb starts our eyes back toward the women in the gas mask. Set against the grid of the bricks, some of which are darkened toward brown, this small figure creates a surprising amount of movement.

The work's title, *Gas Drill*, connects the viewer to two different times in the past. The first was the early days of the war, when newsreel footage

showed British civilians donning gas masks. More distant, but still alive in memory, were images of gas warfare in the First World War. In her War Diary version, Molly both honours and disrupts this connection via a riff on Wilfred Owen's famous "Dulce et Decorum Est."

Owen's lines,

> Gas! GAS! Quick, boys! — An ecstasy of fumbling
> Fitting the clumsy helmets just in time,
> But someone still was yelling out and stumbling
> And flound'ring like a man in fire or lime. —
> Dim through the misty panes and thick green light.[44]

are echoed in Lamb's hand (line breaks added):

> Suddenly, as they are concentrating on other suffering
> platoons
> they hear a dreadful Siren — Gas!
> They fumble with respirators, and drop their capes on the
> ground.
> Their hands freeze hard before they can get into their mitts
> again.
> Then hundreds of amusing orders are shouted to them,
> making them hysterical inside their gas masks.[45]

The CWACs' unnatural postures, lumpy greatcoats and "piggish" faces make it quite believable that when ordered to march "some would right and left wheel, some would stand at ease and some would just wheeze nervously" in -34° air, she wrote a few years later.[46]

While still waiting for her orders to "ship out," Molly painted a backstage view of an Army Show performance. Stuart Smith is surely right that Molly intended the backstage view presented in *The Dressing Room* to be a "singular event that is turned into something universal and in which any CWAC viewing this painting could see herself."[47] An undated sketch

inserted into *W110278* after Molly's transfer indicates, however, that the moment preserved in *The Dressing Room* as it appeared in the 1944 oil did not happen or, at least, did not happen in the way the oil presents.

The oil recreates the hustle and bustle recorded in the pictorial notes made in pencil. Molly shows her art school training and departs from what we can assume to be the facticity of the sketch in a number of ways. First, the darkness of the upper left, which is not indicated on the sketch, is balanced by the white briefs and bra of the central figure. Second, Molly reverses the painting's central figure, so that instead of looking toward us, we see the woman in the bra and briefs from behind, relieving Molly of having to depict her bra-clad breasts. By reversing her position and moving her slightly to the left — thus opening a path for our eyes to move into the scene — Molly turns what was a static position into a dynamic one that leaves us thinking the woman is looking for something and is about to walk toward it. The sense of movement is increased by changing the position of the woman in the pink tutu on the far right; instead of standing still, she is bending and lifting a chair or stool, which, by pointing toward the upper left of the picture, directs our eyes back over the entire scene. Molly's lack of interest in the central figure's face is worth noting: had it even been roughed in, it would have commanded our attention and overridden the drama of the rest of the picture.

The seven or eight other figures, the background, the chairs, and other accoutrements are painted in loose brush strokes that make the figures almost shimmer, the way costumes do under the harsh stage lights. The same is not true of the jacket visible on the far right. In the sketch, half of the jacket is visible at the end of the wall on the right; it is obviously hanging on a hook. In the oil, the jacket, which is rendered in tighter brush strokes that increase its solidity, hangs in front of the wall (or, perhaps, a half-closed door). The line from the central figure's head across the room to the women getting dressed and then the black line atop the mirrors lead the eye directly to the brassard that says CANADA and the chevrons on the jacket's left shoulder. These are the only markers that the dressing room is filled with military personnel. Yet, while they keep

the picture of barely dressed women from tipping over into the ribald, it's a near-run thing. For, as Nathalie Mantha, manager of the Youth and School Program at the National Gallery of Canada and a practicing artist, points out, "Molly uses this door to play with the rule of the thirds, effectively cropping the picture. This has the effect of making it seem as if we are peeking in on the scene. By reversing the position of the woman in the bra and panties, Molly removes any possibility of her encountering us as an equal, which heightens the somewhat 'naughty' nature of the scene."[48]

Once Bruno arrived in Belgium to learn about the working conditions "in theatre," he was assigned to accompany another artist. On 28 December 1944, his twenty-first birthday, Canada's youngest war artist was led on a tour of the several-hundred-yard Canadian lodgement inside Nazi Germany by Captain Alexander Colville.

Chapter 3
War Artists

Art alone can reveal, emotionally, spatially and with biting line and turgid colour, with satire and grandeur of composition, with poignancy, humour, graphically and with convincing personality, all the many-faceted aspects of war. —Arthur Lismer on war art

Between mid-June 1945, when Molly arrived in London, and early September, when what she called "the six richest and most exciting weeks" of her life began with her arrival in Apeldoorn, Holland, both Molly and Bruno were stationed in England.[1] Although they were billeted in different parts of London, most of the thirty-one Canadian war artists worked in studios in Fairfax House. Perhaps because of their schedules, Molly and Bruno did not meet during this period. In the atelier he shared with another artist, Bruno devoted himself to working up some of the nine oils he had proposed to complete. For her part, Molly travelled to various locations in Surrey, Alderbrook, and London to record CWAC activities.

The War Diary Bruno kept while on the continent and the notes he put on the back of his works tell us both the location and date on which he executed most of his more than one hundred watercolours and sketches. Molly must have kept a similar diary, but it is lost, as are most of her pencil and charcoal sketches and many watercolours. Accordingly, while titles such as *Bremen Ruins at Night* tell us the locale of many of her works, it is not possible to place them in chronological order. Taken as a whole, and in some cases individually, Bruno's works show him aestheticizing the horrific violence before him—though not in the way of Filippo Tommaso Marinetti and other Italian Futurists, who believed that "art, in fact,

can be nothing but violence, cruelty, and injustice" and glorification of war;[2] rather, Bruno sought to lessen the shock of violence by eschewing depiction of blood and gore. Molly's works divide into two groups. The largest is detailed descriptions of CWAC life, the presentation of which ran into the inherent problem of making compelling visual narratives of what otherwise might be considered rather quotidian events such as folding sheets, albeit on an industrial scale, or placing letters into a sorting frame. The smaller group shows her coming to a very different solution than did Bruno to the challenge of aestheticizing violence.

On New Year's morning 1945, while at the headquarters of the 4th Canadian Infantry Brigade at Ulvenhout in southeast Holland, Bruno saw his first flight of Luftwaffe planes, flying at treetop level — not to strafe, as Hermann Göring's planes had when Germany commanded the skies in 1939 and 1940. Rather, they flew low in hope of avoiding Allied radar and the wall of flack or swarm of fighters that would follow their detection.[3] Over the course of the next few months, Bruno made good use of the camera (ironically a German *Voigtländer*) and the driver given him as well as orders permitting him to "photograph or sketch objects otherwise prohibited."[4] Local commanders, including a certain Major Churchill who commanded a tank battalion, were eager to help. On the morning of 12 January 1945, the major took Bruno on a tour of the area, "pointing out various points of interest," while later that day, Lieutenant W.E. Green took the artist on a forward reconnaissance where the Germans "ha[d] been quite active recently" and where a new German position had just been located. Despite poor visibility that led to "doubt as to the effectiveness of their fire," on 14 January, Bruno took the occasion to produce a number of sketches of the 5th Canadian Armoured Regiment firing in the direction of Alem, on the other side of the Maas River in Holland.

The most notable aspect of the watercolour *Tanks Firing Across the Maas*, painted a few days later, is not the silhouetted tanks, though the balance is impressive between their bulk and details, such as the cut-out

at the end of the turret of the one closest to us. The sort of detailed description seen in the trucks in *Cross Country Convoy* is less important in *Tanks Firing* than is the unseen, but nevertheless knowable, climax of the narrative in this second work. Rather than constructing the scene so as to capture the devastating effect of coordinated shellfire, Bruno angles it so that the most dramatic aspect is the smoke that will soon form a smokescreen billowing forth from canisters behind the tanks.

The smokescreen can be seen as a metaphor, for in a few moments it will obscure from even Bruno's view these instruments of war—tanks—that caused the "gruesome images" that were so "upsetting" they stilled both the pencils and paintbrushes of Bruno and his fellow war artists.[5] Thus do these artists differ from their Great War predecessors. Though A.Y. Jackson, Arthur Lismer, and the other Canadian war artists avoided depicting dead Canadians, their works are filled with the misery of the trenches, the after-effects of gas attack, dead animals, and endless acres of mud. By contrast, according to Dr. Laura Brandon, retired curator of war art at the Canadian War Museum, war artists of the Second World War focused in a "depersonalized manner" on "locations, events, machinery and personnel of wartime."[6] Bruno's least warlike work, *Dental Treatment No. 2*, details a mobile dental treatment truck; nothing in the white-smocked dentist's look or posture that we see through the truck's open door suggests that even he is capable of inflicting pain.

The war artist's remit, "to record and interpret vividly and veraciously," clashed with Bruno's emotional reaction to the war-torn landscapes that "horrified" and "frightened" him; the memories were still painful four decades later when he discussed them with curator Donald Andrus.[7] Bruno's earliest works on the continent show him coping with the horror of the world around him by depicting scenes that were not inherently violent or, to be more precise, where the violence was safely in the past and, thus, could be contained within an aesthetic that filters what Bruno saw through aspects of the Group of Seven's paintings of the wild, RCAF Flight Lieutenant Carl Schaefer's "expressive realism," and Major Charles Comfort's work.

Even if Bruno had not seen Comfort's mid-1944 watercolour *Battlefield Near Berardi Crossroads*, for example, Comfort's style was a known quantity, and his paintings, especially his simplification of forms, could easily be imagined. Blasted trees, the undulation of the land, the white building in the middle ground, and the red cross on the truck before the building are delineated with the economy of a commercial artist, even as they move partway to what later developed into "magical realism," perhaps best known in the works of another young war artist, Captain Colville. The placement just to the left of the picture's centre of the two crosses and two coal-shovel helmets, indicating that these dead are German soldiers, is an example of Comfort's use of small objects to deepen the meaning of his scene.[8]

In Bruno's *A Crew of the Royal Canadian Corps of Signals* (*A Crew*), painted toward the end of February 1945, a corpsman has climbed a tree trunk, stripped of its branches, and is using it for a telegraph pole. Though the equally nude trees on the left do not touch each other, when viewed from the perspective Bruno chose, they seem to intertwine as they might in a Group of Seven. We are not, however, to understand that the leaves and branches are scattered across the forest floor where, over time, they will decompose and feed new growth. Instead, they have been obliterated by the blast wave generated by an exploding shell or burned by its heat, approaching 3,000°C, that has also charred the trunks. "The destruction of trees in full foliage," Comfort wrote a few months earlier, "leaves a more sinister impression than those wracked by winter."[9] Lest Bruno's viewers miss the point, he placed a splintered tree just in the middle foreground, the pale yellow of its ripped-open trunk pulling our eyes into the void left by exploding cordite. To heighten the tension of this picture of a rear echelon place near Kleve, Germany, Bobak departed from the weather recorded in the War Diary and painted a sky in a muted palette of greys.

In *A Crew* Bruno depicts almost every figure in profile. Given the flattening out of the scene and the blanching out of most details, rendering the corpsmen in profile is almost a technical requirement. For, while Bruno could have given some of the men individualized features, doing

so would have altered the viewing experience because we would have been drawn to the individuated men — and would also have risked destabilizing the flatness of the tableau. As important as this technical point is, however, it alone cannot explain why, in other works Bruno rendered almost every Canadian soldier he painted (though not the named portraits he sketched) in profile, some only schematically, stripping away each soldier's individuality. In *Riflemen of the Lake Superior Regiment*, painted in February 1945, he goes farther: the four Canadian soldiers sniping from behind a rise on the bank of the Maas River are shown from behind, their dark, bulky shapes all but indistinguishable from each other — in fact, since the paint that forms them is from the same end of the chromatic spectrum as is the paint that forms the black storm clouds above and the mud around them, they are close to dissolving into the ground. These presentations do not mean, however, that Bruno equated the Canadian Army with the totalitarian power of Nazi Germany, with its endless footage of ranked goose-stepping soldiers the visual manifestation of the exaltation of the *völk* over the individual, and the dissolution of the individual into propaganda. Bruno's pared-down individuals say something more important.

Every army, Canada's volunteer army being no exception,[10] depersonalizes individuals and necessarily views them as faceless, interchangeable bodies with assigned tasks. The essential difference between this imperative and the Nazi state's *Wehrmacht* was that in Hitler's Germany the dissolution of the individual was the *sine qua non* of the state's definition of itself. This was, of course, also true for the highly militarized Empire of Japan and Canada's erstwhile ally Soviet Russia. By contrast, for Canadians (and all Commonwealth armies as well as the American army), the reduction of individuals in the armed forces was a temporary expedient. Their faces would be returned to them — if they survived.

By the time Bruno received Captain Jack Shadbolt's memo telling the war artists to lay off painting burnt-out tanks, Bruno had painted a number of them, having seen his first, a German one, a month after arriving on the continent. *A Sherman Tank of the Governor General's Foot Guards, Burned Out* (*Sherman Tank*) (p. 195) shows that two months of exposure to

battlefields had not inured Bruno to the destruction and scenes of death around him. Central to the watercolour is the dialectical tension inherent in the aestheticization of violence, or in this case, the aftermath of horrific violence. Neither during the war nor when interviewed by Hugh Halliday for the Canadian War Museum in 1977 did Bruno possess a sophisticated critical vocabulary to discuss how art contains violence.[11]

He did, however, think deeply about the violence that is the heart of war and the occasion for the genre he was working in. "Bruno was a Daedalus, a maker of things," says Smith, "which meant that his mind... recoiled from the horror war inflicts on bodies—and the only one he fully depicts is placidly dead—and, instead, focused on things, objects with which he could build his picture and tell a story."[12] Thus, Bruno explained to Halliday that for a war artist, twisted, charred metal and bent barrels are not simply a tank *hors de combat*, as a battalion war diarist would put it. For Bruno and his original viewers, a burned tank was a sign, almost certainly, of dead or hideously burned men. Few today recall that the nickname of the lightly armoured Sherman tanks Bruno depicted was "Ronson," after the cigarette lighter that promised, "Lights first time" and never failed to "Brew up."

Bruno's orders that he was to filter what he saw through his "artistic sense" (and not through a government-approved style) provided the warrant to transmute burnt-out tanks into something almost benign. Accordingly, he divided the scene depicted in *Sherman Tank*. In the foreground sits the tank, which, like the ones he depicted when he was in Petawawa, once appeared "so brutish and big and deadly." Burned, it is "so dead and clumsy," to borrow Halliday's words—which Bruno agreed with. Bruno goes beyond the mute testimony of open hatches. Though blackened by fire, the turret does not show the degree of blast damage that can explain why it is angled, almost limply, downward. Rather, in an original move he shed light on decades later when he told Halliday that burnt-out tanks were like "old horses decaying in the field," the young artist bent the turret so that it leads our eyes to a dead horse.[13]

From a purely factual point of view, the dead horse does not appear to belong in the scene. Save for the burned tank, this patch of Belgium does not show evidence of war. The ground is not pitted with shell holes. Nor is the ground torn up by sixteen-inch-wide steel treads. Indeed, there is no real cause for linking the horse's death to the war; there is, for example, no wound or bloody ground, nor is there the swarm of flies that one would expect around the head of a dead horse. What the dead horse does is aestheticize death in an image that at once and the same time recalls scenes from Lone Ranger comics and Peter Paul Rubens's sketch of Da Vinci's *Battle of Anghiari*. He has drained the horror he saw by placing it safely within either the popular or the great tradition of art. Lest even this mitigated horror threaten the scene, Bruno situates the drama in a semi-Impressionist landscape: in the middle distance on the right is a hut sketched in the same greens as the luxuriant trees behind. Both fit well with the cottony clouds blowing toward the right that are devoid of the smoke, contrails, or machines of war.

Bruno leaves no doubt that the scene in another watercolour painted at about the same time is of war. In this second work, a telephone or power line hangs twisted from a pole pushed onto an angle, testifying to the power of an exploding shell. Here the Belgian ground is deeply pockmarked. A tank sits in the middle distance on our left; its commander, standing up through the hatch, bends toward another soldier to the tank's left. Predictably, both men are too far from us to be individualized. In the foreground lies another dead horse, its hindquarters lying under a smashed cart that could have come from an early Van Gogh or Krieghoff painting. The meaning of a milk can lying on its side, its contents strewn, is so visceral it need not be explicated.

And yet, Bruno keeps this second watercolour from tipping over into despair. Partly this is due to the background. Incongruously, this grotesque scene unfolds under a gorgeous light-blue sky, highlighted by a few wispy clouds formed by leaving finger-sized shapes free from paint. And partly it is due to the fact that in the left middle ground, walking away from us,

Bruno placed two figures that appear in only one other of Bruno's works, *Communications*, painted ten days earlier. Though Bruno would have seen many such figures in his youth, they likely came to mind because he saw some in Belgian towns like Ghent. The two figures are visual cognates to a word Bruno used when speaking with Halliday about battlefield detritus: "relics."[14] Using the white of the paper on which he was painting on the St. Patrick's Day of 1945 to create their coifs, Bruno painted two habited nuns, who move into the scarred landscape of *Dead Horse and Nuns* with such determination that their habits spread out as if to cover the ruined landscape.

Five weeks later, the American and Russian armies met at the Elbe River, cutting the Third Reich in two. April 25 was also the day that Bruno saw the largest number of dead Germans he would see. It is just possible to hear a hint of *schadenfreude* in the seemingly neutral words in his War Diary: "killed by our artillery and mortar barrages." If so, it was a passing thought — made all the more fleeting by the fact that he had to hightail it to the rear when a German 88 on the other side of the Küsten Canal (in north central Germany) began dropping shells uncomfortably close.

A few days earlier, in what he knew would be one of his last works painted during hostilities, Bruno set down the two sides of a steel trussed bridge that German shells had cut in two, each side pitched on a forty-five-degree angle in the waters of the canal. In the left rear is a large building, parts of its roof blown away, revealing the A-frames. Shelling has destroyed the building's outside walls closest to us. And yet, the signs of war are unemotional; indeed, they seem almost devoid of violence. One reason for this is that while we see the damage, Bruno keeps us from seeing any of the detritus of war: heaps of blasted bricks and, of course, blood. But another reason this work lacks the urgency of battle's aftermath is that what really interests Bruno is the prefabricated Bailey bridge, the depiction of which presented the same sort of challenges he enjoyed solving as a fledgling commercial artist. Its side panels' transoms (transverse *X* supports) are so finely indicated that the ones in front of the two trucks, one a mobile hospital, driving to our left are harder to make

out because the trucks momentarily cut off the back lighting, and their green canvas tarps are so dark they all but blend into the dark grey that denotes the steel structures. The transom that just for a moment lies before the red cross on the white background is concomitantly easier to discern.

Almost certainly by the time Bruno surveyed the scene, the graves registration unit would have cleared away the dead, so the fact that there is no Otto Dix–like grotesque to be seen should not surprise. Yet, given Bruno's postwar paintings with skulls and grotesques, it is notable that, like every other work painted after the day shelling forced him to jump into an old slit trench, Bruno's war art doesn't even hint at the horror of lying, as he did, on a dead German, or what he saw once his sight adjusted to the murky darkness: "flies [were] crawling in and out of his eyes."[15] Instead, by bordering the scene with thick green grasses, placing behind it verdant trees, and situating it under a sky that, while cloudy, includes large areas of bird's-nest blue, Bruno has gone to the obverse and placed the scene as far from the battlefield as the colour wheel will allow.

In later years, Molly spoke as if her appointment as an official war artist coincided with her embarkation for England in early June 1945, two months after the Nazis surrendered. During her months in England, she was, in fact, "temporarily employed...to depict CWAC activities."[16] Molly operated under the same war artists' orders Bruno did, with the understanding that she was to record CWACs' activities and experiences. Accordingly, save for a few faces and the odd head of a man or woman in a crowd signalled only by a circle, Molly's drawings and paintings of CWACs in Britain have little of the whimsy that makes her War Diary such a singular work. If Bruno can be said to have found ways to cloak the violence undergirding the scenes in front of him, Molly faced an equally complex problem. What, beside archival interest, to put it baldly, is the drama in the sketch *Canadian Women's Army Corps Folding Sheets*, which became the oil with the even less promising title *Number 1 Static Base Laundry* (*Base Laundry*) (p. 197)?

The answer is found in how Molly pictured the spaces in which CWACs worked and, especially, how she described each of them. In *Base Laundry*, Molly had the option of angling the CWACs folding sheets from our left, which would have meant that behind them was a solid grey/green wall similar to the one that anchors the "Guppies" in *Gas Drill*. By angling the scene as she does, Molly set herself the challenge of depicting not just the open plumbing, with all the problems of presenting round objects running into the distance, which must have brought back memories of pinions and axles; even more importantly for a painter who did not consider herself a neat worker attentive to details, the angle she choose meant having to depict a complex interior space — or, to be more precise, a complex welter of spaces formed by frames (made up of two-by-fours), some of which run to the ceiling.

While our position prevents us from seeing into these spaces, Molly nevertheless explicated them by creating what amounts to a chromatic scale beginning with darker greys above the structures further away. And, since all of these spaces are "behind" the CWACs, who are dressed in light beige or white work clothes, while the sheets they fold are white (with shadows cast by the folds delineated in light and middle greys or light browns), even the lighter greys closer to the CWACS push them forward, increasing the sense of depth. Although the scene is relatively static, Molly intimates movement via the CWACs in the middle left who hold up a sheet, their bent arms caught at the moment before it is folded.

For her depiction of the CWACs positioned around the solidly rendered folding tables, Molly pulled out from her paint box the brush lent to her by fellow war artist RCAF Flying Officer Miller Brittain. The fully rounded figures, especially of the CWAC in white short-sleeved uniform on the right, recall the social realist figures in Brittain's *Cartoon for the Saint John Tuberculosis Hospital.** In contrast to Bruno's work, which Molly had likely not yet seen, she gives five of the thirteen figures fully individuated

* A few months after completing this socially conscious work, unveiled in 1942, Brittain joined the Royal Canadian Air Force. After dozens of bombing runs, he became an official war artist.

faces. Two are too far away to be individuated. While featureless, the skin tones of each of the others differ and (as is the case with every other servicewoman) each has a different hair colour and style. Further, their postures and bodies differ.

Equally indicative of Molly's interest in people are *The Tea Wagon* and *London Bus Queue*, though her signature interest in movement is not present in these works. The former shows seven women — one surely is a CWAC and, from the blue of the jackets and skirts, two likely belong to the RCAF's Women's Division — getting tea at a snack truck. We see the faces of four of the women. One is looking straight at us, while another is looking down at what appears to be a pastry. Three of the women are in profile, though each is detailed enough that we would have no trouble recognizing them on a street. One woman has her back to us because presumably she is placing her order, while the face of the woman squeezed into the scene on our right is indistinct, though she too wears a blue coat. Far from being schematic, the women in profile are individuated: the shortest is in a grey coat and a red hat and wears an earring; Molly also gave her a button nose. One of the women in blue is also in profile; she stands out not only because of her position but also because of her light, even shiny, face and thick, wavy bob. Off to the far left is a soldier, his back toward us, holding some sort of package.

In *London Bus Queue*, Molly paints a queue of some twenty-three people waiting for a London bus as a panoply of individuated figures. Moving from left to right we see, among others, a kilted soldier wearing a tam-o'-shanter in profile; a svelte CWAC with luxurious hair under her service cap and a sharply delineated nose; two sailors looking at each other, speaking; a dour-looking man with a pointy nose; a CWAC whose facial features are drawn by a pen likely loaded with India ink; and a couple, both in uniform, on the other side of the bus stop pole, his arm around her waist, both with their faces drawn in pen. The figure that grabs our attention, however, is the young woman in the centre of both the crowd and the painting, who, because we are positioned slightly across and a bit down the street from the crowd, appears to stand in front of a much

older woman. The older woman wears a worn, dull-brown, baggy woollen coat that drops shapelessly over her body. Her face, really a pen sketch, is stereotypically plain, her nose owlish. Her blanched face fits with her fatigued stoop. The young woman, by contrast, has delicate features and wears a red blouse, partially covered by a blue sweater, and a green skirt. Her long blonde hair is brushed back; Molly could not have known that a few decades later, someone would dub this style mod. Yet there seems little doubt that this woman standing at the bus stop symbolizes something much more important: though rationing won't end in Britain for more than five years, Molly allows herself to imagine—and want her viewers to imagine—the end of the drab Depression years and six long years of war.

In mid-September 1945, T.R. MacDonald resigned both his commission and his position as an official war artist. This opened the way for 2nd Lieutenant Molly Lamb to achieve her years-long dream. Almost as soon as she was named as Canada's first female official war artist, Molly was ordered to go to Apeldoorn, Holland. Once in Europe, she was given a driver, a veteran of the Italian campaign, who was less than amused to be ferrying around a CWAC artist (who had permission to travel without restriction); Molly won her driver over by giving him the bottles of booze she spirited out of the officers' mess. Perhaps overwhelmed by what she had heard from Colville about his visit to Bergen-Belsen shortly after its liberation, after her visit, Molly did not reach for either pencil or charcoal.[17]

One of the first works Molly executed after arriving in Holland is *Signal Corps Teletypists on Night Duty Apeldoorn*, which shows CWACs at work in a Quonset hut. Molly took full advantage of the properties of watercolour paint applied to a wet page to depict the folds of the hut's sheet metal, which are more evocative than measured. Though she positions us behind the three women, there can be no mistaking that each is an individual. Each woman has different coloured hair, recalling the lesson Molly's one-time teacher Jack Shadbolt taught her on his first day in front

of her class. Molly also makes sure that the Canadian government–issued uniform falls differently over each woman's body, indicating that the artist has thought clearly about the bones and flesh under the drapery. The features of the two male soldiers to the right rear are not even roughed in, though they too are individualized via the greyish skin tone of the one, with orangish skin tone of the seated signalman. This is an early example of what Molly meant when she told Ian Lumsden: "The colours come from me."[18] The CWAC in the middle can also be seen as Molly putting down an important marker. She is seated, but twists to the right. She is not twisted far enough for her to need the counterweight of her left arm, yet by lifting it and by having her left hand point flat toward the left, Molly accentuates the sense of movement. This CWAC's left hand and arm combine with the torque of her body as it pivots on the chair to give her a sinuous curve that moves our eyes toward the upper right, affording us a sweep of the scene.

Today, with our reliance on email and texting, expending effort on the (oddly titled) pencil sketch *Painting, The Base Post Office, Lot, Belgium* and a fully worked-up oil, *Painting, CWACs Sorting Mail* that depict postal clerks inserting envelopes into the postal sorting frame seems quaint.[19] In the 1930s and 1940s, when cities such as New York, London, Montréal, Vancouver, Ottawa, and Toronto had several deliveries *each morning*, mail wasn't at all quaint. Indeed, perhaps the most successful pre-war British documentary was John Grierson's *Night Mail*. The film, which was popular in Canada too, does more than record the Postal Special train's run from London to Glasgow. The clockwork perfection it displays, jump cuts of men shovelling coal into red-hot fireboxes, and the train speeding down the track, were meant to — and were understood to — demonstrate British know-how and strength in a year, 1936,[20] which saw Hitler take the first step toward war: he remilitarized the Rhineland. Coincidentally, the verse commentary read by Grierson as the train climbs was written by W.H. Auden, who, if he wasn't already, would become Molly's favourite poet.

Molly had never been under fire, but she would have known the importance the timely arrival of letters and postcards had for the morale

of the men on the sharp end. In the most personal terms, it preserved soldiers' links to their wives, sweethearts, parents, and children. Even more importantly, regular mail delivery was the tangible, almost daily, manifestation of the unspoken contract in which the soldier offered up his services in exchange for the greatest amount of support that his country could provide for his needs. The shooting may have stopped, but the Canadian troops in Belgium and Holland, and occupying Germany, were still "in theatre" and mail remained psychologically important.

Some of the differences between the two paintings — of women doing what, before the war, was considered men's work — simplify the image. In the oil, deleting the small lights that hung before the mail sorter frame removes a distraction, for example. Removing the tracery (bars) from the windows, may seem minor but has an important effect of showing clear blue sky, which, in these early days after the war, were noticeably free of the stain of bombers' contrails.

By shifting the viewer's angle to the left in the oil, Molly moved the frame to the centre and the CWACs putting mail in its cubby holes in the centre, creating a more active scene. She filled this space with three CWACs, bringing the total number of them to ten. The two on the far left near the windows and two in the far rear are only roughed in, but again, Molly gives enough detail, such as the outline of a white shirt for one and differing postures for all, that we know we are looking at individuals even though we cannot see their faces. The indistinct shadow cast by the CWAC walking toward the rear testifies to the fact that she has just passed the rear of the postal sorting frame and to the strength of the light coming through the windows to her left. Further sense of movement is generated by the position of her feet and the slight twist of her skirt signalled by the darker and lighter striations that mimic the wave of fabric.

The ceiling coffers are present in note form in the drawing, but by depicting them with greater volume, Molly adds both perspective and depth to the oil scene. Similarly, the three CWACs on the right side of the foreground are present in note form in the sketch, and each is in more or less the position she was in the sketch. The two facing us are listening

intently to a senior CWAC, whose back is toward us and whose status is signalled by body language, chignon, and just the hint of stripes on her shoulder. These details and how they work together go some way to belying Molly's claim, voiced decades later, that derided her skill: "I have terrible time, technically with painting."[21]

On 26 June, 1945, Bruno responded to a memo from Shadbolt asking about his future plans. Bruno told Shadbolt that since he did not want to return to his pre-war job as a commercial artist, working on a "contract basis...completing larger canvases would be more satisfactory" to him.[22] Then, with a bit of cheek, he added that it would be "an excellent rehabilitation programme" that would allow him to finish a number of large canvases. Five days later, Bruno celebrated Dominion Day by flying to London.

The works Bruno completed in London and those finished once he was back in Canada in late 1945 divide into two groups. Some confront the aftermath of battle—though on machines of war, not men. But others differ dramatically from the watercolour sketches he produced in Belgium and Germany. Some, including *Advanced Dressing Station* (*ADS*), painted in May 1946 and, therefore, one of the last oils he painted as a war artist, continue to show a sanitized war.

ADS is based on a watercolour painted a year earlier in which the scene unfolds under an Impressionistic dark charcoal smudged sky that strains Schaeferian "expressive realism" to its limits. On the right in the watercolour there is a realistic rendering of a corner of a building. Surprisingly, given the destruction recorded in the rest of the painting, this part of the roof, red brick wall, and even windows are intact. In the short open space, four bare trees mark part of the distance toward the horizon. An army ambulance is parked across the centre foreground, all but obscuring another ambulance and the lower storey of a heavily damaged building; the ambulances and the building are flattened, all but devoid of detail. The red clay shingle roof of this building is partially blown open, revealing

the wood beams supporting it. The left corner has been blasted away; the bricks, again lacking details, lie strewn across the left foreground. Both the second- and first-floor interiors are a jumble of purple and dark-blue forms. Standing in front of the side walls of the blasted building are two silhouetted Canadian soldiers, one in a greatcoat, the other in his uniform, speaking. The entire left-hand side of the painting is filled with the rest of the damaged building, a side view of what was certainly a barn (its roof also blasted open), the predictable telephone pole with dangling wires, and two trees. Unlike the trees on the left, these retain their leaves, as do the bushes on the right part of the foreground. These survivors of the natural world are, however, rendered in washed-out green that makes their hold on life seem tenuous indeed.

The oil of the *ADS* depicts a much-simplified scene. The undamaged house on the right is still there, but the left is now a pale red road that takes up about a quarter of the foreground. The trees in the space between the house on the right and the damaged one in the middle, recorded in the watercolour notes, have vanished. The silhouetted Canadians have been replaced by an ambulance driver who is speaking to another man whose back is toward us. In place of the pile of bricks is a gear assembly for a truck. The building, now rendered in pink, is still damaged, but its broken corners are less distinctly shattered brick; the ten levels of red roof have been reduced to seven and the size of the hole has been reduced by about half. The telegraph pole is there, but the hanging lines have vanished, as have the leaves of the trees on the left and the bushes in the right foreground.

The cumulative effect of these changes does more than alter the scene's aesthetic. Though quite different from Colville's "hyperrealism," the jam-packed watercolour has something of the feel of works like his *Horse and Train* in which the threat of violence is manifest. What will happen to the wounded men if the clouds open up and water pours into the ADS in the watercolour? Does the sole telegraph line bring word of casualties about to arrive from the battle around the Küsten Canal? In the oil painting, by removing so many small details that bespeak war, Bruno has drained the

tension, leaving if not exactly a cartoony feeling of war then, perhaps, one produced for a recruiting poster for the Royal Canadian Army Medical Corps.

Even in his works that confront the aftermath of battle, whether he realized it or not, Bruno followed the Shakespeare plays he studied at Balliol College and kept battle and blood safely off stage. The one exception is the dead German in *Friesoythe, Germany* (p. 198), who lies amid the rubble of the blasted townscape, at the centre of which is a gas pump, leaning on an angle, that is suffused with meaning. On the top part of the glass vacuum chamber (into which the petrol is drawn before it goes to the gas hose) shadows obscure the *S* of the company's name, leaving only HELL. Beneath these letters, Bruno follows Édouard Manet, who declines to show us the lethal wound in his painting of a dead toreador. Bruno further distances us from this dead German by rendering him in hues and with flattened features that would have been familiar to readers of Captain America or Johnny Canuck comic books.[23]

Save for a few buildings, one seemingly windowless and one burning off to the right in the middle distance, the north German town of Oldenburg does not figure in the oil *The Battle of Oldenburg*.[24] Unlike the landscape in, for example, *Sherman Tank*, the landscape near Viehdam, Holland, has been deeply rutted by war. To make the oil even more dramatic, Bruno departs from facticity. The few scraggly trees that had been on the centre right of the pencil sketch on which the work is based have become five trees, two of which are now bare trunks, more mute testimony to the explosions that ripped up the ground and destroyed the gun. The three trees that are full and green cannot, however, be taken to promise growth and renewal. Rather, by dividing the work even more than does the horizon line, they concentrate our attention on the lower half of the canvas; and, in any case, the upper half is a black-and-dark-grey-rimmed stormy sky that can be seen as something approaching a pathetic fallacy (nature imitating the state of mind) of the landscape man has profoundly damaged.

By concentrating our attention on the lower half of the canvas, Bruno forces us to see the devastation wrought by the flight of rocket-firing

Typhoon fighters that supported the 4th Canadian Armoured Division into the blasted hulk of a German self-propelled gun. The blasts did more than blacken the gun; they blew off its turret, deformed its fender, and ripped off other pieces of armoured plating. To draw us further into the narrative, he uses impasto that is so thick in a few places it almost seems as though he's created a bas-relief. The patch of brown impasto on the left of the wreck of the self-propelled gun documents the bubbling of steel caused by the explosion of rockets, while the shadows the impasto casts are real—the impasto is physically standing out from the canvas. Further to the left, both above and below—or behind and in front of—the gun's turret, Bruno uses less pronounced impasto to depict the remains of the track that, in the moments before the explosion destroyed the gun's engine, ran off its sprockets—and just a bit further, impasto records the splash that occurred when the track fell into the ooze. A decade and a half later, Bruno would use impasto to a more sensual affect; here it serves to give his viewers, most of whom had never been near a battlefield, a sense of the "whirl and muddle of war," to borrow the late literary scholar Samuel Hynes's phrase, that had so recently ended.[25]

In works like *Children in Bremen* and *Ruins of Emmerich, Germany* (there being two watercolours with this title), Molly departs from her remit to record CWAC activities. In the work we are considering (on the back of which she wrote "Oct 1945," p. 198), Emmerich is framed by black clouds arching from side to side, which seem to symbolize the work's finely balanced dialectic. On the one side is national pride while on the other is the gathering of mournful images, the result of a bombing raid on 7 October 1944 when 90 per cent of the town that had existed since it was the Roman colony of Emrik was destroyed.

 The national pride is not linked to the two CWACS, who may not have been in the scene at all; indeed, as Molly told Joan Murray in a 1977 CBC interview, she sometimes inserted CWACs for emotional effect or formal compositional reasons. Nor is the national story bound up in the

soldier standing with his back to the river, for we don't even know if he is Canadian. And the symbolic sunrise he looks toward is less than it first appears: whatever Molly imagined as the source of the light, it couldn't be the sun, because through most of Emmerich, the Rhine runs east-west, meaning that this figure with his back to the Rhine was actually looking north. Rather, the national story is found on the partially blackened wall on the lower right. Just before the wall is cut off by the right edge of the paper, we see "WATER RATS," the moniker Field Marshal Bernard Montgomery bestowed on the 3rd Canadian Division during the Battle of the Scheldt in late 1944, and which filled Canadians at the time with pride.[26]

When she painted this work, Molly had no way of knowing the works of Walter Benjamin, perhaps the twentieth century's most important cultural critic, who committed suicide while trying to escape the Nazis in 1940. Yet, her paintings of Emmerich (as well as of Bremen) show her groping toward what was one of Benjamin's great insights: in *The Origin of German Tragic Drama* he argues that in an age without an eschatology,[*] such as the German Baroque period, playwrights "pile up fragments ceaselessly, without any strict goal" other than to fill the void left by catastrophic historical events and in which nature itself is merged into the blasted setting of history.[27] In a like manner, Molly, who has seen the devastation war wrought on Europe and as her War Diary suggests, has lost her faith, piles up fragments to fill a void. She has the ghostly thin branches of another tree bend toward the upper right, which puts them above the A-frames of a no longer existent roof of a building, the walls of which are light-blue and grey, broken by fire-darkened and hollowed-out window frames. These branches lead our eyes to the still-standing walls of a hollowed-out church, symbolic of the collapse of faith engendered by the war (which parallels the breakdown of faith in the Baroque period Benjamin studied). Thus do the blackened limbs of another tree bend, seemingly painfully, to the left, toward the ruins of a factory, drawn in

[*] That is, without a known end of history, such as in the Christian belief of the Second Coming.

blacks and browns with black cross-hatching that simultaneously produces the ruins volume and suggests lichen. Given what Molly saw at Bergen-Belsen and was reading about Auschwitz and the other death camps, it is surely no accident that the factory's smokestack, which stands high enough to be cut off by the top of the page, is the scene's only complete structure.

In most of his works, Bruno blanched the pain of history. In Molly's two watercolours of Emmerich and the haunting picture of bombed-out Bremen she does something different. In this latter, the scratches through oily black charcoal she covered the page with are not (blueprint-like) place holders for windows but rather records of portals blasted away by shells. As Benjamin might have put it, the ruins become runes.

After returning to London in late October, Molly, the most junior war artist, was assigned to share a studio with the artist immediately above her on the appointment list. Bruno was so irked at having to share the atelier that he had had to himself for several weeks that he partitioned it. He was even less pleased when he saw that the interloper was the CWAC 2nd lieutenant he had met a few days earlier. For several days, they worked in frosty silence until curiosity got the better of him, and he peeked around the partition, only to find himself impressed. As A.Y. Jackson put it, after being caught looking, "it was impossible...for him to maintain an aloof attitude."[28]

And when Molly's troop train arrived in Ottawa in late fall 1945, the newly promoted Captain Bruno Bobak, who had already been repatriated, waited on the platform for her. Six days later, 10 December 1945, with Uncle Alex at her side, Molly walked down the aisle of All Nations Church in Toronto. Waiting for her at the altar was Bruno, with Aba Bayefsky at his side. Under the approving eyes of her matron of honour, Mrs. Maybelle Andisons, her one-time landlady in Ottawa, Molly Joan Lamb and Bruno Bobak were married.

PART TWO

1945 - 1973

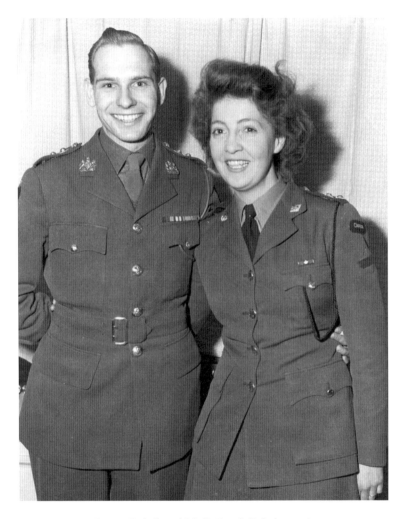

Bruno Bobak and Molly Lamb Bobak, 1946.

(Touchwood Editions)

Chapter 4
Painters Two

Art is a corner of creation viewed through a
particular temperament. —Émile Zola

From the first, the Bobaks' marriage differed from the rush to domesticity that characterized the vast majority of marriages in postwar North America. To begin with, there was no expectation that Molly would give up painting, as was the case a decade later for the not-yet college graduate Mary West.[*] Not from Uncle Alex, who lent the newlyweds his Toronto apartment and atelier in the famed Studio Building (once the home of the Group of Seven) for four months. And not from the Department of National Defence, which, after the Bobaks moved back to Ottawa in April 1946, provided the married and pregnant CWAC officer with a studio to complete her paintings.

Among the works Molly finished before a few months' early discharge for medical reasons (i.e., pregnancy) was *Private Roy* (p. 199) which over the past few decades has become her best-known work. The subject of Molly's painting, Private Eva May Roy, is a radical departure from Canada's (white, largely British) standard wartime story. In this painting of the African Canadian private—the only named portrait of a CWAC— Roy is a physically imposing figure reminiscent of an Emily Carr–like

[*] Upon learning that she was marrying a fellow art student, Mary's Mount Allison art professor Lawren P. Harris Jr. told her, "There could be only one artist [in your family] and that artist is Christopher [Pratt]" (Smart, *The Art of Mary Pratt*, 45).

totemic figure or the woman in the "We Can Do It" poster. Roy's stare is so arresting that the viewer is apt to miss the painting's sophisticated structure. The still lifes sitting before her, for example, do much more than simply fill up space. The items on the right — two donuts, a tumbler, a cup of sugar, a coffee cup with a spoon, a bottle (perhaps of beer), and an iconic Coca-Cola bottle — anchor the scene in a 1940s canteen in much the same way Henri de Toulouse-Lautrec anchored his pictures in Second Empire Paris. And the two apples on the left are both an indication of the scene's location, Halifax, not far from the Annapolis Valley apple orchards, and an homage to Cézanne's apples, which Molly admired. What's more, although the glass, donuts, and cola bottle do not quite seem to threaten to slide off the table and onto the floor (as do the pastries on the tray carried by the CWAC who looks as if she stepped out of the pages of the *New Yorker* in *Canteen, Nijmegen, Holland*), Molly painted them with her Cézannesque brush.

Still, in a way Colonel C.P. Stacey certainly did not intend when he ordered his artists to paint "veraciously," Molly *was* painting truthfully, more "truthfully," it can be argued, than did Comfort, Colville, and even Bruno when they produced their flattened-out works. "Molly's *Private Roy* is an official piece of war art. So, she cannot go as far as Cézanne went in his mature works, in which he breaks the pictorial plane and reassembles it to show how we perceive objects over time and in space," notes Stuart Smith.[1] But by depicting the still lifes as she does, Molly draws attention to the act of perception, and because the objects in the still lifes stand about a metre before the viewer, they impel viewers to look back at them to make sure they saw them correctly; this eye movement provides the feeling of movement.[2]

And yet, since neither the apples nor the donuts are blurred, in the end, they are interpreted as occupying — and more to the point, are *seen* to occupy — fixed positions and, therefore, reinforce the solidity of the grid behind Roy, which Laura Brandon calls, "a master class in composition."[3] The grid, which directs the viewer's eyes first up and down, then side to side, provides the negative space against which Roy stands out. Put

another way, the shadows in the grid formed by the shelves push Roy forward into a position where the lighter colours of the still lifes—mainly whites and tans —relate to the lighter colours of Roy and her uniform, creating balance with the darker areas behind her. This complex balance of shapes and colours produces a three-dimensional impression, making it feel as if Roy were in our space.

In accordance with the regulations that authorized "vivid" works, Molly manipulates the light to further the narration. Had she depicted lighting naturally, the "light" (provided by the white of the canvas) that glistens off the rim of the glass on the left and the cap of the Coca-Cola bottle would also illuminate the area below Roy's arms. Because this area is dark, Roy's brawny, brown arms stand out. The scratches of white — forming light — in the shadow and, indeed, the layered or stepped aspect of the shadow Roy casts are also photonically impossible. However, both make Roy stand out from the shelving, furthering the three-dimensional illusion. The layered nature of the shadow, which merges on the right side of Roy's head, appears to increase her size without actually changing her dimensions. Had Molly depicted the light as it fell on Roy, the dark circles around her eyes could not exist. These dark areas are vitally important because they provide the matte field that turns the simple white of Roy's eyes into a piercing expression.

Art historian Charmaine Nelson has claimed that Roy was "under no obligation (financial or otherwise) to sit for Bobak's portrait" and thus that Molly produced a picture of a "relationship between [a white] artist and [African Canadian] subject [that] comes closer to equality" than did any other Canadian painter.[4] However, though she was not Roy's commanding officer, 2nd Lieutenant Lamb *was* an officer and outranked Roy, who was a private. Accordingly, Roy may have felt that she could not object when Molly asked to sketch her. Further, we do not know enough about Roy's own history to state categorically that she was not intimidated by this white woman, especially one higher up on the military chain than she was. Indeed, given what Molly said decades later about Roy "remaining a mystery" to her, it is more than likely that their conversations remained

rather perfunctory and, thus, Molly herself would not be able to shed further light on this important question.[5] Nelson is on far stronger ground with her close reading of Roy's crossed arms, which "captured an acute feeling of alienation" that was reinforced by the "crowded counter that separates her body from the space of the viewer."[6]

Brandon argues this difference is more than an artistic one. Rather, she sees "much of Molly, of her drive, in Private Roy."[7] Molly's drive included, of course, her quest to become the first female official war artist and, at the point this work was painted, her dreams of earning a living as a professional artist. It also included her making a bold social statement that becomes clear to us only when we realize that this, the only full portrait of a named CWAC, is a member of a statistically minuscule group in the sole women's service that accepted African Canadians. The painter who created a figure that one art historian imagines asking, "Why are you looking at me? Have you never seen a black servicewoman before?" is the same person who, even as a young girl, disdained Kate Mortimer-Lamb's casual anti-Asian racism.[8] The painter of *Private Roy* is the same servicewoman, who, twice during the war, went to see great African American bass-baritone Paul Robeson (once playing Othello in New York),[9] whose support for civil rights was already legendary. And the painter of this work is the same woman who in 1984 "went to bed scared about the fate of blacks in the USA" on the night Americans re-elected Ronald Reagan as president.[10]

Upon returning to Canada, Bruno had deposited the sketches, watercolours, and oils he had executed in Europe as a war artist at a repository in Ottawa. Though *Cross Country Convoy* was part of an official Canadian Army art tour, since he painted it on his own time when he was still training to be a sapper, Bruno owned it. On 4 December 1945, he received a letter from the University of Toronto, informing him that Hart House had purchased the painting for $40 ($584). The letter is signed by Hart House's warden, J. Burgon Bickersteth. However, it is more than likely that Bruno's first professional sale owed more than a little to the "great and

mysterious hand" that had reached out and made Bruno a war artist, for in 1946, Vincent Massey remained a member of the board of Hart House, which he had founded in 1919.

About the same time Molly was completing *Private Roy*, Bruno completed his last war art paintings. *Sherman Tanks Taking Up Positions Under Artificial Moonlight* (*Artificial Moonlight*) (pp. 200–201) depicts a complex scene, but not exactly the one he painted in watercolour *en plein air* on 7 March 1945, when he wrote, "I started painting of the firing in artificial moonlight and completed it the following day."[11] That watercolour, which is now lost, would likely have shown, via billowing smoke or a burst of red flame coming out of a turret, the act of firing.

Artificial Moonlight announces an important, albeit significantly less dramatic, moment than that indicated in his War Diary. These tanks are static, neither moving nor firing. And yet, the painting is dramatic, primarily because of the stabbing shafts of light. Bruno would have known that because of dust and refraction the edges of a searchlight beam are ragged, but he renders the sides of these beams not in a grey *sfumato* effect but in sharp contrast. The widening, hard-edged beams created by the white of the canvas drive our eyes first left, then toward the sky.

Perhaps even more audaciously, Bruno renders the figures—the four or five tanks, one truck and a few bare trees on the left, the ground, and much of the cloud cover—in tones ranging from dark grey to black. Given the diffused nature of artificial moonlight, the sides of the tanks closest to us would not have been silhouetted as they would have been, for example, under a full moon, and hence would *not* have appeared black. By rendering them so, however, and by lighting the tops of the tanks and the hood of the truck, Bruno heightens the tonal scale. The effect is to turn what at a quick glance seem to be cut-outs of tanks into almost 3-D figures with volumetric roundness.

"The drama is added to," says Smith, "by the fact that the painting is divided in an unusual manner. The top two-thirds are the sky, which means Bobak has concentrated the action—the scenes and means of war —in the bottom third of the painting, closer to the viewer's level."[12]

In his last war art work, *Sogel, Germany*, completed in April 1946, Bruno uses thick white oil paint to form the impasto that make up the rocks in the foreground. Beyond the two Canadian tanks driving away from us is a greenish-beige field of destruction. Large deep-brown metal pieces, one seemingly a beam that points forward to the tanks and thereby establishes the depth of field, litter the foreground. Indistinct pieces of wood or concrete lie scattered and in heaps, as they are in a watercolour sketch he made on the streets of the destroyed town on 11 April 1945.

On the right, flames rendered in shiny red rise over the top of the only wall still standing from the building that should have dominated the centre and another ruined structure on the right. The thick black smoke billowing into the centre of the picture and then toward the right all but obscures the telephone pole and dangling wires recorded on the sketch and suggests that this smoke comes from burning oil tanks; this smoke is so overpowering that it takes a moment to notice the fire that generates the pillar of smoke on the left of the road. Executing the work a year after the battle (and end of the war), Bruno added a symbolic moment that is not warranted by any of the four watercolours that depict the *8th Field Squadron Royal Canadian Engineers Methodically Blowing Sogel to Pieces*, as one is bloodlessly named: the tanks pass under the oil smoke toward a bit of blue sky off in the far distance.

Although Molly's pregnancy moved up her date of demobilization by several months, the Department of National Defence did not suggest that she refrain from attending the gala opening of the exhibition of war art, which included *Private Roy*, set to tour the country beginning in mid-1946. Nor did Bruno's immediate postwar employer, the Department of Trade and Commerce, for which he designed travelling exhibits, shy away from contracting with Molly to paint a twelve-metre movable mural for an exhibition intended for Australia; she painted it with their infant son in tow: Alexander, named for A.Y. Jackson and known as Sasha, was born

in October 1946. In May 1947, Ottawa's The Gallery mounted a show of watercolours Molly and Bruno painted in their few spare moments.

Molly took the lead in deciding where her family should live:* after their Ottawa show, she told Bruno that they should build a shelter on her mother's land on Galiano Island and paint.[13] For several months they lived in a wooden cottage Bruno built. Their plans to live on fish while buying things like sugar, tea, and coffee with money from selling their paintings ran up against an economic reality caused by unsold paintings and being stiffed by the owner of a "fly-by-night sawmill" where Bruno worked part-time and for whom Molly worked in a chow house (on her mother's property). When the sawmill went bankrupt, in lieu of the lost wages, Molly made her own justice by arranging to have a stack of lumber spirited away.

Molly and Bruno's house in Lynn Valley, North Vancouver, designed by Douglas Shadbolt and built by the Bobaks, 1948-49.

(*Better Homes and Gardens* provided courtesy of Meredith Corporation, *Better Homes and Gardens*, 1950-1951, photographer unknown)

In 1949, Bruno began teaching design at the Vancouver School of Art. That same year, helped by the apprentice architect Ron Thom, the Bobaks used their lumber to build an open-plan house designed by Bruno and architect Douglas Shadbolt (Jack's younger brother) on two adjacent lots in Lynn Valley that had cost $68 ($745) each. In the handwritten notes to his speech at the retrospective mounted by the Beaverbrook Art Gallery for his eightieth birthday, when remembering the decision to move to New Brunswick in 1960, Bruno wrote that he "<u>definitely</u> had to consult" (emphasis in the original) with

* In contrast, a decade later, in the first year of their marriage, Christopher Pratt decreed that he and Mary would live in Newfoundland; they settled in a house owned by his parents in the remote village of Salmonier.

Molly, who was away teaching in the interior of British Columbia, before accepting the offer to become artist in residence at the University of New Brunswick.[14] In addition to this pecuniary reason, Molly likely agreed to relocate to New Brunswick because of her fondness for her mother's stories of the New Brunswick she had immigrated to immediately after the First World War. Decades later, Molly would discover to her surprise an even closer prior personal connection to New Brunswick, which surfaces in chapter 9.

Though Molly's ignorance of Canada's national sport resulted in her equipping ice hockey players with field hockey sticks, her war artist experience served her well when painting the trade show mural. However, she soon found her style had become "too subjective" — that is, too tied to mimesis.[15] Molly's self-doubt ebbed after a talk with Jack Shadbolt, who advised her to think less about the subject in front of her than the language of painting: how colour, lines, and shapes interact instead of the reality of the three-dimensional objects she was trying to represent in a two-dimensional medium.

Not long after, Jacques Maritain was introduced to Molly's work by her wartime Ottawa landlords, Professor Gordon and Maybelle Andisons, the Thomist philosopher's English translators. Which painting piqued Maritain's interest is unclear. His visit to Canada included a stop in Vancouver, where he could have seen *North Vancouver Ferry* (p. 203). Much like Picasso's *Les Demoiselles d'Avignon*, this picture's fractured planes intersect and then move on, preventing the viewer from settling on one final perspective or image. Impishly, the head of a man changing a light bulb is itself a light bulb. The central figure, the well-dressed businessman, whose head owes much to the central figure in *Demoiselles*, appears to have four legs until we realize Molly has captured — almost as if in a stop-action series — the swinging of the man's right leg. As befits a Vancouver ferry, the drab blues, greens, and browns dominate — until the viewer notices the yellows and reds bursting forth, that change the picture from a quotidian moment into a strange, almost surreal, and oddly humorous scene.[16]

At all events, Maritain was impressed enough with Molly's work that he bought one painting and, using his contacts in the French government from his years (1945-48) as the French ambassador to the Holy See, he arranged for a French government fellowship for Molly to study in France in 1951. The fruits of this fellowship were realized in a series of paintings, including *A Bake Shop, Saint-Léonard*. Using greys closer to the viewer and whites farther away to delineate the wires of the Impressionistic structure, Molly's draftsmanship in this painting shows the impact of her study of Henri Matisse, though not the Fauve colourists. The dark-grey background on the left gives the thin display structure its volume. But it is the black part of the wrought-iron wire of the display structure, which because it is a right-angled assembly is closer to the viewer, that provides the depth of field that allows the structure to appear three-dimensional. The baguettes standing upright on the upper shelf and lying on their sides on the middle shelf are suggestive rather

Molly on Galiano Island, British Columbia, in the early 1950s.

er than minutely described, but their seemingly haphazard arrangement produces a sense of movement and turns what otherwise could have been a rather formal exercise in line and shading into a human moment redolent of daily life in a *boulangerie.*

Molly's success at this point in her career is all the more notable if we compare it to the struggles of her female contemporaries in New York's infinitely larger and wealthier art market. Even though Abstract Expressionism had not yet broken through the 54th Street barrier (so named because the most important galleries in Manhattan were above 54th Street), Jackson Pollock and Willem de Kooning were becoming known. By contrast, their wives, Lee Krasner and Elaine de Kooning (and other female Abstract Expressionists), laboured in almost complete

obscurity. As art historian Mary Gabriel had recently shown, a large part of the reason female Abstract Expressionists remained unknown was the 1949 *Time* magazine feature that asked the rhetorical question, Is Pollock "the greatest living painter in the United States?" above a photo of him looking like a weathered ex-GI (in fact, he had been classified 4-F, unfit for military service, during the Second World War). Nevertheless, largely because of this article and photo, for decades Abstract Expressionism was associated with a Marlboro Man–like view of American masculinity.[17]

Molly faced neither of these encumbrances. First, as noted, through her father, A.Y. Jackson, H.R. McCurry, and others, she was plugged into the highest levels of the Canadian art establishment, such as it was. Having been Canada's only female official war artist meant that even at the beginning of her civilian career, she could call a gallery and get a hearing.

According to the 1954 prospectus of the Vancouver School of Art, in his design courses Bruno focused on teaching "texture, colour, line [and] spatial illusion" of paintings, drawings and etchings.[18] In the early 1950s, these formal principles underlie the remarkable series of woodcuts that brought Bruno acclaim, first in the pages of *Canadian Art* and then internationally. Bruno's view at the time was that Indigenous artists "did such fantastic work [because the] forests were magic, the mists, the rains was magic....A dead tree on the ground, on the beach, looked like the skeleton of a whale. I could see rocks as living things."[19] To today's ears, this sounds like cultural appropriation at worst or a number of facile analogies at best. Putting this aside, however, Bruno announces here an artistic program that is about as far from burnt-out tanks and the gore of war as can be imagined.

At times his effort to re-enchant his pictorial world is successful. The 1950 woodcut *Wildflowers* is a sensitive depiction of nature, its delicate flowing lines evincing Bruno's study of Japanese prints. The three-by-nine-metre "Mural in Concrete" created for the Vancouver School of Art[20] (p. 105) was another moment when Bruno portrayed, as Shakespeare's

Bruno's "Mural in Concrete" created for facade of the
Vancouver School of Art, 1953. (Vancouver School Board)

Duke Senior put it in *As You Like It*, "tongues in trees, books in running brooks / Sermons in stones, and good in everything."[21] The thirty-one different casts—fish, birds, snowflakes, plants, and even beetles—required drawing each image in the negative onto pieces of plywood (to get the requisite depth, several pieces of plywood were glued together) and then cutting with a band saw. The pieces were then assembled in forms, well greased, and the concrete poured in. The mural was held together with iron rods and mortar.

Even after years of studying the mural, Beaverbrook Art Gallery curator John Leroux wonders at how Bruno was able to "make something

so austere but evocative of nature in a concrete modernist building."[22] The work, captured only in images now, can be read both upwards and across, running from sea to sky. The story told on the right side begins with a lobster's claw and ends with a bird in majestic flight. Read across, each level shows Bruno's conception of plant and animal development at ten or eleven different epochs. If we take Bruno at his word, the mural answers the vexed question of where "the artist fits in his community" by allocating to the artist an almost shamanistic role to use local "source materials" to tell a universal story.[23]

Other works are less hopeful, though as a reporter for the school's newspaper, *Varsity*, noted, they showcase Bruno's virtuoso use of the chisel and knife to achieve the exact shape of the cut that holds just enough ink to manifest his "fine feeling for form, for the actual shape of objects."[24] In his 1951 response to Graham Sutherland's *Maize* series, Bruno emphatically rejects the British painter's colourful palette that recalls the tacky multicoloured corn wreaths Americans hang from their doors at Thanksgiving. In *Corn*, Bruno's strong black lines on the white page achieve a hard edged naturalistic view of his subject. Viewed from ground level, the stalk stands out against a prairie sky, the upper two-thirds of which are black, the sign, we assume, of an approaching storm. Having apparently broken out of the hard, dry rocky soil, the stalks have something of the feel of the apple on the tree in the second act of Samuel Beckett's *Waiting for Godot*: intimating the promise of life.

That is until we realize that *Zea mays*, to use its scientific name, is never planted one or even two stalks at a time. To ensure pollination, it is always planted in threes (usually in rows). In other words, the stalks could not have reached this stage of growth without other stalks. Nor can we assume that the stalk has somehow escaped a mechanical harvester, for there is no stubble on the ground that would indicate where other stalks once grew. Instead, the stalks seem to have survived an explosive cataclysm that has swept the ground clean, one hot enough to have melted the ground into egg-like rocks. The watercolour *Dry Cornstalks*, a near

companion piece, hardly solves the problem. Its brittle stalks lie spiderlike on a burnt ground overlooked by dark foreboding hills.

At one level, the three interconnected works dating to 1954 beginning with a pen-and-ink study called *Raven* continue Bruno's investigation into how natural complex forms can be rendered with simple lines. The first investigation was a 1949 etching of a piece of driftwood that was probably prompted by a similar series of etchings by Jack Shadbolt. The pen-and-ink *Raven* could have served as a study for an Emily Carr–like totem sitting in an abstract nest formed by the intersecting lines that form a pentagon. To move from it to two drawings of ravens is to move into a nightmarish, scorched world.

Whatever hint of fertility might be embodied by the eight or nine lines topped by filled-in circles and oblong shapes suggesting buds that reach to the top of the page of the second pen-and-ink *Raven* is all but gone from the watercolour of the same name. It is just possible that the abstracted (swamp?) grasses are alive, though their colours — ochre, black, and tan (this last formed by digging deep into the crayon) — are not promising. As is the case in Wyndham Lewis's *A Battery Shelled*, which presents the stubs of trees left by a First World War shell barrage, "the background is left empty, or disappears, so that distance doesn't run out to the horizon line but simply disintegrates."[25] More importantly, in the grasses is a naturalistically rendered dead raven, a carrion bird and long a symbol of death. Like the "vulture eye" in Edgar Allan Poe's short story "The Tell-Tale Heart," which Bruno would have studied in high school, this raven's curiously open eye draws us into this natural *memento mori* even as it recalls the sort of (gothic) Polish folk tales Bruno would have heard on Babi's knee and the eyeless skull of the decaying German body Bruno lay upon in the bottom of a slit trench.

The purple and blue sky punctuated by bursts of oddly shaped light (formed by rubbing away the wax crayon) in the upper third of *Skull* (p. 202) recalls Van Gogh's starry heavens. Again, we are at ground level, positioned in the grasses, which, as was the case with *Raven,* are brown (trending toward an evil yellow), black, and grey. Bruno puts the viewer

just far enough away from the mass in the middle of the picture so that we see it as a bird's skull; the empty eye socket allows us to orient the black-and-brown image. The beak, essentially an isosceles triangle lying on its long right side, contains a smaller triangular (albeit with rounded angles), the black paint of which provides the darkness-signalling depth that was the bird's nostrils. The beak recalls the turret of the burnt-out tank in *A Sherman Tank of the Governor General's Foot Guards* (p. 195), only here, instead of a turret pointing toward a dead horse, the beak points to a patch of brown ground highlighted by slashes of darker brown and black paint that, even as they give the ground texture, emphasize that nothing here lives.

What has caused the catastrophe?

A detail in *Skull* suggests an answer. From a compositional point of view, the painting's crystalline moon lightens the picture and recapitulates the scratched interior of the void where the bird's eye once was. A close look reveals, however, that many of the lines cut through to the white paper are not straight; one around the midsection stands out as an oblong ring resembling nothing so much as the pictorial depiction of electrons circling the nucleus of an atom.

In 1949, the year Bruno produced *Cornstalks*, the Soviet Union broke the American monopoly on nuclear weapons, and defence planners across North America began considering what would be left after a nuclear exchange. In 1954, the United States and Canada established the Distant Early Warning (DEW) Line in the high Arctic to track Soviet nuclear bombers. That same year, the United States exploded what was then the world's most powerful atomic bomb at Bikini Atoll. All of these events were widely covered in Canada. Within months of the atomic bombings of Hiroshima and Nagasaki, *Fortune* magazine, among others, suggested that Pollack's work befitted the Atomic Age. According to art historian Serge Guilbaut, Pollock embraced iridescent, brilliant sources of light and "heat so intense that it destroys all objects, reducing each thing to a complex, convoluted web of thick sticky undifferentiated fibres" in such works as the drip painting *Shimmering Substance*.[26]

Such deconstruction of pictorial narrative was not in Bruno's tool kit; he could go only so far in "expung[ing] all recognizable imagery" or story from his work.[27] But in a manner not unlike *Godzilla*, the 1954 film that tells about a prehistoric monster re-animated by nuclear radiation, the images of mushroom clouds and their aftermath touched a chord in Bruno, dating back to the war. Then, he had been unable to sketch the gruesome scenes left by his own army's gunners, the very gunners upon whom his life depended.

"Bruno wasn't like Molly," recalls Smith. "He listened to the news and read the newspapers, but she devoured the news and loved to debate it. Rather than debate, he tended to respond to issues with his hands."[28] In a world where nuclear explosions were both celebrated and feared, the artist produced a moon that looks like a gigantic atom and burnt, petrified landscapes that undercut any vision of an enchanted world. Indeed, three decades later, while discussing the third panel of the triptych *The Wheel of Life* (1966),[*] Bruno remarked, "It's not entirely unrelated to those early pictures of grasses because there is a sense of life and death ending up with dried grass, or dried cornstalks."[29]

Despite the underdeveloped financial ecosystem of Canadian arts then being studied by the Royal Commission on National Development in the Arts, Letters and Sciences (better known as the Massey Commission for its chairman, the same Vincent Massey who Bruno met at Canada House in 1944), Molly and Bruno's work was being seen, was drawing accolades, and some pieces were being bought, including Molly's *Little Moreton Hall, Cheshire* by the National Gallery in 1951. In 1954 and 1958, Bruno won a number of prestigious national and international awards, and his *Bird in Grasses* was exhibited in the Canadian Pavilion of the Brussels World's Fair in 1956.[30] Over the same period, Molly had two "one-man shows," as they were called even for female artists: one at the prestigious Waddington's in

[*] See chapter 5.

Montréal and another at the trendy The Gallery in Vancouver. Molly was included in more than twenty group shows, including several international ones. Given her monarchist sympathies, she must have felt very proud of being part of the National Gallery's *Exhibition of Canadian Paintings to Celebrate the Coronation of Her Majesty Queen Elizabeth II* in 1953.

In June 1954, La Galerie Agnès Lefort in Montréal wrote Bruno that four of his British Columbia paintings had sold and that the gallery wanted to retain two others on consignment. Two months later, the Victoria and Albert Museum invited Bruno to send six prints to London so that one could be chosen for an exhibit that, after its run in London, would tour three American cities and Ottawa; the museum arranged for copies of the prints for the other museums to purchase. In March 1956, the Art Gallery of Toronto informed Bruno that 17,000 people had seen the exhibit, which included his works, and two had been purchased. The same year, Molly's *Streetcar* was purchased in a private sale, and the National Gallery, under director Alan Jarvis, purchased three of her works. Then, in November 1958, on the strength of having sold twelve of their paintings for $2,430 ($21,500), the couple gave up teaching art and devoted themselves to working full-time as artists.

When laid out as above, the Bobaks' careers appear to have moved from strength to strength. But in reality, there were setbacks and frustrations. In 1956, for example, Molly was rejected for a show in Montréal. And she must have chafed at the picture that accompanied Fraser Bruce's 1953 article "They Share Art Career" in the *Vancouver Province*. The article includes an insightful discussion about the house they built and their contrasting work habits: "Bruno works with the objective concentration of a scientist... producing ten or twelve studies of his theme," while Molly finds herself "thinking in terms of paint and colour." Jack Lindsay, the photographer who took the picture of the two of them, had either not read or dismissed Simone de Beauvoir's *The Second Sex*, which appeared in English a few months earlier and ignited second-wave feminism: his picture shows Bruno working at his drafting table with Molly dutifully looking over his shoulder bringing him his coffee! Bruce was more

perceptive. The paragraph that quotes Molly about colour (above) ends with her alluding to the problem of balancing being an artist, a part-time teacher at the Vancouver School of Art and on television, a mother, and a wife: "'A woman has to scatter her attention' says the wife-and-mother somewhat ruefully."[31]

In mid-April 1956, Bruno received a telegram saying that he had been awarded a $4,000 ($36,000) Royal Society Overseas Fellowship. Funded by Bruno's fellowship, the Bobaks spent the latter part of 1957 and early 1958 in St. Ives, England. From this Cornish seaside town, Molly and Bruno kept a wary eye on the dominant artistic movement in Britain and North America: Abstract Expressionism. Abstract artists, including Peter Lanyon, Ben Nicholson, and sculptor Barbara Hepworth, walked the cobblestoned streets that had been popular with painters since the middle of the previous century.

For more than a decade, in letters to and from her artist friends, Molly had agreed with their views and expressed her concerns about "modern art." Not long before leaving for St. Ives, she recommended Wyndham Lewis's *The Demon of Progress in the Arts* to Shadbolt. While she found part of what Lewis had to say "bigoted and even crotchety," she agreed with much of his criticism of modern art.[32] The Nova Scotia–born First World War British war artist and one-time *avant-garde* painter himself critiqued his generation for having "gone to school with abstraction [and having] acquired a peculiarly barren technique, in which there are none of the natural delights of interpretation of nature which have always made painting and drawing and sculpture so delightful a discipline." Warming to his theme, he wrote, "A very great part is played in the conversion to extremism by naivety and *snobisme*," a characterization that Molly could easily have written.[33] Both Bobaks deplored the "barren-technique" *avant-garde* artists whom Lewis now decried as producing "none of the natural delights of interpretation of nature."[34] However much Molly might have smiled at Lewis's bon mot, at this point in her career she would not

have had the temerity to coin the word "aheadofness," which was the essence of the pitch made by promoters of *avant-garde*.[35] Art critic Herbert Read's critical review of Lewis's book, which attempted to link modern *avant-garde* artists to Romantic poets like Wordsworth, fell flat with the well-read Molly.

Perhaps impressed by the progress Britain had made in rebuilding itself since the war, by the balm of living in picturesque Cornwall, and especially, by his encounter with the landscapes of J.M.W. Turner, Claude Monet, and Oskar Kokoschka, the sketches and paintings Bruno produced while in Britain and immediately after have none of the apocalyptic quality of *Raven*. In works like the conté *Winter Trees*, haunting images of destruction behind him, Bruno follows Turner and Monet in eschewing fine detail—indeed, almost all detail—in favour of loose, swirling lines. At the last moment, so to speak, the ones that rise toward the top of the left side of the page descend and form trees. In contrast to the effort lavished on the grasses in such works as *Dry Cornstalks*, in *Winter Trees* only a few thin lines of these trunks touch the ground at the bottom of the picture plane.

And yet, the trees feel alive and are firmly held in place by two different compositional elements. The first is the horizon line formed by repeated passes of the conté, its heaviness emphasized skilfully in a few places where Bruno smudged the wax grey and thus gives the illusion of light showing through. The second is an effect caused by the light spot in the centre of the sketch. Its lightness does more than simply highlight the black lines meant to seem closer to the viewer. It provides the contrast necessary for the perspective to be registered—and it is this perspective that helps hold the trees in place.

Bruno's and Molly's refusal to travel to the end of the road cleared, by, among others, Bruno's former employer, Jack Bush of Painters Eleven, did not mean they were untouched by, to borrow the title of its history, *The Crisis of Abstraction in Canada*. Molly's 1959 black chalk sketch *St. Ives, Cornwall* differs substantially from the painting *The Saint Ives Train*, an oil executed a year earlier, and shows her grappling with aspects of

abstraction. In the painting, interwoven leafless branches, rendered in greys broken up by streaks of orange and a sliver of red, act as a scrim beyond which a passenger train chugs just above the bottom of the wooded scene. The echoes of the Group of Seven are so strong that when Jackson congratulated Molly on its purchase by the National Gallery, Uncle Alex probably made her laugh by saying she should have named it *The CNR*.

The sketch, also purchased by the National Gallery, views St. Ives from a position above the water and starts not at the shore but at the side of a building before which a truck and some cars are parked. The precise, spare, lines — some are the angles of roofs that seem almost like perspective lines — lead toward a group of townhouses in the upper right. It takes an act of will to break this transit long enough to count the houses' three storeys and realize that unlike almost everything else in the sketch, Molly has smudged the charcoal just enough to give the front of these houses the solidity to hold the windows in place. As Robert Fulford wrote about another of Molly's paintings of the period, while "formal, abstract values" concern her, she remains wedded to "the works of man."[36]

Bruno's oil, *St. Ives, Cornwall*, is about twice the size of Molly's sketch and, thus, could contain significantly more information. In fact, it contains significantly less. He positions us above what feels like a headland, allowing us to see the sweep of the bay and into the town. In Molly's sketch, we could have counted the number of houses; in Bruno's we cannot. Save for one small building in the upper centre right, in which two daubs of black paint mark the windows, and which serves as the centre of the landward scene, Bruno's quick brush strokes produce more of an impression than a rendering of a townscape.

The precedents of Turner and Monet gave Bruno the warrant to mottle his work, though not quite with a London fog — that would come later. Following these painters that he and Molly had gone "mad for" when they saw them at the Tate in London, Bruno created a haze using the same colours that dominate each part of the built-up scene: blacks and ochre on the left, a small penumbra of red (which delineates the townscape's highest point) and cadmium orange on the far right. Bruno used the impossible

reflection of this yellow into the greyish bay to suggest a glowing sunset. If, as Plaskett wrote a decade after Mark Rothko's death in 1970, the *sine qua non* of abstract art was the absence of a horizon line, then its presence in *St. Ives* shows Bruno's commitment to the observable world and the traditions of Western art, which at that very moment Clement Greenberg, the period's dominant art critic, sought to consign to the dustbin of history.[37] Neither Bruno nor Molly could agree with Greenberg that it "is a fact that representational paintings are essentially and most fully appreciated when the identifications of what they represent are only secondarily present to our consciousness."[38]

The pastel *Wet Morning* dates to 1959, when the Bobaks were back in Vancouver and, thus, was a work of memory or now-lost studies. It shows Bruno's growing interest in buildings, bridges, and boats, as well as his debt to Turner's 1835 masterpiece, *The Burning of the Houses of Lords and Commons*. Bruno has shifted the angle: instead of viewing the British Parliament from where the Westminster Bridge lands at Lambeth, we are positioned in the middle of the Thames looking at the bridge which crosses the picture plane just above its midpoint. In Turner's work, the Palace of Westminster, to use the building's formal name, is all but obscured by the smoke and bright cadmium yellow flames that fix the eye and that Turner allowed to break the laws of optics by reflecting yellow off the Westminster Bridge on the London side. Turner was on safer ground having the flames reflect off the Thames as it runs past Parliament, the light serving also to highlight in the more darkened part of the scene a number of punts rushing upriver. In Bruno's *Wet Morning*, just enough light comes through the heavily overcast sky to illuminate the centre of the river; through the foggy haze, we see a punt and what looks like a tugboat.

Turner uses billowing smoke, tendrils of fire, and a stiffened Union Jack to indicate the wind's direction. Bruno retains the Union Jack and uses scuttling clouds as well as black marks, some outlined by a thin mauve line, forming whitecaps to indicate the direction of the wind.

The famous building of Parliament is indistinct not solely because of the London fog. Instead, following Monet's *Rouen* series, *Waterloo Bridge in Fog* and *The Houses of Parliament, London, with the Sun Breaking through the Fog*, like a replica made of sugar and subjected to the spray of the storm, Bruno's Parliament seems to melt, to shade and fade into the dark lines and smudged charcoal that are the marks of an artist's hand and not nature's.

Completed the same year as *Wet Morning, The Bridges* takes what could have been a banal urban scene, the approach to Vancouver's Burrard Street Bridge and the city to the south, and turns it into a dramatic expanse. Bruno does this by adopting an imagined southward perspective from the city's downtown that would more or less coincide with the twenty-two-storey BC Electric Building completed two years earlier. This sleight of hand roughly follows Kokoschka's *View of Jerusalem* (1929) and, it should be noted, a number of works by war artists of the First World War, including Wyndham Lewis. Bruno pushes the horizon line almost to the top of the page, which tilts the surface downward to the black-and-grey cityscape. Thus, he provides himself with a vast tableau, a theatre, if you will, that links the two parts of the city.

The drama, however, is not found in the only "moving" things, the squares representing cars on the bridge. Under a Turneresque sky filled with sharp streaks of a thin conté crayon making comma-like exclamations in the cloud, the city that unfolds harks back to Bruno's topographical training. Though the lower floors of the buildings at the bottom of the page are cut off, Bruno outlined the buildings' windows and other features in black ink. The way he positioned the work meant that he could not depict the famed Art Deco towers or steel trusses of the Burrard Street Bridge. By contrast, the trusses that support the railroad bridge to the west are visible because the bridge runs diagonally to the angle of view, and, accordingly, a decade and a half after depicting them in his painting of a Bailey bridge, Bruno depicts them again. The buildings beyond False Creek are less distinct because they are farther away. Yet, for a number of buildings on the lower right, closest to the ramp leading onto the Burrard

Street Bridge, itself a straight smudge of very light grey, Bruno again wielded his pen to show windows, angles of roofs, and corners.

The Burrard Street Bridge and the railroad bridge do more than draw our eyes toward the city. Each fractures the picture plane, though the effect differs from the wrenching effect generated by many Cubist paintings. The effect Bruno achieves is similar to what Cézanne did in *Mont Sainte-Victoire*, with its numerous perspectives of the mountain that result from minute changes in the viewer's position. The angles of the bridge lead the viewer to readjust their sense of perspective as the eye moves from left to right and back again. Far from being "modernism lite," this dialectical relationship underscores the viewer's role in creating the very scene they perceive.

Though executed only a year (1959) after *Rain in Venice, Vancouver Harbour* marks an interesting shift in Bruno's handling of water. The lagoon before St. Mark's Cathedral is a mass of swirls, heavy black crayon lines forming *V*'s and right angles pointing upward, and zigzags, as well as the odd almost star shape and, in addition, a few plus signs — balanced by thin waves of clouds that if only glanced at could be mistaken for seagulls in flight. Though the harbour in *Vancouver Harbour* is busier, with at least three oceangoing ships and another twelve boats in it, Bruno depicts it sparingly. The single largest element is the negative expanse of the white paper. Smudges of black, most of which end with tendrils sliding downward, describe the movement of the water, while the steamers are signalled by darker and lighter lines. More than a few critics have noted Bruno's creation of an "abstract visual language of dots, hyphens and exclamation marks to interpret his subject."[39] Dashes form wakes; the surprising long-lasting wakes of several boats in the centre show where the boats' courses crossed. As innovative as these marks may be, they should not surprise. Both they and the flat projection in these works, which allows him to include a tremendous amount of information, can be traced back to the topographical training Sapper Bruno Bobak underwent.

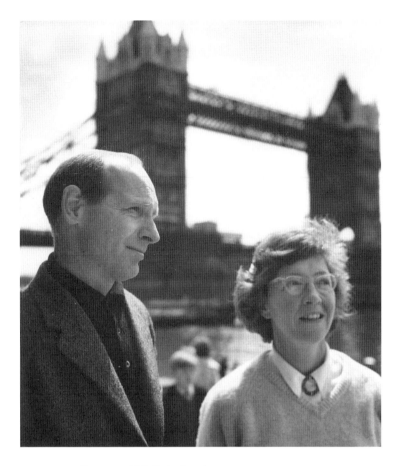

Bruno and Molly in London, 1959. (Joseph McKeown)

In the middle of her 1959 *Canadian Art* article "Leisure to Paint," Molly casts Bruno as something of a Polish Heathcliff, walking the "moors and along the cliffs" while she "stayed nearer home with the baby" (Anny, who was born in 1957), drawing detailed pictures when she could find the time.[40] As the accompanying pictures show, however, in 1957 drawing "precisely" did not — as it would have a decade earlier — shade off into being "too subjecty." She had over the years developed a freedom of style such that even as she chronicled Bruno's assimilation of Turner, Monet, and Kokoschka, she was comfortable writing, "I didn't feel the need to

experiment or to find a direction at the time, as I had been in the middle of a good working period when I left Vancouver — using new sub-divisions as a theme." In her understated coda, Molly was perhaps more sanguine than most parents of a twelve-year-old and a newborn would have been: "It remained only for me to arrange my time so that I could work part of the day."[41]

The houses she depicts in *New Housing Project* hardly had the cachet of *Little Moreton Hall, Cheshire*, painted five years earlier. In that work, she reconfigured the half-timbered walls of the Tudor mansion so that they jut out in architecturally impossible ways, thereby both deconstructing it and emphasizing how the mansion had been added to over a number of generations. The houses in *New Housing Project* cover the entire canvas; indeed, the houses at the bottom of the page are cut off, which makes it seem as if we are standing at the edge of the housing development. As artist Nathalie Mantha points out, "Molly has reversed the usual practice followed in oil paints, where the darker colours are normally in the background, against which the lighter colours in the middle and foreground stand out; this is one of the ways of creating the feeling of depth."[42] In *New Housing Project* the foreground houses are the darkest; those on the left are greys and middle blues, with the black lines used to highlight windows; those on the lower right have dark roofs. The further up the page — which means the further back — the picture goes, the lighter the houses become: yellows, light ochre, and pale blues dominate the angular roofs and walls that seem to touch in an increasingly jumbled geometric, though not entirely, abstract way. Here and there are telephone and electric line poles. The yellow swath division that runs from the bottom centre toward the upper left hints at a street, but there is no street, sidewalk, or, if we can judge from the houses that abut this opening, doors opening onto it. On the other side of the tree that rises about a third of the way from the bottom left, the yellow swath gives way to patches of light-blue, white, and grey, and the houses change too. There are at least two with front doors opening onto what at that point is clearly a road, albeit an empty one.

Cornish Town #2 sandwiches an unnamed town beneath an impressionist grey sky and a green landscape criss-crossed with heavy grey lines. The green is so featureless that at first it appears as if it could be an imagined cliff, and the grey lines intimate rocky outcroppings. The sky is streaked with greens and browns through which, in the upper middle, a wide paintbrush has left stabs of white, relieving the dreary loom that covers more than half the canvas. The town itself is devoid of people, and while there is no reason to doubt that the town is home to interesting heritage buildings, as we would call them today, they obviously do not interest Molly. What interests her is the challenge of depicting in detail the geometrical regularity of the houses: squares, angles, rectangles, triangles, some outlined in black, some set off by the white of a wall, others placed in echelon moving back toward the horizon.

While one can admire her triumph over the technical challenge she had set herself, these two townscapes are, especially in the context of her later work, curiously sterile. It is a great relief, therefore, to enter into the Lelant Pub in St. Ives, in any of its versions. *Lelant Pub No. 1*, for example, pictures the scene looking down the alley formed by the bar on the left and the wall on the right filled with liquor bottles and the taps of beer in front of and reflecting in the mirror on it. The picture is as busy as *New Housing Project*; steins of beer abound on the lower left, while glasses and bottles of wine crowd the middle of the bar, which runs down the left side of the pub. What gives this work the sense of humour Robert Fulford recognized is not Molly's bravura handling of the various surfaces; while the glasses, bottles, and steins are far from crashing to the floor, the tilt of the bar top is just enough so that it feels like a pictorial record of what someone who has drunk a "wee dram" too much sees as they look down the bar. Rather, it is the bespectacled barkeep, who, because of his jacket and slacks, looks ever as if he's wandered into the bar from a drawing room comedy and found himself assigned a role he's quite surprised to find he is both good at and rather enjoys.

Bruno and Molly at the University of New Brunswick, 1961.
(UNB Archives & Special Collections, UA PC 15 no. 26(25), Courtesy Harvey Studios)

Chapter 5
Putting Down Roots

Painting is just another way of keeping a diary. — Pablo Picasso

In late May 1960, Bruno received a telegram from Colin B. Mackay, the president of the University of New Brunswick, offering him the position of artist in residence for the 1960/61 academic year to replace the painter Goodridge Roberts, whose term was expiring. A few days later, Molly and thirteen-year-old Alexander boarded a jet plane bound for Paris. Perhaps with a nudge from Jacques Maritain, Air France had arranged for Molly to organize a two-week-long artists' tour of France for the "society ladies" she taught at the Vancouver School of Art. Though Molly enjoyed meeting Raymond Duncan, Isadora's brother, buying three of Joe Plaskett's works, and seeing *Cavalleria Rusticana* and *Pagliacci* at the Paris Opera House, the tour was not easy. She found Paris expensive and, of course, the waiters rude. Despite what she wrote eighteen years later in her memoir, she was not sorry to see her students fly home.

Instead of Molly and Alexander flying back to Canada, Bruno and three-year-old Anny flew to Paris, and the first part of Molly's Canada Council study fellowship for 1960 began. Convincing the Canada Council to allow her to divide the fellowship over two years so that Bruno could take up Mackay's offer was much easier than it had been to convince the council that in order for her family to stay together, she deserved the same funding as a married male artist—although convince them she did.

After spending several weeks in Paris, where, Molly felt, the nights still belonged to Monet and Degas, the family moved to Oslo, Norway, where they stayed for two months. After an indifferent Canadian consular official failed to help them find a furnished house, they went to the Norwegian minister of culture. There they found a cultural affairs officer who rented them a house he owned, which was filled with original prints and, happily, for Anny, toys. This same official arranged for a studio and, the following year, for the Bobaks to use Edvard Munch's studio. Molly was impressed by Norway's socialist society, partially supported by the country's heavy taxes on alcohol that did little to cut down on drunkenness.

The Bobaks absented themselves from Canada at a propitious time. Though Painters Eleven had broken up in 1960, Abstract Expressionism still dominated the pages of *Canadian Art* and the American arts journals. A.Y. Jackson wrote that even in Toronto, the "market for Made in Canada" was anything but encouraging and that a number of figurative painters were "silently going abstract."[1] Some months later, he harrumphed that immigration of Italians, Poles, and Germans—all of whom had different artistic traditions—to English Canada was "not good for painting."[2]

The Bobaks' arrival in Fredericton in the early fall of 1960 became the stuff of campus lore. Having driven for hours and feeling disoriented, they stopped at the first telephone booth they saw in a built-up area and called Professor Murray Kinloch, their University of New Brunswick (UNB) contact. "Imagine our surprise," Bruno recalled almost four decades later, "when he told us that not only had we already driven past the university but that we were actually in the centre of the downtown," something the recent denizens of London and Oslo certainly hadn't expected when they stopped across the street from Neill's Sporting Goods, a store still basking in the glow of Babe Ruth's visit to buy fishing gear twenty years earlier.[3]

At all events, the Bobaks quickly settled into a house near the university. Within days, they had met both Marjory Donaldson, assistant

director of the art centre Bruno would direct, and her husband, Allan, a professor in the English Department. Soon they also met Inge and James (Jimmy) Pataki. He was a Hungarian immigrant who had grown up in Toronto and was now a music professor and violist in UNB's string quartet; she was a German émigré whose family had sheltered Jews in Nazi Germany.[4] Both couples would be life-long friends of the Bobaks. In 1978, after Inge opened Gallery 78 (largely at Bruno's urging), she became one of the Bobaks' main dealers, as the gallery remains to this day. A few years later, Molly would tell Shadbolt that while she had been "cheerful and rather successful" in Vancouver, "it was Bruno who needed to free himself" from that city's art scene.[5]

Mackay had assured Bruno that, as *primus inter pares* of the art centre, his duties would be light enough for him to continue to be productive: consulting with students studying painting, giving three lectures and exhibiting his new work at the end of his term. While it was not officially a two-for-one deal, Mackay was pleased that Molly was anxious to teach and exhibit her works.

In February 1961, Lawren P. Harris Jr. was the director of the School of Fine and Applied Arts at Mount Allison University in Sackville, several hours' drive away. After attending the opening of the upcoming exhibition at the Beaverbrook Art Gallery, Harris planned on staying overnight so that the three former war artists "might renew their wartime acquaintance."[6] Once alone with Bruno and Molly, touching on what he knew must have been a sore point, he explained to Bruno that had he possessed the authority, he would have bought his small oil *Desert*; on this visit, by contrast, he was authorized to select several graphic works and/or watercolours to bring back to Mount Allison for the Acquisition Committee to consider. The next month brought more good news. With funds provided by the Canada Council, the Vancouver Art Gallery purchased Bruno's etching *Oslo*, and *Canadian Art* published a sensitive article about Bruno written by his colleague from the English Department, poet Desmond Pacey.

Pacey places Bruno's work in an avowed political context, albeit via

the surprising route of Edvard Munch's influence. While Munch's *The Storm* (1893), for example—which depicts women outside during a storm with a house representing shelter behind them—can be seen as a visual cognate to Henrik Ibsen's plays that anatomize the gulf between men and women, Munch's concerns are usually not characterized as "political."* Pacey's point, made unfortunately without reference to a particular work (*Corn* would have fit), is that Bruno was "obsessed at the moment with the violence of the world situation, and with the mixed emotions of attraction, repulsion, fascination that this arouses in him."[7] The Bay of Pigs fiasco occurred while the March-April issue of *Canadian Art* was already on the stands, so this American misadventure in Cuba could not have been weighing on Bruno's mind as Pacey was writing. Whether Bruno was concerned about mounting tensions between the United States and the Soviet Union over Berlin or the debate about the nuclear-tipped Bomarc missiles then roiling Prime Minister John Diefenbaker's Progressive Conservative Government hardly matters. Pacey's point is that Bruno "wants to put forward a pacifist attitude"—though, curiously, he neglects to point to the woodcut *The Pacifist* (c. 1960), which features a three-quarter self-portrait of Bruno** looking uneasily over his left shoulder to where a man is beating another man, already on the ground, in the head with a stone. The article also makes no mention of Bruno's revulsion over what he had seen on the battlefield.

In the autumn of 1961, the Bobaks returned to Europe, staying first in England. While there, Bruno tried to get at least nine London galleries interested in carrying his work. Several of the refusals have the air of polite British form letters: "I'm sorry to have to write and tell you that,

* While Munch's most famous work, *The Scream*, can be linked to *fin de siècle* politics, it
 is usually seen as a document in existentialism.
** Many of Bruno's works discussed below contain Molly, Anny, and Alexander as well
 as self-portraits of Bruno. Rather than litter the text with scare quotes—"Molly" and
 "Bruno"—I trust the context will make clear when I am referring to the individuals
 and when I am referring to their painted images.

as a Gallery, we have a full complement of painters and sculptors."[8] Waddington Galleries' refusal was especially helpful, suggesting five other galleries that might be interested in Bruno's work. In October 1961, Helen Lessore, OBE, refused him a show but suggested four other galleries he should contact. Eight months later, Bruno tried Lessore again and received a very British brush-off: "Nothing will persuade me to take on any more [artists] unless I am quite bowled over by the work, which . . . I am not, in this case."[9]

While waiting to hear from these galleries, Bruno picked up his pen to write his only published article, "The Artist in Canada," which appeared in the 1962 issue of the *Leeds Arts Calendar*. He begins by explaining to readers who live in a country about a third of the size of Manitoba that the tyranny of distance explains why there is no national Canadian art. Because "geographic barriers have forced [economic] influences north and south," each regional art is, he explains, heavily influenced by the closest part of the United States; hence West Coast painters are "closely related to the Northwest painters of the States."[10] Filling the empty walls produced by the postwar building boom created a market that, for the first time in the country's history, could support artists. Financial success has its costs, he avers. For fear of offending the taste of middle-class (and by implication, middlebrow) purchasers, galleries had become less adventurous. It is difficult not to see this last point as something of a dig against the London galleries then giving Bruno the cold shoulder.

While not incorrect, Bruno's explanation of the fledgling Canada Council's role in the funding of Canadian artists is incomplete. For example, the Canada Council was funding the Bobaks' sojourn in Europe, it funded resident artists programs like the one Bruno had just filled and would return to on a permanent basis in the fall of 1962, and it provided funds for the purchase of works of art. As is well known, the Massey Commission argued that in the face of what many saw as an "American [cultural] invasion" arts funding was vital to preserve Canada's (especially English Canada's) national identity, upon which the country's political autonomy rested.[11] What is much less well remembered is that at the

beginning of the Cold War, while trying to define the true "Canadian type," Massey was equally concerned about the "Communist menace."[12] Hence, as historian Richard Cavell notes, Massey "recommended that culture in Canada should be a bulwark of national security."[13] It should come as no surprise, therefore, that the Honourable Brooke Claxton, who had been minister of defence for a dozen years after the war, become the Canada Council's first chair. As leader of the Opposition, Diefenbaker had declared the Council to be Soviet-like, yet as prime minister after June 1957 he did not kill it. For, Claxton noted in a speech decades later, the country had been "Sputnicked out of complacency," meaning that the Russian success with Sputnik in October 1957 convinced Diefenbaker that the Canada Council—the lion's share of its funding going to university libraries and math and science professors—was, indeed, in the national interest.[14]

Exactly how the cultural mandarins who judged artists' applications were part of the battle against Communism is, perhaps, less clear than was the training of scientists. Broadly speaking, the issue comes down to the artists' individual styles, even those that rubbed cultural conservatives the wrong way. In 1946, the US State Department's plan to "celebrate the expression of democratic freedom" by sending an exhibit of seventy-nine works of modern art, including works by Edward Hopper and Georgia O'Keeffe, to Latin America and Eastern Europe ran aground on the shoals of objections by, among other well-trained art critics, President Harry Truman.[15] Three years later, speaking on the floor of the US Senate, Michigan's (McCarthyite) George A. Dondero, likely without knowing it, all but quoted Leon Trotsky's views on the link between the revolution and art: "Art is considered a weapon of Communism, and the Communist doctrinaire names the artist as a soldier of the revolution." On 16 August 1949, Dondero thundered, "So-called modern or contemporary art in our own beloved country contains all the isms of depravity, decadence and destruction. . . . Cubism, Expressionism, Surrealism, Abstractionism . . . are all instruments and weapons of destruction. . . . Abstractionism aims to

destroy by the creation of brainstorms."[16] The senator's, no doubt, careful study of these works yielded unexpected information: "Weak spots in US fortifications, and such crucial construction as [the] Boulder Dam."[17]

Starting in the early 1950s, through front organizations such as the Congress for Cultural Freedom, the Central Intelligence Agency funnelled money to the Abstract Expressionists, though there is no evidence that Jackson Pollock, Mark Rothko, et al. were aware that the CIA was cutting them cheques at one remove. The CIA's interest in the Abstract Expressionists had nothing to do with aesthetics and everything to do with the cold warriors in Washington wanting to use these artists' biographies and, importantly, non-figurative art as a counterweight to Soviet Socialist Realism. The CIA wanted abstract artists to be seen as examples of rugged (capitalist) American individualists blazing new trails (all the while hiding from public view the source of their funding).

The links between the Canada Council's jurors who would judge artists' applications and the CIA were not, of course, visible. Yet, by relying heavily on the advice of the Carnegie, Ford, and Rockefeller Foundations in setting up the council, Claxton had to have known he was coming under some CIA influence, for all three foundations had ties to the CIA. Massey, an art collector and one of Canada's wealthiest men, knew billionaire art connoisseur Nelson Rockefeller (who owned more than 2,000 Abstract Expressionist works), and who during the Second World War worked for William Donovan's Office of Strategic Services, the CIA's predecessor institution; as High Commission to Britain during the Second World War, Massey would have been privy to some of Rockefeller's activities in Latin and South America. The Canada Council's juries operated in the North American art ecosystem influenced by connoisseurs such as Rockefeller and conscious of the growing financial success (with CIA money) of artists like Pollock and Rothko. A further indication of the rather tight links between the art world and the CIA's chequebook is the fact that in the early 1960s, Jacques Maritain was the honorary chairman of the Congress for Cultural Freedom.

Neither Bruno's nor Molly's styles could be considered *avant-garde*. They were, however, painters with unique styles that differed greatly from Soviet Realism. Bruno's Polish émigré background was an added plus.

While waiting for "The Artist in Canada" to appear, Bruno completed *Happy Reunion (London)*, which can be considered with *Father and Son in Oslo* (possibly completed after the Bobaks returned to Fredericton in the fall of 1962, when Bruno took up the permanent position of artist in residence and director of the UNB Art Centre). For a painter who had boldly used the white of the canvas and of paper, these two paintings are notable for the fact that every square inch is covered in thick paint, in places applied with the edge of a piece of cardboard. The aesthetic underlying the profusion of colours that, according to the Manchester *Guardian*'s arts critic, "sing" is diametrically opposed to the doctrine preached by Clement Greenberg.[18]

As art historian Arthur Danto pithily puts it, for the high priest of Abstract Expressionism, "the subject of painting was paint."[19] Art, Greenberg argued, must not pretend to "mean" but rather must revel in being the experience of pure colour and form itself. By contrast, Bruno's and Molly's work kept a grip on the parenthetic part of Maurice Denis's nineteenth-century battle cry (adopted by twentieth-century *avant-garde* artists): "Remember, that a picture—before being a war horse, a nude woman or some anecdote—is essentially a plane surface covered with colours assembled in a certain order."[20] For figurative painters like Molly, Bruno, Colville, and Plaskett, the purpose of paint had less to do with its innate properties to flow or, on the optical level, to reflect certain wavelengths of light and everything to do with using the visual traces paint creates to form recognizable images, albeit ones distilled through the artist's imagination. What was true for Bruno's landscapes was even more true for the remarkable series of paintings, one that, because of its focus on Bruno's image and what he reveals about his emotional life, is without peer in Canadian art.

Critics quickly picked up on Bruno's new focus, with Pacey, likely
with *Happy Reunion* in mind, saying that the artist "has set himself to
explore the depths of his own being and to face the terrifying realities of
the world where wistfulness is no armour and simple beauty no defence."[21]
Referring to Bruno's 1962 show in Britain (incidentally, the first-ever one-
man show by a Canadian artist in Britain), W.T. Oliver, the arts writer
for the *Yorkshire Post*, noted that "these paintings offer more than pleasure
of the eye. Many of them speak freely of the artist's personal emotions—of
the poignancy of parting, the gladness of reunion and of family affec-
tion."[22] Bruno confirmed this in a letter written shortly after returning
to Canada in 1962. After thanking the Norwegian Ministry of Foreign
Affairs for allowing him and Molly the use of Munch's studio, he wrote,
"I think my work...became more personal and concentrated during my
stay in Norway."[23] But in the absence of a diary or a series of letters like
those Molly wrote, we cannot chart the steps from, say, *Wet Morning* to
Happy Reunion or *Father and Son*, and onward. We have only his paint and
canvas, plus what we know of his life—mostly said by Molly and others.

The happy moment that unfolds beside the Thames in *Happy Reunion*
occurs under a Munch-inspired blue sky with stabs of thick green that
would have overpowered the spare paintings of Vancouver Harbour. The
pink swath in the sky on the right, beyond Parliament, which itself is
behind the blue, grey, and black London Bridge, tells us we are looking
to the west, but it does more than just allow us to orient the image; it
functions almost like a spotlight that pulls our eyes toward the right and
thereby directs them toward the embracing couple on the lower right. As
the reviewer for the *Listener* (Leeds, UK) noted, Bruno's paintings do "not
make the work of the viewer at all easy."[24] Viewers had to resist looking
at Parliament and Big Ben, which, in addition to exerting their magnetic
force, are close enough to "stage centre" that tearing our eyes away from
them and toward the couple is disorienting. The feeling is heightened by
a fog just thick enough to smudge the details of Parliament, Big Ben, and
indeed, every other object. We may feel slightly disoriented; yet, we know
that the real drama is the lovers, and we want to know more about them.

So focusing on them—forcing ourselves to resist the magnetic pull of the iconic building and clock—is worth it.

As the *Listener's* art critic noted, "It is not always easy to discover the mood by a casual glance."[25] As her arms hug him and pull him close, and because their faces have the same greyish hue, as they kiss, they seem to merge into each other.[26] The swipes of purple that make up her dress do little to describe her body, yet the striations Bruno left give us the feeling of a body tensing with desire. The small swipe of reddish-brown that stands for her closed left eye takes us far beyond the emotion of a lover and to the edge of a feeling that she is more knowing than his body language indicates. We need not read backward from his later works to see Bruno making a well-known religious motif through the figures' differing body language, which leaves more than an impression that this woman is one of Eve's great-great-granddaughters.

Father and Son tells at once a personal and universal story, set beneath a dark-blue sky and even darker blues that stand for the headlands beyond Oslo. Bruno casts a wary backward glance at his son, the distance between them is measured by blue and ochre striations. But by setting this moment against the city, formed from a welter of greens, reds, yellows, and greys—some in shapes approaching buildings, while others suggest towers, domes, or ships—Bruno expands the narrative to the denizens below; to ensure this link, some of the yellows and greys that make up the city are present among the colours in his and Alexander's faces.

The painting's title echoes Ivan Turgenev's 1862 novel, *Fathers and Sons*, which tells of the disastrous clash of generations in mid-nineteenth-century Russia, and so historicizes the story. But it is the extreme foreshortening of Bruno and Alexander that universalizes the drama. By setting these portraits, essentially a bust of himself and a headshot with a bit of neck of his son, against the city, Bruno makes it appear as though they have climbed a mountain east of Oslo, when in reality there are only gentle hills. Bruno's narrative is more redolent of the Ur-story of the division between fathers and sons—the Binding of Isaac (Genesis:22 2–8)—than he might want have wanted to admit, given his irreligion. Bruno's face

is less wary than guarded; his eyes, like Abraham's as he ascended the mountain in the land of Moriah, slide toward the conspiratorial.

He has caught his son at the moment of supreme dramatic irony that Bruno's wartime Shakespeare professor at Oxford would have recognized. Because we know what is about to happen, we can see more than what Alexander's face registers. He does not yet know that guilelessness is being replaced by recognition of the horror, the realization nothing can bridge the distance between himself and his father. His father's face is burned by the tragedy that he does not yet know will be avoided.

No doubt Bruno was even more heartened by a letter from the director of the Kaplan Gallery in St. James's London, where the show was. While the press coverage was disappointing, Edward Kaplan reported that four works had been sold. Knowing that Bruno lived a scant few streets from the Beaverbrook Art Gallery and that he had had a show there, with understated English tact, Kaplan asked Bruno to pull what strings he could: "Should Lord Beaverbrook call to see us, we shall most certainly make further endeavors to interest him in the idea of presenting a painting to the Tate Gallery."[27]

In late April 1962, the Bobaks travelled to Venice. Perhaps because Bruno had already depicted St. Mark's Cathedral and the Venetian lagoon, Molly's black-on-beige lithograph is of another church, Santa Maria della Salute, which resembles Paris's Sacré-Coeur.[28] Though the church is on the Grand Canal, a fact Molly insists upon by calling the work *Venice* (p. 132), we see only a few squiggles delineating water in the foreground. On the left middle ground, several strong horizontal lines and a few vertical scrawls are enough to evoke the shimmering reflection of the boardwalk—itself formed by only a few vertical lines suggesting wooden planks.

These heavy lines, which are most unusual in Molly's work, link it to one set of works she saw in London and distinguish it from another. Among the Turners that Molly saw at the Tate was *Venice—Maria della Salute*, painted a century before she became an official war artist. In

Molly Lamb Bobak, *Venice* c. 1962
lithograph on paper, 4/10, 35 x 45 cm
(Collection of Alan and Elizabeth Bell. Photographer, Alan Bell)

Turner's rendering, the church is painted so loosely and in the same tans and browns that he uses to indicate the ripples on the lagoon that Santa Maria della Salute takes on a ghostly air or, to keep closer to Turner's interest in optics, is refracted almost out of existence by the mist.[29] Molly's lines were likely influenced by Alistair Bell's Expressionist prints of fishing boats, in which the boats are outlined in heavy black lines. He surely would have noticed his influence on the work when Molly gave him the original of the drawing before the Bobaks returned to Canada.

The work is animated, though not by the wind or sea. Rather, the movement comes from the two groups of figures who slowly emerge from the black background, most likely tourists. One more or less in the centre of the scene bends slightly over the railing, looking, it seems, at the other two figures. The one on the far right of this group leans toward the other

as she points toward their right, her gender indicated by the shape of her hatted head.

Painted in this same period, the oil *London Pub* (pp. 204–5), which at first seems to be an homage to Édouard Manet's *Un bar aux Folies Bergère*, is, in fact, a declaration of independence. Manet positions the viewer in front of the bar and thus in front of the bar's mirror in which, famously, we see both the barmaid's back and the man in the top hat, both curiously displaced to our right. (Technically, it should be noted, since the man stands in front of the bar, we should not see much of him at all.) Molly, by contrast, positions us behind the bar, so we see neither the mirror, which from the Lelant series we know was common in English bars too, nor the bottles of whisky, gin, rum, and other spirits. Glasses, some upturned so we can see their stems, glass beer steins, and two glass cake bells, one of which has a cherry-red pastry in it, are outlined in white—and thus stand out from the dark-brown bar, which, again referencing Cézanne, seems to fall away from them as it runs off the bottom of the page.

The top of the cake bell points toward the front right corner of the room; a black line signals a right angle, on either side of which are windows: one to the left and four to the right. In Manet's work, notes the philosopher Maurice Merleau-Ponty, the mirror, in which we see the revellers, is an "instrument of a universal magic that changes things into spectacles, spectacles into things, me into others, and others into me."[30] In Molly's work, the five windows serve this function, though not as one might expect. While more than large enough for her to have depicted a fractured street scene, Molly fills the windows with a profusion of shapes and lines (recalling Art Nouveau and even Art Deco) that have no reference to either the bar or the street just outside. And yet, white, against brown, blue, beige, and in a few cases, black areas—background is too strong a term—are like runes, records etched into the glass, of the hubbub of crowds that have come and gone, and the hustle and bustle of the world outside a London pub.

Manet gives Suzon, the barmaid, rosy cheeks and downcast, telling eyes. We see nothing of Molly's barmaid's eyes and only the smallest part

of the left cheek, rendered in beige trailing to grey; she is facing away, like the army performer Molly painted in a dressing room nearly twenty years earlier. Suzon's hands lean upon the marble bar top, seemingly grasping it, needing its solidity — perhaps, more than one critic has noted, because of the top-hatted man. Molly's barmaid stands comfortably erect, and though she is off to the right side of the scene, it revolves around her. Indeed, without her height to balance the expanse on the left, the 3-D illusion would collapse. In other words, as was the case with *Private Roy*, the story Molly is telling here rests upon the presence of the barmaid. The blur of white from a cloth she's using to dry a glass is more than an interesting effect; this movement is the very antithesis of Suzon's stiffness.

London Pub can be seen as something of a valedictory statement. As a war artist, Molly depicted hundreds of CWACs' and soldiers' faces. In the Lelant series she painted a number of individuated faces. And in *London Pub* she painted the unnamed barmaid. But just at the point when Bruno sketches the artist Francis Bacon and begins painting his, Molly's, and their children's faces in his work, Molly turns away from faces. Almost all of her art that deals with people from now to when her failing eyes forced her to put down her brush focuses instead on the individuals' bodies, and especially on movement, almost as if her paintings were a choreographer's notes.

Though Molly was generous with her time as a teacher and took note of what other artists were doing, she had no real interest in a sisterhood of artists. If she saw "The Amazing Inventiveness of Women Painters," published in the October 1961 issue of *Cosmopolitan* (in its pre–Helen Gurley Brown period when it was a literary magazine), Molly would have had two reasons to turn down its invitation, as it were, to the party celebrating Lee Krasner, Elaine de Kooning, and the other female abstract artists. First, as evidenced by the Canada Council grant, unlike them, she did not labour under her husband's shadow. In a letter in which he grumpily complains that his "representational stuff is ignored by the critics and reviewers,"

A.Y. Jackson assures Molly that even after her being away from Canada for the better part of two years, she was still "well known and respected in [both the] academic and Avant Guard camps." Since she didn't easily fit into either camp, warriors in each might have begged to disagree.[31]

The second reason Molly would have turned down the invitation was because of her concerns about Abstract Expressionism and where it was taking art. With the exception of Mark Rothko, Molly was extremely critical of the artists who went down the road of Abstract Expressionism opened by Pollock.

In early March 1971, Robert M. Percival, the New Brunswick Museum's art curator, received a letter complaining about the exhibit of Bruno's paintings in the museum's King George VI Hall. From their laughs of "derision or embarrassment," J. Bennett Macaulay of Sussex, New Brunswick, a well-connected businessman known to many in Fredericton, could tell that the adults around him "would not want their children to see" these paintings or "have them in their houses," as indeed he also did not. The prospect of school groups in Saint John seeing these "grotesque, obscene" nudes while on their way to the Moon Rock exhibit dismayed him. To protect the "good public image of the museum," he demanded that the exhibit be closed.[32]

Percival began his response by noting that while Macaulay had every right to his opinions, he, Percival, disagreed with them. The bulk of the two-and-a-half-page letter, however, is a model of pettifogging. The rules of Atlantic Provinces Arts Circuit (APAC), which sponsored the exhibit, forbid removing any work without either its or the artist's permission. Were Macaulay to force the museum to close the exhibit, Percival explains, the matter would wind up in court "on the basis of the defamation of the good name of Bruno Bobak."[33] Given Bobak's national and international reputation, "most representatives of Art Museums, including the National Gallery of Canada...would be brought in on [the] defense."[34] After pointing out that the publicity of losing the case would hurt the museum,

Percival says that he is holding off contacting APAC or Bobak, as he feels sure that Macaulay "may wish to re-consider [his] request."[35] There is no record of Macaulay's response, so we can assume that there the mattered rested.

Macaulay — and, presumably, the vandal who a few days later broke into the museum and slashed one of Bruno's paintings to ribbons[*] — was discomfited by both the style and the subject matter of the works. Macaulay was likely unaware that he was technically correct to consider the portrait of Molly in *The Artist with Molly* (p. 206) "grotesque," a style of art perhaps best exemplified by the Hunchback of Notre Dame. Her left leg is out of proportion and left big toe is not articulated. Her left arm, which hangs over the artist's (Bruno's) shoulder in a semi-embrace, is discoloured and too large for her body while the fingers of her right hand interlaced with the artist's left hand are unnaturally long and thin. Even more strikingly, the dark purple of Molly's face, the colour shift of her right arm — grey to white to grey to flesh tone — and the greyish tone of her legs are not the colours associated with healthy skin. Indeed, the use of grey (*grisaille* is the technical term) can unsettle viewers because it suggests an unfinished work and thereby draws attention to the process of painting, in the same way dramatic irony does in theatre, and thereby breaks the illusion of the proverbial well-wrought urn of art. Molly's white shift displays not even a hint of the swell of her right breast. And yet, perhaps because the paint is applied unevenly and even appears to be melting, she is strangely sensual.

Viewers unfamiliar with Edvard Munch's manipulation of lighting in *The Sick Room* (1885), for example, would have been baffled by the lighting in *The Artist with Molly*. Munch's first critics in the *Norwegian Intelligencer* (25 October 1886) found the daubs of white paint that light the face of the bedridden girl to be "incoherent" because little else is lit by what should have been a cone of light.[36] Here Bruno painted both the artist's face that looks out at us and the right side of Molly's face as if they were in a

[*] No further details are available, alas.

shadow while the rest of their bodies is lit. Both faces are made up of dark browns, ochres, and a few small patches of what approaches purple, with their features outlined in heavy black lines. The placing of the two faces in semi-darkness heightens the sense of intimacy.

For Macaulay, however, it is the artist who is most obscene. From the catalogue or other information, he would have known the artist's face is Bruno's and assumed (correctly) that the body was his. Outlined in black, the body is a kaleidoscope of whites, light blues, and greys, while his legs, again without clear articulation of the knees, are taupe and grey. The artist's left arm is bent so that his hand is in front of his genitals, though a splotch of black paint shows his pubic hair. Between the thumb and forefinger of this hand—which resembles Michelangelo's David's tense left hand in the moment before it is brought into the drama—is a long paintbrush that traces the line the artist's penis would, uniting virility and artistic creation at a stroke.

Presumably, Macaulay would also have been discomforted by the Expressionist aspects of the 1963 oil *Father and Daughter*. The blue background has no cognate in normal space. Anny's semi-articulated legs do not clearly connect to her body, while at the same time they seem oddly realistic in the sense they give of a five-year-old squirming on a trusted adult's shoulders. Even more so than in *Father and Son in Oslo*, Bruno departs from expected facial tones. Bruno's distortion of reality lies at the opposite end of the spectrum of, for example, Colville's hyperrealism.

Though we know who these figures are, by painting them in purples, greens, tans, and blues Bruno achieves two ends. He "pays homage to the materiality of paint," notes William Forrestall.[37] However, unlike the Abstract Expressionists, he bends that materiality toward a clearly defined narrative. Secondly, the unexpected, even shocking, colours distance us from this everyday event taking place on Bruno's shoulders. This distance, however, is not meant to make us care less about Anny and her father. Rather, it is meant to universalize the scene, to move the focus from the instance to a general idea of a happy, playing child. This

painting was among those that Luke Rombout, then the director of the Owens Art Gallery at Mount Allison University, had in mind when he wrote, "Because of the autobiographical content of his paintings...we see mirrored in these canvases a fixed image of the artist himself. His visual vocabulary describes eloquently the kind of man he is—or wants to be."[38]

In 1964, Bruno produced the first of his three large triptychs, the others being *The Wheel of Life* (p. 207) two years later and the *Farmer's Family* in 1970; each covers several dozen square feet of canvas. Traditionally, triptychs are read left to right. Bruno told Stuart Smith, however, that in his, the centre panel should be read first, then the left one and, finally, the one on the right. *The Seasons* begins, therefore, with a picture of a couple rendered almost entirely in flesh tones. Shown from their waists up in a passionate embrace, the couple is clearly naked, though because her right arm strokes her lover's face, the woman's right breast is all but hidden. Above them is warm blue, broken here and there by red applied with a thick brush. The waves of red, streaked with thin blue lines that trace the outside line of the enraptured couple, signal their passion while creating a unique and private place.

The panel on the left shows the outcome of the couple's passion, two happy chubby babies. The chromatic difference between their bodies (which, with the exception of the white of their diapers and a few grey and dark-brown spots, are mostly in flesh tones) and the background function differently than does the same relationship in the central panel. Instead of enfolding the babies, the blues and whites thrust the babies forward toward the viewer's world. This effect is heightened by what looks like an upside-down black right-angle carpenter's tool almost touching the left ear of the child on the right and the fact that the baby on the right steps toward us on the dark-green ground on which daubs of white symbolize flowers. While the babies are indebted to Roman putti, Bruno uses one to form an homage to the religious artistic form he borrows: he gives the blonde-haired baby on the left an arm and hand that bears more than a passing resemblance to God's right hand that reaches for Adam

on the Sistine ceiling. In a traditional triptych, the baby John the Baptist, for example, would point to the Annunciation or Crucifixion. Bruno's figure, by contrast, points back toward the moment of his creation by the enraptured couple—and past it to the final panel.

The Expressionist blues and reds of the central panel's background extend into the upper left of the panel on the right. But the powerful emotion does not last; indeed, these colours are blanched by heavy light-blue. This blue, applied so quickly and with such force that we see the striations at the end of the brush stroke, pushes the two figures forward. What Anthony Tucker intuited a few years earlier—that Bruno was laying claim to "the complex, fragile, inevitable and yet fundamentally antagonistic, relationship of intimacy between man and woman"—manifests itself here in much the same way that Kokoschka claimed that Expressionism accorded with Sigmund Freud.[39] The man, an early middle-aged Bruno, who turned forty-two the year the work was painted, is now pensive, less sure of himself. The dark greys of his body and his heavily shaded eyes highlight his difference—distance—from the woman who, though her face is rendered in grey, has a light flesh-toned right shoulder and arm that hold Bruno and cup his face. Since the figures and the positions of this couple are almost identical to those in *The Tired Wrestler* (p. 210), which was painted about the same time and for which we have an explanation by Bruno, his words can explain the image:

> She is small but manages to embrace him completely, she is his mother, his wife, his lover, she is comforting him, understanding him. . . . There is hope in the gesture of her upturned face and searching eyes, and strength and the powerful embracing but gentle hands. . . . The composition of the painting is a circle. The two figures are one.[40]

≠

"To understand Bruno," Donald Andrus told me, "you have to understand that there were at least two sides to him. There was the psychological side we see in his Expressionist and other art." But there was another side, one commented on also by Brigid Grant Toole, who told me about Bruno's charisma. "Part of Bruno's charisma," says Andrus, "was his dry sense of humour," epitomized by the story dating to the early 1960s when Andrus and Bruno found themselves in a bar in Knightsbridge (London) filled with young Trotskyites. "Several beautiful twenty-somethings were drawn to the then fortyish Bruno. One of them started insisting that Bruno 'come spend the weekend with her at Daddy's country house.' (Daddy, incidentally, was the Duke of Devonshire.) Bruno demurred, 'I don't think I can do it this weekend. I think there's something good on television.'"[41]

The five large oils Bruno executed in 1966 are at once remarkable works of art each in their own right and essential for understanding how Bruno's work relates to his marriage and emotional life. In the absence of records indicating the order the five works executed that year were conceived or completed, it is convenient to discuss them in the following order: *The Embrace, The Wheel of Life, Anxiety, Remorse,* and *A Tender Nude.* (*Remorse* was reworked as a serigraph and renamed *Consolation* in 1980; see p. 244.) *Embrace* shows that for at least part of this pivotal year (or perhaps at various times during the year) Bruno could revel in depicting sheer sexual power. The powerful, sinuous lines that make up the couple in the 1970 etching *The Embrace* (p. 172) turn the white of the paper into palpitating flesh. The thick horizontal black and white lines above, behind, and around them can barely contain the couple's passion. As in Gustav Klimt's *The Kiss*, Bruno's lover's embrace is so all-consuming that the figures become one.

In the painted version of *The Embrace*, the lovers are surrounded by fiery red. This is also the colour of the work's underpainting, which, like the work's other colours, was applied by a brush heavily laden with paint often worked up into impasto. Given Bruno's own words above (about *The Tired Wrestler*), it's hardly surprising that the female figure, who is

less obviously Molly, is the more dominant one. "Note," Forrestall told me as we looked at the work, "how she is coming towards us; he is in some ways enfolded into her. And the impasto reinforces this just as the heavy impasto of her hair functions as a striking marker of female myth and power."[42] The red of the apple on the tree also allows the painted *Embrace* to link ever more closely with the most powerful love story, Adam and Eve.

The sexual politics of the period were complex. As was the case on many campuses in North America, sexual experimentation was *de rigueur* among some of the UNB faculty in the swinging '60s. Smith's late wife, Valerie, told him that while Molly and Bruno had taken part in a number of key parties, on the whole, Molly was not interested in sex.[43] Perhaps because of the irregular relationship between her parents, and her father's many liaisons, Molly had a rather jaundiced view of men and sexuality. Indeed, writing in 1972 after a good friend came to say he was leaving his pregnant wife, she wrote that the story "sounded exactly like an exaggeration of our own. From a man's point-of-view and even from mine, I can see where our marriage and his and millions of others have failed.... Sex, mostly, but in everything else." Their friend's wife, Molly was told, "hates sex—does it as a favour—not unlike me when I was younger." Turning the spotlight on her and Bruno's marriage, she continued, "Suddenly the wife swapping, the drinking, the restless going out every night has meaning."[44] In 1977, she turned down theatre director Bill Glassco's offer of an affair, as she did another friend's offer eleven years later.

Judging from *Anxiety* and *The Wheel of Life*, Bruno had a complicated relationship with his sexual and emotional life. According to psychologist and marriage counsellor Dr. Martin Rovers, with whom I discussed what Molly wrote about and others said about affairs such as Bruno's, "Affairs are really emotional fantasies, but only fantasies, and as such are usually fraught activities that often backfire on the husband, who steps out of his marriage. As emotional fantasies, affairs usually look different in the morning light, and the affair sees that the grass ain't greener on the other side, and when you find that out, you can blame your wife or whomever you want. But it was still your fantasy and, thus, unfinished business from

long-ignored childhood abandonments (in this case)."[45] Recall here Bruno's abandonment by his mother and his cold relationship with his father.

Part of the power of *Anxiety* comes from the narrative distance between these woodcuts and the passion depicted in the *Embrace*. In *Anxiety*, the powerful arms that had drawn the woman to her lover in *The Embrace* belong to another figure with Bruno's face. However, in this picture, his arms are crossed almost limply, in front of his body.[46] Bruno's expression sits somewhere between morose and disillusioned, while Molly's, which appears in profile atop a withered body, is streaked with pain. Her overly long and thin arms are clasped around Bruno's head—more, it seems, out of resigned habit than out of the protective cocoon seen in both *The Seasons* and *The Tired Wrestler*.

The Wheel of Life can be read as a report of what remains once a couple's intimate life becomes a battlefield. At first glance, beneath the deep red cutting through the blue on top of the central background that suggests a fiery sunset of passion, three naked babies seem to be climbing over their parents in bed. A closer look reveals something different. First, no one smiles, not Molly, not Bruno, not even the babies. The heavy-lidded eyes of two of the babies suggest they have been crying. Second, the babies are not cavorting. Rather, like figures in a Hieronymus Bosch painting, they are holding on to a parent's arm or head to keep from falling into the lower third of the painting. The area Bruno's right hand points to is a skull-filled chamber, rendered in dark greys, brown, and black.

The blue and fleecy sky of the panel on the left provides some relief. The light skin tones of the babies who, from their awkwardness, are struggling to take their first steps on green grass among a few white flowers, sustain this emotion—that is, until we realize that now there are only two babies, leaving the third's fate hanging. Both babies point back, toward the bottom centre panel and its skulls and skeletons.

The final panel transports us to the realm of Polish folk tales or tarot cards. Under a blackened bare tree (beyond which is a dark grey sky that merges into the brown landscape) sits a crone. The features of her dark-brown face, painted in thick black lines that are so clean they could have

been inked, are those of a desiccated Molly. Cradled in her parched arms that end with Dracula-bony fingers is the body of a man with Bruno's face. His position resembles the one Bruno gave the "dead Bruno" in *Lazarus*, painted a year earlier, even as it makes one think of the *Pietà*, albeit without the hope embodied in the story of the Passion. (A full discussion of this work is in chapter 8.) The background—swaths of brown and dark grey—is utter desolation. The passion that created the babies is spent, the hopes turned to dust, and only the haggard beldam with Molly's face survives.

A Tender Nude (p. 207) at once captures the unalloyed sexuality at the heart of any affair and the guilt arising from one. At first look, we notice that the woman is alone in bed. She hasn't been for long. The thick streaks of white, applied so quickly that some of the grey underpaint shows through, form undulating waves in the sheets and creases that trace the presence of the lover we can imagine standing and looking at this beautiful, sensuous nude woman on the bed.

Instead of rendering her face and the left arm that curls around her head in flesh tones, Bruno paints them in browns, purples, and black. Nor is the lighting natural. Her features and a painterly lighter green line traced between her forehead and hair seem as if in a shadow; Bruno's exquisite colour sense, incidentally, can be seen here, for the absence of this line would seriously destabilize the colour scheme. By shadowing her features, Bruno has produced a "small veil" designed to fire the viewer's imagination; in an interview with Joan Murray, Bruno discussed just such a veil as being that which divided the artist's rendering of the "erotic" from the "clinical" nudes found in *Penthouse*.[47] One of her legs vanishes beneath the brown blanket shoved to the bottom of the bed, while another lies bent above the blanket as if she were in a semi-fetal position. Black and shading brown intimate the hair on her pubis, a once forbidden subject.[48] Bruno forces the viewer to linger over her body by suggesting her right nipple with an enigmatic purple/brown smudge and so faintly outlining her left breast with a few swirls of blue, grey, and white it could almost be missed were it not for the rough impasto.

The darker reading of *A Tender Nude* starts with the hand that lies over the woman's stomach. Unlike "the creamy coloration of her torso and legs," noted by Donald Andrus, this hand is rendered in browns and greys.[49] On a formal level, these colours balance her shaded face and left arm to our right and the brown blanket to our left. At the same time, these colours draw the viewer's attention away from her sensuous body clad in virginal white and toward the hand that, while anatomically part of the nude woman, barely seems to be hers. The other Expressionist aspects of the work, chiefly the browns and greys, hardly provide a warrant for the distortion created by the hand, the bony fingers of which cover about half the width of her stomach.

In later years, Bruno will sketch and paint a number of women whose hands are the source of their pleasure. Here, however, in the years which Molly recalled him saying "that our life was dead and unexciting," meaning their sex life had collapsed, Bruno reaches for one of the most identifiable Expressionist images: the bony fingers F.W. Murnau gave to Count Orlok in the 1922 silent film masterpiece *Nosferatu*.[50] Since it is her hand, she is, in fact, in no danger. Yet the hand appears to come from behind her, and, thus, it seems that Bruno has captured the moment before it grasps this femme fatale and pulls her into the dark void—a void signalled by the purple shading to brown "shadow" her body casts on the sheets. Thus does *A Tender Nude* morph into a narrative in which a temptress, perhaps the *nosferatu* par excellence (the word means "unclean spirit"), expiates guilt by destroying herself.

Both Bruno and Molly were active in 1967 with national and Confederation year projects. By 1967, Molly had already been a member of the National Film Board's (NFB) board of directors for several years. While, in the years to come, she would also join the National Capital Advisory Committee, Canada Post's Stamp Committee, and the National Gallery's Acquisitions Committee, despite her success networking when she as a young CWAC, Molly was not a natural bureaucrat. She found

operating within the financial constraints set by various governments to be frustrating. As well, never one to hold her opinions back, she found that many of her fellow cultural figures did not listen to her; she repaid the compliment by having rather low opinions of their intelligence. One important exception on the NFB's board was the Quebec actor and later lieutenant-governor, Jean-Louis Roux.

For his part, Bruno was tapped to be the arts director for the Maritime Pavilion at Expo 67 in Montréal. Though most of the relevant records have been destroyed, it appears that Bruno concerned himself with choosing artworks and shipping them, and with displays and lighting. No doubt much of his time was spent massaging the egos of artists who would be present on-site over the course of the six-month international exhibition.

Bruno produced one Centennial-themed piece, to be displayed in Fredericton's Centennial Building. *Miners*, which was executed in 1966, is a 2.4 × 3-metre gouged plywood mural and is one of two works he did of miners. The other smaller work is *Minto Miners* (p. 147), which is undated and is now owned by the CollectionARTNB (the provincial art bank of New Brunswick). *Miners* has its genesis in a March 1965 letter that Bruno and New Brunswick artists Claude Roussel and John Hooper received from the New Brunswick government's "Mural Committee" asking each to "submit a model of a proposed metal structure for the main lobby of the New Brunswick Confederation Memorial Building."[51] The artists were told that the work "should present a montage of Provincial activities—historical, cultural, political, educational and industrial"—and should use "simplified figures in a symbolic way, bearing in mind that the building is a Centennial memorial commemorating Confederation." These last words, no doubt, were meant to ensure that the works would not recapitulate the left-wing politics of Miller Brittain's planned mural for the Saint John Tuberculosis Hospital in 1939.[52]

Bruno chose the coal mining industry as his theme. His submission is lost, but a small pen-and-ink sketch of two miners, done while preparing the model, survives. The miner on the left wears a helmet, and his right hand is holding the end of the shaft of a pick, the business end of which

is by his left leg (his arm crosses his body at his waist). The miner on the right does not have a helmet, though his being a miner is not in doubt: he holds a shovel with his two hands so that it crosses his knees. Both men have the sort of moustaches we might associate with immigrants from Southern Italy.

The paper on which these men are sketched is almost totally black. Around them is a small area of white that arcs around the miners, who themselves are formed from heavy black lines with a few white areas indicating their faces, hands, and legs. The effect is a stunning metaphor for men emerging from the blackness of the coal mines.

Before gouging the wood that became *Miners*, Bruno painted it black. The gouges that created the body-shaped areas around the figures in the final version and that make up the lines creating arms, legs, faces, a helmet, pick, shovel, and sledgehammer revealed the light reddish-brown colour of the wood block. There are good formal reasons for Bruno to have altered the posture of the figure on the right; his stoop would have thrown off the balance of what are now three figures because it would have created a downward line that would lead the viewer into sheer darkness. His stoop would also have undercut the political/social/historical theme that the mural develops. His moustache (the only one in the mural) no longer droops as a metonymy of hard work but rather is bushy and thus bespeaks virility; it has the added structural function of focusing our eyes on the lower part of his face, from where we see the sinuous muscles of his neck. Like those in the model, these three men are surrounded by the blackness of the mine, but, unlike them, their bare brawny arms are unsmudged by coal dust. They fulfill the mandate the mural committee gave Bruno: produce a triumphal vision of New Brunswick industry.

Minto Miners is likely closer to Bruno's own views. Though it is not set in a gallery of a coal mine, the Expressionist background of ten or eleven bands ranging from dark grey to black, light-blue, and, on top, dark-blue shading into dark purple drains the scene of light. Against this background are seven miners who, because they are not wearing mining equipment, are on their way to or from work. The mine in Minto, New

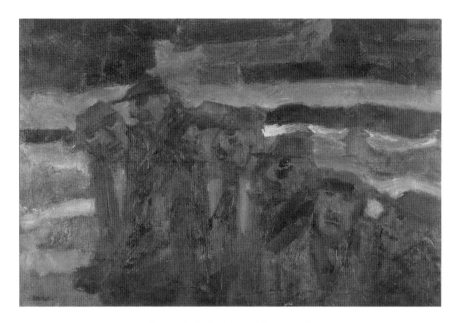

Bruno Bobak, *Minto Miners*, n.d.
oil on canvas, 87.5 x 129 cm
(Collection ARTNB)

Brunswick, had been infamous since 1937, when it drew the attention of
the *United Mine Worker's Journal*: "Nowhere on the American continent,
is there a strife which combines the elements of greed, harshness, cold,
suffering, and want, as exists" in Minto.[53]

 Far from being brawny, these men, their faces darkened almost to the
hue of their worn hats and caps and black misshapen overcoats, walk bent
over. The miners in the Confederation building look straight out at us
with eyes so clear we can see their whites; the Minto miners' eyes are black
daubs or slashes. The two men who look our way appear so tired that we
have no expectation they have taken notice of us. *Miners*, the largest mural
ever executed in New Brunswick, is a superbly balanced work, its three
men each being about the same size and the sledgehammer held by the
man on the left balanced by the pick on the right. And, as he did so often,
Bruno painted himself into the work: he's the central figure and the only
one wearing a helmet. *Minto Miners*, by contrast, almost literally shows
the men being run into the ground. The tallest are on the left and each

man after becomes smaller and less distinct until in the right lower corner is a man who all but dissolves into the stygian darkness at the bottom of the picture. Their poverty is obvious: it was the same Bruno knew in his youth.

Chapter 6
Who's Afraid of Virginia Woolf on the Saint John River

No longer would interiors, people who read and women who knit, be painted. There should be living people who breathe and feel, and suffer and love. —Edvard Munch

The Right Honourable Vincent Massey died on 30 December 1967, and his state funeral took place a week later on a bleak winter day in Ottawa. Molly spent the next few weeks working on an oil that commemorated it. It was the first of three funereal works she would paint over the next quarter century.

Molly had good relations with politicians across the political spectrum, though she was a loyal New Democratic Party voter and contributed paintings to party fundraisers; upon delivering to her one of these paintings that he had framed, Alexander ribbed her saying, "Here's your socialist contribution."[1] She was also friends with the powerful McCain family and knew the even wealthier Irvings socially. She counted Richard Hatfield, Progressive Conservative premier of New Brunswick from November 1970 to October 1987, as a friend and, while disagreeing with many of his policies, supported his decision to make the province officially bilingual; she painted his funeral in 1991. Though she did not have a direct connection to Prime Minister Lester B. Pearson, she corresponded with the then president of the Privy Council, Walter Gordon, and strongly supported Pearson's nationalist policies; in 1972 she painted Pearson's funeral.

Molly's ebullient personality might at first seem to make her an odd choice to paint obsequies. Indeed, the central image Canadians knew

from the televised funeral of President John F. Kennedy — the flag-draped coffin — is not even present in either *Pearson's Funeral* or *Funeral, Richard Hatfield*. Were it not for the title, *Massey's Funeral,*[*] most viewers would probably miss the catafalque carrying his coffin (p. 208); it's in the upper middle in the gap between the marchers. *Massey's* unfolds against a gradient of dark whites; light, middle, and dark greys that make up the ground and bits of sky that can be seen between the black limbs of the leafless trees. In *Pearson's*, the cortège bearing the casket has reached Wellington Street at the foot of Parliament Hill; the snow covering the hill is only incrementally whiter than the grey mist that softens the brown colour and details of the Nepean sandstone and limestone of the Parliament's buildings. It rained during Hatfield's late-April funeral and the people waiting outside the church are sombrely dressed in black or dark grey. But despite the settings and the sombre dress of many, none of these works is especially melancholy — because the rites for the dead hardly interest Molly.

In 1978, Molly told Joan Murray that her works were "not a psychological study of crowds," which is one more example of an artist not being a good critic of their own work.[2] None of these paintings depict fully articulated individuals, though this is not the reason the people in these crowds avoid the fate described by Elias Canetti in *Crowds and Power*, written with the experience of Nazi Germany in mind. What alarmed Canetti was the moment of "*discharge*," when "the individuals who make up the crowd get rid of their differences [of rank] and feel equal" — though the equality is one which abolishes each member's individuality.[3] But the way Molly paints the crowds — or, more specifically, the figures that make up the crowds (as well as the onlookers, a separate crowd, if you will) — keeps the individuals from combining in the way Canetti feared. In *Massey's*, the marchers are painted — signalled is a better word — by quick black lines topped by small white slashes suggestive of sailor caps or heads. They play their part in a choreographed state funeral

[*] From here on these paintings will be referred to as *Pearson's*, *Hatfield's*, and *Massey's*.

and Molly gives these service men and women respectful but not rigid poses. Nothing in their armature suggests, however, that they could form rigid goose-stepping rows of soldiers like those seen in Moscow's Red Square on May Day. The onlookers, made from quick brush strokes by a paintbrush dipped in blacks and greys, likewise lack solidity — almost as if Molly rendered a painterly version of the sort of gauzy overexposed photos favoured by her father, which through their long exposures record traces of movement.

Molly's composition also mitigates the possibility of seeing the events in *Massey's* through the lens Leni Riefenstahl used to film *Triumph of the Will*, her paean to the 1934 Nuremberg Rally. True, the marchers move toward a traditional vanishing point more or less in the middle of the upper third of the work. But this point is formed by something that Massey himself would likely have smiled at: it is framed by the lattice-like intersection of branches, recalling (as befits Massey the nationalist and art connoisseur) the Group of Seven. Even more importantly, despite the presence of this vanishing point, *Massey's* is not constructed around a single perspective. Indeed, one of the strongest sightlines is formed by the front row of the second from the bottom echelon, which drives the viewer's eyes to the right, away from the line of the march and toward the onlookers. Molly's composition mimics the way people watching a parade actually behave: they look around.

Neither a gathering outside Parliament on a winter's day to watch Pearson's body's last trip off Parliament Hill nor the line outside Fredericton's Christ Church Cathedral waiting to bid farewell to the man who had governed New Brunswick longer than anyone else was a fit occasion for Molly to depict the sort of free re-combinations in works such as *The Legislative Ball*. Yet Molly keeps the group of people waiting at the foot of Parliament Hill and outside the cathedral from becoming the sort of "religious crowd" feared by Canetti. While a few of the mourners in each work are detailed, the majority are rendered impressionistically, which allows the feeling of movement without that movement becoming "rhythmic." In Canetti's view, one manifestation of a crowd's power

is the "rhythm of their feet, repeating and multiplied. Steps added to steps in quick succession conjure up a larger number of men than there are," something the former soldier and painter of *Gas Drill* was careful to disrupt.[4] The people waiting outside *Hatfield's* are milling and, thus, incapable of producing such a hypnotizing rhythm. Those who line the route from Parliament Hill and on Wellington Street stand in anything but ranked order.[5]

Massey's is the most traditional, with most of the onlookers in black, though a few wear white and at least two have on blue winter coats. The people in *Pearson's* stand out against the whites and greys of snow, and the ones in *Hatfield's* against the unusually verdant grass of early spring (though beneath the still-bare trees), by their less-than-sombre dress. In *Pearson's*, too, the crowd wears blues, salmon reds, blacks, and whites. In 1991, when Molly painted *Hatfield's*, red, blue, and even yellow umbrellas were common, but in 1968 they weren't, and certainly would not have been taken to a state funeral in rather staid Ottawa. The colourful umbrellas in *Pearson's* are one more example of the colours coming from Molly, but this is less important than what these dots of coloured paint signify: whether or not they are historically accurate, they insert into the scene a discordant note and militate against the totalizing effect of the crowd.[6] The bubbles of colours that seemingly float above the crowd shift the register of the scene even more so than the various colours of the winter coats. In his 1895 classic *The Crowd: A Study of the Popular Mind*, Gustave Le Bon wrote of how "an individual immersed for some length of time in a crowd soon finds himself…in a state, which resembles the state of fascination in which the hypnotized individual finds himself in the hands of the hypnotizer";[7] despite the solemnity of the occasions, Molly provided her viewers with a visual experience of something entirely different from this hypnosis. In *Hatfield's*, the colours go so far as to give the gathering a hint of the air of a garden party.

The year of Trudeaumania, 1968, was also the year in which the June issue of *artscanada** carried Molly's only political article and the year she executed her most overtly political work, *Demonstration U.N.B.*, prompted by the Strax Affair (discussed below), which Bruno also included in a work describing the idea of protest, painted the same year. Six years after the Bobaks arrived in Fredericton (fulfilling Goodridge Roberts's prediction that if they lasted a year they wouldn't leave), Molly's "Letter from the Maritimes" begins with the tone of a New Brunswick Department of Tourism brochure: "The abandoned farm houses look beautifully melancholy in the winter under the snow, and in the spring with lilac bushes still blowing against them." After the obligatory reference to the province's history of rugged individualism, she abruptly shifts gears and praises the province's Liberal government's "programme of [closing one-room schoolhouses and opening] centralized consolidated educational facilities and other costly and necessary reforms" as being the only "realistic approach to equip New Brunswick to cope with today's world."[8]

Among the subjects Molly hoped these consolidated schools would teach was art. Her talks in high schools around the province had left her dismayed at students' profound ignorance, even hostility, toward art. UNB housed an art centre and the Beaverbrook Art Gallery mounted world-class exhibitions, but in the schools, art education was considered merely "fun" and was confined to the primary grades. Molly's words might look like special pleading by someone devoted to art and who was an artist entrepreneur (a term she would have hated) who needed a steady stream of customers. Hers was, however, a profoundly democratic conception of art.

Molly was distressed by the fact that most of her fellow New Brunswickers viewed art as "something to be looked at by privileged members of society on a Sunday afternoon and meaningless for everyone else."[9] Nor should the elite of the art world tell people what they should like. What mattered, she believed, was a viewer knowing what they liked

* Formerly *Canadian Art*, the magazine changed its name to *artscanada* between 1968 and 1983.

and, for the art educator (who gave art lessons at UNB, in schools, at Sunbury Shores Arts Centre in St. Andrews by-the-Sea, NB, as well as in Banff, AB), teaching how colour, line, and composition work together to manifest the artist's vision.

Nor was Molly's support for Premier Louis Robichaud's Programme for Equal Opportunity limited to its reforms of education. Three years earlier, the premier had written, thanking her for supporting his efforts to improve the province's educational *and* healthcare systems.[10] After Robichaud's re-election in 1967, Walter Gordon wrote telling her that the federal Liberals were happy that Robichaud would be able to continue his reforms.

Demonstration U.N.B. (p. 209), painted sometime after the Strax Affair (1968-69), is one of Molly's few works dedicated to a specific political event. Given the issues roiling North American universities in 1968 — the Vietnam War, civil rights, and, at Montréal's Concordia University, the racist policies that sparked the Sir George Williams riot — the new regulation that students show their identity cards before checking out books from the Harriet Irving Library was small beer indeed. The Strax Affair began when the head librarian called the campus police after a group of students led by physicist Dr. Norman Strax showed up at her desk with piles of books to take out but refused to produce their identity cards. A day later, instead of leaving the campus after being suspended by UNB's president, Colin B. Mackay, Strax, and a number of students went to Strax's office in Bailey Hall and started a sit-in.[11]

After two months, during which riots almost broke out a number of times between the protestors and campus security, the Fredericton police forcefully removed the demonstrators. UNB then took out an injunction barring Strax from the campus, which university officials thought would stop him from joining that year's *Encaenia*, or graduation march.[12] Once the graduation march reached University Avenue, however, officials were unable to prevent Strax, in his flowing academic robes, from joining the procession. UNB reached an out-of-court settlement with Strax and the suspended students, before their case against the university for suspending them went to trial. These events led to Mackay's early retirement and

a change in university government credited with establishing academic freedom in Canada.

The importance Molly gave to the events that unfolded a few hundred yards from the art centre and the gym where she regularly swam can be seen from the size of her canvas (102 × 122 cm). Set during winter, the demonstration takes place beneath a dark grey foreboding sky giving way to something approaching black. The left side of the painting is dominated by the Old Arts Building, which housed UNB's administration. Red, not white, light glows ominously from the ornate windows. The bare tree on the far left is rendered in black, giving it the wan solidity of a tree in winter. The building is painted impressionistically. The windows and architectural details* further away from the viewer are less delineated. This rendering is more than a manifestation of distance: it is an aesthetic choice that detracts from the building's solidity and, thus, slyly undercuts the illusion officialdom portrays about itself.

For a number of reasons, Molly's decision to leave the placards blank is important. First, it allows the white placards to be an important structural device; their whiteness, formed from thick paint, links with the whiteness of the snow on the ground and the tufts of snow on the overhangs of the third-floor mansard windows, tying the scene together. Second, even with the size of the painting, writing would grab the viewer's attention and would have limited the painting to one specific protest and not the idea of protest itself. Writing on the placards would also have taken attention away from the protestors, who are Molly's main interest.

Though she has given no detail to their faces, the individuals that make up the crowd do not lose their uniqueness. Indeed, their individual selves, their whole bodies in space, are extremely important. From the news coverage of protests in the United States, Molly would have known that much more important than protestors' chants was the "body count" (ironically, the term adopted from battle reports filed by US officers in Vietnam) reported by the press. Accordingly, by showing up to protest

* The lower two-thirds of the building is Palladian while the third floor (which was added later) is nineteenth-century Second Empire.

(or, in this case, being summoned into existence by Molly's paint), the protestors effectively turn their bodies—i.e., their individual selves—into something like what linguistic philosopher J.L. Austin called a "performative utterance": a speech act that seeks to change a situation in the world.[13] Their very presence says "I protest" and adds strength to the effect of the protest. Rather than be factual representations of the protestors she saw on the UNB campus, Molly's representation of them as something approaching pure utterance means that they burst the bounds of merely recording her opposition to UNB's position in the Strax Affair and become support for protest *grosso modo*. Further, by ranging the crowd up the hill from the viewer and by showing the bent knees of the figures closest to the viewer (as they walk from the foreground), Molly does more than simply lead our eye into the crowd, she invites us to join the act of protesting.[14]

By the late 1960s, the distance had opened that would soon become a chasm between Molly's leftist and Bruno's increasingly conservative views. As in so many other relationships, the lever was the Vietnam War, which Molly vocally opposed; in May 1970 Molly damned President Richard Nixon for the American "incursion" into Cambodia to "flush out Communists."[15] Bruno's views were more complex, though apparently not because of the Soviet domination of Poland; likely because he had volunteered for the army rather than become a Zombie, Bruno "wasn't keen on draft dodgers."[16] Yet he let young men who had come to Canada to dodge the draft hang around the art centre so they could listen to the records played on the stereo. Not forgetting his penniless youth, when possible, he gave some of the draft dodgers little jobs to do so they could earn a bit of money.

Bruno was also a more subtle political thinker than his reticence to discuss politics might at first suggest. Andrus recalls,

> We were in London in the late 1960s and the conversation
> had turned to Vietnam. The English around the table

denounced all things American. Bruno listened and then asked if these people had ever been to the United States and did they understand what it meant to be raised, for example, in the patriotic Mid-West? This was pre-My Lai [the massacre, which became known in November 1969], and he argued that you couldn't blame the American soldier; the politicians were to blame.[17]

Bruno's *Untitled Demonstration*—or, to be more precise, a mash-up of demonstrators objecting to different issues—is much less sanguine about protest than is Molly's. This accords with what Bruno wrote in an undated note written to accompany the oil *Comfort*: "I shy away from groups, causes and mass protests."[18] Some of the issues on the placards—"Filth on CBC" and "No War"—did not fall into the New Brunswick government's remit, still less the city of Fredericton's. "For Equal Opportunity" referred to former premier Robichaud's policies, which Molly endorsed. Strax is there with his placard calling for change in the governance of UNB, though, since Bruno was good friends with Mackay, it is safe to assume Bruno was not helping spread Strax's views. The Bobaks were on the province's

Bruno Bobak holding *Untitled Demonstration* in his atelier, c. 1970
(Photo courtesy of Gary Stairs)

A-list for social events—but Bruno allowed himself a moment of *lèse-majesté* by picturing Lord Beaverbrook as the banker in Monopoly.

By positioning the demonstration at the viewer's height, Bruno brings the viewer closer to the demonstrators than does Molly's work. Entrée into Bruno's depiction might be facilitated by Bruno's self-portrait (looking left) in the middle foreground. However, by giving himself Hulk-like, green skin, he has done more than exercise his Expressionist brush,

which can also be seen in the greens, ochres, and blacks that make up the picture's background (sky). Though unnatural, these colours, applied in heavy slashes, have the effect of foregrounding the protestors, pushing them forward toward the viewer — and, given where the work now hangs, seemingly into a Fredericton city hall committee meeting room.

The green of Bruno's face works differently than the purple and lime green used to make the hair of the two female protestors and the grey on Lieutenant-Governor Wallace Samuel Bird's face. The greys on Bird's face fit his faux–Father of Confederation dress. Standing out against the blacks, beiges, and ochres around them, the women's cartoony hair colours draw us into the crowd, if only because we want to know who they are and where they stand on, say, the contentious issue of "Sin" that animates another person in the work. By contrast, Bruno's green face *divides* him from the demonstrators. The distance is heightened by the black smudge in his left eye socket that obscures his eye and prevents him from seeing and partaking in the demonstration behind him. Far from being an Everyman showing the way to social praxis, this diegetic Bruno is more than uninterested in political action, he is oblivious, which suggests that the artist saw such protests as little more than street theatre.

Almost exactly a year after Pierre Trudeau was elected, Molly started having second thoughts about him. On 24 April 1969, she met with Under Secretary of State for Culture Jules Léger in an attempt to secure increased funding for the National Film Board; Molly still sat on the NFB's board of directors. Four months later, she received a confidential letter from Dr. Hugo McPherson announcing major budget cuts to the NFB brought about by what she called "the terribly low budget."[19] "What," she asked rhetorically, "is the gov't thinking about?" before noting, "Bruno has lost faith in Trudeau ages ago — not just about the Film Board, but about damn near everything from the lifting freeze on railway subsidies, to housing — not implementing the Carter Report [on fair taxation] — a lot

of talk and no real actions excepting reactionary action — damn them."[20] She welcomed the offer, but rightly expected little to come of Premier Robichaud's December letter of support for the NFB and Canada Council funding.

That November, a quarter century after being demobbed, Molly had not forgotten what it was like to be a soldier, and it still informed her views and art. Having had to miss that year's Remembrance Day ceremony, she returned to work on an oil of Fredericton's cenotaph, a work which she felt had broken out of being a trope and come to "mean something" special.[21] And then, a week later, the distressing news broke of the My Lai Massacre, where, as she wrote, "women and children were shot down by the Yanks." Pro–Vietnam War American hawks and those committed to the belief in American exceptionalism would have taken issue with Molly's statement in her Diary that "Americans are no more immune to atrocities than anyone else." But this is not a pointed accusation; the woman who had seen first-hand how war devastated Belgium, Holland, and Germany continued, "Apparently [no] one has yet learnt that we're all capable of atrocities in circumstances like war." The one-time soldier who wrote a war diary that mocked the very institution she volunteered to serve saves her harshest criticism for the media. The "middle aged people [who] are having a ball, talking about these incidents on the radio, etc." are, she clearly believes, clueless about what the experience of battle can do.[22] Though she likely would have been loath to admit it, here, at least, she comes close to agreeing with her husband's views.

Whether Molly realized it or not, a year later, her entry for 16 October 1970 (during the October Crisis) is undergirded both by her military background and having seen or heard clips of the famous confrontation between CBC reporter Tim Ralfe and Trudeau in which the prime minister, asked how far he would go with a military response to the kidnappings of James Cross and Pierre Laporte, said "Just watch me." Though she notes the "great anxiety" in the airport, she does not appear to share it as she "watched troops going aboard transports bound for

Montreal." Indeed, the young men she saw boarding the transports must have reminded her of the troop ships she saw in Halifax. The discovery of Laporte's body "stuffed in a car near a military airport" was different: "God knows… [it] shakes one's 'liberal' safe views."[23]

If 1966 is the pivotal year in which Bruno's art manifests the difficulties he felt in his marriage, 1970 is the pivotal year in Molly's Diary. There are intimations of problems in 1969, the first year of the Diary, chiefly her observation that they "do not agree on what Art means," Molly taking the position that it "allows a person to sense something beyond his own set of limitations."[24] Toward the end of summer, her mood had darkened considerably: "I hate life at the moment" and "[feel] dead inside."[25] Four weeks into 1970, the leitmotif that will run through the next three decades is heard for the first time: "There's something nasty between Bruno and me. I suppose I'm neglecting him & there's a remoteness — full of foreboding. . . . He fills me with resentment and I am worried about his soft life."[26] She linked their fighting and her distress to the drinks they had each night and noted how she alternated from pitying Bruno, which, however anguished an emotion, held out for her some kind of hope, with simply giving up. After Bruno accused her of destroying his confidence, Molly thought, coming close to blaming herself, that perhaps her popularity and success were the reason Bruno felt "isolated and lonely."[27] Knowing that Bruno no longer enjoyed his administrative duties and that they did not need his UNB income, Molly wanted to suggest that he quit the art centre, which would also free up time for him to paint. She feared, however, that he would angrily reject the idea.

At the end of March, for the first time, Molly records Bruno "knocking" her (verbally) in public, at a dinner with the Donaldsons. Ironically, that same month, Molly and her friend Joan Shaw went to see that 1960s exemplar of tortured marriages, Edward Albee's *Who's Afraid of Virginia Woolf?* In early July, Molly wrote, as she will scores of times over the coming decades, of escaping to British Columbia; in this iteration, she hopes

to stay three or four months teaching and painting. "I feel so locked in and can't talk to Bruno. I told him of my plan around midnight but he didn't answer." What Molly gives herself with one hand, however, she immediately takes back with the other: "We'll see how things are in the next few weeks but the way it is now is impossible and I have a nervous tremor."[28] It is a sign of how new Molly was to honestly recording her innermost thoughts that when she tells herself that she can flee to British Columbia, she doesn't address where thirteen-year-old Anny would live. By the end of the year, however, while she still balks at making an immediate decision—"I'll give this a try until spring"—she includes her daughter in her plans: "If I have the guts, I'll go west with Anny."[29]

When Bruno's long-running affair began with Carolyn Cole, who came from a long-time Fredericton family and was married to CBC Radio personality Leon Cole, is unclear. More than one of my interviewees thought it was before 1970. Later, Molly would refer to these as Bruno's "insatiable years," making it all the more telling that in 1970 he produced a trio of pictures that, taken together, chart the unravelling of male physical strength.[30] The first work, *George*, is Bruno's second portrait of George Gordienko, the Winnipeg-born wrestler The portrait is somewhat less muscular than the one executed six years earlier, in which Gordienko's body is made up of areas of flesh tones, browns, whites, greys, and blacks that together give it volume reminiscent of Auguste Rodin's nude *Study for Balzac*, but the 1970 Gordienko is still extremely muscular; he continued to win titles as late as 1974.

Bruno places Gordienko against a blue tonal background and inside dark-blue outlines that do more than simply make his light beige and grey muscular body stand out. The light-blue lines that delineate the wrestler's body seem to radiate from it, symbolizing strength. Gordienko stands in a classic body-builder pose: his body angled to the left so that his left shoulder is closer to us with his head turned so that he looks out at us. His right hand holds his left wrist; his left arm is slightly bent, showing the

bulk of his shoulder and forearm, a position that Bruno would have seen in posters of his friend and at wrestling matches he went to in London. And which most North American males would recognize from Charles Atlas advertisements that appeared in the back of comic books, as well as those who followed the career of Arnold Schwarzenegger, who by 1970 had won three Mr. Universe titles.

Andrus's argument that Bruno modelled *The Tired Wrestler* on Norwegian artist Gustav Vigeland's sculptures applies equally well to the second of the three athlete-themed paintings from 1970, *The Twins*. Given Bruno's military background, the source is also stunningly ironic, though Bruno almost certainly would not have known it. When Bruno saw the massive sculptures in Oslo's Frogner Park, art historiography stressed Vigeland's design of the Nobel Prize medal and how the massive sculptures of nudes in the Skulpturpark were, like Edvard Munch's painting *Bathing Men*, linked to the Nordic ethos of virile (nude) men in connection to nature. This was part of the "national paradigm" of the Norwegian state, which became independent from Sweden only in 1905.[31] But there was a darker side they were not mentioning.

Vigeland died in 1943, so he never had to answer for warmly receiving prominent members of Vidkun Quisling's government and visiting German Nazis into his studio or his praise of "German soldiers with their excellent discipline to walk around between my work" in the Skulpturpark. While art historians do not speak of Vigeland as a quisling, Munch, who died in 1944, made clear what he thought of Vigeland's politics by ignoring "every attempt by the Germans to make contact with him" and refusing to sit on the "honorary board of arts" with the traitor.[32] Even as recently as 2015, a book with the promising title *Vigeland + Munch: Behind the Myths* gets around the problem of Vigeland's pas de deux with quislings and Nazis by discussing Vigeland's work only up to the First World War!

At all events, Bruno's *The Twins*, who we can tell are wrestlers from their red capes, seem to have broken out of one of the statues in the Skulpturpark (or, more, prosaically, from the child's toy Rock 'Em Sock 'Em Robots that came on the market in 1964). In both *George* and the

1964 painting of Gordienko, the athletes' muscles bulge. Taking his cue from Vigeland's heroic nudes, the twins' muscles, signalled by exquisite use of dark shading next to lighter areas, recall Muhammad Ali's fluid musculature in contrast, for example, to George Foreman's bulging muscles. Even more importantly, Bruno follows Vigeland, who often roughed in his sculpture's faces, and paints the twins as if their natural faces were the masks worn by wrestlers. The twins' clenched fists and stances, as well as the way their reddish bodies stand out from the background, are unmistakable exemplars of masculine power and virility.

The third athlete-themed picture is *The Tired Wrestler*. Against a dark background, a recognizable Bruno stands in the same three-quarter view Gordienko does in *George*. For a man in his mid-forties not known for working out, his upper left arm is surprisingly muscular. Indeed, given the bony picture of himself in *Self-Portrait, Age 41*, painted a few years earlier, this heft is as much a fantasy, as is more plainly seen in *Self-Portrait in Red Dining*, in which a spindly Bruno stands before a poster of Gordienko onto which Bruno has painted his own face.[33] In a bow toward verisimilitude, the aging wrestler's upper right arm vanishes into the black background while his small hand clasps his left wrist.

This wrestler wears a mask, though not like the ones worn in the 1960s by the Blue Demon or The Avenger, which bespoke both mystery and power. *The Tired Wrestler*'s mask could easily be mistaken for the gauze wrapping more easily associated with someone who has survived a terrible fire. Equally importantly, masked wrestlers never appear without a scowl or smirk on their lips. *George*'s face is placid, while the twins are robotic; the aging wrestler's lips, by contrast, are somewhere between a purse and frown. His all-but-sheathed head and the work's title, *The Tired Wrestler*, with its connotation of a punch-drunk athlete and his decaying body—and echoes of the 1962 film *Requiem for a Heavyweight*, which starred Anthony Quinn, Jackie Gleason, and Mickey Rooney—leave no room for the type of virility seen in *The Artist with Molly* or *George*.

These three athlete-themed works show that as Bruno entered his third decade as a professional artist, he had not lost his ability to tell a

captivating narrative. Even Molly, who at times said that Bruno's work had declined, could not deny it: "Bruno is doing a marvelous 80 x 40 inch canvas," she wrote in early 1971. "My god he is an artist... he really is."[34]

A little over a year later, Molly received a letter from her old friend, architect Ron Thom, saying that Marathon Realty Ltd. was backing down on its proposal to redevelop the riverside section of downtown Fredericton. Marathon's proposal would have seen what today is the Barracks tourist area torn down as well as the destruction of scores of stately elm trees and historic lawns. In their place, Marathon planned to build a Brutalist-styled commercial centre, characterized by Stuart Smith as "a sixteen-foot-high solid brick wall suffocating Queen Street."[35] Smith, Molly, and Bruno were among the concerned citizens who, after founding the Fredericton Heritage Trust, made their disdain for the project known to Mayor Bud Bird and, crucially, engaged Thom in their battle with city hall.

Thom, who at the beginning of his career had helped Bruno design the Bobaks' home in Lynn Valley, British Columbia, was "now renowned as one of Canada's leading design architects" and was among those architects who followed Jane Jacobs in "believing in a more organic, fundamental relationship of cities, peoples, and their buildings" than what Marathon was proposing. Equally importantly, notes John Leroux, he was an inspired speaker who could show the "merits and precedents of saving the irreplaceable historic architecture that lined Queen Street."[36] Though Thom wasn't thrilled by the final design, he and the members of the Fredericton Heritage Trust accepted half a loaf.

Molly's support for the NDP and her role in the fight against Marathon Realty would seem to have pitted her leftist politics against the Bobaks' increasing wealth. After all, in 1969, only nine years after arriving in Fredericton, she and Bruno owned three properties. A drop in the stock market was enough to note, but not enough to worry her: "who cares, we have the farm."[37] Their art sales were generating cheques in amounts such as $2,600 ($17,000) for Molly and $2,000 ($13,000) for Bruno. The Bobaks

were so flush that in October 1971 they paid $10,000 ($65,000) cash for their house. But their rising income did not alter Molly's politics, as can be seen from her complaints about the Trudeau government's economic policies. In early 1971, in spite of an "immoral level of unemployment," their stocks were doing well: "so much for the capitalist system," she lamented.[38]

Although Molly viewed the business side of being a successful artist with disdain and sometimes wished she could simply give her paintings away, she knew her worth, as can be seen by her complaining in 1972 that she was being underpaid while teaching at Banff because of a number of extra students; at least, she said, her airfare had been paid by the school. Perhaps in a way that only someone raised in a family of means can, Molly took her increasing bank balance as the natural order of things. It surely afforded her the means to visit British Columbia to see her mother and father without giving a (recorded) thought to budgeting for the trip.[39] And, after Anny moved to Galiano Island, Molly had the funds to visit her when she wanted to — the frequent and long visits having the added benefit of putting time and distance between Molly and her fraught marriage.

For all that, Molly's (and, for that matter, Bruno's) healthy bank accounts did not appreciably alter their day-to-day lives. For example, she spent 4 July 1969 cleaning house and washing the floors. When their basement needed work the following month, she and Bruno dug it out, while Bruno and Alexander lay the cement work and poured the concrete. She made apple jelly and pies by the half dozen. She hated labour-saving appliances, preferring to use a wringer washer and to hang up damp clothes — even in winter — rather than use a clothes dryer. She insisted on using an old-style kerosene stove, which periodically had to be taken apart and cleaned of soot. When Mrs. Stairs visited one November day in 1969, Molly chatted while attacking a pile of ironing. On 9 August 1971, the amount of clothes she washed was worthy of comment in her Diary.

Within their marriage, Molly viewed their financial status as a two-edged sword. First, she knew their income and holdings would make

living apart from Bruno feasible: thus, the rhetorical question at the end of the 4 April 1972 entry to her Diary, "Shall I go to the River (House)?" At the same time, while the thought of separating was "intriguing and distinctive," the thought of having to go through the division of their assets was "ghastly" because it was so mercenary.

At the same time Bruno's oils expressed his pain, as artist in residence and director of the UNB Art Centre, under which hat in October 1969 Bruno invited Jack Shadbolt to spend a week giving workshops and lectures at the art centre, Bruno documented dozens of fellow faculty members, students, and visitors. In some of these sketches, Bruno uses black lines to achieve the same sort of effects as in his Expressionist works. For example, the contours of the *Unknown Professor*'s head and shoulders are recapitulated by heavy black lines, while the right side of his face is distorted in much the same way the man's is in *Love Sick*. The faces of both James (Jim) Chapman, professor of history, and Brigid Toole Grant are mottled, placeholders for what, were Bruno to have worked them into pictures, would have been the loading up of his paintbrush with hues other than flesh tones.

Most of the sketches, however, are traditional artist's studies. Knowing how his friend and long-time next-door neighbour, classics professor Leonard Smith, felt about his receding hairline, Bruno emphasized it. He also has some fun pairing Smith's serious expression with the carefully developed (via cross-hatching) plaid shirt, incongruously graced with a tie. Capturing Professor Leger's countenance was either something of a problem or his face intrigued Bruno. Over the course of four sketches, Bruno tried him in four quite different poses and emotional attitudes.

One of the few sketches of women in the Beaverbrook collection is of a student named Monica Abishit. She is shown in profile, caught in a moment of reflection, bent slightly forward. The right side of her head and face are outlined, so the creamy white of the paper provides the hue of her skin. The end of the ruler-straight line indicating her right jaw

bone thickens to show her strong chin, above which are thin lines tracing her lips and above them her aquiline nose. To show where her black hair caught the light and glistened, Bruno lightened pressure on the charcoal, and here and there allowed the thinnest of white lines to break up the grey/black shading. Though underdeveloped, enough of her right arm and torso are present to enclose the white negative space. This enclosure sets off the figure against the heavy black shading that rises from the lines of her shoulders to about halfway up her face. Given the fraught nature of Bruno's depictions of women in *A Tender Nude* or *The Wheel of Life*, it is notable not just how chaste this image is but also how the shading above her shoulders and beside her face gives this sketch something of the air of a Greek bas-relief, ennobling Abishit.

His sketch of Stuart Smith is a twice-told tale. Dominating the paper is a bust-like sketch of the professor in one of the era's academic accoutrements, a crew-necked sweater with a diagonal-striped tie. Smith looks upward and slightly to the left, as though detecting the presence of his alter ego: another, much lighter sketch of him over his left shoulder. Taken together, the two images recall the distinction at the heart of Raphael's *The School of Athens*. The first image depicts Smith in an almost Neoplatonic moment looking toward the heavens. Since his gaze is toward our world in the second sketch, Bruno casts this Smith in the role of an Aristotelian realist. This split portrayal has the feel of a gentle poke at his friend and frequent lunching partner, who, as an art historian, belonged to a fraternity Bruno found dodgy at best.

The only sketch that can be definitively tied to an oil is of Allan Donaldson. The sketch in the collection donated to the Beaverbrook Art Gallery shows the English Department professor in exactly the same pose he has in *Kent's Punch* (p. 211), complete with his cowlick; the pencil mottling on his face becomes the Expressionist greys and ochre in the 1970 oil.

The conviviality signalled by the title *Kent's Punch* and the liquor-filled glasses lifted by Professor William (Bill) Bauer's English Department colleagues to a toast he is making is undermined by both the men's

expressions and Bruno's palette. With the exception of Bauer, no one smiles. Professor Fred Cogswell, on the bottom right, is close to scowling. Standing to Bauer's left is Professor Kent Thompson, his pursed lips imparting irony to the fact that he has raised his glass higher than the others. Professor Robert Gibbs, on the far left, looks at Bauer with what would have been a neutral expression had it not been for Bruno's palette. The almost pastel blue daubs on his face and eye sockets transform his expression into one of suspicion. Bruno has captured a moment when whatever is being honoured with a toast barely papered over the rifts among these English Department colleagues who, it was well known, "despised each other."[40]

With the exception of poet Alden Nowlan's black-and-gold stripped tie and his black sports jacket, the other men's jackets and shirts are something less than detailed essays of creases and lapel angles. The rumpled surfaces that, together with the heads and a few hands, all but fill the frame — there are a few brown interstices visible between the six standing men — are so fulsome that we are apt to miss an example of Bruno's expert handling of colour and superb draftsmanship.

Using bodies, glasses, and empty bottles (likely painted in with white paint so thinned as to be translucent), Bruno describes at least twelve receding horizontal planes within the picture. "The four bottles are important for two reasons," notes Stuart Smith. "First, with an economy of colours — blues, yellows, and reds — Bruno was able to create believable bottles that are both there and not there, being transparent, at the same time. Secondly, Bruno has arranged the bottles to form the only 'three-dimensional' area of the composition, which is so strong we hardly notice that the men are pushed so close together as to almost reject 3-dimensional space."[41] Almost, but not quite. While the space is flattened, Bruno carefully overlapped the men, taking care to ensure that the darker suits were further back, thus allowing, for example, Donaldson's lighter suit and face to stand out.

On a more a more personal level, Bruno's disillusionment with UNB is evident. In the years after Colin B. Mackay resigned as president,

President James O. Dineen's management changes and budget cuts required Bruno to write reports justifying the continuance of the art centre and his position as permanent artist in residence. Indeed, in early 1971, Bruno's disenchantment led him to submit a resignation letter, which in the end, was not acted upon.

Bruno's engaging and iconoclastic wit often cleared the gloom, as we will see in some of his paintings — and in his social presence. On Christmas Eve 1970, the UNB community was shocked when Professor Walter Baker and his daughter were killed in a car accident. In a way quite different from, but not unrelated to, how Molly used umbrellas and colours to prevent paintings of Vincent Massey's, Lester Pearson's, and Richard Hatfield's funerals from tipping into the mournful, Bruno took it upon himself to prevent grief from overwhelming the Bakers' family, friends, and colleagues who gathered at the Baker home after the double funeral. "About fifteen minutes after we gathered at Bakers' home following the funeral, Bruno arrived dressed as a nineteenth-century undertaker straight out of Dickens, complete with top hat," says Andrus. "There was stunned silence. But, within fifteen minutes, Bruno had helped dispel the gloom and even had Baker's widow laughing. I don't know anyone else who could have gotten away with that."[42]

In May 1973, Molly received a check for $1,660 ($9,000) for the diptych *Encaenia*, which she worked on through the later part of April.[43] In this painting, Molly's loose brush strokes that seem to — but do not quite — blend into each other ensure that our eyes move along the line of graduands. To capture the hard-left turn the graduands had to make after the university's gates, Molly positions herself (and the viewer) slightly above the street at the bottom angle of what amounts to a *V*. Thus, we see the procession coming diagonally from our left and vanishing in the distance diagonally to our right.

Most figurative artists would have given the figures closest to us more detail than those in the distance. But had Molly fully articulated the arms

and hands of the figures approaching us, for example, balance would have required that she do the same for those walking away from us. This would have unbalanced the work, effectively dividing the Encaenia procession into four parts: two of detailed renderings of the marchers and two of less detailed individuals in the distance. Such a division would, effectively, replace the work's most dramatic moment, the procession's left-hand turn at the bottom of the *V*.

Instead of detailing faces, as, for example, Auguste Renoir might have done,[44] Molly signals faces with white ovals. The absence of noses, eyes, and lips does not produce a sense of blankness as if these persons were automatons waiting to have an identity etched into them. No less than Renoir's figures, Molly's figures are engaged, active, full personalities. The whiteness of the graduands' faces is not empty but full — of potentiality. By leaving these faces uncoloured, she has made them, in Smith's words, "universal because they stand for the generations who have followed this route on the same joyous occasion."[45] The whiteness of their faces also has a structural, though far from static, role: the white dots tie the procession together and convey its movement, because our eyes cannot help but connect the dots and, thus, move within the work or, in more narrative terms, along — and with — the procession. This difference from Renoir's figures marks one of the essential functions of Molly's mature art: filling the void between the individual and despair, be it with figures celebrating or with the fragile, mutable beauty of flowers.

PART III

1973-1990

Bruno Bobak, *The Embrace*, date unknown
woodcut on paper, 63.8 × 94 cm

(Purchased with funds from the Senator Richard Hatfield Memorial Fund.
Beaverbrook Art Gallery, Fredericton, NB)

Chapter 7
Picturing Desire

I paint flowers so they will not die. — Frida Kahlo

On 4 March 1973, Molly came home to find a cheque that poet and short story writer John Metcalf had left on her kitchen table. A few days earlier, UNB's writer in residence for the 1972/73 academic year had dropped by the Bobaks' house on Grey Street not far from the university's gates. Seeing that Molly was painting, in his courtly manner, Metcalf apologized for interrupting her. Molly responded by asking him if he had eaten breakfast. When he answered no, she put down her paintbrush, invited him to sit down, walked to the refrigerator, took out some eggs and bacon, and began making Metcalf breakfast. "When I started eating, Molly returned to her easel," Metcalf told me. "We talked while she worked. By the time I'd finished breakfast, maybe 40 minutes had passed, Molly had finished the painting."[1] Before Metcalf left, Molly gave him the painting of an anemone (p. 213).

A few days later, Molly and Bruno had dinner with Metcalf and brought up what Metcalf had told them about a new Canada Council program to finance writers working abroad. Metcalf feared that it could not help but be political and would probably choose from well-known figures. When Molly mentioned then CBC host Adrienne Clarkson, Bruno cut in and said, "Yes, you & Adrienne Clarkson." Later, ruminating on Bruno's cutting remark and what he had said about her "personality, which seems to get [a positive] response from others," Molly drew a distinction

that while technically true was somewhat beside the point. Thinking, no doubt, of Bruno's recent bronze medal in a print competition in Italy, she told herself, that she had "had far less 'success' than Bruno": people may have been buying her work, but *pace* A.Y Jackson, neither the critics nor the establishment took much notice of her.[2]

In fact, as Bruno well knew, the bronze medal aside, his work no longer attracted much praise from critics—or as much as he wanted from that other barometer of value, the buying public. As it would for any artist, being overlooked by the critics rankled, but what hurt, as indicated by Molly's reference to the buying public, was that the sales of Molly's work—flowers and crowd scenes—far outstripped his. For tax year 1972, for example, Molly's work produced a tax bill of $60,000 ($340,000); since the marginal tax rate was 60 per cent, Molly's income for that year was $120,000 or the equivalent of $577,000 in 2019 dollars.[3] Bruno's jealousy at Molly's financial success must be put in perspective: though she sold much more than he did, Bruno's work did find its buyers through shows at Gallery 78, Walter Klinkhoff's, and Roberts. Still, he was bitter; in early January 1975, prompted by the news that the Canadian embassy in Paris had just bought one of Molly's watercolours and her good conversation with the owner of the Capital Art Gallery, Bruno sniped that "all galleries are commercial," by which he meant middlebrow.[4]

On the other hand, though Bruno was moving toward the August 1976 night, when, in the midst of a fight about Carolyn Cole, he would tell Molly, "I'm just a boring old man," at times, he wore with some pride the fact that his Expressionist figures were not popular, and he was able to provide some historical perspective as to why they were not popular.[5] Because Canada is a "pioneer country," Canadians "don't think [or] feel the same way about figure painting as Europeans," he told Joan Murray. "A man out bicycling or camping has a natural affinity for landscapes." Lacking "large, wide, open spaces," Europeans turn "inwards.... They see themselves rather than their environment." Canadians "don't buy figure paintings" and even fewer "would hang a nude over their mantelpiece."[6] And, since advances in printing meant that reproductions of works like

Thomson's *The Jack Pine* and Colville's *To Prince Edward Island* were both vivid and cheap, fewer still bought works in which the figures' faces and postures told of inner turmoil.

If, as Molly wrote in 1975, "their life is like a Tennessee Williams play," then the most Williamsian character in the family romance was Carolyn Cole.[7] She was not just a background character; she was often in the foreground — for instance, as she did at least once (in August 1975), staying up till midnight with Bruno after Molly went to bed. Molly's Diary allows us to chart the deterioration of the Bobaks' relationship (from her point of view) and her reaction to Carolyn's intrusion into their marriage. In February 1973, Molly found Bruno "turned off" and felt "detached and confused." That April, they took a trip to Spain. While it had good moments, such as visiting Goya's house and when Bruno drew in the hills above the Mediterranean, the trip did little to bring them closer. Indeed, a few days after they returned to Fredericton, Bruno did nothing to help clean up flooding in the house until both Molly and Anny got at him about his behaviour.

A trip to Bermuda in early 1974 was no better. An uncharacteristic entry in March 1974 spoke of Molly's envy for the hundreds who made a "quick departure from the world" when their Turkish Airlines DC-10 exploded after taking off from Paris's Orly Airport.[8] In June, Molly wrote that "Bruno drinks like a fish, besides that does nothing," although, in fact, Bruno kept painting.[9] In October, even the usual balm of fishing with his friend Jimmy Pataki did little to improve Bruno's mood. The following February, Molly wrote of him throwing a brandy glass into the sink after she made a flippant remark while he raged about dishwasher foam on the kitchen floor.

Bruno could escape the tensions that filled their home, first on Grey Street and, after October 1974, on Lansdowne Street, by going to his office and studio at the art centre — where, conveniently, Carolyn was his secretary. Molly effected the same by keeping a heavy schedule of

housework, painting, teaching in St. Andrews by-the-Sea and Banff, and loading herself with invitations that regularly took her away from Fredericton. Even after she felt the other members of the NFB board were no longer listening to her, she stayed on and made regular trips to Montréal, Ottawa, and Toronto.[10] In Montréal, she stayed at her friend Claude Bouchard's apartment, where she enjoyed the gourmet dinners he prepared and the friends he invited over. The lure of having another reason to travel to Ottawa partially explains her "Yes!" at being invited onto Canada Post's Stamp Selection Committee in 13 September 1973.

It was, however, in their paintings that both artists sought solace from their tumultuous home and emotional lives. In 1978, Molly curtly dismissed Bruno's claim that the trio of works—*Two Nudes*, *Journey*, and *Artist and Model Before Mirror*—he painted in 1975 were about "love"; she saw, simply, "cruel" depictions of her and "sweet" ones of Carolyn.[11] After years of battles with Bruno and his flaunting his relationship with Carolyn, Molly was in no mood to remember that for Bruno, "a lot of love is sad," as he told Murray: "People are hurt and they try to express themselves."[12]

While the physical joy Bruno felt from his affair with Carolyn can be sensed in a series of drawings and a number of cartoons, including two made for Donald Andrus, all of which we will look at below, the three large oils he executed in 1975 tell a very different story, one he drew attention to when he told Donald Andrus, "I feel there's a lot of myself in these figure paintings. They're much more personal" than his landscapes.[13]

At first glance, *Two Nudes* seems to be of a piece with the sensuous reading of *A Tender Nude*. The man's nude lover scrunches beside him on a dishevelled bed. His right arm drapes over the upper part of her back; his hand is just far enough below her shoulder to be touching her left breast, which is hidden by her thigh. Bruno's bravura handling of the purplish-greys that dominate the faces[14] draws attention to the act of artistic creation. Both the unnatural colours and our awareness that we are

looking at an artifice creates a certain distance. Paradoxically, this distance does not push us away — but makes us want to bridge the distance. The colours can be seen as creating a wall. Because we can feel it taking shape, forming before our eyes, so to speak, as we wonder about Bruno's palette choices, we reserve the right to try to penetrate it, to know what mind lies behind the colours that seem almost temporary.

When compared, for example, with the raw sexuality of *The Seasons*, *Two Nudes* seems fairly chaste. Though intertwined with his lover, Bruno is separate from her; their emotional distance is signalled by his eyes and mouth. His face lacks even the hint of smile. Nothing in his expression suggests the physical satisfaction a man expects to feel when holding his naked lover. He looks down and away, toward the corner of the painting, almost to the floor itself. The greys around his eyes create a perplexed, even bewildered, expression that underscores the sense that he has little control over the situation (and mirrors the feeling engendered by the distance noted above). As William Forrestall points out, Bruno bears comparison with some of Colville's self-portraits in the sense that Bruno depicts himself "not as the central actor in these dramas but rather as the one being acted upon."[15] Giving the female figure the face of the woman he accuses of dominating him redoubles the picture's narrative, which shows a weakened man and a woman who, despite — or because of — her nakedness is "comfortable and in control."[16] Far from indicating weakness, the greys on her forehead emphasize the power of her black eyes that are not just looking at Bruno but judging him.

If the woman is, in fact, Molly, then we might conclude that Bruno has pictured a harridan. If the woman is, rather, the representation of a more universalized naked female (an idealized Carolyn?), then Bruno is picturing something even more psychologically complex. Her sexual availability, desirability, and her desire for him combine to bring "neither joy, nor love, nor light,"[17] nor any obvious sexual satiation. Instead, given his weakened appearance, Bruno has pictured a psychological state akin to the nineteenth-century psychologists' and moralists' view of the male orgasm, the word for which was "spend," with all that word's links to a

bank account being drawn down. No matter which woman she is, therefore, the man is the victim, which, as Molly's Diary shows, is how Bruno frequently describes himself.

Journey (p. 212) is deeply indebted to Kokoschka's *The Tempest* (or *The Bride of the Wind*), painted on the eve of the First World War and after the end of his famously torrid affair with Alma Mahler. From the leading exponent of Expressionism, Bruno borrowed the figures' positions, though it is Bruno's sleeping form and head leaning on his right shoulder, and not Kokoschka's in a semi-recumbent position. Bruno dispensed with the cockleshell boat that just manages to support Kokoschka and Alma, choosing instead to have his two nude figures—whose flesh varies from natural tones to blues and greens—swept to our left toward an unseen, even unimagined, point by staccato lines of green, blue, and white that somehow keep them afloat.

Bruno follows his master in placing the woman at the centre of the scene. Despite the pain of their breakup, Kokoschka's picture of Alma is "composed and unified," turning her into a sleeping beauty.[18] The Molly who replaces Alma is infinitely more powerful, as can be seen from her knowing expression and wide-awake eyes that peer out from behind the dark brown splotch Bruno placed on her face. Even more important is where Bruno has placed Molly's hand: between her legs. Judging from the expression on her face and his limp penis hanging beneath her right elbow, she has no need of him for *eros*.

In 1979, Bruno told Murray that the reason so many of his works contain self-portraits was because, given a mirror, he was always available to model. The one work in which we see him in a mirror, *Artist and Model Before Mirror*, owes more to Pierre Bonnard's post-Impressionist self-portraits from the late 1930s and early 1940s, for which he used the bathroom mirror, than to works like Munch's *Self-Portrait under the Mask of a Woman,* which Bruno would have known. (One can easily imagine him lamenting that he could not use the same title.) Munch's mirrors, as art historian Allison Morehead notes, "telescope time." Mirrors signal "not only a moment in the making of the work but also the moment in which

we as viewers encounter the artist in the work, as if one of us has traveled backward or forward in time. This momentariness," she notes, "is often emphasized by the artist's expression, usually a fleeting one: a hint of a smile, a mouth slightly parted as if about to speak, an arched eyebrow animating the moment."[19]

Bruno's reflected expression has none of this animation. It follows Bonnard's example; it avoids being narratively opaque because the far-right corner of his lips dip just enough for the viewer to pick up his despondency, which we feel from his downcast eyes that appear to be looking toward the lower right hand of the mirror and scene. Mirrors increase the frontage of a picture and, as such, should supply more information: think of the king and queen Velázquez inserts into *Las Meninas* via the mirror. In his own work, Bruno has filled the mirror's frontage with the reflection of the seated model and his mirror image, to the exclusion of anything behind them. By so crowding the mirror's scene, Bruno frustrates the viewer, who expects to see deeper into the field where the artist stands (and, technically, where we, the viewers, stand).

The nude Molly in the mirror wears a forlorn expression and looks to the lower right, refusing to engage us (assuming she can see us in the mirror), the reflection of her husband, or herself. Perhaps she doesn't want to see her deflated breasts. With the exception of a couple of brown and greenish-beige splotches on her arms and legs, her skin is a ghostly white. Even more importantly, given the sexual issues in their marriage, her not-quite-clasped hands are between her partially open legs, leaving only a few places where the black of her pubic hair shows through. This connects to the cultural moment: In the 1970s, the so-called Pubic Wars raged between *Playboy* and *Penthouse*, as each broke with the practice that had been in place since the Renaissance to shy away from the depiction of pubic hair. As Devon Smither has recently shown, and as Bruno would have known, Bertram Brooker's depiction of pubic hair in his 1937 oil *Torso* ruffled more than a few feathers in staid Canada.[20] As late as the 1980s, some art manuals enjoined students from depicting pubic hair or, for that matter, detailed renderings of nipples. At all events, given the state of their

marriage, Bruno may be saying less about Molly's sexuality and sexual availability than about the importance of sexual activity *grosso modo*.

While Bruno painted naked self-accusation, Molly painted flowers. The still life John Metcalf watched Molly paint belongs to a decades-long project that saw her produce more than a thousand paintings of wildflowers — black-eyed Susans, peonies, cosmos, poppies, and others — that were entirely different from the flower still lifes she produced in the 1950s and early 1960s. The flowers in those earlier works were significantly denser than the ones for which she became famous. In addition to being something of an homage to her father's collection of Asian art, *Summer Flowers and Chinese Tea Pot* (1953) shows Molly coming out from under her Cézannesque tabletops as it were. Perhaps influenced by Bruno's *Cornstalks*, the summer flowers are schematic. The white and dark blossoms are partially dried out. The teapot is almost volumetric while, were it not for a few spots of shading, the flower pot would appear as an outline of one. *White Tulips*, painted in 1956, is a much fuller work. As Michelle Gewurtz, curator of the Ottawa Art Gallery and author of a monograph on Molly, writes, the vases are "filled with white blooms, with a few blue flowers that resemble irises added to offset the monochromatic light grey background. The petals and leaves have a geometric and angular quality that was typical of her preoccupation at the time" (when she also painted *A Bake Shop, Saint-Léonard*).[21]

Sometime after arriving in New Brunswick, moved partly by the fact that when not undertaking large oils Bruno painted watercolours of wild-flowers and partly by the profusion of them in and around Fredericton, Molly began using an old brush with a few hairs left in it to "say something about the elegance of these crisp-growing fronds" (a large divided leaf).[22] In works such as *Poppies in a Ginger Jar* or *Paper Poppies*, she places the loosely painted, though clearly distinct, red poppies (and, in the second work, white flowers with yellow and yellow-and-black flowers) in vases that sit on greyish/black tables.

The flower paintings for which Molly is best known are shot through with ironies, only some of which Molly was aware of. At the same time that Bruno was filling almost every inch of his canvases with thick strokes of paint and backgrounds born of his inner turmoil, Molly was heading in the exact opposite direction in her paintings of flowers (and, as we will see below, of crowds). How did these insubstantial images—made from quick brush strokes that often trailed off to striations—buoy her against the lows that not even her closest friends knew about: "waves of despair and remorse" about being terrible parents, and "appalling depression and vague thoughts of doom," which on some days prevented her from being able to paint?[23]

Part of the reason is the healing balm of work, satisfaction of a job well done. Part of the reason is that she identified with the wildflowers. "For Molly," notes Smith, "flowers were beautiful, fragile—and they didn't hurt anybody."[24] Wildflowers and her efforts to record their fragility filled the void left by the absence of faith, a void she was more conscious of than she otherwise might have been because of her love of the rituals and music of the Anglican Church. Accordingly, as she told the audience at the Robert McLaughlin Gallery in Oshawa, Ontario, they are "awfully fragile and blowing in the wind and we use adjectives for them and equate them with life. They're everything I rather love about life, temporary, you can't be here forever. We're very sturdy but we could be blown away tomorrow, you know, all the things that give an edge to one's life."[25]

Further, as Molly knew, while Van Gogh's and Cézanne's flower still lifes broke new ground, in the grand sweep of art history—which valorized religious, historical, and abstract painting in turn—still lifes occupied a lesser corner, one judged suitable for women's "gentility."[26] Painterly depiction of plants were, as art historian Kristina Huneault shows, a "means by which women could become acquainted with—and implicitly socialized into—an ordered [patriarchal] system."[27] Like Joyce Wieland's and Mary Pratt's work, Molly's flowers were sometimes derided as "kitchen art."[28] Molly herself—partly because she painted them quickly and partly because they were the backbone of her income

—called the flower paintings her "pot boilers."[29] Although Molly once told Joan Murray that an artist should avoid "politics," in the context of her marriage asserting her status as a woman was close to an existential need. Accordingly, when telling Murray that Mortimer-Lamb's paintings of "gardens and all that were very feminine," Molly caught herself up short and asked the rhetorical questions: "Why call them [flower paintings] feminine? Why can't men feel that way?"[30]

Another irony is the origin of the flowers Molly used for models. In her mind, recalls Smith, Molly set out "to capture the unique moment embodied in a wildflower in its natural context. This is why store-bought roses were not important for her; they came with no context. Put another way, for her, 'Eating fiddleheads is good. Picking fiddleheads is a religious experience.'"[31] Yet, however much flowers she immortalized formed what she called her "religion," even a "miracle"; the flowers placed before her easel were no longer *in* or *of* the garden.

Indeed, as author Frances Itani relates, the wildflowers were often subjected to tremendous violence.[32] "One day we went for a walk in a forest and came back to Molly's house laden with wildflowers," recalls Itani, who was visiting to discuss Molly's illustrations of one of Itani's books. "Molly laid them out on the ground and with a mallet began smashing the stalks, before putting the wildflowers in a jug she would paint later."[33] So while her paintings may elicit delight and may feel Edenic, the fact that Molly used flowers violently ripped from their natural habitat shows how she was enmeshed within what cultural critic Theodore Adorno called "second nature"[34] and, indeed, shows that Molly was more closely tied to the tradition of flower painting than she at first appears. Thus, Molly's flower paintings remind us of the violence they would otherwise seem to have been an escape from.

Joe Plaskett's claim in the introduction to *Wildflowers of Canada: Impressions and Sketches of a Field Artist* (for short, *Wildflowers*), Molly's memoir published in 1978, that the "plants speak for themselves" and that "there is the quality of independence, as if the personality of the artists has not intruded" accorded with Molly's own statements that painting flowers

was akin to automatic writing.[35] Indeed, half worrying if she had anything to say, she told Brigid Toole Grant that she "just see[s] something" and paints it "without thinking beyond the visual thing."[36]

This "I am a camera" notion that Molly would adopt was no more possible for her than it was for the authors of the near namesake *The Wildflowers of Canada*,* published in instalments in the *Montreal Star* in the 1890s. As Huneault shows, however much the artists who contributed to this volume may have believed that their personalities were absent, they were (profoundly) present. Since individual specimens vary depending on soil and climate, "illustrators regularly smoothed over imperfections, enhanced colours, or modified proportions in order to capture the species' most distinctive elements." The effort to be *true to nature* ended up with the botanist-painters having to "decide what was nature in the first place."[37] Just as Molly, the war artist, sought to capture the most characteristic actions and settings of the CWACs, Molly the field artist captured nature. Indeed, even when she painted flowers *en plein air*, Molly chose her easel position very carefully, as Andrus recalls. "Since she was trying to capture that particular flower under very specific circumstances, she had to paint quickly before the sun moved too far or the breeze altered the position of the flower."[38] More commonly, Molly painted indoors, though unlike Mary Pratt, more often than not, Molly brought the cut and beaten fronds into her kitchen or studio.

The final irony is the one identified in a different context by Walter Benjamin: "There has never been a document of civilization, which is not simultaneously one of barbarism."[39] Molly's artifice obscures the violent origins of her artistic object by turning them into documents in the history of art. Molly's flowers owe nothing to Pegi Nicol MacLeod's sculptural flowers, which, even as they echo aspects of the Group of Seven, present an unabashed female sensuality. Nor are Molly's works informed by the foliage in Prudence Heward's work or J.E.H. MacDonald's *Tangled Garden*

* The similarity of this title and the one chosen by Christopher Ondaatje's Pagurian Press, the publisher of Molly's memoir, may at least partially account for why Molly loathed the title.

10, to name only two other artists she might have drawn on. Molly's illustrations also evince no traces of Emily Carr's stylized nature or her tonal flower still lifes.

In an interview in 2000, Molly addressed her artifice while discussing the criticisms some made that her works were "sloppy" (because of watermarks) and seemed simple to paint. She gave away one of her techniques: "I put water on the paper and drop paint into it."[40] But unlike Abstract Impressionists like Jean-Paul Riopelle, who manifestly avoided ordering their paint so that it represented known objects, Molly put her brush into the inky water and began to draw paper poppies, cyclamens, cosmos, or more than a dozen other flowers.

In *White Tulips*, Molly filled the picture plane with paint, just as Bruno was doing at the time. Against a tonal white-and-grey background are two vases, each with a number of white tulip cuttings, which together have seventeen flowers and at least twenty leaves, some bending over the vases. The vase on the right contains a few blue flower petals which touch, and even vanish into, the top of the plane, while the reflection of the vases vanishes at the bottom of the plane. The work's volume and organization make it as solid a flower still life as possible. In her later flower watercolours, Molly removes information, in some cases leaving shadows suggestive of vases and watermarks suggestive of blossoms. The effect of her quick brush strokes that often trailed off to striations was to increase the fragility of her subject at the same time as giving the petal the feeling of movement.

Works such as the Beaverbrook Art Gallery's *Flowers in the Studio* (p. 185) show Molly foregrounding what the phenomenologist Maurice Merleau-Ponty writes about in his study "Cézanne's Doubt" and other works: how consciousness deals with "perspectival distortions" created by pigment on canvas or paper. "When seen globally," Merleau-Ponty observes, both the vase and the distortions, such as those arising from *Flowers in the Studio*'s Cézannesque table, give way, "as they do in natural vision ... to the impression of an emerging order, of an object in the act of appearing, organizing itself before our eyes" (in an analogous way to how

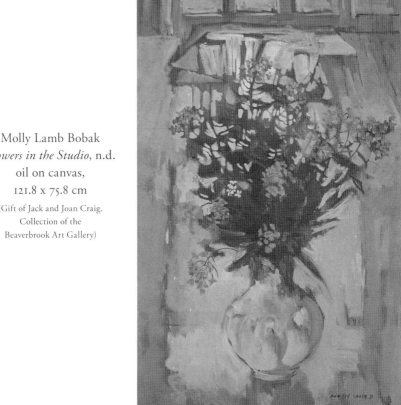

Molly Lamb Bobak
Flowers in the Studio, n.d.
oil on canvas,
121.8 x 75.8 cm

(Gift of Jack and Joan Craig.
Collection of the
Beaverbrook Art Gallery)

an out-of-focus object in the distance comes into focus the closer we get to it).[41] Accordingly, while it may seem that we can focus on the flower pot, Molly has arranged the pigments so that we are drawn into the "other space" (white space) and then, because the pigments that make up the pot are still within our field of vision, we are pulled back to it. The visual effect is similar to the one experienced by students in Psych 101 when they see the Rubin vase: depending on the pitch of one's eyes, one sees either two identical black faces facing each other or a cut-out silhouette of a vase. While Bruno's Expressionist works wrench viewers out of their everyday world and thrust them into his inner topography, part of the purpose of Molly's flowers (and crowds, as we will see) is to create a play

of perception that, while intellectually interesting and complex, adds to the viewer's *delight*.

In 1977, Ian Lumsden found Molly's use of large amounts of negative white space in her paintings of skaters (discussed in coming chapters), and flower still lifes to be noteworthy enough to ask her about it. Molly pointed to David Milne, the American abstract painter Sam Francis, and an unnamed work of "Eastern Art" that she saw in New York the early 1960s as warrants:[42] "I'll never forget it, just two little persimmons at the bottom of the page and I was so conscious of the empty space and how good it was with the two little busy pieces."[43] The negative space is so powerful, in works such as the one Metcalf was gifted, it seemingly dissolves the vase; indeed, Metcalf recalls that while Molly started the watercolour by roughing in the vase, she soon abandoned it, leaving, if we focus on it, what resembles a broken piece of ancient pottery that is all but disconnected from the painting's main concern, namely the sprigs of anemone sent to her by a friend who lived on one of the Channel Islands.

Both Heffel's online guide to the secondary art sales market and an online search indicate that the vast majority of Molly's flower pictures either have no vases or do not have fully worked-out vases. And those that do have fully worked-out vases are not set against grey, red, or bluish tonal walls but seem suspended in white space. In her skater paintings, Molly contains the white space within the oval formed by the skaters. In her flower paintings, she controls the white space by, almost without exception, placing it to the right of the figure. Critics might well have found Molly's work more interesting had she placed the white space on the left, but doing so would have created significant difficulties for her audience, who expected to "read" a painting as they do a text: from the left to right.

Preventing such a lacuna from opening up was so important to Molly that in works like *Spring Bouquet* (p. 213), where the flowers are more than halfway from the left side of the page, the artist uses heavily diluted black paint to rough-in the wall behind them, complete with windows, that

extends some distance toward the left of the flowers. As well, in the same plane as the flowers is a series of blue-black tinctured shapes that extend to the left, the final one ending a few inches from the left side of the piece of fine paper ordered from a store in Paris.[44]

While it is possible that the first blue/black shape was "a happy accident," as Brigid Toole Grant termed a water spot in another of Molly's works that I showed her, the series of watermarks in the *Spring Bouquet* had to have been intentional.[45] They also can be viewed as an example of Molly's turning the modernist idea that the artist must acknowledge the materiality of the artwork toward a purpose that would have horrified Clement Greenberg: the creation of a narrative structure. Instead of spilling paint for the sake of it, these splotches create a horizon line and fix the flowers in space. Finally, an even lighter shape extends all the way to the paper's left corner, which means there is no expanse of formless white to the left of the daisies.

In a work like *Lilly*, because there is not the hint of a vase, there appears to be nothing that would amount to a horizon line. Yet by depicting the green stalks so densely and in such depth in relation to the ethereal blossoms above, Molly gives them enough solidity that they themselves suggest a horizon line. Indeed, the curvilinear tangle of the stalk forms, albeit in miniature, a moderately dense canopy with "branches" close enough to the ground to be climbed. In *Spring Bouquet*, the leaves and petals are there, but they are loosely painted. The *sfumato* effect produces traces that subtly replicate the track of the slightest breath of wind that caused the petals to move along.

Other works, such as Gallery 78's *Poppies*, intimate not just the fluttering of the edges but the movement of the entire poppy. Molly lightly inks in morphological features and "blossoms" made from tinctured water that fill in space and are reminiscent of the sort of double-exposed photos her father developed in his dark room when she was a child. The effect is profound. For not only has Molly indicated a possible "that-has-been" but she has also indicated a possible "anterior future" (e.g., "I will have

finished reading the book by tomorrow"), to borrow terms from the French structuralist critic Roland Barthes's study of photography.[46] Molly tipped her hand in 1997 when she drew attention to her love of Virginia Woolf's *To The Lighthouse*. One of the central moments of the book is Woolf's description of artist Lily Briscoe at the moment of committing pigment to paper or canvas:

> Where to be begin? — that was the question at what point to make the first mark? One line placed on the canvas committed her to innumerable risks, to frequent and irrevocable decisions.... Still the risk must be run; the mark made.
>
> With a curious physical sensation...she made the first quick decisive stroke. The brush descended. It flickered brown over the white canvas; it left a running mark. A second time she did it — a third time. And so pausing and so flickering, she attained a dancing rhythmical movement, as if the pauses were one part of the rhythm and the strokes another...she scored her canvas with brown running nervous lines which had no sooner settled there than they enclosed...a space.[47]

Molly's wispy, ethereal flowers strain at such limitations. In portraying objects in motion, moving in space, Molly pushes up against the limit of the painting, which amounts to a freeze-frame, and has the effect of intimating the existence of an alternative history of how she would present these poppies.

After a dinner with friends in March 1972, Molly confided to her Diary, "Bruno simply horrible. God Damn him, showing Amy his 'silly pornographic' drawings and telling off colour jokes."[48] A few months later, an evening with the Patakis went off the rails when Bruno and Jimmy

Pataki "hatched a plan to see a porno: Erotica or Bare Something." Molly reluctantly went along. "The movies are hoaxes...shot for 5¢ in some Hollywood swimming pool the size of a kidney table," she groused before getting to the heart of the matter: "I have no sympathy with men—they don't know what they want—always trying to prove something."[49]

Bruno's drawings that Molly lumps together as "silly pornographic" nudes can be seen as being analogous to Molly's flowers, showing her husband's joie de vivre that is so absent from his larger Expressionist works. His sketches divide into three groups. The first is not all that different from Molly's *Min and Bin Visit J.C. in N.Y.C., 1963-64.* The one-page, eight-scene work echoes her War Diary style. The second scene, "This Was Burlesque," is a profile of a kneeling naked woman. Her arms are extended behind her, causing her shapely breasts to push out as far as possible, ending in nipples resembling rocket nose cones. Scene five is of a svelte belly dancer gyrating under the words, "Happy New Year at the Egyptian Gardens."

The second group, the "Fat Ladies" (the term is Bruno's) series, were products of Bruno's imagined printing company, Marmot Press—the name is a play on the name of a species of large squirrel that lives in Poland: *Bobak Marmot.** One of the series shows a frontal and rear view of a heavy-set woman wearing long black gloves and black stockings held up by a small black garter belt. Her undersized breasts, really just thick half circles with dots for nipples, are less enticing than her come-hither expression, achieved with an economy of lines, and sensuous, clearly well-lipsticked, upper lip. In the mid-1970s, Marmot Press printed a number of T-shirts of this Fat Lady, wielding a dominatrix whip, to raise funds for the UNB Art Centre. "They may have been 'naughty' but they sold like hot cakes," recalls Andrus.[50] We can get some insight into the popularity of these T-shirts from E.H. Gombrich and Ernst Kris, who, following Freud, argued, "There was a time in all our lives when we enjoyed being rude and naughty, but education has succeeded—or should have succeeded—in

* Bruno's nickname, used also by his son Alexander, was "Marmot."

turning this joy into abhorrence.... In caricature, however, these forces find a well-guarded playground of their own."[51]

Like the Christmas cards and other cards for which Bruno was renowned among friends (below), these cartoons demonstrate Bruno's excellent draftsmanship. Bruno draws his subjects with "a rudimentary line or two and trusts the viewers to supply the depth for themselves."[52] His approach is closer to a cartoonist like Charles Schulz and a complete contradistinction to his Expressionist works. One of the first "Fat Ladies" dates to 1971, when Andrus was still fuming about an Atlantic Provinces Art Circuit (APAC) meeting he organized at Concordia University. A non-francophone curator had insisted that all publications be printed unilingually in French—even though the point of holding the meeting in Montréal was to attract American universities such as Dartmouth and the University of Vermont to join APAC and share exhibits. This issue, however, did not lend itself to caricature. What did was Concordia's inability to organize the 11 a.m. coffee break and the pretensions of such academic conferences.

On the left of the image drawn with blue ballpoint pen is a standing naked man holding up a fat naked woman whose legs are wrapped around his waist; they are obviously happily copulating. In the centre are three other naked conference attendees standing together. The rather nervous thin man's dangling penis seems all the more forlorn in comparison to the smiling happy full-figured woman to whom he is speaking. On the right is a door with a sign saying "APAC MEETING" tacked to it. The door has just been opened by a fat woman holding a tray with a thermos of coffee and cups. Beneath this less than intellectually engaged group is the caption, "It was at 11 this morning I wanted coffee—You fool."

Another example of caricatures from the early 1970s came when, knowing that Andrus was suffering the "blues" from a failed romance, Bruno offered him some visual solace. In the cartoon, a naked Andrus sits on the side of his bed, his head in his hands. Behind him are two women jumping on his unmade bed and two others, one doing a handstand, the

other apparently readying to do so. Across the scene is a banner speaking for them, "We will all do for you Donald."

In fact, the sketch is complex and owes more to Peter Paul Rubens's *The Three Graces* than it does to *Playboy* and *Penthouse*. The self-consciously bawdy message, which recalls wartime BBC Radio comedy, pushes Bruno's sketches far beyond the staid context of the traditional aesthetics of the female nude. In his classic study, *The Nude* — which discusses, chiefly, the female nude — Sir Kenneth Clark argued that Rubens's fleshy nudes rose to "art" although they "seem at first sight to have tumbled out of a cornucopia of abundance; the more we study them the more we discover them to be under control," governed, as it were, by well-established artistic norms.[53] According to art historian Lynda Nead, the classical construction of the female nude more or less ignores its nakedness and sublimates its sexuality. The "base matter of nature," a naked woman's body — and, especially, Rubenesque women with their rolls of flesh — is magically transformed into art when the artist adheres to two aesthetic injunctions.[54] The first was laid down by Aristotle. For him, the "chief forms of beauty are order and symmetry and definiteness," the paradigmatic example being the Venus de Milo.[55] The second is to avoid representing anything that would incite lust, that being the province of pornography, the etymology of which is Greek and means, essentially, "whore writing." According to Clark, Rubens's genius was to find a way to render large women so that instead of seeing an abundance of flesh, we see, or, at least Clark did, the Aristotelian notions of "order and symmetry." Such a way of seeing *The Three Graces* ensures that it falls within the ambit of Immanuel Kant's signature addition to the Western aesthetics: the experience of beauty occurs when a viewer views the object with "disinterested contemplation." By happy coincidence, the German word for the opposite of the type of experience of beauty Kant valorizes is *lust*.[56]

Bruno knew his art history and the aesthetic injunction against depicting plump women as sexual. He likely also knew that moralizing

censors belonging to the Ontario Society of Artists exhibition at the AGT in 1933 rejected Lilias Torrance Newton's *Nude* because a female's pubic hair was held to be more sexually explicit than bare pudenda. Bruno would have had no doubt that Andrus would see the APAC cartoon as Bruno's thumbing his nose at conventional notions of beauty by depicting fleshy naked women as sexual beings. The less-than-double entendre, "We will all do for you Donald," becomes even funnier once we hear the echo, as Andrus did, of the wartime BBC Radio show known as *ITMA* (*It's That Man Again*), in which a certain Mrs. Mop introduced herself in a sad and whingeing voice that did little to hide the double entendre, "Can I do yer now, sir?"[57]

The works that offended Molly include the nude Bruno gave to John Metcalf in 1973. Knowing that his friend was going through a difficult marital breakup and was lonely for companionship, Bruno sketched a young woman pleasuring herself and gave it to Metcalf, telling him it would help when he was alone. Andrus, who had been given one of Bruno's explicitly erotic works in a similar situation, thinks that among the first of these erotic sketches was one of a young woman named Charlotte. All three of these women can be considered classically beautiful.

There is no doubt that at the time the members of the censorship boards of Ontario, New Brunswick, and Nova Scotia would have considered *Charlotte* pornographic. She lies on a bed looking at us, her naked legs wide open. Her left hand palpates her left breast while her right rubs the cleft between her full labia. Indeed, at first glance, the sketch even seems to fall within Bruno's understanding of pornography; he told Joan Murray that *Playboy* pictures are pornographic because of their mimetic reality (putting aside, of course, the "perfection" achieved by air brushing). *Charlotte* doesn't go quite that far, however: it "leaves something to the imagination" of the viewer.[58] In other words, Bruno seeks to involve the viewer in completing the scene, perhaps by imagining Charlotte's orgasm — and thereby not only involves the viewer in the completion of the erotic story but, because of the subject's sexuality, engenders desire in many of her viewers. Bruno seeks to engender something quite different

Bruno Bobak, *Untitled, Fishing Community*, c. 1939
watercolour on paper, 37.4 x 50.8 cm

Molly Lamb Bobak, War Diary:
"Life begins as Second Lieutenant (Part II)" (Last Supper)

(Library and Archives Canada, Acc. No. 1990-255-172 Gift of Molly Lamb Bobak.
Courtesy of Library and Archives Canada)

(above) Bruno Bobak,
Cross Country Convoy, 1943
watercolour on paper,
30.5 x 57.2 cm

(Hart House Permanent Collection.
University of Toronto, Toronto, ON)

Bruno Bobak, *A Sherman Tank of the Governor General's*
Foot Guards, Burned Out, 1943,
watercolour on paper, 27.6 x 37.2 cm

(CWM 19710261-1514, Beaverbrook Collection of War Art,
Canadian War Museum. Courtesy of the Canadian War Museum)

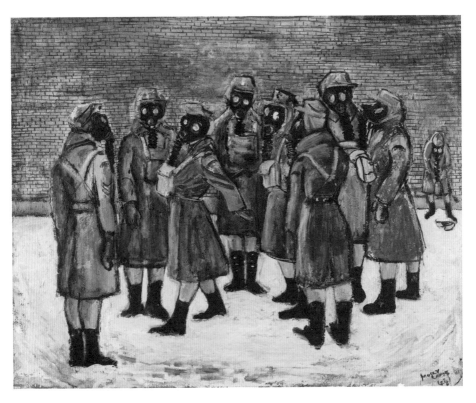

Molly Lamb Bobak, *Gas Drill*, 1944
oil on canvas, 68.8 x 86.8 cm

(CWM 19710261-1603, Beaverbrook Collection of War Art,
Canadian War Museum. Courtesy of the Canadian War Museum)

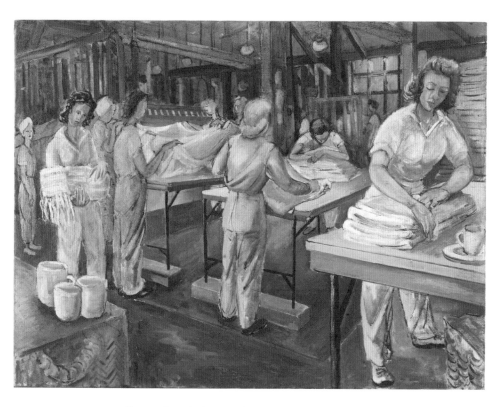

Molly Lamb Bobak, *Number 1 Static Base Laundry*, 1945
oil on canvas, 76.7 x 101.5 cm

(CWM 19710261-1618, Beaverbrook Collection of War Art, Canadian War Museum.
Courtesy of the Canadian War Museum)

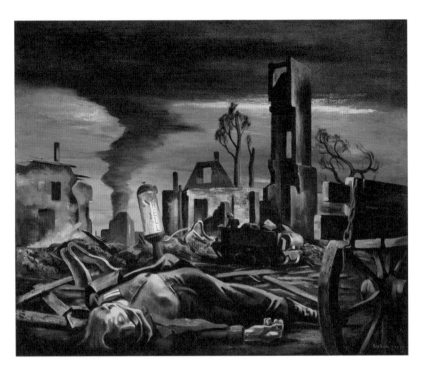

Bruno Bobak, *Friesoythe, Germany*, 1945
oil on canvas, 102 x 122.2 cm

(CWM 19710261-1477, Beaverbrook Collection of War Art, Canadian War Museum.
Courtesy of the Canadian War Museum)

Molly Lamb Bobak, *Ruins of
Emmerich, Germany*, 1945
watercolour, ink, charcoal,
and graphite on paper,
35.7 x 50.8 cm

(CWM 19710261-1628, Beaverbrook
Collection of War Art, Canadian War
Museum. Courtesy of the Canadian
War Museum)

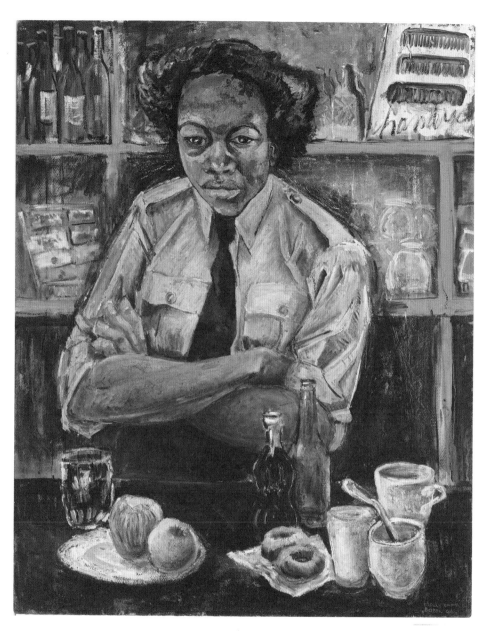

Molly Lamb Bobak, *Private Roy,* 1946
oil on fibreboard, 76.4 x 60.8 cm

(CWM 19710261-1626, Beaverbrook Collection of War Art, Canadian War Museum
Courtesy of the Canadian War Museum)

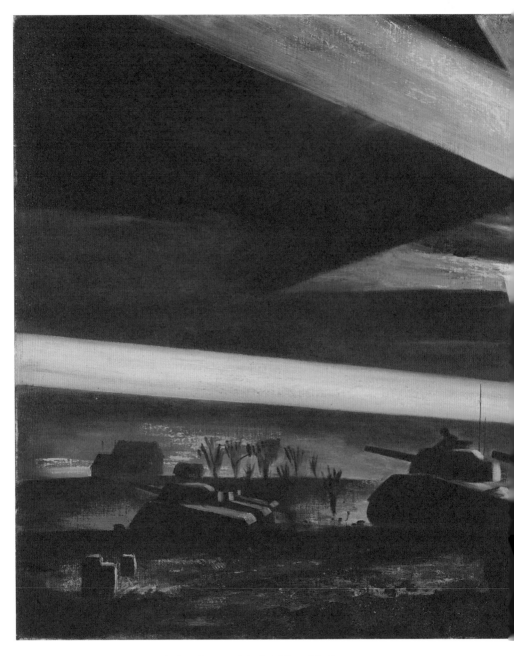

Bruno Bobak, *Sherman Tanks Taking Up Positions
Under Artificial Moonlight*, 1945
oil on canvas, 71.7 cm x 122.3 cm

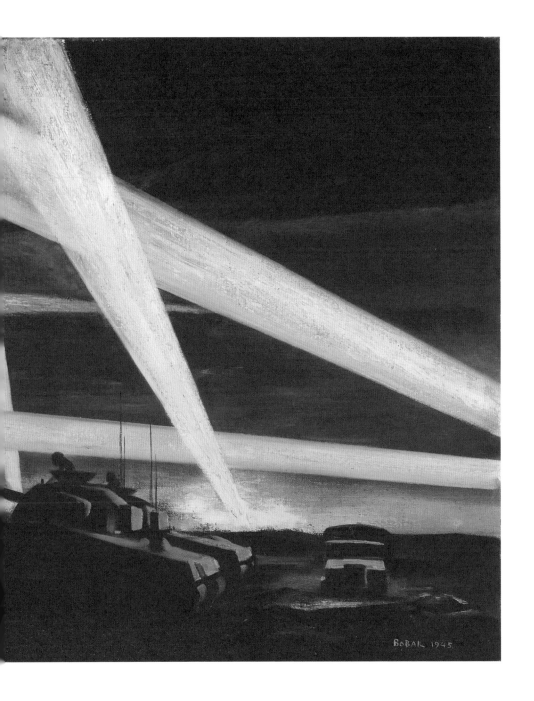

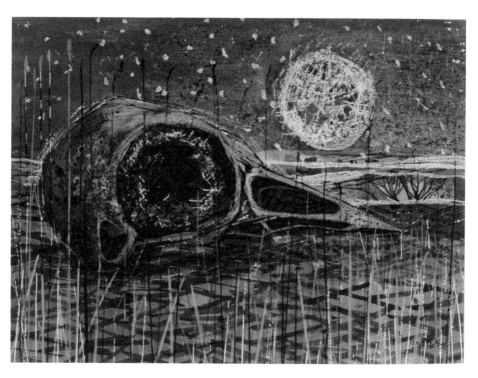

Bruno Bobak, *Skull*, 1954
watercolour with wax crayon and charcoal on paper, 27.9 x 39.4 cm

(Gift of the Artist. Beaverbrook Art Gallery, Fredericton, NB)

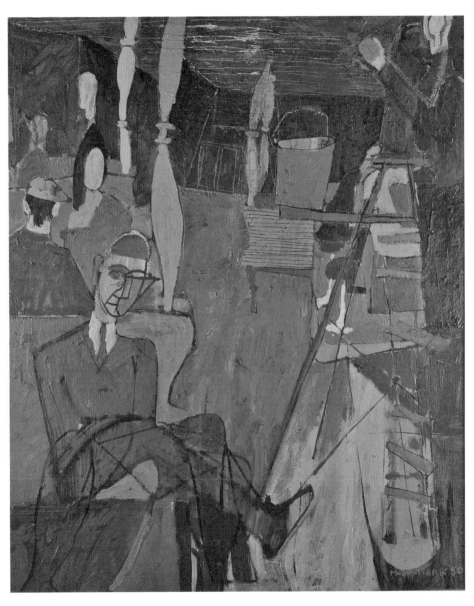

Molly Lamb Bobak, *North Vancouver Ferry*, 1950
oil on fibreboard, 59.8 x 50.4 cm

(Art Gallery of Greater Victoria, Victoria, BC)

Molly Lamb Bobak,
London Pub, 1962
oil on canvas, 45.5 x 53.5 cm
(Gallery 78, Fredericton, NB)

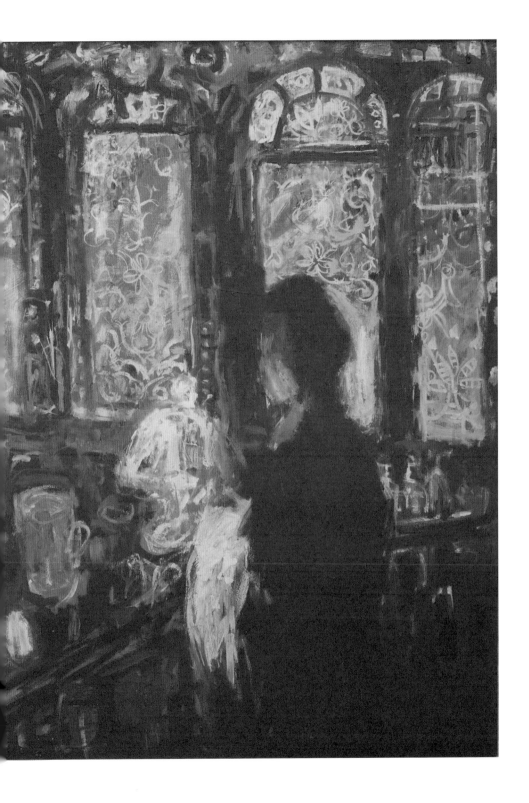

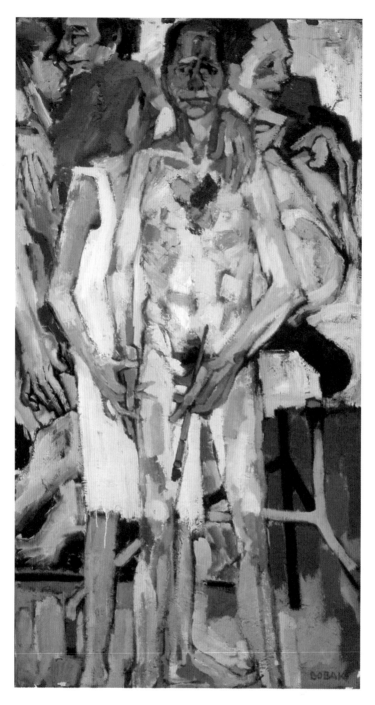

Bruno Bobak, *The Artist with Molly*, c. 1963
oil on canvas, 177.8 x 95.9 cm

(Gift of the Artist. Beaverbrook Art Gallery, Fredericton, NB)

Bruno Bobak, *The Wheel of Life*, 1966
oil on canvas, triptych, 152.4 x 253 cm
(Confederation Centre Art Gallery, Charlottetown, PEI)

Bruno Bobak, *A Tender Nude*, 1966
oil on canvas, 76.2 x 152.4 cm
(Gift of the Artist. Beaverbrook Art Gallery, Fredericton, NB)

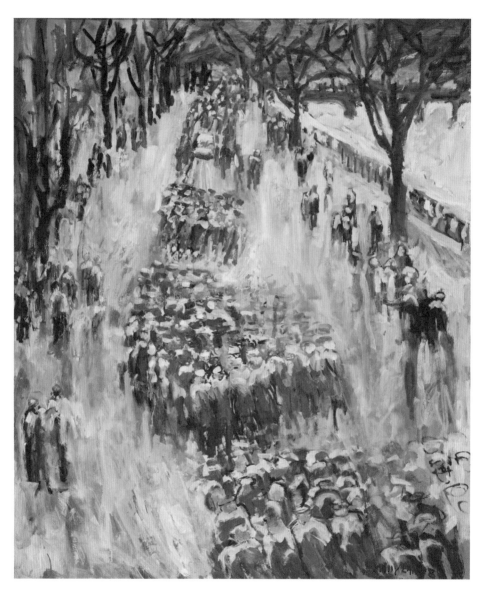

Molly Lamb Bobak, *Massey's Funeral*, 1967
oil on masonite, 121.9 x 101.6 cm

(Gift of Dorothy and Edgar Davidson. Collection of Owens Art Gallery,
Mount Allison University, Sackville, NB)

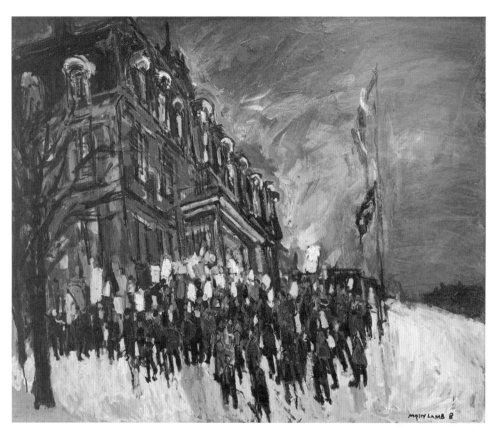

Molly Lamb Bobak, *Demonstration U.N.B.*, n.d.
oil on hardboard, 101.6 x 121.9 cm

(Collection Faskens Law Firm. Photo by Miriam Redford)

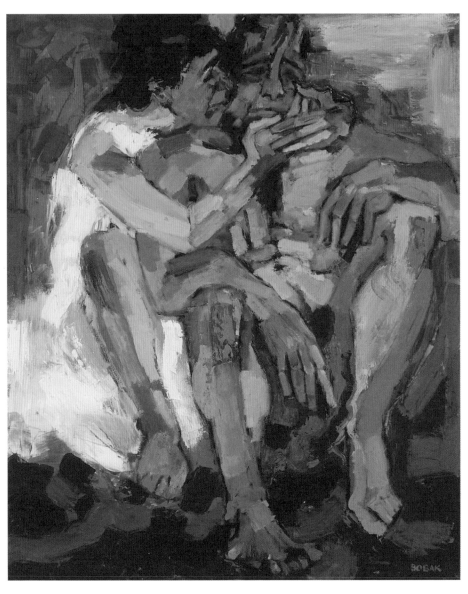

Bruno Bobak, *The Tired Wrestler*, 1964
oil on canvas, 120.0 x 100 cm

(Gift of Mel and Stephen Ross in memory of Ruben Ross.
NAC: 965.29. Leonard and Bina Ellen Art Gallery, Concordia University, Montreal, QC)

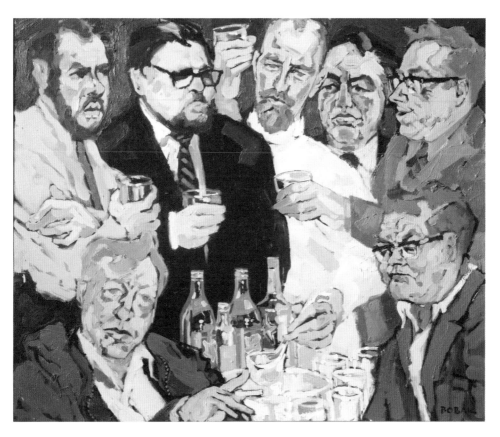

Bruno Bobak, *Kent's Punch*, 1970
oil on canvas, 101 x 122 cm

(University of New Brunswick Permanent Collection, Fredericton, NB)

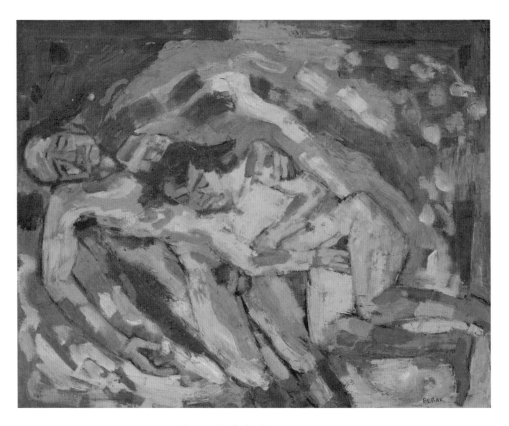

Bruno Bobak, *Journey*, 1975
oil on canvas, 121.9 x 152.4 cm

(Gift of the artist. Beaverbrook Art Gallery, Fredericton, NB)

(opposite) Molly Lamb Bobak, *Spring Bouquet*, n.d.
watercolour and graphite on paper, 56 x 73.5 cm

(Private collection)

(above) Molly Lamb Bobak, *Anemone*, 1973
watercolour on paper, 41.28 x 57.15 cm

(Collection of John Metcalf)

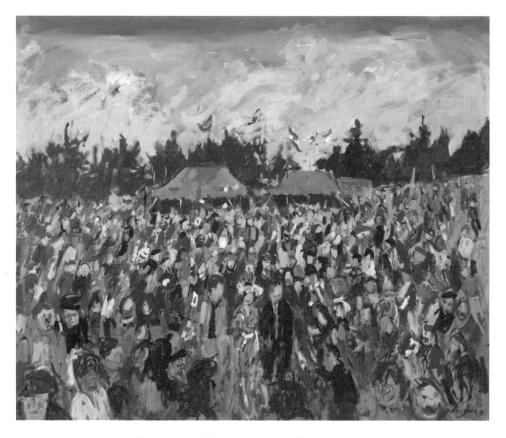

Molly Lamb Bobak, *John, Dick and the Queen*, 1977
oil on canvas, 101.3 x 121.2 cm

(New Brunswick Art Bank)

(opposite, top to bottom)
Molly Lamb Bobak, *The Lighting of the Christmas Tree*, 1982
oil on canvas, 76.2 x 101.6 cm

(Private collection)

Molly Lamb Bobak, *Black Rocks, Caeseria*, 1985
oil on canvas, 76.2 x 101.6 cm

(Private collection)

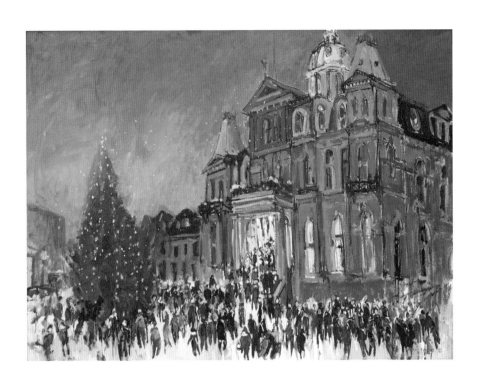

Bruno Bobak, *Garden*, 1985
oil on canvas, 91.4 x 121.9 cm

(Collection of Mr. and Mrs. Gary H. Stairs)

Bruno Bobak, *The Home Pool*, c. 1985
serigraph on paper, 40.6 x 56 cm

(Beaverbrook Art Gallery, Fredericton, NB)

Molly Lamb Bobak, "Bubble Gum Benny"
in Sheree Fitch, *Toes in My Nose and Other Poems* (Doubleday Canada, 1987)

(Courtesy Department of Education, University of New Brunswick)

Molly Lamb Bobak, *Trooping the Colours*, 1989
oil on canvas, 99.97 x 120.65 cm

(PPCLI Museum & Archives: NAA1641)

Molly Lamb Bobak, *The Raising of the Cross,* 1996
oil on canvas, 121.92 cm x 91.44 cm

(Christ Church Cathedral, Fredericton, NB)

Bruno Bobak, *Gary Stairs Fly-Fishing*, c. 2005
watercolour on paper, 53.3 x 37.8 cm

(Private collection)

Molly Lamb Bobak, *LBR (Lady Beaverbrook Rink)*, 1975
oil on canvas, 101.6 x 121.92 cm

(Collection of Arnold and Judy Budovitch. Photograph by Jason Nugent)

Bruno Bobak, *Summertime in Fredericton*, c. 1997
oil on canvas, 101.6 x 121.92 cm

(Beaverbrook Art Gallery. Purchased with funds from the Senator Richard Hatfield Memorial Fund.)

from "disinterested contemplation" and draw us into the visceral pleasure of the moment.

The key to understanding *Charlotte* is her expression, which has nothing to do with Hugh Hefner's photographers and even less to do with Kant's aesthetics. Bruno gives her much the same expression the Baroque sculptor Gian Lorenzo Bernini gave his subject in the statue *The Ecstasy of St. Theresa*, which prompted one libertine French cardinal to say he didn't know what being shot with an arrow felt like, but he certainly recognized her expression. Charlotte's pre-orgasmic look invites us to imagine the pleasure she experiences. Her masturbation differs, therefore, from Molly's in *Journey* (p. 212) because Charlotte's is unalloyed pleasure without the slightest hint of reproach.

While the sketch could be dismissed as being one more example of a nude woman under the "male gaze," doing so would be to miss the point.[59] True, the artist is male, and, thus, no matter how many women view it or find it arousing, it came to existence under a male hand, but through her lidded eyes, Charlotte engages us — and her creator — on her own terms. Inasmuch as any figure in a work of art can be, she is her own agent. The lines Bruno put on the page celebrate female pleasure. It is her body that registers the pleasure of the moment. It is her body that, *pace* Kant, incites our desire. And, it is worth noting, it was sketched around the same time that Bruno sold thirty-five small nudes in a gallery.

Helen (p. 226) and *Fat Girl* — who looks enough like Helen for us to call her *Helen II* — are, perhaps, more problematic. Both women are obese and, thus, share nothing with the period's cultural definition of how sexually active women should appear. Both have broad legs and buttocks; the difference between Charlotte's breasts and theirs is made all the more stark by their large, dark areoles.

Bruno makes no effort to discipline these women's bodies by "quoting" a classical work. Still less can we imagine Sir Kenneth studying them to discover how their "cornucopia of abundance" is, in fact, orderly. Helen sits, perhaps on the floor, her legs open, revealing her pudendum. Helen II is seen from her left side, on right knee with her arms splayed and her

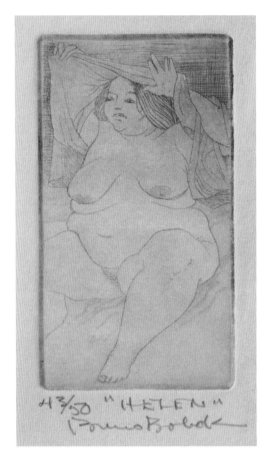

Bruno Bobak, *Helen*, n.d.
etching on paper, 15.5 x 10.4 cm
(Beaverbrook Art Gallery, Fredericton, NB)

left leg on the floor so that her body is pitched toward the right; her huge left buttock dominates the picture. The two figures are, however, among the most profound of Bruno's investigations into feminine beauty and sexuality.

Both Molly's Diary and his daughter's memoir make clear that Bruno was anything but a feminist. Yet in these sketches he depicts something almost unknown in the art of the 1970s and 1980s. It hardly matters whether Bruno was attracted to larger women (though the evidence is that he was). What matters is that just as he broke Canadian convention by painting his own nude self-portrait and using his wife as a nude model, he depicted Helen not as a woman who hides her body in shame but as a woman comfortable with showing off her sensuality and sexuality. Helen

II knows that since she is drying her hair, her arms are above her head, revealing the ripples of flesh running down her upper arm, but she refuses to look away from us. In *Helen*, she readies herself for sexual pleasure in one of the less back-breaking Kama Sutra positions, as she looks back, knowingly, toward us. Like the more classically beautiful Charlotte, each of these women is her own agent—from everything we can tell, supremely uncaring what aestheticians like Clark might say about their "unruly fleshy folds."

In neither sketch is there much of a background, which means that, were it not for the matting, there would be almost no distance between the pictorial space and our space. The Helens' sheer physicality, therefore, seems to spill out of the pictorial space. Helen II beckons forth her excited—but unseen—lover, who we can easily imagine touching her. This is precisely the phenomenological moment that horrified the moralists who removed Prudence Heward's nudes from the walls of the Art Gallery of Toronto when Bruno was a student there: fear that the image of a woman enjoying her body, her sexuality, would awaken the (male) viewer's corporeal sense of desire. The desire to touch a figure in a painting, or, more specifically, to take even the first step on the road to imagining engaging in sexual congress with her, marks the distance between the traditional (Kantian) conception of interacting with art and Bruno's own—while at the same time underscoring his sophisticated understanding of the limits of the traditional notion of the beautiful nude.

Chapter 8
"The Fall of the House of Bobak"

The Queen arrived — everyone cheered and clapped — it was
tremendous. Then I found John & we drove in the motorcade along
the Trans Canada where people were all out with flags — 3 little sisters
all dressed in red shirts & white blouses! What fun. Then to the park
where 8,000? kids were gathered from all over N.B. — Acadians and
English speaking alike — a huge scout jamboree — tents, marquees,
flags, standards — a pipe band, Madawaska Dancers, Les Petites [sic]
Chansons & oh, I don't know, little Acadian Singers and an oil drum
band from Saint John. It was like the Battle of Agincourt. I could hardly
draw from the excitement & emotion. Queen came … mighty roar —
she walked among the little kids — the festivities began —
it was all splendid. — Molly's Diary, 15 July 1976

The breathlessness of Molly's description of Queen Elizabeth II's visit to
Fredericton on 15 July 1976 (above) all but sweeps away years of recording
depressing political news. Three years earlier, Watergate felt "like the end
of Democracy."[1] In January 1975, she noted ruefully and fully conscious of
the irony that at the same time the United States was selling Iran $6 billion
($27 billion) of planes, Secretary of State Henry Kissinger said he would
not be averse to fighting the Arabs for their oil. Canadian politics was
little better; she mentions inflation a number of times and the obscenity
of allowing a million eggs to go bad while keeping them in storage to
stabilize prices. The federal election in June 1974 saw Pierre Trudeau's
Liberals win, as, she wrote, people voted against Stanfield's wage and price
controls. That November, Richard Hatfield's Progressive Conservatives
were returned in New Brunswick; the silver lining for Molly was that the
NDP candidate in her riding doubled her vote. A year later, she summed

up the defeat of Premier Dave Barrett's NDP government in British Columbia: "Another awful Bennett reign [begins]."[2] At home, she tried talking with Bruno about his political prejudices to no avail. But now the queen was here.

In the photo published in the *Gleaner*, Fredericton's newspaper, of Hatfield and Molly standing before her *John, Dick and the Queen*[3] at the opening of the queen's exhibit, we can almost see him thinking what he wrote on a card in June of 1978: "You have painted a sparkling Queen and captured a sparkling moment." In the two years since Molly had started blocking in the canvases, that sparkling moment, the euphoria of the Olympic celebrations, had faded. Stagflation (as inflation rose and unemployment mounted) confounded economists and politicians both. Just months after the Olympics, the nation was shocked by the election of the separatist Parti Québécois, which Molly accepted with a certain equanimity since she thought René Levesque honest and, like her, he "hates to be part of the big multi-National take over of Canada."[4] Within a year, however, she had become concerned about the *pure laine* aspect of Quebec nationalism. At a dinner party in Montréal hosted by her friend Claude Bouchard, another dinner guest, who worked at the Quebec finance department, told Molly that "artists, writers, etc. are beginning to fear the Nationalist 'dictatorship.'"[5] The scene Hatfield recalled, the one that unfolds beneath a swirling white-and-purple sky and in front of shapes that stand for, more than depict, trees has, therefore, more than a whiff of *fin de siècle*.

In the curiously named *Like Agincourt*,[6] one of the other paintings executed in celebration of the queen's visit, the sense of movement comes from both the sky and the crowd. Half of the summer sky is filled with a huge billowing cloud that runs from heavy greyish blues to lighter streaks, showing the wind aloft. The crowd, numbering into the hundreds, seems to undulate. Molly arranges them in a series of diagonal lines, some closer to the foreground and some more distant — but all running toward the viewer; to ensure the appearance of movement, Molly carefully delineates scores of legs, some bent in mid-step.

Molly at work in her studio in 1978. (Erik Christensen/*The Globe and Mail*)

Since *John, Dick and the Queen* takes place on the same day as *Like Agincourt*, Molly fills the sky with the same swirling clouds, though at this time of day of greys and blues. Given *John, Dick and the Queen*'s subject matter, a viewer would expect to find the trio in the middle or in a "bubble" that would draw attention to itself and, thus, to Her Majesty. Instead, as she often does — so often that it seems as if she is making a statement about the relative unimportance of actors who deem themselves, or are deemed to be, central players in life's drama — Molly places them near the edge of the painting, in the lower foreground, surrounded by figures of the same size (p. 214). Finding Saunders, Hatfield, and the queen requires sweeping over the pictorial space in much the same way readers of *Where's Waldo?* would a decade later.

This sweep through a riot of colours — blues, whites, flesh tones, browns, greys, pinks, blacks, purples, and reds — signalling (rather than detailing) heads, torsos, hats, faces, and fluttering Canadian flags is like what Rainer Maria Rilke had in mind when he wrote to his wife about

Cézanne's colours on 21 October 1907: "One has to leave them [the colours] alone completely, so that they can settle the matter among themselves."[7] It is this settling of matters, the way one hue or colour hands the viewer off to another and the concomitant relations formed by adjacent colours, such as the green of the grass and the red of the Canadian flags, that drives the movement that ends only when the viewer alights on the queen, who is wearing a colour-saturated royal-blue dress and white hat. To reinforce this sense of movement, Molly positions the queen so that the step her right foot is about to take will lead her out of the picture plane and into the viewer's space.

The gift that Bruno gave his wife on her fifty-sixth birthday touched Molly deeply. The single-stemmed amaryllis, which had lain under the snow, "had been dry and dark for so long" before it "pushed its way out of the round air hole." She could do no other than "admire the struggle for life."[8] Both Bruno and Molly would have known that the flower's folk meaning, dating back to ancient Greece, was "determination," and among the Victorians it stood for a "strong, self-confident and very beautiful woman."

There would be other moments of tenderness over the next few years, such as the night of 5 March 1976, when they had "a loving talk about Sash" or her worry later that month about Bruno's high blood pressure. A dual exhibition of their works in February 1977 prompted Molly to say that Bruno's works from ten years ago were "still powerful."[9] She was delighted the following October when Bruno won $1,000 for designing a gold coin. When Bruno "cut out the brandy" for a few days, Molly praised him in her Diary—"What strength he must have summoned up"—and then added, "Now everything is positive."[10] In August 1979, she was profoundly upset when the Post Office Stamp Committee rejected his submission for a horticultural stamp (presumably with Molly having recused herself). In September 1980, she was happy that Bruno had a successful show at Galerie Walter Klinkhoff, selling fifty works.

More common, however, were anguished days and nights, caused by

Bruno's relationship with Carolyn Cole. After the two went away together to Cape Breton in the spring of 1976, Molly's comment to herself, that women like Carolyn "hate, resent their husbands. Looking for something they won't both get," comes close to killing with kindness.[11] In August, after Carolyn had come to Molly to say she had fallen in love with Bruno, Molly noted, resignedly, "Both those people are suffering from being alive."[12] At least once in 1977 Bruno spent the night at Carolyn's. Molly could not help but sniff "UGH!" as she related that one mid-November night, Bruno invited Carolyn over for a "Drinky Poo."[13] When Bruno's father died and Molly and he were to drive to Montréal before catching a plane to Toronto, Bruno invited Carolyn to go with them to Montréal. Bruno's having Carolyn sit up front with him in the car humiliated Molly, who thought, "What stupid looking people."[14] In December 1977, after a pub crawl they went on alone, Carolyn dropped Bruno off at home at 2 p.m. the following day. If anything, Molly was as put off by Carolyn's crassness as by her relationship with Bruno: a year later, the day after she went with Bruno to a Christmas party at Carolyn's home, Molly sniffed, "Vulgar house full of lights blinking on and off."[15]

Molly's jaundiced view of both Carolyn and fidelity may not have always tamped down feelings over the affair, but they were not the cause of her greatest anguish. Bruno's attacks on her, born out of his feeling he "was a failure" and his heavy drinking, were.[16] A conversation Molly recounts with artist Carol Fraser shows that Molly had confided in her friends and that their perceptions of the Bobak marriage aligned with hers. After talking with Fraser in November 1977, Molly wrote, "Bruno began his descent ever since he realized that his large [Expressionist] figure paintings weren't really accepted by the public, etc.—then he goes cynical, drank too much, etc. etc." Three days later, she added, "Sometimes I come close to understanding—Bruno, some years ago, felt he'd never made it to star status in painting—he never quite achieved the fame or glory of say Alex Colville."[17] A few weeks later, Brigid Toole Grant, who greatly admired Bruno's work (she proudly displays a number of his works in her home), told Molly that she was "convinced Bruno's problem is all

booze—just a slow ugly business—not quite affecting his work but just the same changing his whole personality."[18]

Bruno was not without his own confidantes. During an argument on 29 April, precipitated by their 1977 income tax bill, which was so high because of Molly's sales, Bruno told Molly that Richard (Rick) Naill (professor and cello player in UNB's string quartet) said that "he didn't know how he (Bruno) could live with such a Dominating woman." Though Bruno told Naill that he "could stand it because he really didn't care," the number of times Bruno accused his wife of dominating him and importance of this theme in his paintings suggests otherwise.

At the end of July 1977, Molly summed up another "TERRIBLE FIGHT" by saying, Bruno "sees himself as a poor dominated man besieged by two strong bitches [Molly and their twenty-year-old daughter, Anny], as he put it."[19] Late in the year, Bruno's "ugly" mood grew into a fight about finances.[20] Bruno, Molly believed, resented the fact that she had "carved [out] a small and comfortable place in 'Canadian' art"* since I ceased trying to compete or be famous years and years ago."[21] The fight on 21 November 1977 ended with Bruno holding his head in his hands, beginning to make a list of their possessions in preparation for their separating and with him accusing Molly of "dominating him all his life."

Bruno's 1977 reworking of the scene in the 1965 oil *Lazarus* accords with what we see of his emotional life in Molly's Diary and his other work in this period. The changes Bruno makes reverse the narrative suggested by the title of the 1965 work.

In the 1965 version, a strong, self-confident Bruno made a number of religious motifs his own. True to its title, an obviously alive Bruno rises

*　 'It is interesting to contrast this statement with one Molly made in a letter Shadbolt had written eleven years earlier. "The thing I've found from my own experience, and in seeing old friends like Carl Schaeffer and Paraskiva [*sic*] *Clark and other dropouts*, is that somewhere along the line, at least in the public level, you no longer are on the way up—and finks like J. Barry Lord don't know you exist and old Mother Hubbard is just too tired to care" (emphasis added). (30 December 1966, Jack Shadbolt Fonds, UBC.)

above one we are to understand has died. The risen Bruno looks out at us with an expression that verges on the childish in a way not dissimilar to the guilelessness of Victor Frankenstein's creation before he discovered the truth about his fabrication. Even as Bruno's left hand pulls a white winding sheet over the dead Bruno's genitals, his right strokes the dead man's forehead, though without sorrow, for, he must know, he arose from the very body he now is separate from.

The river that runs through the mid-ground is more than decorative. By placing an Expressionist rendering of bustling Fredericton behind the river, Bruno ensures we know the river's name: the Saint John River. A more traditional painter would have relied on the Christian symbolism of the river named by Samuel de Champlain for St. John the Baptist, who baptized Jesus in the Jordan River and thus was the harbinger of the Resurrection. Even as Bruno invokes this association, he pushes it to one side by fusing the view of the river with flowers running down the hill that presage the flower children of the Summer of Love two years hence with Fredericton and the railroad bridge. Whatever sorrow is embodied in the dead Bruno is balanced, even surpassed, by the hope invested in the civic world of human relations.

At first glance, the changes in the 1977 version seem more a manifestation of the fact that when a woodcut is pulled, the image is the reverse of that incised in the wood: the heads that were on the left are now on the right, for example. Yet this change drastically alters the focus. Now, our attention is on the Bruno propped up on one arm looking out at us, not with a bemused look but with one where the black lines and downcast eyes create a woeful countenance, which accords with what we see of him through Molly's Diary. Nor is there now even a hint of the hill, Fredericton, or the Saint John River. The figures stand out, not quite naked, but alone.

The shift from paint to black ink and the decision to eschew cross-hatching to show volume and modelling in favour of a mixture of stark and staccato lines increases the Expressionist distortion of the figures; the exchange of grey paper for paint, thin but thick enough to provide substance, is more than an aesthetic difference for it casts the entire image

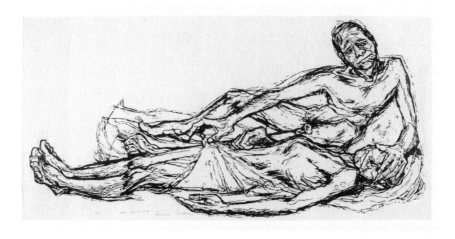

Bruno Bobak, *The Suicide*, 1977
woodcut on paper, 76 x 137 cm
(Purchased with funds from the Senator Richard Hatfield Memorial Fund.
Beaverbrook Art Gallery Fredericton, NB)

into a grey zone. In years to come, to Molly's great distress, Bruno will give voice to a distressing anti-Semitic streak that she traces back to his father; these figures show, however, that contrary to what critics of Francis Bacon's nudes thought in the 1950s, Holocaust imagery—weakened, emaciated bodies—became part of the vocabulary available to artists wishing to depict the horrors experienced by men, women, and children.[22]

The 1977 reworking of *Lazarus* contains none of the hope intimated by its name or the imagery of verdant grass and the city beyond. Renewal requires transcending the limitations of the merely existent as a different future is imagined. Bruno has reversed the image as presented in *Lazarus* and thereby has reversed the narrative flow into the future, but not the history that has occurred—a point underscored by the work's title: *The Suicide*.[23]

Equally indicative of the chasm that had opened between Bruno and Molly is Bruno's oil *The Outing*.[24] Redolent of Grant Wood's *American Gothic* (1930), this oil depicts the Bobaks all bundled up standing before their house. Snow sits on the roof over their porch and on the portico above the green front door. Bruno has flattened out the house, which

pushes him and Molly toward us in what is an almost unnatural manner. She is wearing a black coat, grey scarf, and a lighter grey toque with a tassel on top. The slate mottling of his winter coat highlights the dominant tan; he, too, is wearing a toque.

Though they stand together, they could scarcely be more separate, which probably explains Molly's comment that the "double portrait of them shocked many" who saw it at the April 1978 homage to Bruno at the UNB Art Centre where it was first exhibited.[25] Even the repetition of the facial colours — grey, lead white, and some reds (suggestive both of the materiality of Bruno's palette and either wind-burned or frostbitten flesh) does not unite them. Behind her black-framed, dark-blue sunglasses, Molly looks ahead, her lips so tightly drawn that the natural red of the lower lip has been blanched out, the couple pictured so differently from the *Arts Atlantic* cover later that year that carried a black-and-white photo of a watercolour of Bruno and Carolyn in bed.[26] There is not the slightest inclination of her body toward Bruno's left hand, which loops inside her right arm. From within the complex colouring of his eye sockets (highlighted by dark greens), Bruno looks down toward his left at Molly. His mouth, too, is tightly drawn, with only a small line of red signalling his lower lip. Though Bruno is the larger figure and his left hand and eyes are the only parts of the work that suggest movement, he once again casts himself as being less than the central actor of the drama, the one who is somehow playing catch-up, the Everyman who complained on 18 December 1977 of the "complete bondage of men to whims of women," and who didn't need to read his wife's Diary to hear her, "Ho-hum," to know how tired she was of this refrain.

Though giving of her time as a friend, teacher, and supporter to causes she believed in, Molly did not count herself part of the sisterhood of politically active feminists. She had achieved success largely on her own merits. A dozen years later, in the early 1990s, while thinking of Sylvia Plath, Molly acknowledged that she "never faced the underside of the art world like

Plath did"; what she now saw as her easy road made Molly doubt the worth of her work.[27] A few days later, still referencing Plath, she thought, "On this journey I've seen some things I've done, mostly watercolours and the only ones that have any 'Thing' are the ones I've unselfconsciously bypassed the subject and used it, of course, but without quite knowing, got beyond — over the edge to art."[28] Yet, perhaps because of her taking on the challenges of being an artist and knowing how often she disappointed herself (if not her gallerists), Molly had little time for women like Carolyn, who, "such a dull predictable swinger," the day she was "all dressed up. Resplendent in pink velvet, knee pants, boots and spurs."[29] Thinking that women like Carolyn were "casualties of women's lib" because they were "so ordinary" is in equal measure snobbism and a not unexpected Nietzschean thought by the artist.[30]

Molly felt that the implicit promises in "women's lib" — and here she has in mind a caricature of second-wave feminism, the notion that all women's activities were worthy of being valorized because they were women's activities — could not help but be unattainable and, thus, would make these women "selfish and uninteresting."[31] Always a serious reader, in 1980, without admitting it to herself in her Diary, she turned to the reading list of second-wave feminism. In September 1980, she read George Eliot's, Virginia Woolf's, and Alice James's[32] diaries, which proved to be something of a two-edged sword. On the one hand, they filled her with "spirit" and showed that "we never really change." On the other, they further distanced her from her husband: "I cannot bear the myths Bruno watches on TV."[33]

Molly does not explicitly say that she identified with Prince Lev Nikolayevich Myshkin in Fyodor Dostoevsky's *The Idiot*. Still, her statement about the novel, "All dead true," indicates that the story of a good and just man who is consistently taken advantage of struck a chord with the woman who, between 1976 and 1980, decided a number of times to leave Bruno and then relented, accepting his apologies.[34] On August 1977, for example, after a terrible fight, she resignedly wrote, "I suppose I will always stay [I] want to look after Bruno." One year later, after another

fight, Molly packed a bag and started walking toward Alexander's house a few streets away.[35] Before she got there, she noticed Bruno driving behind her. When he stopped the car, she got in.

Not even the "jollity" that so often grated on Bruno, and which her friends enjoyed and admired, could always keep Molly from self-doubt.[36] There were days like 25 August 1978, when she fell into an uncharacteristically deep trough of despondency and "dream[s] of ways of doing away with" herself. And again two weeks later, after Bruno berated her for not caring about Carolyn, Molly wrote, using an uncharacteristic word, he "make[s] me feel like a sinner, perhaps I am."

And yet, during some of the worst fights about Bruno's affair and while fighting over Bruno's refusal to go see his dying father, Molly had one of her "best painting days in years" working on an oil of daisies and two watercolours.[37] In September 1976, despite Bruno's "horrible mood," the "Queen series [was] moving on."[38] Three years later, a few days after a row that was ostensibly about Molly's lax bookkeeping but was really "about my selling," she had a "breakthrough on McGill oils, especially the winter one."[39] A good painting session on a January 1982 afternoon following a fight with Bruno relieved some of the frustration. Nonetheless, at times Molly was assailed by two (somewhat) interconnected doubts about why people liked her work. At times she felt she was "nothing but a big fraud," that her acclaim owed more to her charm and personality than it did to her work.[40] More than once, Bruno used this as a cudgel.

Molly could hardly escape signs of her success, beginning, of course, with her bank balance.[41] Her Diary notes various others. A visit to the law offices of McCarthy and McCarthy in the TD building in downtown Fredericton in 1976 led to her being ushered into the law firm's largest boardroom, where she saw her *Remembrance Day* hanging. Christmas Day of that year she spent working on twenty canvases Walter Klinkhoff's had requested ASAP. In 1977 she signed hundreds of copies of *Wildflowers of Canada* in Toronto and Fredericton. In January 1979, her secondary Montréal dealer, Paul Kastel, took thirty-nine paintings and sold them all quickly. Her success was so great that she couldn't help voicing the

complaint other artists would give their eye teeth to make: The "trouble with my work is feeding dealers rather than the search and effort for myself," a worry she had shared with Shadbolt in a few months earlier.[42]

Molly never indicates that she rereads her Diary entries. Had she done so at the close of 1980, she might have noticed that in criticizing her own work as "too tight, grey and safe" and "too subjecty and too realistic" she had hoisted herself onto one horn of a dilemma. The other horn of the dilemma was her agreement with Joe Plaskett's article that criticized the abstract sculptor Henry Moore for "detaching himself from the real looking and making standard masterpieces — formula more related to themselves than to a constant fresh vision."[43]

In 1979, Molly's friend Frances Itani asked her to illustrate her forthcoming children's book, *Linger by the Sea*. She left all but one picture to Molly's discretion. Yet, the mere fact that Molly was illustrating someone else's narrative meant she was working with a vision other than her own.

The brother digging with a shovel while his sister looks into the hole in the sand are not closely linked to Itani's text about how "night waves have COMBED the beach, leaving the sand rippled and clear."[44] Nor are Molly's figures similar to the solid, volumetric renderings in children's books like Jean de Brunhoff's Babar series or the clearly outlined faces and bodies in Charles Schulz's *Peanuts*. Molly's are, rather, quick Impressionist-inspired pen sketches. The boy's left arm, for example, is described by oblong shapes leading toward where his left elbow should be and from there to the handle of the shovel. His right leg is a series of lines and a wash to fill in the missing musculature and knee. Yet this sketch achieves an undeniable sense of movement, perhaps

Molly Lamb Bobak, illustration from Frances Itani's *Linger by the Sea*
(Brunswick Press, 1979)

because instead of the boy's right leg, for example, being fully formed, the sinewy lines suggest the shifting of muscles beneath the skin.

Molly believed that painters should not work from photographs. In spite of this, perhaps because she had not been around young children in recent years, in order to help make understood the movements of the children jumping and running, she had her camera with her when Itani visited with her children. "They were five and seven at the time; Molly told them to go and play and jump around and she took pictures of them," says Itani.[45] The photos helped Molly get the coordination of raised arms and bent legs as the children jumped around. The blue wash used in the final production may not have been to Molly's or Itani's liking, but the thinned blue ink around the children's arms and legs produced a blurring effect, which it is easy to imagine young children seeing as traces of movement, reminiscent of a Bugs Bunny or Road Runner cartoon.

As was the case with Molly's paintings of other beaches (as we will see below), there is nothing about the beaches in *Linger by the Sea* that marks them as particular places, though Itani thinks that the one with dune grass was based on a picture she gave Molly of a favourite beach in Prince Edward Island. Instead, the beaches are the product of what children's author Sheree Fitch (whose works Molly would illustrate years later)[*] considers to be the illustrator's task: "seeing beneath the text into a landscape in which the child being read to or reading the book feels safe and can imagine the depicted experiences."[46] Thus, even though young children could not name it, Molly is careful always to provide a strong horizon line and to delineate the sand from the sea and both from the sky.

Not until the very last image does Molly allow herself an almost Turneresque moment: though the trailer it features remains stable, all around it are swirls, smudges, drips, and wash that deconstruct more than describe the ground, trees, and sky, forming a pathetic fallacy linked to *what might have been* the children's reaction to the rain that reminded the children of "millions of tiny lead soldiers."[47] But, as David Lewis, author

[*] And in 1988, Molly illustrated Itani's book of poems, *A Season of Mourning*.

of *Contemporary Picture Books: Picturing the Text*, notes, "Pictures are never just pictures, they are pictures-as-influenced-by-words."[48] Thus, no matter whether Molly's young viewers see a world in tumult, the words on the page underline their safety: "If Mommy and Daddy were not reading by the soft glow of light, we would be frightened."[49]

In mid-May 1979, Bruno hinted to Molly that he "had sent a friend away," which she took to be his way of saying the affair with Carolyn was over.[50] If Molly had hoped that the exit of Carolyn from their lives would lead to an improvement in their marriage, she was quickly disabused of the notion: nine days later, she recorded "Bruno talks mean about women."[51] Over the next few months, the family politics whipsawed almost as much as the national politics did after the election of that "Oaf," Joe Clark, until his defeat in the House on 13 December 1979, setting the stage for Pierre Trudeau's return to power on 18 February 1980, just in time to lead the "No" side to victory in the First Quebec Referendum later that year.

Some days Bruno was silent; others he spent "snipping" at Molly; worse were those when the television blared.[52] At other times he was in a "gentle mood" (making 14 July the "best day in ages") and one day in August 1979, instead of leading to the expected fight, Molly found the drunk Bruno to be funny.[53] As the year wore on, however, there were more dark days than good ones. In August, Bruno was upset about Molly's slipshod invoices — which, because Molly hated paperwork, was not without warrant. She, however, saw Bruno's fury as being less about her bookkeeping than about her "selling."[54]

Bruno told Molly that three new paintings in a 1980 exhibition of his works show his "very personal feelings about" her.[55] The first, *Consolation* (p. 244), is a serigraph reworking of *Remorse*, produced sixteen years earlier, which ends the series that began with *Embrace*. *Remorse* follows *Anxiety*, which, as noted, depicts the betrayal of the promise contained in

Embrace. The alternating black and white lines that form the background of *Embrace* — which, together with the black line bordering the enraptured couple, have the effect of foregrounding the entwined pair — have collapsed, forming a darkened, cave-like space reminiscent of his postwar etchings. Inside it are the figures in profile facing left, their downcast faces mottled with ink splotches. His body, on the right, is more clearly defined than hers — or at least his torso and right arm are. Though her body beneath her neck is indistinct, there is no doubt she is lying in his embrace.

In the 1980 version, Bruno has altered the narrative in a subtle but significant way. In *Remorse*, our visual experience of the scene ends with the man's clearly delineated and strong left shoulder and arm. The figure's abstracted fingers emphasize the difficulty of this embrace, which remains incomplete. The strong shoulder, by contrast, bespeaks a certain strength, the promise contained in the title, *Remorse.* By reversing the figures' position in the later work, he makes our "reading" end in the upper right-hand corner, which is also where both their eyes direct us to. Instead of a vision of strength, we end in darkness, where neither the act of nor the receipt of *Consolation* seems possible.

It is tempting to see the light palette of *Lovers* and *Love Sick* as indicating that they were painted during a more peaceful time than 1980 was. The dominant colour in both works is white, while the arms and legs of both couples are mainly light flesh tones; the grey and green tones in the legs and one arm of the male in *Love Sick* seem more like Expressionist tropes than deeply emotional statements. As compared with the nest-like web of darkness in *Consolation*, both of these oils depict a couple sitting on the edge of a bed. While the left leg of the man with Bruno's face in *Lovers* is at an impossible angle and freakishly long, that matters less than how the nude Molly leans back to the left inside the crook of the man's splayed thighs. Her akimbo left leg both hides and touches his genitals, while his left hand, darkened a few shades to make sure we see it, lies over her pubis.

And yet, all is not well. For even as their bodies intertwine and touch each other's most private parts, their faces tell a sadder story. Once again, Bruno looks away, down toward the bottom left of the picture. His mouth

Bruno Bobak, *Consolation*, date unknown
etching on paper, 24 x 21.4 cm
(Collection of the Beaverbrook Art Gallery, Fredericton, NB)

is even more grimaced than was the Bruno's in *Consolation*. The squiggle of grey on his left forehead is less a tuft of hair than the suggestion of the crease in his balding head symbolizing his dejected emotional state. Molly's multicoloured face is, by contrast, strong; her lips are completely outlined and filled in with red. The ochre of her hair does more than balance the same colour that shadows Bruno's face; the heavy brush strokes that make up her haircut stand in sharp contrast to the thin brown paint that forms Bruno's hair. The splotches of red on her cheeks suggest that we have come onto the scene not long after she orgasmed. His bent body and expression suggest something much less.

The figures in *Love Sick* are neither Bruno nor Molly. The woman's face, seen in profile, is finely drawn in flesh tones highlighted by light-blue streaks; the heavy impasto of dark-blue streaks provides both the glittering effect of hair and the naturalistic shadows. His angular face, which verges on the cartoony, is a pastiche of colours. His half-open mouth, formed by

a black line with a dab of light brown for his upper lip and greyish-purple for the lower, reveals two front teeth while suggesting neither a kiss nor speech. The pigments that make up the browns, blues, and beiges of his face break the light plane produced by the lightness of her face and arm, which is beneath his face. By absorbing more of the light cast on the painting, these pigments capture the moment, described often by novelists, when emotions stronger than concern cross a character's face.

Like Molly in *The Artist with Molly*, this woman wears a white shift. Like "the Artist," the "love sick" man is nude. Instead of standing with a strategically placed paintbrush, he, however, sits on the bed, his legs open. His penis, a stab of brown surrounded by grey, hangs at eye level, in the middle of the work, flaccid.

After a decade, Bruno returned to what amounts to a visual campus novel he had begun with *Kent's Punch* (p. 211). Ignoring the precedent of Molly's foray in the campus story genre, *Encaenia*, Bruno's four-part novel[56] continues to chart a dark story. Except for a few splotches of hair colour and the reddish beard of Professor Richard Naill, some beiges in the musicians' faces and light brown liquid, probably whisky, in their glasses, Bruno's palette in *After the Concert* is a chromatic black and white scale. In Bruno's handling of the blacks and greys is a masterclass demonstrating that oils can be so diluted they approach wispiness and shading of charcoal, and that Expressionist effect can be achieved without colours such as blues, reds, purples, greens, or even heavy impasto. Perhaps not surprisingly, in these paintings of men whose livelihood—and art—relied on their ability to execute intricate fingerings, Bruno has lavished more care on the joints of their hands than he does in most of his other works.

Nothing in either work identifies its scene as belonging to the last quarter of the twentieth century. In *After the Concert*, the players wear formal dress, white bow ties sit atop full-dress shirts, vests (their white colour coming from the linen, not canvas, on which Bruno painted as much as from the underpainting). Each musician wears a swallowtail black

evening jacket* and cuff links. Nothing suggests that these men were Bruno's colleagues and, in the case of Jimmy Pataki, a good friend and frequent fishing buddy.

Although they fill the picture plane, save for second violinist Paul Campbell's arm around Pataki's shoulder, which does not register at all in Pataki's stance, the musicians are as divided from each other and the viewer as the figures will be in *Snooker.* Indeed, Molly felt that the absence of amity turned the work into a "cruel portrait of the Quartet."[57] Naill, whose head is rendered almost in profile, looks intently at his three-quarters-full glass. Even though first violinist Joseph Pach's bent right arm holding his glass (on the lower left) vanishes from the picture plane and re-enters it—and thus enters the viewer's plane—he is completely unconcerned with what is happening on his right. Arlene Pach, Joseph's pianist wife who, when the scores dictated it, joined them to create a quintet, is placed far from her husband, behind Campbell, apparently rushing somewhere, unable or uninterested in joining them in a post-concert drink. In his rendering of Pataki, Bruno aligns himself with what Edvard Munch portrayed in the swirling smoke in *Self-Portrait with a Burning Cigarette*: the moment when, having taken a puff or two, Pataki feels the calming effect of nicotine (which the heavy smoker Bruno knew well) as he looks into the wisps of smoke.

The painting's grey-scale produces a distance between the players and the viewer. Because greys and blacks dominate, these paintings have the feel of the square black-and-white photos with scalloped edges that by 1975—thanks to colour Polaroid pictures and 35mm cameras—are associated with photographs taken before the mid-1960s. It is just possible, therefore, to see *After the Concert* as in harmony with Bruno's belief that "there will never be another great musician like Beethoven because of the cost of orchestras and technocracy."[58]

Five years later, years filled with increasingly difficult campus politics, Bruno painted the last chapter of his campus novel, an oil named *Snooker.*

* The shape of the tails is not obvious in the painting, but Stuart Smith confirms they were swallowtail.

In it he uses a rather light Expressionist palette that on its own suggests a lighter, happier atmosphere. A few odd greys, greens, and purples on the faces, the white shirt of the shooter sliding over to streaks of grey, and sweeps of purples, greys, and greens on another set of rumpled shirts, jackets, and sweater, make this one of Bruno's most colourful paintings.

Despite the fact that they are playing a game, the emotional register is far from jovial, however. Although all are pictured as they appeared ten years earlier, which explains the presence of a still very much alive Professor Walter Baker, Bruno has pointedly not taken the opportunity to revel in the waters of their younger days. Instead, the group bears the emotional scars of ten years of difficult campus politics, Bruno's increasingly difficult position within UNB, and, of course, of his grim personal life. It might not be going too far to view the work as a kind of palimpsest in which Bruno has scraped off the present to reveal how the past contains the seeds of his discontent.

From the extreme left of the picture, Professor Harold Smith watches the shooter, Professor Ross Darling, as does Professor Joseph Pach, whose expression verges on angry. Smith, who occupies the centre of the picture and is so tall the top of his head is cut off, stands stiffly, chalking his cue. Oddly, since he is presumably the next to shoot, he doesn't seem interested in whether Darling will make his shot. Standing between Patch and Smith is the frowning figure of the late Professor Walter Baker, whose play worried no one, for, as Bruno liked to joke, "He was the only physicist who couldn't figure out angles."[59] All, including a grimacing Bruno to Smith's left and, behind Bruno, the youngest of the group, Donald Andrus, looking at us with an expression bordering between bored and not wanting to be there.

Smith's cue is the key to the painting, and not only because cues are essential for the game. Together with the cue held upright by Patch, the cues tie the picture together because, since they are held laterally, they intersect with the right bumper of the snooker table and Darling's cue. The cues also serve as markers, a civilian version of a weapon, if you will, that reminds Forrestall of the ethos in Quentin Tarantino's *Reservoir Dogs*.

"The men all have a sense of purpose: competing with each other. While not obvious at first, they are all wearing the uniform: jackets or sweaters and ties. They are standing very close, much closer than men normally do, almost armed to the teeth; their cues could be swords."[60] The equation of cues with swords recalls Lieutenant (and later Captain) Bobak's efforts to aestheticize violence and underlines an important difference between Bruno's painting of game play and Molly's athlete-themed paintings below; for Molly they are about movement, while what Bruno pictures is how game play—actions in a rule-based world that is both separate from and part of the everyday world—channels violence into representative forms that do not threaten the social fabric.[61]

Chapter 9
A Sense of Place

Seeing Pictures Everywhere — Molly Bobak, Diary, 1 August 1987

Molly had to renew her passport in January 1981. Since the last time she had done so, the government had added the requirement that a copy of the applicant's birth certificate must be included in the application. After rummaging through her papers, Molly discovered that she did not have her birth certificate. What for most would be a bureaucratic headache became an emotional issue once Molly realized that she had no memory of ever having seen her birth certificate.

Molly's irregular place in the Lamb family had been a simple matter of fact. It had not prevented a happy childhood, joining the army, becoming a successful artist, being a member of national committees, or hobnobbing with the politicians and business leaders of New Brunswick or in Ottawa. Nor had she hidden her past; she wrote about it in *Wildflowers of Canada*. Now, at sixty-one years old, she suddenly felt it's "no fun being a bastard."[1] In May, she thought to ask the Permanent Trust Company, where the Bobaks had investments, if a copy of the certificate was in her file; it wasn't there either.

The birth certificate was found in 1986 by a friend who, on a hunch, went to look for it in a small New Brunswick town where it was known Molly's mother had lived. She had, Molly now learned, gone there to give birth. The birth certificate did more than change the story of where Molly was born from British Columbia to New Brunswick; it made Molly feel

"like a criminal."[2] For her entire life, she had been either Molly Joan Lamb or Molly Joan Lamb Bobak. There, in black and white, was a name she had never seen: Joan Mary Mortimer Lamb.[3]

New Year's Day 1982 was perhaps the worst day of her marriage. Returning to the house after leaving it because of a fight, she fled again after seeing an effigy of herself in "jeans on the study on the floor." When she returned a few hours later, she saw "the figure on its knees embracing" the seated Bruno in supplication, a presentation of Molly entirely at odds with the way she had lived her life.

The previous year had been punctuated with fights, slights, and worse. At least in February 1981, Molly had been able to break out in rhyme: "He regards me as a snob. I regard him as a slob."[4] She wasn't smiling at the end of April when she came home from a trip to find "Dog shit all over, flower pots on their sides," and Bruno sitting in the kitchen.[5] Two days after the confusing night when Bruno first ordered her out of their bed and then came "to beg her to come back to bed," Molly felt for the first time that her eyes were now limiting her ability to paint.[6] In July, after days of feeling "beaten up," she "want[ed] strength to terminate the situation" but again demurred.[7] Though the Bobaks' friends and colleagues in Fredericton were either circumspect or preferred to remember these years through sepia glasses, Molly's Diary makes clear that more than a few of the many dinner parties ended with drunken rows. Stuart Smith recalls, "As the tension in their marriage mounted over the years, it affected not only both of them but also . . . the social circle that had existed for years; the ease of it, so to speak, was gone and dinner parties were often trials."[8] Trouble had been brewing for years; though they fought about their children, money was one of the worst sparks. In February 1980, for example, a dinner with the Donaldsons and Patakis went south after Bruno bragged about how much money he and Molly had made.[9] At a dinner at the Patakis' a year later, Bruno switched sides: he called Molly a snob and said rudely that since she was "a rich 'made it' artist" she should not talk about the threat

that budget cuts at UNB posed to Pataki's string quartet.[10] In February 1984, he complained that Molly was making too much money, and she responded by mocking him for cutting out coupons and insisting on using the Seniors' Day discount even though they were very well off.[11] She was distressed when Bruno would not agree to reducing the rent on the granny suite for a young couple: "Old privileged men are the very worst kind of prejudice—greed."[12]

One June morning, Molly recorded the previous night's events that involved her daughter-in-law, Edith: "When Joan [Hoyt] left, Bruno showed some of his venom—he is too much. Edith was dismayed for me and I'm beginning to think that this can't go on again. He is quite impossible. Sour, rude, cruel and as Edith says, playing petty evil little games. There's a terrible streak in that man."[13] Again and again, Bruno complained about Molly's housekeeping, a complaint that is especially hard to believe, given Molly's recording of cleaning the basement, shovelling snow, washing the floors, cleaning their kerosene oil stove, and doing the laundry.[14] In September 1983, for example, while Molly was visiting Anny in British Columbia, Bruno lost his temper on the phone, demanding to know, "Where is the parmigiana cheese," prompting Molly to return to the leitmotif, "I know now we have to have a show down about our future."[15] By then, the trip she had taken in May and June to Florence, where she did a traditional watercolour of a bridge that concentrated on the sky and the reflections of the buildings and the bridge into the Arno River, were just memories—as was the "very good" feeling that followed when one of her travelling companions named Tommy said "he'd like me to be his paramour."[16]

Though Bruno was jealous of Molly's success and the coterie around her, he was not without his admirers, including Inge Pataki, who mounted a number of shows of his work at Gallery 78, and Eric Klinkhoff, who continued to be Bruno's Montréal dealer. And then there were the Sabats. Molly detested Jerome and Christina Sabat and their son, Peter; she saw them as doing little more than feeding Bruno's need for "devoted slaves," an image that is all the more powerful coming as it does the year that

began with finding Bruno's effigy of her.[17] Jerome had bought Bruno's best work; she was especially upset that he owned a nude of her. She was dismissive of the Sabats' son, Peter, who was taking painting lessons from Bruno and had, in fact, learned to paint "exactly like Bruno," which meant that for Molly his work could never be new, fresh, and personal.[18] The day after a dinner at the Sabats' in November 1983, Molly wrote, "At Sabats B[runo] + whisky — the fun started almost at once."[19]

A February 1984 encounter with the Sabats at the Beaverbrook Art Gallery shook Molly. She was already feeling a lack of confidence after having had a rough time painting two watercolours of flowers. The show didn't help matters, left her feeling adrift and wondering, "What am I doing."[20] She felt even worse when she saw Bruno and the Sabats talking together. Though Molly doesn't record the subject, her Diary entry for the following day suggests that they were criticizing her: "One believes in myths and nonsense. Like being out of step....Some boredom and jealousy." The next day, the artist who earned so much money from painting that only a month earlier she signed the papers to establish (for tax purposes) Molly Lamb Bobak Inc. sounded as unsure of herself as if she had just graduated from arts school: "Imagine, my work has been accepted."[21]

Though back in 1977, Molly told herself that she had "carved [out] a small and comfortable place in 'Canadian' art since [she had] ceased trying to compete or be famous," much of the time she felt her place was insecure, and she had her grievances. At the opening of a show devoted to Frederick Varley in February 1982, she found herself having a glass of wine with Alex Colville, whom she had known since they were war artists four decades earlier. His imperious behaviour left Molly feeling "demoralized and unconfident." Then, for the one and only time in her Diary, her correspondence, or her War Diary, Molly vents that in the army, she ran up against "cold...supreme" behaviour associated with "army men" who could just about tolerate a CWAC artist.[22]

A month earlier, Molly found herself simply unable to accept Mary Pratt's congratulatory note for Alden Nowlan's recent *Atlantic Insight* laudatory article about her. Indeed, not even a large cheque from Walter Klinkhoff soothed her, as she admitted to herself in her Diary: "Curious that [Mary Pratt's] reputation is #1 with slide realism," which, Molly felt, showed Pratt had "no idea of the 'old' language of art."[23]

Determining what Molly means is not difficult. For, after assuring herself, "Not that it matters," she likens Pratt's work to the "amateur stuff like the Fredericton Society of artists."[24] As Molly, who had taught art for decades, knew, amateur artists strive for verisimilitude—that is, to paint realistically. For Molly, the "old language of art" meant going beyond what art historian David Burnett and Marilyn Schiff call Pratt's "pictorial phenomenalism," the "emphasis on the light on the surface of objects."[25]

As a war artist in the field, of necessity, Molly worked with photos. But she believed that the painter's perspective "is totally different from the photo and natural life perspective,"[26] which echoes Arthur Lismer's statement as to why war artists were not war photographers. Painters must "reveal emotionally, spatially and with biting line and turgid colour, with satire and grandeur of compositions, with poignancy, humour, graphically and with convincing personality, all the many-faceted aspects of war."[27] Photographs can be referred to for forgotten detail, but the role of the figurative artist is to grasp more than the surface, represent more than the facticity of a scene.

For Molly, Pratt's exacting paintings of crabapple jelly, eviscerated chicken, or ice lack the insertion of the artist's perception that she saw in Plaskett's work, and by extension of her own when she had not fallen into the trough of being too tight or subjective. Pratt positioned objects on the canvas (and, hence, they are seen to be in 3-D space) in exactly the way they are on the photograph and not blocked in by the artist—whose job, Molly believed, is to create within the walls of the canvas an illusion filled with intention. Had Molly known, as Carol Bishop-Gwyn shows in her recent book on the Pratts, that Mary "projected the slide and, using a pencil, drew the outlines of the image on the canvas...writing codes for

colour and light,"[28] Molly might have summed up her view of Mary Pratt with something even more pungent than her quote from her friend, John Fraser: "'Our Lady of the Slides.'"[29]

Surprisingly, given her criticism of Mary Pratt's photorealism, Molly liked Bruno's early to mid-1980s flowers. Nor could works like *Winter Lilies* or *Garden* be considered as putting an oar into Molly's boat because, as we will see, their aesthetic is totally different from hers. *Winter Lilies* reprises the aesthetic of several works from the late 1960s and early 1970s in which Bruno turned from his Expressionist landscapes back toward the natural — though not to the abstracted world of his early woodcuts, rather to his training as a commercial artist, whose job is to create a clear, memorable, and convincing image. According to Marjory Donaldson, with "their delicate textures and realistic blooms, these flower canvases remind one of Dutch or Flemish *trompe-l'oeil* still lifes."[30]

Like Molly's flowers and crowd scenes (which we will look at below), nothing in *Winter Lilies* (1980) nor in *Garden* (1985, pp. 216-17) suggests the strife in the painter's life. The snowy field beyond the window in *Winter Lilies* is peaceful. The Norman Rockwell–like scene is complete with undulating snow-covered ground punctuated by evergreens and grasses that rise above the snowy blanket; these beige grasses share nothing with those that had fascinated Bruno in the late 1940s. The posts of the fence that runs more or less through the centre of the snowy field are both to be expected and a sly way of echoing the divide of the window's muntin (grid); the fact that the emotional register of the scene is the same on either side of the fence — a pictorial device that might normally signal a divide between different registers — only reinforces the unity of the tranquil scene, and the fence acts like a silent exclamation mark.

There is no tension between the fields and the lilies, even though the lilies are inside and, thus, do not sleep. The red of the tall lily on the left — which goes from deep red to translucent because it is backlit by the light coming off the snow — sets off the whites of the field and greens of

the trees. The deep green of the slightly bent stalk, which crosses both the centre line of the muntin and the fence in the distance, creates a three-dimensional effect replicated by the amaryllis on the right. When viewed from the proper position — the muntin should be at eye level and about five feet away — the window ledge, which at first looks like a Cézannesque exercise of differing planes, turns into what seems to be a 3-D solid form. Though Bruno does not eschew perspective, the painting's depth is achieved mainly through careful layering (much like the glasses in *Kent's Punch*) rather than through the mathematical rules laid down by Leon Battista Alberti during the Renaissance.

Garden is more personal, for Bruno was an expert gardener. In a more complex way than *Winter Lilies*, which is organized around the muntin, *Garden* demonstrates Bruno's superb draftsmanship — which, admittedly, is harder to see in his Expressionist nudes. "Bruno's solution here to the traditional problem for landscape artists — devising a foreground, middle ground, and background that work together to create the illusion of space — begins with his careful description of the deeply coloured and individualized flowers," says Smith. "He then uses the corner of the house onto which the sunlight falls to establish the middle ground. To ensure its link to the foreground, he connects it via the white hollyhocks that rise toward the light." The trees on the right, in among which is just a glimpse of another sunlit house, do more than fill in what otherwise would be a hole. "They screen the far distance, allowing the eye to move forward, thus giving the middle distance its due, but prevent the viewer from dropping off a cliff, so to speak."[31]

Garden differs from the 1982 work *Still Life with Squash*, which is almost photographic in its detailed depiction of eleven vegetables. The hard edges between, for example, one of the green peppers, its shadow, and the checkered table cloth, sharply defined as if drawn with a T-square, come close to contradicting Manet's famous observation: "There are no lines in nature, only areas of colour, one against the other." The scene in *Garden* is a dialogue between the Impressionist-inspired background, where the bushes and flowers merge into each other, and the sharper edges

of the red and pink poppies and hydrangeas. The almost *sfumato* effect
behind these flowers has the strange effect of softening the hard edges
Bruno painted, giving the whole scene the feel of swaying in the wind.

The Lighting of the Christmas Tree (*Christmas Tree*) (p. 215), painted in
1982 and proudly owned by Inge Pataki, is lyrical, even puckish work.
There being no need to question officialdom here, Molly gives the New
Brunswick legislative building as much solidity as her loose brush could
allow without tipping over into caricature. From the windows comes
convincing yellowish light.[32]

Even though it is an unnatural purple, the colour of the sky in *Christ-
mas Tree* has an important, and surprising, function. The purpose, as
William Forrestall notes, "is not to draw attention to itself. Rather because
it is unnatural, but unobtrusive or, better, does not clash with the colours of
the scene, the sky and its indication of weather are effectively removed from
the viewer's concern. Somewhat paradoxically, the unnatural colour of the
sky allows the viewer to concentrate on other elements of the painting."[33]

The chief element of the painting is not the Christmas tree in the
title set up before the legislative building but rather the crowd. While
the "anarchic" nature of crowds, the "rhythm of disintegration and
reformation," provoked joy in Molly, she maintained she was not a
psychologist of crowds; still less was she a filmmaker.[34] Her medium was
even more constrained than was Andy Warhol's in *Empire*, which records
more than eight hours of people walking into and out of the Empire
State Building one day in 1964. As is the case with the crowd pictures
we've already considered, in *Christmas Tree* Molly hid the artifice that
makes the crowd seem anarchic when, in fact, it was highly structured.
First, many of the figures have bent arms and legs, indicating movement.
While the number of shadows might make one think there is a light
source coming from the building stronger than the yellow light, there
is no warrant for this belief. Indeed, there is no source of light capable
of creating the shadows, but what matters is that Molly paints them in

and, thus, comes close to doubling the number of figures in the picture plane without actually doing so. Further, since shadows are insubstantial, present though volumetrically absent at the same time, they add a certain effervescence to the gathering.[35]

Additionally, Molly runs the group of figures so close to the bottom of the picture plane that in a few cases feet disappear, which has the effect of making it seem as though the crowd is about to enter the viewer's space and make them part of the crowd. Further, she creates an artificial horizon that runs across the top of the buildings to the left of the legislative building. What we might term the "effective horizon line" is an implied line running just above the heads of the figures furthest from the viewer, which, on the viewer's left joins a line formed by the heads of revellers standing on the far side of the steps of the legislative building—thus enticing the viewer's eyes to move to the right and then up. Molly balances this lower line with strong vertical figures—the revellers—who stand out against the whiteness of the snow, and so creates an upward movement.

In *Christmas Tree*, Molly employs the traditional single-point perspective. The vanishing point is behind the Christmas tree and bordered by the angular thrust of the buildings. However, having established it, she all but ignores it, something she arranges by having the lights of the Christmas tree pale behind the light coming from the windows and ornate portico of the Old City Hall. Grabbed by this light, we look toward it and move our eyes over the heads of the revellers to the right and away from the vanishing point. Though we cannot see their faces, we see enough that their body language tells, as curator Hilary Letwin put it, of "people excitedly calling to each other...chatting about this and that" even "whispering the latest gossip."[36] Molly liked the work so much she used it as the picture on the Bobaks' 1982 Christmas cards.

A decade later, Molly returned to the challenge of painting a night scene that she believed to be "genuine" but feared it failed to "say anything" and relied too much on "a sort of surface enthusiasm."[37] Given the melancholy of aging and the further deterioration of her relationship with Bruno, Molly's anguish is understandable, but misplaced, at least for

her art. *First Night* depicts the New Year's Eve fireworks as seen from the Green, a park on the south side of the Saint John River in Fredericton. In the darkness of the first moments of 1 January 1993, the figures standing on the Green are black, with a few sprigs of yellow, red, and white, the colours of hats, scarves, and a few jackets. Unlike the all-black, cut-out-like figures in *Skaters*, which bear a passing resemblance to the figures in *Mad* magazine's "Spy vs. Spy" feature because of their bulky winter coats, the people welcoming the new year are full, rounded individuals.[38]

The stances of the revellers gathered in small knots in *First Night* differ from those in *Christmas Tree*. Instead of being oriented toward each other so that they can speak, they look toward the night sky. Above the wide expanse of the almost blackened Saint John River, here and there the purplish black sky is pierced by pinpricks of sharp light—and ripped by streaks of glistening white.

Because Molly positions us above and behind the Green, looking down at the scene, the vertical thrust of the revellers is not enough to tie the scene together as it did in *Christmas Tree*. Her solution to this problem in *First Night* involves two elements. First, the leafless trees are formed from heavy black lines. As their fully volumetrically realized limbs reach up into the purplish black, they are met by the second element: the white tendrils of Time Rain or Spider fireworks.

"For a painter, anything ephemeral such as the bright lights that quickly disappear against the night sky is a challenge. Fireworks move and transform themselves. You blink and you have missed part of the action,"* says Nathalie Mantha.[39] For Cézanne, this gap, the moment between perception and execution (actually within the moment of perception of, say, Mont Sainte-Victoire) is angst ridden. Molly does not follow her master there. The fact, as art critic David Sylvester remarks, is that "one never copies anything for the vision that remains of it at each moment.... Working

* Recall Alex Comfort's method to capture shell bursts on the canvas, mentioned in chapter 3: "One, two, three, wumph."

from memory: the artist can only put down what remains in his head after looking," and turning toward the canvas—something Molly embraced.[40]

When an article called Bruno "a man of compassion" in January 1983, Molly quipped that she couldn't remember when he had been one.[41] Nevertheless, the woman who found it impossible to leave her husband of thirty-two years was (predictably) concerned about how the retrospective of Bruno's works, curated by Donald Andrus, opening at Concordia University on 19 January, would affect him. The fact that it included few works after 1970 could not help but put Bruno in the state of mind of Claude Lantier, the artist protagonist of one of Molly's favourite novels, Émile Zola's *The Masterpiece*:[42] "But once you feel you're going downhill, let yourself drop, and smash yourself to pieces in the death agonies of your talent that's out of keeping with the times, your failure to remember how you produced your immortal masterpieces and the staggering realization that your efforts to produce any more have been, and always will be, entirely fruitless."[43]

Molly considered the show "a complete knock out" and noted how the praise of others had made Bruno momentarily forget his jaundiced statement, "Painting is something you churn out for the public," that he had used to criticize Molly's success.[44] But Bruno's feelings about the retrospective were even stronger than Molly had feared. As he and Andrus walked around the show, Andrus asked how Bruno felt about it. His immediate response was, "It's like attending my own funeral." A few moments later, he added, in what Andrus clearly recalls as a "tone just verging on irritation," and which he took as a reference to Bruno's feelings about his work over the previous decade, "People think that an artist should go on and on, and not retire. Why shouldn't an artist be able to retire from making art?" Then Bruno added—quite disingenuously, as we will see—that "he had quit painting."[45]

While the Concordia exhibit was still running, Bruno heard from other artists who praised the show. Five months earlier, when one particular

critic saw one of his drawings that had been framed for a show, and was so impressed she recalled it hitting her like a ton of bricks.[46] The critic in question was named Molly Lamb Bobak.

The show garnered good reviews, but they did little to improve Bruno's demeanour, as she told Shadbolt in a letter written on 2 April 1984. "For too many years now he's been 'difficult' — really a pain to live with …but from my point of view his despair and cynicism have been quite a burden — even his Retrospective didn't help — in fact, I suspect it made him wistful[,] regrets that his energy seemed to have left him and, perhaps, he had hoped for bigger 'success.'"[47] Three weeks later, before the retrospective had even been taken down, Bruno stunned Molly by telling her that she "should destroy the diaries in case he is murdered — so the police do not find them and accuse her" of the crime.[48] And in mid-June, it was Bruno's turn to think of leaving; after packing a suitcase and leaving the house, he came back when he realized he had no place to go.[49]

Molly found the politics of the first half of the 1980s difficult to deal with. The ignorance and hubris that she saw in America was epitomized by the Texas state senator who declared, "Armageddon is a proven future fact."[50] After the attempted assassination of US President Ronald Reagan in 1981, she wrote, "What a strange and violent country."[51] In September 1983, she noted that British prime minister Margaret Thatcher was a "frightening woman hell bent on armaments and missiles," a thought she likely kept to herself because on that day Bruno was in a good mood and cut her hair.[52]

Molly's most consistent political comments, and the only ones that can be linked directly to her paintings, concern Israel and the Jews. Although she did not always agree with Israel's actions, such as the 1982 invasion of Lebanon, Molly counted herself "a Zionist at heart" and probably had since Pamela Diamond's family stayed with the Lambs in the late 1930s. Molly's knowledge of Jewish history was significantly greater than the simple fact that 2nd Lieutenant Lamb had been to Bergen-Belsen. She knew the little-known fact that Queen Victoria (correctly) believed that

Captain Alfred Dreyfus, who had been convicted of treason for selling French defence plans to the Germans, had been framed because he was Jewish, and that her Imperial Majesty called Dreyfus "the Just."[53] In 1986, Molly was distressed to hear her friend Joan complain that the "Café Martin in Montreal [was] now being frequented by Jews."[54] Molly's alliance with Jews was also professional. "It is the Jews who buy my work," especially at Galerie Walter Klinkhoff in Montréal and Roberts Gallery in Toronto; "I owe them."[55] She was especially close to Eric Klinkhoff, who sometimes returned to Montréal laden both with Molly's paintings and jars of her homemade marmalade.

Israel, as noted above, had become another topic that she could no longer discuss with Bruno, who had become increasingly anti-Semitic.[56] She was particularly dismayed in March 1990, when Anny's (then) husband, John Scoones, blamed "Jewish money" backing MacMillan Bloedel for the clear-cutting of British Columbia forests. Molly wrote in some sorrow how even people who live on British Columbia islands, "where life is easy and rich," are "always in need of scapegoats."[57] A year later when, as the Americans rolled toward Baghdad during Operation Desert Storm, her friend Wolfgang said, "In this war we just hate the leader, but in the last war you all hated Germans" before making a "mad insinuation about Jews," presumably that they somehow were profiting from the war or secretly directing American foreign policy. "People certainly don't change underneath," she commented sadly.[58]

Scared by what she had seen in Europe after the Second World War, Molly did not rejoice when the Berlin Wall came down and East and West Germany united: "My generation feels it is a disaster. West Germany cocky and sinister . . . racial."[59] A few years earlier, a friend named Mary knew that Molly would agree with her agony over her son Dimitri having "a live in German girlfriend. Could there be any [thing] more bitter than to have one's dearest only son marry into the Third Reich!?"[60]

In 1984, about the time Prime Minister Trudeau was giving a "profound peace talk," Molly was invited by the United Jewish Appeal to go on a cultural exchange to Israel.[61] Arriving in Tel Aviv on 8 March, Molly spent

almost a month there, afterwards telling Shadbolt how stunned she was to see among "relics of rusty parts of 2nd World War vehicles, very poignant memorials to the soldiers who didn't make it through the hills to the city in the '48 war" [for Israel's independence] among the pines, rocks, and dry earth.[62] She visited the usual places: Dome of the Rock, Gethsemane (which her hotel window looked out upon), the Holy Sepulchre, Yad Vashem, Galilee (the blooming fields made Molly wonder what Jewish farmers could do with New Brunswick), and the Wailing Wall.

While she painted this last, *Kotel* in Hebrew, her rendering of the stones that were put in not long before Jesus's time, a sketch of a Roman aqueduct, or bird's-eye view of Jerusalem that recalls her almost abstract pictures of Vancouver, are significantly less interesting—and since Molly does not mention them, likely they didn't interest her much—than other paintings not so obviously Israeli. Within days of returning to New Brunswick, she "tore into 3 canvases of Caesarea," the beachfront community where she had stayed for a few days at a condo owned by the uncle of her friend Judy Budovitch.[63]

As Budovitch expected,[64] Molly and her bachelor uncle, David Gaum, who shared a medical practice with his brother in Cape Breton, hit it off. "He had been a doctor in the war. When Molly spoke about him after she came back, I could see that once you know you have shared that sort of experience, there is a level of understanding that goes deep," says Budovitch. What's more, "they shared a love of music and reading."[65]

Brigid Toole Grant's observation that "Molly's seascapes are really an excuse to show active people enjoying themselves; they could, in fact, be anywhere" applies to her Israel paintings as much as it does to those painted on the shores of the Bay of Fundy.[66] Given the importance land holds for Israel, it might seem contentious that Molly chose not to include any obvious Israeli images. But the absence of anything indicating this is Israel is not, I must emphasize, an effort to efface Israel or Israelis.

A watercolour study of black rocks in Caesarea owned by Budovitch is more telling than the finished oil, *Black Rocks, Caesarea*. The oil depicts

an empty, almost abstract beach with a couple of large black shapes in the left middle ground and stabs of brown in the foreground leading to the rocks that could have come from Turner's brush (p. 215). In the watercolour, two small figures are set against the greyish black of the rocks and the blue sea above (but, really, beyond them). Long gone is the stiffness seen in *Swimmers at Elk Lake No. 1* or *On the Beach*, both painted in 1959 — caused, curator Cindy Richmond notes, by making the figures at the bottom of the scene too large. The figures in Budovitch's watercolour are more articulated than many of Molly's figures: their heads, bodies, and legs are clearly filled in. From the bend of the legs of the one on the left, who is wearing red swimming trunks, we can tell they are running into the water.

Even as these figures serve a technical purpose — indicating the height of the black rock and as part of the perspective line — they play a vital narrative role. What's important is not whether, if they were to turn around and look toward the artist (and us), they might well see military patrols (behind where the artist stood). Rather, what is important is the universal moment when older children or early teens run into the water and turn, raising their arms to show off to their families. Budovitch's watercolour is, therefore, similar to *Summer Storm*, in the sense that this work dating from the mid-1960s is less about the trees and houses on Waterloo Row, a few blocks from where Molly painted it, than it is a gentle scene in which children rush home in the rain.

Twilight, Israel Beach is a much more developed piece than *Black Rocks, Caesarea*, which is perhaps most notable for Molly's daring use of purplish-blue swath, the firmament that covers about a quarter of the work and the great waters being an unnatural black area that fills another quarter of the picture plane on the left, only to vanish behind a spit of land on the right. Almost two-thirds of *Twilight* is the beach, which runs on a diagonal from left to right, ending at four high-rise apartment buildings: their Impressionist (shading into Expressionist) indeterminacy had, in fact, a natural cause, the bending of light by the heat waves rising from

the sand. The swirls of reds and oranges in the clouds are expressive, for there is no setting sun refracting through the clouds — and they might reasonably be seen as Molly's answer to the anguished swirls in Bruno's works such as *Journey*.

More striking than the beach, sea, or sky are the fifty or sixty people walking along the beach. We barely notice that none of the figures are fully articulated. Instead, what we notice is the figures grouped together in twos, threes, fours, and, further down the beach, in even larger groups. Different groups are doing different things: the couple in black jackets in the centre right of the lower part of the painting have either just kissed or are about to, while the couple a bit farther down the beach are holding hands. The blues, greens, whites, blacks, and reds of the peoples' jackets pull the viewer into the crowd and, thus, along the beach. The absence of specific Israeli details universalizes the image and thus makes it all the more political: what we see are Israelis (and, probably, visitors to Israel) doing something unremarkable on a sunny fall afternoon, walking along a beautiful beach, just ahead of the strand.

Together, these canvases form a corpus that, Molly told Shadbolt, made her feel that "I know sometimes what ART is!" With paintbrush in hand, she "rushed at a canvas with the security [?] of exactly what was in my eye and — there it was — a painting I really knew was terrific — still a subject — but so much part of the paint — all wedded — all alive."[67]

At an event in Ottawa celebrating the publication of Michelle Gewurtz's monograph *Molly Lamb Bobak: Life & Work* in November 2018, Laura Brandon told a story about Bruno dating to 2005 that by then had been making the rounds for more than a decade: "When I asked him what he was working on, he answered 'Nothing. I'd rather be fishing.'"[68]

Bruno's words were not a riff on the "I'd rather be sailing" bumper sticker. In the mid-1960s, he and Molly, and Stuart and Valerie Smith explored the brooks and streams around Fredericton. While Molly and Valerie sunned, Bruno and Stuart fished for trout. "Bass fishing only

became popular near Fredericton after the Mactaquac Dam was opened in 1969, which changed the course of the Saint John River and created a lake," says Smith.[69] By 1970, Bruno was regularly going fly-fishing for bass with Jimmy Pataki; when Bruno's brother Ernie visited, he went fly-fishing with him too[70] — on 26 August 1977, Molly recorded that they caught seventeen bass. Bruno and his friend (and former student) Gary Stairs fished at the Miramichi Fish and Game Club on the Main Southwest Miramichi River. According to Stairs, Bruno caught his first Atlantic salmon in 1985 while they were fishing the Cains River in west-central New Brunswick.

However popular fishing was in the Bobaks' adopted province, angling was not an obvious avocation for a man whose strongest childhood memory of the water was of corralling potatoes dumped in Hamilton Harbour. The Toronto of Bruno's teens was not yet divided from Lake Ontario by the Gardiner Expressway, but the factories and derelict buildings along what was then Highway 2 hardly beckoned people to the shoreline. His art school trips to the Toronto Islands were undertaken to give experience painting romantic subjects (such as tumbled-down houses and docks) *en plein air* and did not include fishing. Nor, during the Bobaks' sojourns in England and on the continent, did Bruno evince any interest in fishermen, fishing boats, or seine nets hung to dry, even though the depiction of these last would have been the sort of challenge one can easily imagine the artist who painted barbed wire enjoying.

Whether impromptu overnight or several days long, fishing trips provided Bruno with the sort of structured escape from his tumultuous home life that Molly found via her membership on national committees. According to David Young, a young lawyer who, along with his wife, Margo, rented the Bobaks' granny suite on Kensington Court from 1982 to 1984, fishing gave Bruno a break from the art centre and offered "a diversion from painting." How much Young knew of the state of Bruno's marriage is unclear. Molly does not mention him being present for any of her fights with Bruno, but it was public knowledge that the marriage was difficult. Clear to all, however, was the fact that "Bruno loved male

company," as Young says—then adds, "Bruno enjoyed fishing and later, with a drink, ruminating about the events of the day"—including, fishermen being fishermen, telling of the one that got away.[71]

According to University of Maryland professor Geoffrey Greif, author of *Buddy System: Understanding Male Friendships*, the activities at fishing camps are "a classic example of male friendship that features shoulder-to-shoulder activities." Where women's friendships are held together by talk and sharing of emotions, "male friendships turn on purposeful action that puts few emotional demands on them; angling is a perfect example because each fisherman is supposed to be quiet and yet they are engaged in collective action with a clear goal in mind."[72] Greif's phrase "purposeful action" is suggestive, for it places Bruno and the act of fishing with his friends close to Smith's understanding of what underpins the ethos of many of Molly's paintings, from her CWAC days to her crowd paintings.[73]

Molly's criticism that Bruno's works show a lack of "vitality and ambition" and that he had turned to producing standard landscapes that are "clever, unfelt sellers to a certain public taste" is both unfair and sounds a bit too much like special pleading designed to distract attention from her own almost industrial production of flower paintings.[74] The small pastel-coloured unnamed 1995 watercolour of two men fishing at the Wasson Bar Pool (*Wasson Bar*) on the Main Southwest Miramichi River near Doaktown (about ninety kilometres from Fredericton) is not as ambitious as *Journey* or Bruno's three triptychs. Still, in ways Molly was (albeit understandably) wilfully blind to, this and some of Bruno's other fishing paintings are not only interesting, they show him groping with the complex dialectics of sports fishing.

The first thing to note about *Wasson Bar* is its horizon line. Instead of being kilometres away, since the top of Glynn Weaver's head almost touches the horizon line, it is at most a couple of hundred metres away, where the greenish-blue of the river meets the grey-scale sky. By pushing the horizon line so far forward, Bruno achieves the opposite of the effect that Édouard Manet created in *Déjeuner sur l'Herbe*, in which, as Peter Gay notes, the "indeterminate distance" produces a "vague, ambiguous,

mysterious" feeling.[75] The impact of Bruno's clearly delineated, though artificial, horizon line is so great, so reassuring that we don't notice the world around Abe Trashinsky and Weaver has been reduced to water and a darkening sky.

The second point to notice is how Bruno telescopes time. Since Trashinsky and Weaver are practising "catch and release" (as they had for years), Trashinsky has only a matter of moments to free the salmon from the hook before it begins to suffer oxygen deprivation. And yet, as Trashinsky frees the seven-kilogram salmon, we notice the perturbations from catching the salmon have ebbed enough for the river to reflect back Trashinsky's green hip waders and the darker green of Glynn Weaver's hip waders.

Bruno's main concern in *Wasson Bar* is less about the salmon that won't end up on a dinner plate than it is about reconciling two opposing images: or, better, the creation of an image in which the antithesis of nature—men with hip waders, vests, and modern fishing rod and reel—is subsumed within nature. He does this first by flattening out the portraits of the men so that they have less individuality than do his Expressionist figures. Though identifiable, the renderings of Trashinsky and Weaver are well on their way to becoming types, men linked to nature via complementary colours: the men's greens with the river's blues and turquoise. The blacks that speckle them suggest not a storm but rather the natural sky. Yet, even as they are partially dissolved into nature, the fishermen alter nature. Their presence embodies the dialectical tension at the heart of angling in the same way Molly's flower paintings embody the dialectical tension of destroying flowers to paint their image: though they are literally immersed in nature's waters, these men and their fishing poles turn nature into "second nature." The change is just enough that the decidedly unnaturally dressed anglers can go about their business in the belief that there is a fine freemasonry between those who know how to cast and reel and the fish that gives himself up to be caught.

Something similar is at play in the silkscreen series that begins with *The Home Pool* (c. 1985, p. 218). In the series, the colours of the high riverbanks

are striations of grey and black: the black is a placeholder for vegetation, while the grey shows the veins of granite. Above the steep banks, also formed from black and other shades of grey, are tangles of trees that would have been very much at home in a Group of Seven painting. Between the banks is the Miramichi, made from two different fine-line screens onto which Bruno had trawled yellow and then black ink, placed the screen on the page, and pulled it through a press. The title, *The Home Pool*, presumably the yellow area in the centre of the river, is hardly enough to override the dominant feeling of nature's ruggedness. Indeed, the veins of granite and their echoes in the trees nudge the work's chronotope toward something approaching geological time.

Between pulling *The Home Pool #2* and an unnumbered *The Home Pool*, Bruno left the sky, riverbanks, and trees untouched but—either through subsequent pulls through the press or by altering the pull that had laid down the black—added the black forms of two fishermen. One is on the lower right and the other more or less in the centre of the scene, near the lip of the pool. The granite veins are still there, but we hardly notice them. Instead, we are drawn to the arch formed by the fishermen's bodies and angles of their fishing poles. In theory we can see through this arch and look upriver. But we don't. The apex of the arch does more than divide the picture in two: it acts like an exclamation mark, signalling that the most important part of the composition is the depiction of the men and their gear. Instead of inviting us to run upriver, connecting us to geological time, we cannot help but remain in human time, wondering what these two men, on this day, will tell.

One story they almost certainly will not tell is what art historian John Berger calls the "Historic Past Tense" of the land, the phrase defining a painting, like several of Goya's, that record the brutality of history.[76] Unlike the history bound up in *Minto Miners*, for example, Bruno's fishing-themed paintings follow the Group of Seven in erasing First Nations peoples from the land. Save for some moments of dialectical tension, Bruno's fishing-themed works are close to complete idealizations. The questions he elides here and in the many works in which he paints

Molly's nude body (while ignoring or belittling her role in running their home) are the essential unanswered questions of idealized leisure — the questions that Alain de Botton and John Armstrong, authors of *Art as Therapy*, want to ask the late Baroque painter Antoine Watteau about the economic realities underpinning the luxurious garden scene in *Rendez-vous de chasse* (c. 1717): "Where are the servants who must bring wine and fruit? Where are the peasants the leisure class rely on for their income?"[77]

Bruno and Molly on the occasion of their being awarded
the Order of Canada in 1995. (Photographer unknown)

Chapter 10

Two People Who Have Outworn Each Other

Lovely day, opening stocking around the fire. Bruno gave John
[Scoones] a drawing of "little" Anny. Best Christmas Ever.
—Molly Bobak, Diary, 25 December 1985

At the beginning of 1986, for only the second or third time, Molly directly addresses the keeping of her Diary—prompted, it would seem, by her reading of John Glassco's *Memoirs of Montparnasse*, which tells of this Canadian's experiences in the Paris of Ernest Hemingway, James Joyce, Gertrude Stein, and Morley Callaghan.[1] "I wonder why I keep this mass of Hillroy [*sic*] scribblers in the attic. I have the arrogance so that they may be interesting to some future person. Of course, we wish this sort of nonsense while [we] still believe in death and being the end of the personality."[2] These last few words are the only such words in Molly's Diary, and are probably explained by the fact that a day before, the Bobaks learned Bruno's eldest brother, Henry, had died.[3] Two days later, Molly was less concerned with metaphysics than with her shock that Bruno, by far the wealthiest of Dziedzik Bobak's sons, "didn't want to be responsible for paying for Henry's death."[4]

In mid-February, two days after she returned from Toronto and Alexander told her she should leave Bruno since he "was so much better without her," Molly confided to her Diary:

> At noon (and I could write a bitter short story on this),
> Bruno started in on his beastliness—ungrateful women
> who take all from men & then leave them—well, perhaps,

its [*sic*] been all written before. It is so unreasonable and so
absurd & lopsided there [is] no talking to him — what phony
he is to himself — so like his father — blaming everyone and
being so righteous himself. The old story. What will I do, I
wonder — I have promised myself to find a little house — to
move away somehow. But whatever happens, I cannot think
there is anything left.

Len Smith came in as usual for a Brandy and Bruno told
him that the latest astronaut launch where everyone blew up
in 72 seconds [the Challenger disaster], was not true. No one
was in the spacecraft — it was merely a testing of a bomb.
Even Len looked uncomfortable.[5]

There were good days. Strangely, one occurred in February 1987 when
Carolyn Cole, who remained a member of the Bobaks' social circle,
came over to play her daughter's first professional tape; Molly was deeply
impressed with the singing of Holly Cole. On 6 March was another when
Molly wrote, "Curious how he can change." Bruno's good behaviour
makes her forget (or want to forget) the trajectory of their relationship. By
contrast (and as an example of how she compartmentalized her life), as
Bruno varnished a number of works for an upcoming show at the Roberts
Gallery, she thought, "I can hardly believe it is by the same person who did
the rich flowers or Expressionist figures. Amazing, and to me very sad."[6]

In early April, a day after Molly complained that Bruno was up to his
"usual antics," they had their most intimate talk in years. Not surprisingly,
the talk focused on art, with Bruno admitting that "he felt dead artistic-
ally." Molly kept her thoughts about his recent work to herself, and was
amazed when he asked, "Do you think you ever got the old feeling back
once you've lost it."[7] The "surge of compassion" Molly felt was strong
enough to keep her from answering, "It would help if you'd quit drinking
so much."[8] The better angel of Bruno's nature that had alighted on that
night was somewhere else two weeks later when relations had become so
difficult that a friend helped Molly secretly carry bedding to her studio

in town. Given what she saw as Bruno's lackadaisical attitude toward his duties as director of the art centre, Molly was pleased to hear him say that he was going to see UNB President James Downey to discuss taking early retirement; he was sixty-four. She was staggered by his hubris of telling Downey that he "still wishes to 'honour them with his presence,'" which, she noted, meant, "I want to keep my studio," before adding, "Oh well."[9]

In late May 1986, Professor Mary Lou Stirling of UNB's Faculty of Education introduced Molly to Sheree Fitch, a young author of children's nonsense poetry, who had just signed a contract for her first book. Fitch asked Molly to illustrate the book *Toes in My Nose*, to be published by Doubleday. Molly soon had reason to regret the decision to collaborate. Fitch, who admits to being more than a bit starstruck, wasn't the problem — Doubleday's editors and "rules of inclusion" were. Of the first, Molly wrote, "Perhaps I'm too naïf to understand working with people"; since *naïf* means both "naïve" and "naturally flawless," Molly leaves open whether she'd "never been good at it" (working with other people) because of naivety or because of a natural purity.[10] Of the second, the socially liberal and loyal NDP voter summed up the rules of inclusion, which dictated the percentages of "boys, girls, wheelchair patients, black, pink, yellow" and must have brought back her worst memories of being a CWAC artist, simply as, "What a horrible business."[11] As the pressures on her mounted, however, Molly again found escape in painting, reporting on 16 May as being "a great day with oils." And a week later, the day she finished the rough illustrations, "So worked on watercolours and in the afternoon in oils. It all seems so effortless — no pressure."

The figures in Fitch's *Toes in My Nose* differ significantly from those Molly created for Frances Itani's *Linger by the Sea* a half decade earlier. The children and adults in Fitch's book are among the very few with faces in Molly's postwar art. This cannot be explained by the upcoming birth of Molly's grandchild, because Molly learned of her daughter-in-law's pregnancy after having finished the illustrations. Most are

cartoony, but some, like those of the parents in "The Sneé," are realistic. Equally striking is the fact that almost every figure is fully rounded and volumetric, the main exceptions being the figures in the first two poems of "Step Away" and those in the two-page spread with "My Bouncing Ball" and "Bubblegum Benny." In each of these, Molly places the figures far enough away that their absence of volume is believable, indeed, expected.

"My Bouncing Ball" and "Bubblegum Benny" (the latter telling the story of Benny, who flew to the moon on the strength of a bubblegum bubble he blew, p. 219) unfold against the recognizable landscape of downtown Fredericton; the bare trees suggest it is late fall. Other landscapes are less clear. "I Wonder About Thunder" is divided into two parts longitudinally. On the bottom is a child in a rain slicker. Above the child and the raindrops that tie together lower and upper images, Molly has painted perhaps her only pictures of angels, busily pushing "cannon balls" around the clouds to produce thunder.

"A picture book tells a story. And, the artist should enhance the story, adding subtext to it," says Fitch.[12] Adding subtext means that the artist is adding a type of text, making the story space partially theirs. The part in Molly's hands is what Andrea Schwenke Wylie calls the "*pictura*," following the established term "fabula," which means "a memory trace that remains after the reading is completed."[13]

Perhaps the most memorable image is of the manic little boy in Doctor Stickles's office. Stickles was in fact a well-known Fredericton family doctor. "Molly's gift," Fitch says, "was to be able to see with the eyes of a child." Accordingly, even as the text of the eye examination chart clearly places this scene in the "landscape" of a doctor's office, Molly's "whimsy" was perfectly calibrated to Fitch's text, which tells of tickling and wiggling.[14] The boy tickling the absurdly thin Stickles leads the good doctor, as imagined by Molly, to laugh so hysterically that his stethoscope flies off his neck (p. 275).

Molly's original illustration of "Doctor Stickles," from *Toes in My Nose and Other Poems* by Sheree Fitch (Doubleday Canada, 1987)
(Collection of Department of Education, University of New Brunswick)

On 24 April 1987, after *Toes in My Nose* had become a bestseller, Molly received a congratulatory call from Premier Hatfield. The call is only one more example of Molly's stature. Seven months earlier, the Bobaks were guests at Rideau Hall. After dinner, Prime Minister Brian Mulroney invited Molly and several other women upstairs to see a painting of Molly's. Acting as docent, the prime minister told this small group about a recent show of Molly's work at Walter Klinkhoff's gallery, prompting Molly to write to herself, "Bruno and Molly have become part of the Establishment."[15]

Though renowned for being cheap, Bruno allowed himself to take on the airs of a successful businessman and investor, attending, for example, the board meeting of Imperial Oil in 1980, and later closely watching

his investments on the stock market ticker displayed on a television at his bank. Molly may not have known that Bruno held the mortgage for one of his colleagues[16] and that in 1982, upon learning that Donald Andrus was donating his $1,500 guest curator fee to help pay for the retrospective at Concordia University, Bruno said he would "gladly throw my entire C.A.R. [Canadian Artists' Representation] fee of $1,960 into the pot."[17] Likely because of her father's position in British Columbia's mining industry, Molly was less taken with the trappings that her fame and artistic success brought. In 1988, she accepted a commission from Mila Mulroney for a painting for Brian's fiftieth birthday, and at the opening of the new National Gallery, she embraced both Mulroney and his wife — though she quickly adds, "but never their politics."[18] A year later, Molly twice turned down invitations to dine at 24 Sussex: first with the Japanese prime minister and, surprisingly, given her monarchist views, with the queen — because she had prior teaching commitments. Teaching also trumped going to Ottawa to have dinner with the Mulroneys and Mikhail Gorbachev, president of the Soviet Union, in May 1990.

Molly travelled regularly to Ottawa, Montréal, and Toronto to attend meetings of the NFB's board, Canada Post's Stamp Acquisition Committee, and the National Gallery's Acquisition Committee. Her term on the latter started well enough. At the early January 1986 meeting in Ottawa, the committtee seemed receptive to her idea to show the best of Canadian art in Washington, where the new embassy to the United States would soon be opening. After the meeting, she and her friend Claude Bouchard let their hair down in a most surprising way: They went to a strip joint she remembered as "Bare Bodies or Something" — Bare Fax still exists at the same address just below Parliament Hill in the trendy ByWard Market. Molly was surprised at how pretty the girls were and, unsurprisingly, didn't know that when a man gave her a rose, he was not complimenting her; she was supposed to pay for it.

After they'd had a few drinks, Bouchard suggested they leave, saying, "Imagine the headlines if the cops came in: 'Former Parole [Board] Director and members of the National Gallery [Acquisitions] Board

arrested in strip joint.'" Perhaps the lark brought back memories of the "cat house" she'd spent a night in a few short streets away when she was a CWAC. At all events, Molly wrote the next morning that she had "gone to bed happy," which, it will be recalled, is quite different from how she felt about going to see the porn film a decade and a half earlier with Bruno and the Patakis.[19]

It didn't take long, however, for Molly to lock horns with Phyllis Lambert, chair of the Acquisitions Committee, over the purchase of Barnett Newman's *Voice of Fire*, famously, vertical bands of blue, red, and blue.[20] Their clash on 22 August 1986 left Molly feeling "inadequate." At a meeting the following February, Molly argued that $60,000 ($124,000) should be used to purchase Canadian art. No doubt forgetting that Lambert (née Bronfman) was Jewish, Molly let her emotions get the better of her in her Diary by calling Lambert "a little female Hitler."[21] At the 26 July 1988 meeting, Molly went toe to toe with Lambert, saying that if the gallery was dead set on purchasing a non-Canadian, Abstract Expressionist work, it should consider one by Lucian Freud, prompting another committee member to tell her later, "You have courage," Molly recorded in her Diary. Molly believed that the letter she wrote to Dr. Shirley Thomson, director of the National Gallery (whom Molly had originally liked), after her clash with Lambert was what prompted Thompson and board member Brydon Smith to engineer her removal from the Acquisitions Committee.[22] Before this occurred, however, the Acquisitions Committee voted to purchase *Voice of Fire*; keeping with tradition, rather than cast a "No" vote, Molly abstained.

The purchase of Newman's work for $1.8 million was announced in March 1990, which confirmed Molly's rather cynical view of the world art market—presented as if she were not herself enmeshed in it via her connections to Klinkhoff's and Roberts's galleries. "I tend to think that the artsy world is an international conspiracy between women (mostly), art curators, public chic galleries and other commercial entrepreneurs. They buy and sell their special stables with the seriousness of sharks."[23] For Molly, the public outrage about the price of the work missed the

point: the National Gallery was neglecting Canadian art. She must have felt some sense of vindication two years later, when it was discovered that since its unveiling *Voice of Fire* had been hanging upside down — and no one had noticed.

Despite of the fact that several times Molly professed no interest in where her money was invested and that more than once it looked as if the glue that kept her at home was her complete distaste for the idea of separating their assets, on 31 July 1986, Molly recorded the Supreme Court had ruled that after forty-four years of living common law and having had six children, a woman was entitled to one-third of the couple's joint property. At the very least, this suggests Molly has gone a bit further down the road of making a mental list of assets than she let on even to herself. A week later, Bruno accused Molly of "not paying her own way," when, in fact her income was much greater than his.[24]

In August, Molly turned her ire on Bruno's recently completed oil, *Last Departure*. What Bruno called his latest "art work," while Molly's scare quotes fairly drip with sarcasm. First, she noted, the "thin, bad paint, awful dead grey and red colour." The subject matter was not only "personal" but, worse, it was "'small' and obvious." The image of the two of them standing before an SMT (Maritimes) bus, with Bruno "looking sad, holding me, turning away — and Baby [the dog] in her red kerchief looking nice" dismayed her. Nothing in the work evinced the technique she had once admired or touched the bar of what Molly considered art.[25] For his part, Bruno must have seen the work as recording what he saw when he looked into the void of marriage, all the while thinking, as he told Christina Sabat, "I only want to love someone and to express myself through my work."[26]

To Molly and Bruno both, each new year, and even each new day, must have seemed like a replay of the previous. The year 1986 closed with Bruno saying, "How can I be nice when you threaten to leave every two weeks?" and Molly writing, "I should have had energy and courage long ago [to

leave]. I must be infuriating because I don't care any more.... Sad to see how his intellect has slipped."[27]

On 30 November 1987, after coming home from the hospital where they saw their newborn grandchild, Julia, Molly wrote gently of "her perfect little hands curled deliberately against her face, a face with a perfect replica of Edith's mouth." But far from helping to bridge the gap between her grandparents, Julia soon become another reason for them to fight. On 2 December, Bruno was furious that Molly went to see Julia without him. The following day, after seeing Edith tending to her infant, Bruno was "HORRIBLE and lewd," causing Molly to do her "usual rush out trick." In the months to come, Bruno objected when Molly went to babysit.

Molly sought solace in music and reading. During her 1987 visit to England to see her dying half-brother, Abby, Molly found that the country parson they heard spoke well of the transfiguration, but, she concluded, he "isn't a patch" on Richard Strauss's[28] tone poem, *Death and Transfiguration*, which "says it all."[29] Figuring she knew the story already since she found it impossible to permanently separate from Bruno, Molly felt she didn't have to read the 1987 bestseller *Men Who Hate Women and the Women Who Love Them*. Knowing that Shadbolt and his wife, Doris, both of whom can now be counted as Molly's friends and not Bruno's, were well aware of the difficulties in the Bobaks' marriage, Molly confided to him from Galiano Island: "I left Fredericton because I simply couldn't stay a moment longer in the atmosphere of predictable anger, drinking (not to access but enough to make a fury every evening) and old age despair. I'm not about to chat about these familiar things that seem to happen to a great many people, including me! But I simply had to make the difficult and guilt ridden decision to get out."[30]

Three months later, during Christmas, Molly had the silly fantasy that Bruno and Carolyn would go away together, which would, of course, have relieved Molly of struggling with the decision herself. Toward the end of the year, she rejoiced at having finally bought a cabin on Galiano Island,

which meant she no longer had to impose on Anny during her increasingly long escapes to British Columbia.

What by mid-November 1989 Molly called "mental abuse" altered her understanding of D.H. Lawrence, who shared her love of Cézanne, who "set the unmoving material world into motion. Walls twitch and slide, chairs bend or reared up a little."[31] The first of Lawrence's novels Molly records reading is *Sons and Lovers* in 1988. However, she had read his letters sometime before 1962 and again in 1987, probably in tandem with her visit to his house in England, when she recorded her reaction to Aldous Huxley's "Introduction."

Molly agreed with Huxley's rather twee view that Lawrence was more interested in defining "spiritual passion and reverent ('religious') feelings about life and sex" than with depicting raw sexuality, a view famously not shared by the British and Canadian censors who banned *Lady Chatterley's Lover* until 1959 and 1962, respectively. Given her home life, it is hardly surprising that she criticizes the "critics who's [*sic*] limited little minds missed the point entirely—grubby, limited people—it explains the Banal exploitation of sex now."[32] As she finished the "sad" letters, Molly writes of the "restless almost condemned man, angry and [illegible] for goodness," and seems ready to sign on to what she understands as the Lawrencian political program: "a new start—a revolution based on No money—how right he is and imagine the 'filthy minded' people who were shocked at his work."[33] Molly is heedless of how a revolution that ended "money" (and wealth) would affect her life and ability to travel to see Anny.

By the end of 1987, however, even as she praises the vividness of the double drowning in the unfinished novel *Mr. Noon*, Molly reconsiders Lawrence. Her reconsideration has more to do with sexual politics, which seems to be cutting too close to the bone, than with a thorough understanding of Lawrence's politics, which, in fact, ran close to fascism.[34] Molly is repelled by Lawrence's "Snarls against 'Gentle Reader' or 'Bitch Reader'—yes—against women who he needed so much. He thinks the true God is the one about sex in the big sense."[35] Molly would have had more to chew on had Huxley included Lawrence's 5 December 1918 letter

to Katherine Mansfield in which Lawrence wrote, "I do think a woman must yield some sort of precedence to a man, and he must take this precedence. I do think men must go ahead absolutely in front of their women, without turning round to ask permission or approval of their women."[36]

Although Molly was pleased with her watercolours of flowers, the painting of the skiers at Crabbe Mountain (northwest of Fredericton), and the three Santa Claus parade oils and one of a horse show, the two that meant the most to her in the late 1980s were *Trooping the Colours* (*Trooping*) and the *Ritz Carlton*, both of which were painted in 1989. *Trooping* (p. 220) stemmed from Molly being invited to the seventy-fifth anniversary of the Princess Patricia's Canadian Light Infantry (PPCLI). Her description of the events on 9 August 1989 is breathless:

> [I]n the blazing sun, Rod took me to the bleachers (I was 3 above the Countess Mountbatten) so I had a wonderful view. I sat beside the commander of the "Vingt Duez" [*sic*][37] . . . then came the trooping—all the gay crowd—all the commands & old rituals! Wonderful—great band music including [Land of] Hope and Glory. I was swimming with emotion—could hardly sketch though I tried. . . . It was too much for words & though I suppose Henry Miller would have been sickened—not me, though. They carried the PPCLI [battle] flags—formed a guard for the new fellows to march out on—THIS is what I will paint—the trooping [of the colour] with the old & new present.

Though the trooping of the colours is a formal ceremony, and its intricate choreography dating back to the seventeenth century enthralled Molly, the scene in *Trooping* is not especially formal. Through the centre of the large work that she handed over to General Lewis MacKenzie at CFB Gagetown in December 1989, hundreds of PPCLI privates (Molly not

knowing quite what to make of the presence of Heather Erxleben, the first female Princess Pat) trace a sinuous line across the parade field almost to the gates of the Currie Barracks, a long, three-storey, white building with a red roof.[38] First, by drawing the marchers in quick strokes — modern battlefield green and black berets for the first three-quarters of the marchers and RCMP-like red serge and white pith helmet for those in the foreground — Molly makes it impossible to imagine them as Leni Riefenstahl did "Aryan" athletes in *Olympia*, morphing into ancient Greek statues in a Nazi phantasmagoric "Festival of Beauty."[39] Second, Molly, who we must always remember had been a soldier, knew what military historian Marc Milner once told me: "Fascists have good kit." Her refusal to focus on but, in fact, to make it impossible to focus on the soldiers' kit distinguishes her depiction of marchers from Riefenstahl's; in *Triumph of the Will* the lingering shots on the black leather of the Wehrmacht and SS uniforms were a stand-in for the violence at the heart of Nazism.

Molly's quick strokes are detailed enough for us to see the swinging arms of the marchers on the left, while their left legs seem to merge as if we were watching a film running faster than twenty-four frames per second. The sense of movement is heightened by Molly's departure from naturalistic depiction of the shadows the sun cast that August afternoon. Had she depicted the shadows that fell on the right side of the line, the parade square would have been smudges of dark grey that would have undercut the painting's feeling of movement. Instead, by painting in a few and by making them smaller the further up the line (i.e., by ignoring the sun's angle), she enhances the feeling of movement.

The raggedness around the dignitaries and onlookers, who are drawn in the same Impressionistic strokes as the marchers, is not from inattention to detail (something she is often accused of). Rather, it suggests movement in the crowd in contrast to those who line up for military parades in, for example, Pyongyang, North Korea. Imagining these civilians coming to something like attention is difficult; imagining them doing a *Sieg Heil* is risible.

In the left middle ground of Molly's work stands a cameraman.[40] The

inclusion of the cameraman is a self-referential moment (akin to "dramatic irony") that draws attention to the fact that Molly's picture, too, is an artifice created from one particular point of view and not, therefore, omniscient. In other hands, what might simply have been a boiler plate exercise in military symbols, Molly created a memorial to the democratic ideals for which PPCLI fought for in both world wars and to the Canadian soldier writ large, for they were notorious in their lax attitude toward spit and polish.

More interesting than what today we dismiss as the maunderings of a successful artist is the refrain first heard when she had completed her CWAC paintings and that continued for more than half a century: her work was "too tight. Too subjective."[41] Twice, in 1980 and again in 1989, Molly records the work that signalled the end of her funk, both of which are of Montréal scenes: McGill University's Roddick Gates on Sherbrooke Street and *View of the Ritz Carlton*, only the latter of which is available to examine.

In her oil of the Ritz-Carlton's iconic sign and wrought-iron awning looking west, Molly notes, she "used up the palette": browns, ochres, and bluish-greys for the buildings across the street (the painting's right side), and though their windows are mainly signalled by black (with a few points of yellow) they don't appear dark but rather seem to shine. The foreground is among the brightest expanses of canvas Molly has painted. Most of Sherbrooke Street itself is light bluish-grey; the cars on it present a gradation of colour starting with white oranges and moving in echelon through reds, purples, and darker colours. The wide sidewalk that makes Montréal such a wonderful city to walk in is by turns reddish, yellowish, and finally white in the middle distance; these are Molly's colours, not nature's, for no matter what the sun's position, cement is never red or deep blue.

A figure in the middle of the foreground is so close to the bottom edge of the picture plane that its legs are not visible. And it is made up of so many colours it is difficult to make out its bodily shape. It might seem to be overdone until we realize that its purpose is not to describe a person

but rather to guide our eyes forward, deeper into the picture. This figure ensures that instead of our gaze being grabbed too quickly by the white light in the background of the picture, we stay on the sidewalk and engage with the seven or eight figures under or near the Ritz-Carlton. Each of these figures has what for Molly are clearly delineated legs and torsos; a few have long shadows stretching toward us.

As is the case with the windows across the street, these figures are black, though they are anything but sinister, as, for example, the figures in *Ruins in Bremen* are. Whether some of them know each other is both unclear and unimportant. Rather, as a bend in a knee here, a shift in the deepness of a shadow there, and the opening of the one gate or another make clear, whether or not they are walking together, these figures' movement both accords with and creates the syncopated movement of the metropolis. Their movements are balanced by the flags flapping in the wind above the awning.

It would be hard to imagine the painting's background had Molly not painted scores of skater scenes and hundreds of flower paintings with the sophisticated use of white space (which will be discussed more below). Here, however, instead of the white being contained within an oval, it forms the background of the work. The square measure of the white above one of the buildings on the right side of the painting, the area above the distant reach of Sherbrooke Street, and above the wrought-iron awning comprises about one-fifth of the painting. And, while it is technically empty, it provides the light to make everything visible as well as indicates the time of day, later afternoon, for the shadows stretch toward the east. Even more importantly, the whiteness has the effect not of swallowing the scene into its void but rather of pushing it forward, even as it forms a gauzy embrace.

Molly declared that the work is "very suggestive and releases her from clichés."[42] Half a century earlier, both she and Bruno had "gone mad for Turner." And while it is perhaps easier to see Turner's influence in Bruno's *Wet Morning* and *Rain in Venice* than in Molly's work, he is also present in the ghostly forms lit only by the fireworks or the Christmas tree. The

Turneresque side of Molly's work was one answer to the question, voiced here in late 1997, "Why do I get stuck on the things as things."

View of the Ritz Carlton represents another answer, which positions her much closer to Turner's great rival, John Constable. The point isn't that Molly was a history painter in the sense that Constable was; *Vincent Massey's Funeral* and *The Queen's Visit* owe nothing to him. Rather, the point is that in *View of the Ritz Carlton*, Molly stands with him in honouring "the facts of things," which, according to Stanley Plumly "is the same as trying to discover the native richness within the raw material."[43]

In *The Hay Wain*, Constable depicted the hay wain, the shoreline, two young men, a dog, two black canal horses, and other identifiable features of English country life near Stores. In *View of the Ritz Carlton*, Molly included a number of identifiable details: a readable Ritz-Carlton sign; fluttering flags of Canada, Quebec, the United States, and Germany; a carefully rendered red fire hydrant; two light standards; the buildings across the street with their rectilinear windows; and the ornate stonework on the first floor of the building on the corner of Sherbrooke and Drummond. To make them as clear as they are, Molly turned from her normal loose brush work to a more detailed approach. In *View of the Ritz Carlton*, she released herself from what at times threatens to be her own cliché. Here, the objects depicted more or less true to themselves combine under the light and in the compositional form to create a unity of purpose and visual experience that turns the cityscape into a form of poetry.

Over more than five decades of correspondence with Jack Shadbolt, Molly publicly remained loyal, even diffident, to her old teacher, praising his books as they came out and catalogues of his shows. In the privacy of her Diary, however, Molly could barely contain herself. Molly called Shadbolt's Beaverbrook Art Gallery jargon-laden lecture "too self-conscious and analyzed."[44] After reading Scott Watson's book *Jack Shadbolt*, no doubt thinking of many of the letters Shadbolt wrote to her, Molly thought, "there is a sort of humiliating abusive tone in all that Shadbolt says."[45]

Molly found Shadbolt's emphasis on Emily Carr's sexual frustrations "absurd." At all events, what matters here is the vehemence of Molly's rejection of Shadbolt's finding of phalluses and vulvas in her works and his use of words like "rutting" and concepts like "sexual violence."[46] In the same Diary entry, equally important is her anger at the

> sweeping way he [Shadbolt] gets rid of Lauren [*sic*] Harris as the elite Prince of the Hill. Doesn't he know that Harris gave very thoughtful lectures, and on a social level opened his house to young (arrogant) artists—where we drank, ate and made merry. Doesn't he know that Harris backed Joe Plaskett—to my mind the best of the lot of us.

Her spleen vented, Molly silently thanked Shadbolt for his "positive drive that swept a lot of us into enthusiasm and serious [art] business."[47]

At times, Shadbolt triggers a dialogue Molly confines to her Diary. After dismissing Shadbolt's claim that he had always been a "Structuralist," she tells herself that "Formal structure could never do anything but give a language"—which may not mention figurative content but nevertheless privileges it.[48] For Molly, the language of art, be it her Impressionist-inspired brush strokes or Bruno's Expressionist paintings, has value only because it tells a human story.

Two years later, a letter from Shadbolt caused Molly to consider "symbolism," which more than once she claims was not part of her repertoire. Molly rejects the traditional definition of symbolism rooted in religious iconography. Traditionally, symbols are like keys: in devotional works, St. Peter, for example, carries keys—the keys to heaven. Such symbols allowed the illiterate masses in the Middles Ages to read the artwork on the walls of their churches and cathedrals.

Molly's definition is more personal, even phenomenological. She defines symbolism as the "essential belief of the mystery of acknowledging without the benefit of words, the boiling down of everything to a puff of feeling."[49] The phrase "without the benefit of language" means that Molly

decouples the sign, to use the technical term for St. Peter's keys, from the experience of meaning. For her, there is no one-to-one relationship (*adequatio*) between the image and its "meaning" that would be true for all viewers. Rather, Molly points toward a pre-linguistic affect, "a puff of feeling" that is experienced before the viewer understands the image in terms of language and their prior understanding of art and religion or other social systems. Her use of the word "mystery," though it shades toward the religious, underscores the point that for her "symbolism" is not a constructed path of meaning, as it is for example in Bruno's work, but rather a cognitive/emotional experience that, while triggered by the picture, is centred on the inexpressible experience of the viewer—with the understanding that not every viewer will experience it the same way. Put another way, for Molly, what matters is the experience of experience, not the pop quiz that might follow viewing a painting.

Molly's practice as a painter was unflagging, and it was financially rewarding. In the first two months of 1988, she completed twenty-five watercolours (as well as twelve drawings and fourteen oils). The cosmos painting was priced between $1,500 and $1,650 ($2,800–$3,000), while paintings of red poppies fetched $1,200 ($2,200). All were sold. On 19 July 1989, Eric Klinkhoff called to tell Molly that the latest consignment of paintings, totalling $200,000 ($362,000), had sold in *ten minutes*. According to price lists preserved in the UNB Archives, the cost of a 46 × 61-centimetre watercolour went from $450 ($1,500) in 1978 to $1,200 ($2,600) in 1984. A painting of a cosmos in 1988 cost as much as $1,650 ($3,100). Oil paintings were considerably more expensive: in 1984, 56 × 76-centimetre paintings were priced at $3,300 ($7,000), while 102 × 152-centimetre ones were $9,900 ($21,000).

In March 1987, to take a representative year, from Walter Klinkhoff alone, Molly earned $32,000 ($65,000), not including his 25 per cent commission. For that year, her income totalled $300,000 ($540,000). In November 1988, Molly deposited a check for $47,000 ($89,500) into the

bank account of Molly Lamb Bobak, Inc. (MLB, Inc.) July 1992 was a slow month for her: she deposited only $4,000 ($6,500). In 2000, the last full year in which Molly kept her Diary, MLB, Inc. had $500,000 ($730,000) in the bank and she was advised to start taking a salary.

But as the 1990s advanced, neither her steady income and lightning-fast sales nor praise from her artist friends was enough to keep Molly from falling into doubt about her work. "I'm no Emily Carr, I'm just a popular painter," she wrote in October 1991 — the comparison is all the more interesting because while Molly recognized Carr's importance, she was not, as Pegi Nicol MacLeod was, one of her favourite painters.[50] A year later, she felt, "I'm not a good painter but don't want to quit yet," and asked a few months later, referring to herself, "Why do people buy her oils?"[51] In 1994, she felt she was a "fraud" and wondered, "Who is MLB?"[52]

Fortunately, Molly's doubts didn't stop her from working, even when, for example, on 15 June 1993 she noted, "Wrecked two watercolours. I've lost the idea of painting. I can't even repeat. Two poppy paintings started well but failed." She was back before the easel the next day and fixed the two paintings. Molly's success in rescuing these watercolours, it is worth pausing to note, runs counter to even her belief that her technical ability was wanting, for to keep a rewetted watercolour from running toward a muddy colour is one of the hardest things for a painter to do. By contrast, on 11 February 1995, she was thrilled by a large oil of a beach scene.

As their marriage deteriorated, Bruno, who kept meticulous records,[53] used the finances of painting as a stick with which to beat Molly, complaining on 23 January 1988 that she painted her watercolours too quickly. As well, he repeatedly complained about her bookkeeping, knowing that this complaint would sting because of Shadbolt's 1978 tax evasion trial. Although Shadbolt was completely exonerated, he had landed in trouble with Revenue Canada because of shoddy bookkeeping.

In June 1988, the month that Molly heard from UNB that the alumni of the class of 1936 wanted to go ahead with the stained glass window[54] Molly had designed for the university's chapel, Bruno told her she was a "dope" for continuing to paint, since she got to keep only 25 per cent of

what she earned.[55] Early in their careers, most gallerists took 40 per cent of the price of a work. By the mid-1980s, the division had change to 60 per cent for the gallerist and 40 per cent for the artist. Out of her 40 per cent, Molly had to pay her business expenses: supplies, framing, rent for her studio (when it was outside their home), her agent's fee (starting in 1985), and, of course, taxes.[56] Molly professed to understand little about finances, including the setting up of trust funds and tax shelters: "I hate it all but it seems necessary for a successful old painter," she said in 1991.[57] Three years earlier, she hadn't disputed Bruno's financial point, noting, however, "I'm living well, I like to paint."[58] At the end of the '80s, she was somewhat less circumspect following an argument about money: "I make double the money [he does]...but I paint."[59]

After the row on 13 January 1989, Molly's words turn almost to poetry: "We are Two People Who Have Outworn Each other."[60] Things between them were not better in early March, when Bruno was furious after he saw that Molly brought copies of *Toes in My Nose* and *Wildflowers of Canada* to their new house. And, then, at the end of the month, Molly, again showing her ability to compartmentalize, praises Bruno's work, or at least some of his older work. She sums up the exhibit in Saint John, New Brunswick, of the works that had recently toured Poland in one word: "Impressive."[61]

On 13 February 1990, a year after Molly and Bruno moved into a smaller home Bruno designed (and which she did not like), Alexander and Edith staged an intervention, calling on Molly to separate from Bruno. It is unclear from Molly's Diary whether her son and daughter-in-law knew that back in December, Bruno blamed Molly for the fact that "my children have turned against me," though they likely had heard the charge before. They surely knew the refrain that Molly's success and her public life infuriated him.[62] Edith, who was keeping Molly's books, also would have known that with another $40,000 ($72,500), Molly had more than enough means to leave Bruno.

The "long and difficult" letter Molly wrote Bruno in early March when

she was in British Columbia triggered the expected, but not hoped for, reaction. Molly had tried to avoid dredging up old hurts and avoid making accusations. She told Bruno that she "couldn't go back to such a strained and destructive life" and accepted her share of the blame in having made it.[63] Whatever slim hopes Molly had when she sealed the envelope were dashed on 13 March when Bruno called. Noting his "abusive tone," Molly asked if he had received the letter and he hung up. The silence that followed — during which the sixty-eight-year-old artist tried to imagine what the rest of her life would look like — was broken by the ringing of the telephone. When she picked it up, she heard her husband of forty-four years asking her to come back and promising to reform.

Molly's reaction, "I believed him, of course," does not surprise Dr. Martin Rovers. "It is a piece with her saying in 1977 that 'I suppose I will stay and want to look after Bruno.' Despite the many promises and disappointments, Molly's behaviour is common for people, probably mostly women, who have experienced, and been told too often in childhood that 'You must look after your man,'" says Rovers. "But it is all just a familiar path that 'I am too afraid to be alone.' She feels she was responsible for her husband's wellbeing and puts it above both her own and the pleas of her children to get out of the marriage. Even the 'falling into each other's arms' [when Molly returns to Fredericton] is stereotypical, a momentary comfort, blotting out of the reality of the underlying problems that inevitably resurface quickly"[64] — as, indeed, they did a few days later.

The following August, Molly was hospitalized for tests resulting from high blood pressure and tension. Though she found the medicare system to be democratic, she found the experience of being in the hospital strange. It was a "not boring, surreal, hermetically sealed world where even the ambulance sirens through the walls" somehow became "POETIC."[65] She was released after five days with instructions to take it easy.

PART FOUR

1990-2014

Chapter 11
The Compleat Angler

Human beings like a prospect from which they can survey a
landscape, and at the same time they enjoy a sense of refuge.
A cave in the side of the mountain, a child's tree house, a
house on the hill, the king's castle.... —Denis Dutton

In spite of Bruno's statements about having "retired," his avocation as a fly fisherman, and the times he told Molly he no longer had the feeling for art, toward the end of 1990 he was hard at work on a commissioned portrait of Antonio Lamer,[1] who after ten years as chief justice of the Supreme Court of Canada was retiring from the bench. To her surprise, Molly, who disliked Bruno's contemporaneous fishing-themed and landscape paintings, and who had held her tongue when he went to Ottawa to take pictures of Lamer before starting to paint, liked the portrait.

When set against the portraits of his three immediate predecessors as chief justice of the Canadian Supreme Court, Brian Dickson (1984-1990), Bora Laskin (1973-1984), and Gérald Fauteux (1970-1973), Bruno's portrait of Lamer seems almost a throwback to the imperious portraits of John Robert Cartwright (1967-1970) and the thirteen men who preceded him as chief justice. Lamer's robe of office is not an amalgam of angular modernity and a Roman toga set against a mottled light background, as are those worn by Dickson and Laskin (both painted by Cleeve Horne). Nor does Lamer's portrait partake of Eva Prager's German Impressionist (verging on Expressionism) aesthetic that leaves Fauteux wearing a robe that appears to be dissolving at though he were caught in the USS *Enterprise*'s transporter beam. Instead, Lamer's scarlet robe topped with ermine, which stands out against the red tonal background, is volumetric,

its folds gently indicated by shadows in much the same way as they are in Sir Charles Fitzpatrick's portrait, painted in 1918 by Kenneth Forbes, a noted portraitist.

What distinguishes Lamer's portrait from all but Henri-Elzéar Taschereau's, painted almost exactly a century earlier, is that Lamer is standing (p. 295). Although the photographs Bruno took of Lamer at the start of the project are lost, judging from the four studies held by the Beaverbrook Art Gallery, the bust-like paintings titled *Judge Lamer I*, *Judge Lamer II*, and *Judge Lamer III*, and the final untitled study (referred to herein as *Lamer IV*), Bruno had always intended to paint Lamer standing.

In *Lamer III*, the blacks and greys that form the background of the first two studies have become reds, with the result that the justice seems to have moved significantly forward, his dark grey hair lightened in places by the light coming from his left. He is even further forward in *Lamer IV*, in which he fills more than two-thirds of the pictorial space, his white-and-scarlet uniform standing out boldly against a dark tonal background. Many of Bruno's works, notes William Forrestall, "can be seen as responding to the request, 'Give me a rough guide as to how someone looks.'" The studies of Lamer answer a different request: "Give me a technical description of this man."[2]

By the time we reach *Lamer IV*, Bruno is no longer concerned with refining Lamer's facial features. Instead, by adding a prop — an open book in his hands — and by giving him an expression, somewhere between thoughtful and searching, we know that we have entered his space. Although we know this is someone important and that we have interrupted him, he does not look annoyed. "It's a profoundly democratic work," says Forrestall. "You don't need any art historical or aesthetic training to understand it. We've just disturbed him; he's reading the law, and even if we didn't recognize the book in his hands as a law book, the fact it is bound in leather tells us it is important."[3] And yet, instead of anger in his eyes or even annoyance, we see a twinkle and around his mouth — not lines of tension but enough of the beginnings of a welcoming smile that

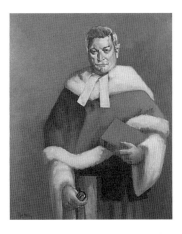

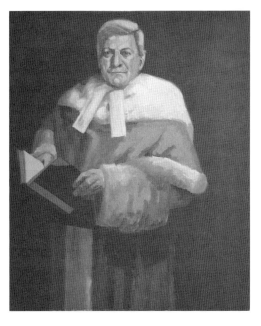

(above) Bruno Bobak,
*Right Honourable Antonio
Lamer, P.C., C.C., C.D.*
(Copyright © Supreme Court of Canada.
Photo by Philippe Landreville)

(right) Bruno Bobak, untitled
study (*Lamer IV*), 1990
oil on canvas, 122 x 102 cm
(Beaverbrook Art Gallery)

we can imagine the good justice lifting his hand from his black lettered law book and ushering us into his chambers.

In the official portrait, Lamer's face shading from beige on its lit side to shadowy grey on the other is not quite as welcoming as in *Lamer IV*, but to use the matrix established by art historian Catherine M. Soussloff, it lines up with Kokoschka's and not Gustav Klimt's portraiture. Klimt "stood for an approach to portraiture that distanced, or abstracted, the subject from others in society and from the viewer," often by depicting the figures as "self-absorbed" and looking away from the viewer.[4] Not only are Kokoschka's subjects oriented toward the viewer, the "acidic tonalities of the complementary colours" he used in the background create "tonalities that set the face and the gesturing hands off from the surrounding clothing and background" and thereby push them into the viewer's space.[5] Bruno's exceptional handling of colour ensures that, resplendent in his robe of state, His Honour stands out against the tonal red background and is on the cusp of stepping into the

marbled Chief Justice Portrait Gallery in the Supreme Court Building in which the painting hangs.

The closed, beige leather-bound book with 1990 (the year of the portrait's unveiling) embossed on its spine could have led to a different narrative arc than does *Lamer IV* and its symbolically open book. It didn't because of another prop that is also present in Dickson's and Laskin's portraits: his glasses. Almost certainly, the majority of the thirteen chief justices before them wore glasses, but equally certainly, both they and their portraitists would have felt that showing them with reading glasses would have diminished their official presence and even led to the unfortunate connotation of diminishing the clear-sightedness of the court's judgements.

Bruno, who, a lifetime earlier, stood before Canada's High Commissioner to Britain and reminded him that sappers could not be official war artists, was less concerned with the traditional iconography of power than with showing that the very embodiment of the power was human too. The feeling that Lamer is about to step into our space speaks to how Bruno and Lamer want the justice to be perceived. This effect, so reminiscent of Molly's paintings, differs in one important way: instead of a group stepping into our space, which, almost by definition would mean we are caught up in its excitement, Lamer gives the impression he's about to stick out his hand to give a hearty handshake and then explain the role of the Supreme Court. He would have had much to talk about, for during his tenure as chief justice he fleshed out the meaning of the Charter of Rights and Freedoms.

Molly considered it a "terrific traditional tonal portrait" of the chief justice who she found to be a "sexy, sweet fellow."[6] And so, for at least a short time in early December 1990, this portrait helped to buttress their relationship, the family romance that a decade earlier Molly called "The Fall of the House of Bobak."[7]

≠

In January 1991, Molly watched agape at the "selling of the Gulf War," doubted that "Saddam=Hitler," and was horrified that all but one Tory voted with Prime Minister Mulroney to join the American-led coalition.[8] "Saddam screams about Satan and Bush. God awful, folly of us to bring God into Man's horrifying folly and greed."[9] She was dismayed one day when, after hours of watching the news, Bruno's blood was up and he had come to think of himself as a military expert.[10] Molly was not surprised when Desert Storm, the counterattack on Saddam Hussein's forces in Kuwait that began on 16 January 1991, triggered Iraq's Scud missile attacks on Tel Aviv and Haifa, which greatly upset Molly and her close friend, Judy Budovitch. In addition to being a member of the Beaverbrook Art Gallery board, Budovitch was a member of the boards of the Canadian Jewish Congress and the United Israel Appeal of Canada—and, as we saw in chapter 9, had family connections in Israel.

Molly's opposition to the Gulf War was profound, causing her to note that "this depressing politics" belonged in her Diary in case she ever read it again, presumably so she would recall the context of these days.[11] Yet, Molly's unstated but nevertheless present belief that the artist's role was to transcend the everyday world of politics led her to critique the "avant guard man [who] did a performance at the National Gallery and threw blood over the walls." Her words, "God give me an innocent sailor who at least is exposed to the horror," redolent of the terror faced by merchant seaman on the North Atlantic during what Molly knew was a necessary war, shows how profoundly the years as a CWAC shaped her.[12] The entry's final words, "What exhibitionists artists have become," reaches back past the performance artist's blood to Andy Warhol, Jackson Pollock, and even Pable Picasso—and decries the modern emphasis on the artist as celebrity.[13]

Through the 1990s, Molly kept up a steady commentary on Canadian, American, and world politics. Like the Canadian political philosopher George Grant, though from the other side of the political spectrum, she opposed the creeping Americanization of Canada. On 24 April 1993, two

months after her seventy-third birthday, Molly summed up Mulroney's tenure: "He made us into the 51st state," a poignant symbol for Molly being Smucker's takeover of E.D. Smith, which was still "very good [jam] but now owned by Americans." In 1995, she recorded the scandal that followed after the killing of Shidane Arone by members of the Canadian Airborne Regiment in Somalia as well as the fact that 8,000 Tutus "were mowed down" in Rwanda.[14] While she no doubt agreed with Canadian essayist George Woodcock's critique of the effect of American fast food on Europe, she dissented strongly from his view that this aspect of American culture was "worse than Hitler": "but tell that to the Jews," she wrote.[15] She considered the Art Gallery of Ontario's decision to hire an American as director in October 1995 a similar betrayal. On the international level, Pope John Paul II's values, she believed, were "solid, if you're not a pregnant woman."[16]

By far, however, it was the second Quebec Referendum in October 1995 that consumed the most ink. Though she had liked René Levesque, by 1995 her views on Quebec politicians had turned acid. The day before the "No" rally in Montréal, she feared the country was heading toward civil war. As hundreds of thousands gathered in Montréal on 26 October, she wrote, "More and more…we are up against a petty Hitler. He [Lucien Bouchard, who was the main spokesperson for the "Yes" side] can say anything and people will raise their arms—a strange and frightening" thing to watch. When the "No" side won by less than 1 per cent and Quebec premier Jacques Parizeau blamed the loss on "money and the 'ethnic' vote," Molly was shocked that such "a racist and violent statement" would be uttered by a politician in Canada. She found Bouchard's statement that Quebec needed "more white French babies" to be simply "shades of Hitler."[17]

During the "tense and awful" days leading to the referendum, she found some solace painting *The Raising of the Cross*—a painting of Fredericton's Christ Church Cathedral, which on 18 October 1995 had its spire topped by a 230-kilogram cross lifted into place by a helicopter.[18] Her Diary shows that she was not worried about being too "subjecty." Her

work on this picture also puts the lie to the claim that Molly was always a fast worker unconcerned with details.* The painting's most striking feature is not the wispy cathedral, the crowd before it, or even the surprisingly detailed scaffolding. Rather, it is the bronze cross, which seemingly floats in the sky (p. 221). Molly did not have to organize the painting thusly; just as she showed the whirling effect of the helicopter's rotors, she could have sketched in the cables holding the cross aloft. The decision not to show the cables holding the cross likely owed something to the long artistic tradition, going back to early paintings of Emperor Constantine's vision of a cross in the sky along with the renowned words *In hoc signo vinces* ("In this sign, you will conquer") before the Battle of the Milvian Bridge, which made him master of Rome in AD 312.

In late October, she concentrated on "building up a surface," which included applying the undercoating and blocking in the colours, such as the orange-copper of the tower. After the scaffolding had come down, she realized the "proportions were all wrong. . . . I made a mess, but at least there's more feeling for the mass now."[19] In mid-November, while being driven past the cathedral, Molly realized that the windows in the painting were too small.[20] Here she puts down her marker on the other side of the river from her master, Cézanne, who thought, as phenomenologist Maurice Merleau-Ponty put it for him, "The landscape thinks itself in me and I am its consciousness."[21] While Molly would agree that every painting is an interpretation — and likely that every painting session is itself a separate act of interpretation — her comments about the windows mean that unlike Cézanne, she believed in the independent status of the object being painted, and the artist owed that object its full measure of devotion.

* Molly's concern for and knowledge of the architectural members of the cathedral are also evidenced by her taking the time on 9 June 1992 to explain them to her granddaughter, Julia.

≠

At intervals, the cold war between Bruno and Molly flared into a hot one, with her "devastating" him in February 1992 when she said she never should have married him.[22] A month later, he got back at her by stating she was "terrible in the sex department."[23] Now more than seventy years old, Molly began seeing their fighting in eschatological terms: "destined to go on until death."[24] And she could resignedly (and with more than a whiff of the Anglican *Book of Common Prayer*) say, "I never had the courage to get out — just run away from time to time, with punishment upon returning."[25]

It is hardly surprising, therefore, that about this time, Molly, who had long had a taste for W.H. Auden's poetry, which she enjoyed discussing with Allan Donaldson, told herself that Auden's idea of love[26] was also hers.* Given her openness to Joe Plaskett and other gay men, Molly would also have been attracted to what Dennis Paddie calls "Auden's 'Gay' Version of Christian Spirituality," albeit without the doctrine implied by the last two words.[27] Additionally, given the years of difficulty in her marriage, Molly must have intuitively understood Auden's notion that "aloneness is man's real condition," ameliorated somewhat by those who, in the mould of a "'landless knight,' a 'GAWAIN-QUIXOTE,' go in quest for a like-minded community."[28]

Painting remained Molly's consolation. After a rough couple of days with Bruno, who was again jealous of their granddaughter, Julia, on 31 March 1993, Molly noted her "Depressing Life with Bruno. He is so negative" — and then recorded that she had had a "Good serious paint."

* Although, given her own willingness to be a war artist "in theatre," it seems likely that Molly was not aware of the controversy that surrounded Auden's decision to remain in the United States while his countrymen were waging war against Hitler. Evelyn Waugh, the author of *Brideshead Revisited* (another novel Molly liked) and who was not known for bellicose masculinity, jabbed at Auden for decamping to America, "at the first squeak of an air-raid warning" (Heitman, "Messy Genius of W.H. Auden," n.p.).

Had she looked back in her Diary almost exactly two years, she would have seen, that after Bruno's tirade at lunch, she "Flees to painting."[29]

In June 1995, Molly was surprised to find that Bruno owned several numbered companies, and while she did not know their total worth, the existence of these companies indicated he was wealthy. All the more reason, she felt, to be dismayed at what Bruno said late in July: he was "a dreary old man dreaming of grateful days of cabbage — no shoes" of his youth.[30]

In September, the tension broke with a storm about how women keep men in "degrading positions," her income tax bill of $59,000 ($91,500), MLB Inc., and "other silly things that come in the mail."[31] Bruno's resentment covered "everything from baking bread to cleaning the car" and his attack left Molly reaching for a word she had first used five years earlier. "If this is not abuse, I don't know what is," she wrote before castigating herself for not having her mother's strength: "I never had the power to leave like Mum would have had."* A year later, Molly first began referring to herself as "abused."[32]

On 13 June 1995, Molly wrote that "Bruno [is] a real pro fisherman," after spending a day with him and Stairs at the Grilse and Grouse, a fishing camp they co-owned with a few other men and had been built a year earlier. A year later she made a point of noting that she and Bruno did not "squabble" while at a fishing camp.[33]

Like other "male" activities such as hunting or playing ball, angling can be an instance of "hegemonic masculinity," the sociological technical term that has replaced "toxic masculinity." However, the fishing trips described by Gary Stairs and Bruno's lawyer friend Fred McElman were far from mano-a-mano slugfests. Traditional gender roles, such as cooking, were not necessarily seen as chores or always formally parcelled out according

* Recall that when it finally came, Mary Williams turned down Mortimer-Lamb's offer of marriage.

to a rules-based system that sociologists have pointed to as one of the hallmarks of male activity. During one fishing trip at the Northwest Forks Fishing Camp, McElman led a party that included Alan Graham, the New Brunswick minister responsible for fishing, from the camp right after breakfast. "On the way back for lunch, I realized that we hadn't allocated any food for lunch or who would cook. We returned to camp to find that Bruno had taken the leftovers from the previous day and made a wonderful, tasty and balanced, soup," recalls McElman. Another time, after McElman caught salmon, "There was much debate on how to cook it. One of us suggested that cooking it in tin foil was one idea. Another said it would be nice if we had some fennel to season the fish with. 'Just a minute,' said Bruno, reaching into his bag, from which he pulled out some fresh fennel; he had anticipated he might be called upon to cook for us."[34] This "one for all and all for one" attitude of Bruno's was, no doubt, one of the things about the time Molly spent at the fishing camps that impressed her.

Sitting on a fifteen-hectare piece of land near Doaktown, New Brunswick, the Grilse and Grouse fishing camp, built in 1994, started out as a design on Bruno's napkin. He refined it, creating linear drawings that showed the layout of the camp and the main lodge. It has three bedrooms, a kitchen, and large living room and a sun/dining room with a stunning view overlooking the river about fifteen metres below the rise the lodge is on. "The carpenter that built it did not work from engineer's drawings but from Bruno's sketches," says Stairs. Stairs's heavy equipment company arranged for the pouring of the lodge's cement basement (which is large enough to hold several canoes and masses of fishing gear). The lodge is stick built (two-by-sixes with joists), with long carrying beams inside. It has a cathedral ceiling with tongue-and-groove panelling. The outside is clad with cedar shakes. "The lodge is so well constructed that it can be heated and used throughout the winter," says Stairs.[35] As I saw when Stairs brought me there in August 2018, the lodge is decorated with oils, sketches, pen-and-ink drawings, and both the printed woodcuts and the

black-ink-stained wood used to make them. Stairs's admiration for Bruno's woodworking skills was obvious when he showed me some of the furniture Bruno had built.

Bruno's skill with tools was legendary. In 1984, David Young and his wife moved from the Bobaks' granny suite to a house they bought a few streets away. Young did not realize that the workman upgrading the almost century-old house had destroyed the ornate archway that divided the living room into two parts, a larger area at the front of the house with the fireplace and a smaller area that formed a sort of a den. The archway could be rebuilt but the intricate wood curlicues on the ends, he knew, would be difficult to replace. "When I told Bruno about this and what the archway looked like, he took out a paper, drew a few lines. And I said, 'Yes, that's it.'"[36] Young didn't think anything more about it until a week later, when Bruno showed up having carved a new archway complete with the intricate curlicues.

Since the late 1400s, fly-fishing and the making of flies have been favourite subjects of genteel English writers. The genre's most famous work, Izaak Walton's *The Compleat Angler,* published in 1653, lists twelve different types of flies. For the beginning of May, Walton, who fished mainly in the River Tey (known today as Tay River), advised using a ruddy-fly: "The body made of red wool, wrapped about the black silk; and the feathers of the drake; with the feathers of a red capon also, which hang dangling on his sides next to the tail." According to Piscator, Walton's mouthpiece, whose name means "fisher," this and the other eleven flies form "a jury...likely to betray and condemn all the Trouts of the river."[37]

Both Walton and J.M.W. Turner, who became an avid fly fisherman late in life, would have recognized some of the materials Bruno, Stairs, and their other fishing buddies used to make flies: dyed deer hair, horse hair, and various feathers. Writer and painter alike would have been jealous of the synthetic glitter (gold leaf, the only form of glitter available until the twentieth century, was ruinously expensive) and polyester thread. While tying the Green Machine, General Practitioner, White Wolf, and other

flies, each innovation representing the angler's hope that this one will fool a bass, trout, or salmon into biting and impaling itself on the barbless hook, Bruno and his friends faced one of the same problems Piscator and Turner faced: large fingers tying small knots in fishing lines. Bruno's solution to this problem was to build a number of small jigs. They are "ingenious devices that held the fishing line so that you could make the twists and turns," recalls McElman. "He made them out of clothes pins and nails. The clothes pin holds the fly line so you can wrap it around a nail to tie a particularly difficult knot."[38] The lines that twist and turn that Bruno drew in a picture of a nail and clothespin jig bear resemblance to the drawings Sapper Bobak would have made of barbed wire a half century earlier.[39]

While Walton's book was not on the table at either the Northwest Forks or the Grilse and Grouse fishing clubs,* its spirit — akin to a seventeenth-century *Zen and the Art of Motorcycle Maintenance* — was very much present. For, as much as the third most republished book in English after the Bible and Shakespeare's collected works is a treatise on angling, it is also, according to the English essayist William Hazlitt (d. 1830) "the best pastoral in the language."[40] Dating back to Ancient Greece and Rome, the pastoral genre celebrates the purity of lives lived close to nature. In his introduction to Bernard Riordon's *Bruno Bobak: The Full Palette*, Herménégilde Chiasson, then lieutenant-governor of New Brunswick, as well as a painter and art connoisseur, invites us to see Bruno's sophisticated German-inspired Expressionism in terms of Existentialism, "a protest against what he had seen and experienced" in the Second World War.[41] But McElman's and others' memory of Bruno sets the painter himself squarely in the pastoral mode. "I don't have any doubt at all that Bruno took great satisfaction about being out in nature, wading rivers, fishing rivers and simply being in nature. And not being overly concerned about whether he caught anything," says McElman.[42]

* The full title of Walton's is *The Compleat Angler, or, The Contemplative Man's Recreation*.

Just as Molly's Diary records numerous instances in which she comments on the sky,[43] Bruno often drew his friends' attention to the colours at sunrise or sunset. "I remember once looking at one of his paintings and saying that the sky doesn't look natural," says McElman. "Then, I started looking at the sky more and realized he painted it as it was. In other words, I saw more colours in the sky after examining his paintings. A number of them had a pink hue that I had not ever noticed in the sky until then."[44] Wayne Burley, president of the Nature Trust of New Brunswick, who rented an apartment from the Bobaks for three years in the 1980s, told me, "When driving around we still say at sunset, 'There's a Bruno sky.' He depicted what no one else in the province was able to depict about the sky of New Brunswick."[45]

Bruno may have been off duty when fishing, but he was constantly observing rocks, pools, and the nature around him. "One day we were walking on a trail," McElman recalls, "and he stopped and said, 'Look at this...' It was a small orchid native to New Brunswick, perhaps four inches high and white, that I had never seen. Then he made a painting of it and where it occurred in New Brunswick."[46] Bruno would sometimes recombine images of images of rocks and pools and create his own version of New Brunswick's fishing landscape, as he did in the *Wasson Bar* and the *Home Pool* series discussed above.

The title of the 1992 watercolour *Gary Stairs Fly-Fishing* suggests that Bruno's friend will be front and centre. He is present, but he's down on the lower left and, in a departure for Bruno, depicted in almost Colvillesque simplicity. His grey vest and shirt, for example, are formed from at most four tones. The sun that falls across the left side of his face and neck lightens his skin to an almost uniform beige (p. 222).

Directly in front of Stairs and occupying about a third of the painting's width are the shallow rapids over which the waters of the Miramichi run toward us. Yet, surprisingly, the movement of the painting is upriver, back over the rapids. Bruno draws us into the scene by placing the most striking colour — the white churning water of the rapids — between two areas of green vegetation and then indicating, via a small arm of white running

toward the upper right, that the river we have traced curves to the right and out of sight. Before we know it, we have forgotten all about Stairs and find ourselves imaginatively wandering around the bend in the river and further into a world so verdant it is hard to believe it came from the same hand that had sketched *Cornstalks* and *Raven*.

Grilse and Grouse was the third fishing camp Bruno was part owner of. The first was at Blackville, New Brunswick, about 125 kilometres northeast of Fredericton. The other was the Northwest Forks Fishing Club, organized by Fred McElman, where in 1991 a camp (partially designed by Bruno) was built; sometime later, Bruno drew a map of the camp.

While nowhere near as detailed as the sapper maps the one-time lieutenant Bobak had drawn in the army, the map shows Bruno's topographical training: from the blue he used for the river, the ridges that indicate the indeterminate contour of its bottom closest to shore (which changed year-to-year because the Miramichi is an alluvial river), and the symbols for the bridge and the swamp, this last looking like porcupine spikes. The long dirt road leading to the camp is light brown and Bruno drew little circles, the topographical mark for sand, and which also indicated the road was rocky. Years of Expressionist painting notwithstanding, Bruno's interest remained in depicting the kind of details he did when painting tanks in the army, visible in the piping atop the water tower and in marking the exact position of the pump, both specified by the symbol for pump and by the clearly printed word "Pump" with an arrow.

A fisherman's sense of geography is not like the army's sense, however. Just as, for 3,000 years the *L'nu* ("the people") have heard about Ableegumooch (Rabbit) and Keoonik (Otter), two trickster figures who played pranks on each other and, like modern cartoon characters, sometimes killed each other only to randomly come back to life, a fisherman's landscape is made of stories, memories, and advice. Fishermen's maps are more concerned with identifying and naming camps and fishing pools than with

the mathematical grids used by the Royal Navy agents interested in lumber for ships and tall trees for their masts, who mapped New Brunswick in the eighteenth and nineteenth centuries. Near 47° 16' 27" N / 66° 19' 05" W, the coordinates for the confluence of the Northwest Miramichi and the South Branch Northwest Miramichi, you will find Crown Angler's Reserve Camp, American Pool, and Scott Pool. At Northwest Forks, Old Camp Pool is the pool closest to the Old Camp. Judges Wharf, essentially a platform and steps that lead down to the river where the bank is steep and slippery, was built in 1997 when two judges came to the camp. Last Chance needs no explanation. Muskrat Run was the part of the river where there had been a muskrat nest.

Though Bruno did not indicate it on the map, the owners of Northwest Forks know of another run, Bruno's Run. Instead of recalling a particularly good place to fish, Bruno's Run recalls an event. As the story goes, one early morning Bruno went to the outhouse and left the door open. While sitting on the "throne," he looked up to see a bear looking at him. "He didn't dare stand up, but he slowly extended his foot and caught the door and swung it closed in the bear's face." The bear waited around a considerable time but finally left. "Bruno opened the door and ran to camp. Ever since then, we've called the path to the outhouse 'Bruno's Run.'"[47]

McElman, Stairs, Burley, Smith, Andrus, Toole Grant, and other friends and colleagues of Bruno told me of their friend's sense of humour. While it is evident in the Fat Ladies series discussed in chapter 7, it is, perhaps, easier to see in the pen-and-ink drawings, some on paper, some on cards, and even on envelopes in which he enclosed his share of the yearly expenses for the Northwest Forks. One, that dates to the late 1990s and hangs among more than a score of others behind McElman's desk, shows him and two other men standing in the water, signalled only by a few squiggles running around their legs. McElman's line, stretching to the left, is already in the water, and Bruno has caught one of the other men in mid-cast. The third man is answering his cellphone, a large one of the period. The caption, presenting a receptionist's voice over the phone, reads:

McElman & Associates…

Please hold…

Mr. McElman is on the other line.

Adler Run, which also dates to the 1990s, tells the story of a man wearing a Tilley-like hat and hunting vest with bulging pockets, standing almost waist-deep in water; his assured stance telling us he's an experienced angler. And yet, despite everything—including the knowing way his left hand holds his rod upright—something has gone hysterically wrong. Hanging from the branches above him are metres of fishing line and, on the right side, the fishing lure and weight.

The Brunos that appear in his Expressionist works are either scared, confused, or defeated. None of these descriptors can be applied to his sketches of himself on Christmas cards and paper. One pencil sketch shows a smiling, bemused, and grizzled Bruno outside in the snow, his red stocking hat signalling the time of year. To his left is a snowfish: a fish sitting atop two round balls that could have been part of a snowman. Leaning against the largest ball is a sign saying "All My Own Work," an in-joke with two registers. The first plays on the fact that everyone knew the silkscreen Christmas cards the Bobaks sent out were produced by both him and Molly. The second, registered perhaps only by Andrus, refers to the fact that outside the National Gallery in the late 1950s, there was a man who set out his work, which, incidentally, impressed Christopher Pratt, with a sign saying, "All my own work."[48]

The image of the "The Last Moose Hunt" turns the tables on the drawing's title, which suggests the hunt undertaken by licence holders at the end of September and the stereotypical image of a moose strapped to the back of a pickup truck with the hunter's gun on the rack at the back of the cab. Instead, Bruno treats us to a large moose swimming in the river. The not dead, but certainly shocked, hunter, wearing both Bruno's face and a checkered flannel shirt, lies on the moose's back, held in place by his tie, which is lashed to the moose's large antlers. Clearly the moose had read

the province's rules about travelling with firearms, for the shotgun is safely stowed, pointing away from the viewer, in the moose's rack-like antlers.

The moose looks back toward us. Its wink tells us all we need to know about how this great beast regards the inversion of what hunters take to be the natural order of moose hunting season.

Molly adored cross-country skiing, but the closest she got to downhill skiing appears to be painting the skiers on Crabbe Mountain, near Fredericton. While she saw Paul Henderson's famous goal in the 1972 "Summit Series" on television, competitive sports left her cold. She differed, therefore, from her contemporary Elaine de Kooning, whose *Baseball Players* focuses on the climactic moment when a player, likely Jackie Robinson for the rabid Brooklyn Dodgers fan, slides safely under the catcher and touches home plate to score. Indeed, Molly was so unconcerned with game play that her wartime *Hyde Park Baseball Game* not only doesn't show a play, it has no baseball diamond in it! And yet, Molly was at times drawn to painting sporting events because they were interesting sites for depicting crowds and movement.

One important example of these works is the 1975 oil, *LBR*, that depicts Budovitch's husband's hockey team at play at the Lady Beaverbrook Rink in Fredericton (p. 223). By running "the audience [crowd] down one side" of the rink and having "the white ice and two or three skaters and no horizon," Molly shows her debt to the American abstract painter Sam Francis (oddly, given her hostility to abstract art).[49] The crowd, which includes the players on the bench, runs from the bottom centre of the scene around in an oval before vanishing into the upper right-hand quadrant. The five players on the bench wearing red-and-white uniforms become less articulated the farther each is from us. By the time our eyes pass the third or fourth man on the far side of the bench, the remainder of the players and the spectators beyond them appear as seemingly random daubs of colour and a few lines.

About two-thirds of *LBR* is the greyish-white ice surface, most of which is negative space. Only a small part, essentially a triangle described by the players rushing toward the net on the far side, is "in play." Only six of the ten players we see can be made out, though a tangle of greens and whites to the right of the goal (on the viewer's left) likely accounts for the other players (minus the goalies, whom we cannot see); one official, signalled surprisingly clearly in his striped shirt, is also present.

Instead of a freeze-frame of a scoring play or an acrobatic stick save, Molly has once again created an essay of movement. Thus the importance of the slashes of bright white at issue from the skates of the player on the far left wearing the number 4 on his red-and-white jersey and the fading white dots that are now behind the player on the far right who is wearing a green-and-white jersey. The strong forward movement of the players leaves more and more ice open. To prevent an unbridgeable gap opening, which might have been dealt with by moving a few players around on the ice, Molly uses what at first look like sticks held by the players on the bench on the left. These are not sticks but a bit of hockey rink minutia: dividers in the glass screen — the sort of architectural member that one would more expect from the commercial art–trained Bruno than the artist who hated painting pinions as a CWAC. They serve, however, an important function; they "cover" part of the ice surface and point toward the action, and, therefore, effectively abbreviate the empty lower right hand of the rink.

In a real hockey game, the line of action ends at the sideboards. Molly's interest, however, extends beyond the sideboards. Accordingly, although none of the figures behind the goal are clearly articulated, they are bunched together and volumetric enough to convincingly impart the excitement of the crowd looking down at the play close to them. The figures farthest from the play appear to be standing, which allows them to look down at the ice and turns them into structural elements because they lead the eye to the I-beams that support the rink itself, thus tying together the upper and lower parts of the scene.

Visits to Paris's Stade Roland Garros in 1993 and Wimbledon two years later led to a number of tennis-themed works. The most interesting is

Centre Court, Roland Garros, though not because of the game play. The tennis player at centre court in Paris is all but incidental to the intriguing technical problem of depicting the "bowl" of Stade Roland Garros with its crowd seating rising in tiers in the background. To do so, Molly positions the viewer with a group of spectators who are sitting just below the bleachers. This allows her to look down onto the court, on which are sketched the lines of the court and, barely, the net, which occupies the centre right of the lower part of the stadium. The gap between court and bleachers would have yawned empty and disconnecting—had tennis rules not fortuitously demanded that the umpire's chair rise high above the court (on what is our left). The supports of the chair become, essentially, a black ladder that leads to the upper tier of the stadium.

The spectators are divided into two groups. The first group sits close enough to where Molly has positioned us that for one of the few times in her crowds, we see an individual in profile in almost the same kind of detail Bruno is known for; indeed, this figure's wooden expression and clayey colour seem more Bruno than Molly. Save for the finely drawn back of a spectator wearing a red windbreaker and a backward ball cap, these figures are oddly static. By contrast, the figures in the upper tier are drawn loosely, most heads being only beige circles and most torsos being coloured triangles; faces, arms, and hands are not described. And yet, when viewed as Molly intended, that is, from afar (the other side of the stadium), the riot of reds, greens, whites, and blues becomes another example of a crowd caught in a moment of action quite independent of the action on centre court. Molly's great achievement is to make it seem as if the individuals' positions are random. They could not be, but by making it seem so, she places this crowd outside the matrix that concerned Gustave Le Bon and Elias Canetti.

Both Molly and Bruno painted football pictures, as different from each other as we would expect. Predictably, Bruno's 1975 oil, *The Football Player,* focuses on a single player, dressed in UNB's black and red. His jersey number, 66, indicates he is either an offensive or defensive lineman, yet his body seems to lack the usual heft these positions demand. Much

of number 66's face is obscured by his helmet. Given that this work was painted around the same time as *Remorse*, it is hardly surprising that what we see of his face owes much to Kokoschka and, through him, to what we perceive as an innate intelligence not usually associated with linemen. This accords well with the player's arms, outlined in white and grey and flesh-toned hands, both of which impart a sense of determination and style.

Putting aside her shaky grasp of the numbering system that distinguishes the players' positions, what is important in Molly's painting of a Fredericton High School football game, likely the one played on 31 January 1994, which she said she would like to paint, is how different directions of movement across the picture plane that, from a geometrical point of view, have nothing to do with each other together create the play. First, let us note Molly's departure from her renderings of tennis and hockey players—and the figures in works like *Massey's Funeral* (p. 208) and *First Night*. These high school football players are among the most fully rounded volumetric figures of her mature work. The direction of play can be determined from the quarterback, the figure closest to us in the middle foreground, who looks to his right front. His legs and the position of his body suggest that he has just thrown a pass. Whether it was caught concerns Molly as little as the lack of hockey sticks concerned her in *LBR*. The direction of play is mirrored by the clouds in the sky, which, from their shape and position of the blue patches of sky, appear to be being blown from left to right.

Molly is less interested in the position of the ball than she is in depicting the clash of the linemen, the home team in yellow and black and the visitors in red and white, whose struggles dominate the middle ground of the work. In a real football game, at least some of these players would already be on the ground, but verisimilitude was not Molly's aim. Rather, representation is in service of the relation of colours and shapes in the painting: by keeping the twenty or so players upright—and catching several in mid-stride (on clearly articulated bent legs)—Molly creates an undulating field of strongly defined vertical colours that moves toward

and away from the viewer as it moves up and down from left to right. These players are moving in a strongly horizontal line, which intersects the diagonal line that begins with the quarterback.

While the school and a light standard topped by stadium lights in the distance form the horizon line, they are too far away to have much effect on the scene. The clash of linemen, the attempt we can assume to catch the ball (and to tackle the player who has it, if indeed he has), is contained by the two referees. Their importance is signalled by the clear drawing of their striped uniforms — stripes being the sort of detail that Molly would usually have rendered with quick Impressionistic strokes. By executing the officials so clearly, she appears to come close to Bruno's statement about game play in *Snooker*. The essential difference is Bruno's aestheticization of violence, which, he implies, is ever-present among the snooker players. In this work, Molly signals that the ostensibly violent and chaotic activity on the field has meaning only insofar as it conforms to the rules of the game; since the field on which the play takes place is a painting, without putting too fine a point on it, she underlines that visual meaning is dependent on certain strictures and principles, *pace* Clement Greenberg.

Arthur Irving came to visit the Bobaks in late November 1995. The billionaire, who, since the death of his father, K.C. Irving, had directed Irving Oil and was known for his buccaneer capitalist ways, wanted to save a little money. By going straight to Bruno, Irving not only hoped to save on the commission but to avoid dealing with gallerists he found to be "too aggressive."[50]

Among the works he likely considered was the newly painted *Saint John Harbour* (*Saint John*). This work can best be considered in conjunction with two other works, *20th of November 1979* (*November 1979*) and *Charlottetown in Winter* (*Charlottetown*), because each shows Bruno's interest in the human environment of the Maritimes.

November 1979 may have a few lively strokes of pink marking the grey

sky in an Expressionist manner and a number of Impressionist ice floes on the surprisingly brown Saint John River. But the work is dominated by a rendering of the unfinished Westmorland Street Bridge, crossing the Saint John River on the west side of downtown Fredericton, which shows a debt both to Alexander Colville and Carl Schaefer as well as the teachers at Central Technical School. The bridge is a continuous streel structure supported by a number of beams; the former provides a strong horizontal sweep, above which is the horizon, while the latter provides a series of upward thrusts that, together with the horizontal sweep, form a visual cognate of syncopated rhythm.

Beyond the bridge, forming part of the horizon line, is the Carleton Street Bridge, built almost a century earlier. At first glance, Bruno's rendering of the steelwork of the trusses would likely not pass muster with the former sapper's sergeant major. A closer look reveals, however, that while the lines of the steelwork are rather Impressionistic, they are organized geometrically and criss-cross each other in exactly the way they would appear to someone positioned slightly to the left of the centre span — and would be expected to catch the eye of a sapper-cum-war artist who painted a Bailey bridge in the last days of the war in Europe. In other words, Bruno depicted how the angle at which the bridge is looked at determines which plane the viewer can see. Had we been looking at the bridge straight on, the steelwork closer to the viewer would overlap the steelwork on the other side of the bridge, which we wouldn't see. However, since we look at the bridge at an oblique angle, we see both the steelwork closer to us and that further away.

Since the ramp leading to and from the Westmorland Street Bridge on the Fredericton side had not yet been completed when work stopped for the season in late November 1979, the bridge ends abruptly. Had Bruno positioned the viewer perpendicularly to the bridge, this would have left the viewer hovering, so to speak, in the air above the snow-covered north bank of the Saint John River. Bruno avoids this by positioning the viewer closer to the south bank of the river, looking at the bridge on an angle.

This orientation allows the line formed by the bridge's roadway to be continued by part of the roof of city hall, the back of the barracks at Officers' Square, and the Centennial Building.

The highest structure near the river is the bell tower of old city hall. However, it is not the highest point in the picture. Because of the painting's projection, the highest point is the third of three cranes on the south bank of the river. This crane rises toward the upper right and is about half again as high as the two other cranes, which rise toward the left. Because they are black, the three trussed lines that they form, each of which is partially obscured by the roadway, provide the depth against which the roadway of the Westmorland Street Bridge stands out.

Though it is an oil, *Charlottetown in Winter* has the feel of an Impressionist charcoal sketch. The placid waters before the city are broken here and there by swirls of blue indicating the swell of low waves in this protected harbour. Just above the middle ground is a barely visible tugboat making its way toward the left. Beyond the waterfront, the city rises: white, signifying tufts of snow, has the curious effect of anchoring the dark shapes in a known visual vocabulary: industrial buildings and houses. To the right of the centre of the scene is Charlottetown Cathedral; the white of the snow on the great expanse of its roof echoes the water in the harbour and sets off the cathedral's two black spires that rise into the grey sky. Bruno balances the cathedral by filling part of the space to the left of centre with two billowing black clouds and to the cathedral's right with one. Neither is Turneresque. Far from suggesting steel mills, like the ones Bruno knew from having lived in Hamilton, the columns of smoke rising above this city—which still does not have any heavy industry—are redolent of the constant battle people wage against the cold of the Canadian winter.

The orientation of *Saint John Harbour* (1995) recalls the one Bruno used in *Wet Morning* almost three decades earlier. The viewer is positioned some ten or fifteen stories above the port looking east toward its mouth. To the right of this imagined point, Bruno details the number (five) of supports

in each of the high container cranes as well as the distance between the cranes and the nearby low-slung support buildings. On the left, closer to the viewer, a smaller boat is tied up to the quay, which is outlined in grey. On it stands the small Saint John Coast Guard Base Lighthouse, a faux lighthouse built in 1985 as a tourist attraction.

Whereas *After the Concert* showed what can be done with grey-scale, *Saint John Harbour* demonstrates how an almost totally brown essay can achieve a Romantic view. Yellowish browns define most of the sky and about three-quarters of the water. Dark browns, including shadows from the container cranes (themselves defined by even darker browns) dominate the right side of the boat basin. The grain elevators on the left side of the boat basin and its cranes and conveyor belts are dark brown. The stern of a docked freighter is also dark, almost black, brown, as is its shadow on the waters.

The closeness of these hues could have produced a muddy picture. Bruno avoids this, however, by using the light of the rising sun, which comes from the painting's vanishing point: the gap between the two land masses that form the entrance to Saint John's inner harbour. The sunlight glistens off the water all the way to the bottom of the picture frame, forming a yellowish "road." Because of the darkness on either side of this "road," the yellow leads our eyes forward and up, producing a sense of movement that masks the fact that nothing in the painting is depicted as moving: no boats sailing, no cars, and no stevedores. The absence of workers does not mean that Bruno disregards them. Rather, by portraying the built environment, including a freighter and a smaller boat, in such sepia tones, Bruno transforms what is otherwise a sweaty world of hard labour into a romantic scene.

Chapter 12
"I Belong to Myself"

Every portrait that is painted with feeling is a portrait
of the artist, not of the sitter. —Oscar Wilde

At the beginning of January 1996, the director of the Art Gallery of Ontario wrote Molly, suggesting that she donate *Meal Parade, Hamilton Trades School* to the gallery. This work was chosen likely because of its historic value in helping to launch Molly toward becoming the first official female Canadian war artist. If this letter gave Molly reason to reconsider her opinion of the new American director of the gallery, the feeling didn't last long.

In May, a condescending letter from the gallery asked Molly to pay for the appraisal of the work; the appraisal was necessary so that the gallery would be able to issue Molly a tax receipt. Even more infuriating was the restorer's question as to what glaze she used. Anticipating this question, she had written on the back of the painting, "commercial linseed oil."[1] Disheartened by two years of rude letters and red tape, she told the gallery to send the work back.

It arrived on 20 July. C.O.D.

One of the two national accolades Molly received after turning seventy came more easily.[*] In the fall of 1992, she was working with historian Carolyn Gossage on the publication of her War Diary; Molly must have found it quite fitting that she first heard of Gossage's plan the day after

[*] The other was the Order of Canada, recounted in the Prelude.

317

watching the episode of *The Valour and the Horror* devoted to General Guy Simonds, who commanded large parts of the Canadian Army in Italy, at Normandy, and in northwest Europe, and who, Molly wrote, "came off badly—what a fool. We used to call him the 'Brill Cream [*sic*] Boy.'"[2] She found the collaboration with Gossage difficult, largely because Molly had her own ideas of what the accompanying text should say and knew she was a good writer. After venting her spleen a few times in her Diary, Molly ended up being pleased with the book. Aware of this project by the doyen of Canadian female artists, the National Archives wrote Molly, asking if she would deposit the original of the War Diary in the archives. Though she likely would have anyway, reading that those charged with preserving the nation's textual past considered work she did on her own time and which helped her become the only female official war artist in the Second World War a "National Treasure" didn't hurt the archives' case.[3]

Two and a half years later (June 1995), Molly's friend John Saunders took several hundred scribblers that made up Molly's Diary at that point to the National Gallery. Knowing how Bruno felt about Molly recording their lives every morning at their kitchen table, she was glad that Bruno was away when the boxes were loaded into Saunders's car. There is no indication that Molly reread the Diaries before sending them to the National Archives.[*]

Thanks to her regimen of walking her dogs, swimming at UNB or in the Saint John River, housework, and, still, shovelling snow, Molly was in remarkable shape for a woman in her seventies. Between 1993 and 1998, in addition to many trips to visit Anny on Galiano Island, Molly travelled to England, Paris, and Prague. Her eyes were another matter. Her left eye was the worst; twenty years earlier it had had surgery for a detached retina. For several years she'd been putting in drops because of glaucoma; now, in January 1994, she required stronger drops. And, instead of seeing

[*] It is not known when the scribblers that make up the last six years of Molly's Diary were delivered to the National Archives.

more yellows, as she had after her first operation, the eye was plagued by floaters.

Bruno was not as active as Molly and had not, as she had, given up smoking. He had both high blood pressure and high cholesterol, drank too much, and was something of a hypochondriac. On 9 December 1995, however, he had blood in his urine, signalling that the prostate problem for which he had been taking pills for some months had worsened.

Molly cancelled an upcoming trip to British Columbia, where in addition to seeing her daughter she could see Daisy, the beloved dog she was forced to send to Anny after it bit a woman.[4] Anny, in turn, made plans to fly to Fredericton. Molly ends her entry for 9 December with the revealing sentence: "In spite of all the years [of marital strife], confronted with deep concerns." Two days later Bruno was X-rayed. On the sixteenth, his doctor told him not to worry and he was slated for a prostatectomy in January. Christmas and his seventy-second birthday were nervous and, because of his catheter, uncomfortable times.

On 7 January 1996, Bruno was in a particularly foul mood, but, Molly added, "Who can blame him really, walking around with tubes." That night, with the operation looming, he didn't want to go to bed. Despite her hatred of the television shows Bruno watched, Molly stayed up with him watching television. A week later, Anny arrived for a few days' visit; when she left, Bruno accused Molly of having fun with her while he was dying. Knowing the fragile state he was in, Molly was less than affected by his histrionic accusation than by what it said about his fear of death.

The operation went well. Once home near the end of the month, Bruno was depressed, fearful, and he was not grateful for anything Molly did for him. Some months after recovering, Bruno repackaged the fear into a sketch for Donald Andrus. It shows Bruno after he's dropped his pants and opened his jacket. His once thin, though clearly muscular legs have turned into flabby thighs and spindly ankles. The tight skin he once depicted with stabs of different colours now resembles a chicken's, signalled with great economy by a few well-placed lines and dots. More than once Bruno had depicted himself with a thin waist and well-sculptured torso; now we

see a potbelly covered by a tight dress shirt atop which is a poorly tied tie. A few scraggly follicles are all that remain of the hair once luxuriously shown with heavy paint, which over-represented the hair that started to recede rather early in Bruno's life. The clean-shaven face seen in dozens of works now has a grizzled beard.

Most importantly, the sexual tension that animated so many of Bruno's paintings is not absent. Rather, it is unimaginable. For running down from his penis hidden by baggy boxer briefs is a catheter that ends in the urine bag strapped to Bruno's right leg.

Several parts of the sketch contribute to the humour. First, the note that accompanied it reads, resignedly, "This is what you can look forward to Don." Second, the overstated manner in which Bruno opens his jacket recalls the vaudeville and British Music Hall raincoat-wearing exhibitionists exposing themselves to women. "Bruno knew that I knew he had seen 1987 British black comedy *Withnail and I*, in which a character is caught by police in a washroom and, with a sheepish smile, is forced to open his raincoat to reveal that he has a bladder full of someone else's urine strapped to his leg in an attempt to avoid drunk driving charges. He knew I'd laugh at the image," says Andrus.[5]

Thirdly, the sketch is humorous for the same reason Charlie Chaplin's walk is funny. Because of the catheter, when Bruno walked, he waddled, unnaturally, like Chaplin and thus would seem, in the words of French philosopher Henri Bergson, like "something mechanical encrusted on something living" — which, in Bergson's view, is inherently humorous: "WE LAUGH EVERY TIME A PERSON GIVES US THE IMPRESSION OF BEING A THING" (emphasis in the original).[6] With the catheter coming out of his body and the bag strapped to his leg, this Bruno is closer to a Mel Brooks version of Frankenstein than he is to the image of the virile nude artist that so offended J. Bennett Macaulay.

≠

While maintaining her exuberant public demeanour, perhaps triggered by Bruno's operation and other events, Molly (understandably) became more conscious of "time's winged chariot." At the last day of March 1994, for example, which was a better painting day than the previous day had been, after learning that her friend William McCain had died, Molly fell into a pantheistic frame of mind: "I feel in my old age that the spirit of Babi, of dead mice, and even ants forms the vast energy of whatever's out there."[7] At McCain's funeral a few days later, Molly was mainly distressed by the fact that the choir sang three hymns out of tune and by the minister's insipid homily and the "impersonal service."[8]

In September 1996, Molly noted that she felt "she's reached another stage—closer to death and detached from normal life." The emotion was so strong, for the first time Molly writes, "No thought of painting."[9] At the 1998 Christmas concert at the Christ Church Cathedral, the reading was of the "love of God and his hate of enemies." Back home, the militantly areligious Molly asked herself about who became God's friends or enemies: "How does he choose, I wonder?"[10]

Whatever hopes Molly might have once harboured about politics providing answers had all but vanished by the late 1990s. Her opinions remained strongly left-wing, in contrast to Bruno's and the growing conservativism of some of her friends. So too, was Paul Martin's 1998 budget, which contained no new money for healthcare; she considered the then minister of finance and future prime minister to be a redneck.

In the years after the second Quebec referendum, Molly's attitude toward Quebec hardened further.[11] She was disappointed in 1998 when the Supreme Court upheld what many viewed as an unfair contract that allowed Hydro Quebec to purchase power from the Upper Churchill Falls (Labrador) power plant at a steep discount and then resell the power to the United States at a great profit. And she allowed her feelings to spill over into the sort of ethnic rhetoric she otherwise deplored in New Brunswick's anti-French Confederation of Regions (CoR) Party: "We

can expect no help from the Federal Government [of Jean Chrétien]; they are all French."¹² Yet, to her dismay, Bruno fished with CoR's leader. Two months later, she was upset at the Quebec nationalists who protested against the unveiling of the statue of Churchill and Roosevelt that commemorated the 1944 Quebec Conference, for which Molly had created the Army Show's sets and costumes.

Nor did old age bring a lessening of tensions. On 27 February 1997 Bruno was upset by the fact that Molly, who had been listening to the radio, told him she already knew the news: "You know everything," he barked. One April night that same year he made a scene about Israel and washed tirades of fury over Molly about whether she agreed or disagreed with what he was saying, including with what she saw as his "hereditary loathing of women."¹³ Two days later, he declared that while he might live another ten years, Molly would live twenty; women's longevity when compared with men's was one of Bruno's favourite rants. In one, after he went so far as to say he was four years older than Molly, she couldn't help but set him straight.* In early 1998, a fight that began at dinner at the Patakis' in which Bruno made a "fanciful statement about spoiling the next generation" ended with Bruno kicking Molly out of bed.¹⁴ Molly kept silent the next day, and when Bruno didn't say anything, she concluded he "cannot accept any blame for our situation."¹⁵ The following July, Bruno told Molly all "the things he hated about her," going so far as to accuse her of "faking blindness"—an attack that undercut what Molly saw as her recent attempt to get along.¹⁶

Molly's acceptance in 1995 that she was a verbally and emotionally abused woman and the effect that realization had on her reading led her, however, to conceptualize Bruno's anger and its effects on her differently than she had previously. Whether on someone's recommendation or not is unknown, but in the '90s she read works that dealt with women and

* To spare the reader a double-check, Molly was three years and ten months older than Bruno.

their struggles against domineering men. One example is Robert Graves's historical novel *Wife to Mr. Milton*, which tells the story of Marie Powell, who at sixteen is forced to marry the misogynist author of *Paradise Lost*. Molly's socioeconomic status could not have been more different from Paula Spencer's, though Molly deeply identified with this female protagonist, who explained away the bruises by saying she had walked into a door, an excuse that gave Roddy Doyle's 1996 novel its name: *The Woman Who Walked into Doors*. Like herself, Molly remarks that Doyle's protagonist

> can smell the attacks building up simply as they watch T.V. together. She tries to avoid them as the pressure slowly mounts — she agrees with all he says — but to no avail. I don't want to sound over dramatic or put myself into the false position of being battered about — but for a long long time now, I've had to run from a sort of frightening word "abuse" — to my horror, I heard Paddy Doyle's character doing what I do — agree, try not to talk back, etc. I think it is a most common thing and when there's no physical violence, it is hidden — one questions oneself about "guilt" — my practice is to get out and now at this age, although it is harder to travel . . . the great mystery is why people (women mostly) can not leave or why they come back. Outsiders can never know this private business — the surface looks good![17]

Heartened by her reading, Molly saw anew the dialectic between Bruno's behaviour and her inner core. "I've always been detached," she wrote in 1998.[18]

In fact, she had been thinking in these terms for at least a year, since a celebration of the Christopher and Mary Pratt works at the Beaverbrook Art Gallery. Molly's negative reaction to what she saw as the Pratts' emotional exhibitionism about their sundered marriage tells us

something about Molly's own life that she rarely shows: regret at having to balance the role of wife and artist (and, of course, mother). More than one of the Bobaks' friends told me (in confidence) that while it cannot be said that the Bobaks neglected their children, it was always clear to all, including their children, that for both Molly and Bruno each one's career as an (independent) artist came first.[19] "Mary spent years mothering as Christopher became famous,"[20] Molly wrote, knowing from her own life how much Bruno wanted her to mother him. However much she understood this need (made manifest, of course, in both *The Tired Wrestler* and his explication of it, as seen in chapter 6) given Bruno's abandonment by his mother, it was something Molly was constitutionally incapable of even agreeing to, much less actually doing. Three weeks later this woman, who was Mortimer-Lamb's and Mary Williams's "bastard," the first official female war artist, and a woman who made her way through the art world largely on her own terms, declared, "I belong to myself as I always have and will."[21]

Molly's characterization of Mary's *This is Donna* (Mary's painting of Christopher's model-cum-lover) as "sickening" has less to do with the painting's formal qualities, such the almost blinding light shining on Donna from her right or Mary's challenge to the traditional female nude and still less to what art historian Verna Reid sees as Mary's attempt to endow "Donna with individuality."[22] Rather, Molly has intuited what Bishop-Gwyn told me: "Mary got back at Christopher the only way she knew would hurt him. She painted Donna in a series of works—and did so better than he had."[23] *This is Donna* is, then, a settling of accounts, and it is this to which Molly objected.

Molly's Diary presents the world forthrightly and shows that she was no shrinking violet. She tells of shouting matches with Bruno and expresses regret for her own rhetorical excesses. She records her disappointments and the times she was angry at her children. Over thirty years, even friends come in for criticisms and remonstrances she would have loved to give. However, settling accounts requires the kind of psychological bookkeeping that is foreign to the woman who,[24] after recording a horrific fight, turns

on a dime and records the joys of walking the dog, a woman more than one of my respondents called "joyful." Using art to settle accounts, as her dismay at Bruno's "cruel" pictures of her in the 1970s indicates, was more than simply distasteful to an artist who was proud of the fact that "there is nothing threatening in my subject matter."[25]

For a painting to settle an account, the viewer must know who is being depicted; accordingly, such a picture, as *This is Donna*, must be a portrait. As noted above, with only a handful of exceptions, after Molly's war art period, she is supremely uninterested in depicting the *sine qua non* of portraits—faces. Instead, Molly is interested in picturing people doing things: participating in the Santa Claus parade, watching fireworks, skating, running along a beach. The people in her paintings are hardly emotional ciphers, but their emotions are less inwardly determined than are Bruno's figures (including his nudes that wear Molly's face) or Mary Pratt's. Instead, Molly's figures get their emotions from the acts they are doing—and since most of those acts are joyous, the world Molly depicts is infused with joy and the narrative is so enticing that her viewers are caught up in jouissance.

After the party for the vernissage of the Pratts' Beaverbrook exhibition, Molly wrote, "I'm no Mary Pratt and Bruno is no Christopher[26] but we've stayed more or less together—an arrangement made most probably for convenience & laziness and just maybe for an affection of a kind." And, ever conscious of her need to get away, Molly adds, "And I do have Anny & John & Galiano."[27]

On 11 September 1998, after recording that Bruno said Molly could not eat squash from their garden until she had finished the cauliflower, Molly wrote "Bruno wishes for a full sex life" and that she was "not into it." Whatever relations they had clearly left both frustrated, for a year later Molly wrote, "Mom didn't trust sex after she got me. So in some ways, I was retreating very clumsily from the whole idea."[28] The wording of the first sentence in this quote is so uncharacteristically ungrammatical that

we can only guess at the strength of the emotions that lay behind these words.

It is hard not to see Bruno's *Summertime in Fredericton*, painted in 1997, as an exercise in wish fulfillment when set against his sexual frustration (vis-à-vis both Molly and that which is common among aging men) and his emotions that led to the behaviour Molly saw on a typical night (9 November 1997):

> But by supper the pressure began to build — The inevitable leading up to an absurd row — it could be about my clothes, or my lack of experimenting with food — a general sort of hate & cynicism for people we know — all prearranged and absolutely chilling. I ended up shouting & going upstairs.
>
> Alas it will never change — only I suspect, get more into the despair of old age.... the long dark evening was endless.

The narrative unfolds against a familiar background depicting Fredericton and the Saint John River in the background. Bruno depicts a naked couple — another Bruno and Molly — cavorting on a blanket in a park (p. 224). She is lying naked against him; his left arm embraces her, his left hand covering her right arm and falling to the swell of her right breast. The Expressionist reds and blues in both of their faces and dabs of blue and greens and browns that pepper the bodies of these forty-something-year-old nudes seem to serve less of an emotional purpose than a chromatic one: they balance the reds of the setting sun and the cerulean blue dashes of the sky in which fleecy clouds touch the upper left of the picture frame.

A closer look reveals, however, that all is not well. The setting sun cannot possibly provide the light that reflects in two lines across the river. These lines, in turn, lead our eyes directly toward the cleft formed by Molly's half raised leg and her thigh. There, we find her right arm, bent at the elbow so that her — not his — hand is at her pubis, with all that suggests about his role in her sexual pleasure. This shift in narrative shifts

the purpose of at least one of the colours in her face: the red that spreads from Molly's closed left eye now appears as tears.

Painted for Gary Stairs, *Winter Geraniums* represents a different kind of escape and harks back to Bruno's war work and the shows he worked on at the Toronto Art Gallery. Unlike the snow in *Winter Lilies*, here the snow, rendered in shades of white and extremely light-blue, extends only a hundred feet or so to a house rendered in a flattened manner that recalls *A Crew of the Royal Canadian Corps of Signals*, though, of course, the house is undamaged.[29] While the scene contains no "action," Bruno creates a theatrical feel by hanging the geranium from the top of the window sash, making it appear "above" the house seen through the window.

The flowering geranium's stalks — rendered in deep greens and, for the flowers, pinks — hang down on either side of the black hanging basket; they do more, however, than simply pick up the horizontal lines of the grill. They combine with the beige curtains that, since they are half open, seem almost like the curtains of a stage. The backlight from the snow coming toward the curtain (and hence the viewer) is greater on the left side, suggesting that an unseen, though not thick, cloud is moving over the sun. Far from dividing the two houses, the untrampled snow links the two houses as it reflects enough light to brighten several of the petals of the stalk on the left.

Over the course of her Diary, Molly commented on a number of painters. Goodridge Roberts's 1981 show was "a knockout."[30] In a 1982 talk she argued that Millar Brittain was one of Canada's finest draftsmen. Two year later, she singled out Brigid Toole Grant's painting in which there are "mysterious pieces of dark verandah and bright street lights beyond" for especial praise.[31] In 1992, she found the works of Fredericton-based artist Stephen May "stunning" — a judgment, incidentally, Bruno did not share.

Unfailingly polite with other artists in public, Molly was less sparing in her Hilroy scribblers. The Willem de Koonings she saw in 1974 "confirmed

[her] worst suspicions"; despite having some pretty colours, they were "very painterly but had little to say to me."[32] She found an exhibition of Gordon Smith's "awful, thin and mannered."[33] A year after praising May, Molly was more critical, finding that despite good painting, his work lacked "a clarity of purpose."[34] She believed Robert Bateman to be "a phony." She found that paintings in a November 1995 exhibition of Lawren Harris's later work failed to live up to his early paintings. She was unsparing in her criticism of Peter Sabat, declaring in November 1994 that his work was derivative (of Bruno) and that he produced "undigested surfaces."

In 1996, she was thrilled to read an article that argued, "back in the 50s & 60s" Canadian painters, including Bruno, Gordon Smith, Jack Shadbolt, and several Toronto-based painters, owed more to the British painter Graham Sutherland and other British artists than to the New York School, which she loathed.[35] Warhol left her cold, though she liked the Ashcan School.

Molly spent most of January 1999 reading Pegi Nicol MacLeod's letters and thinking about the artist who was sixteen years her senior and who, before her death in 1949, had had many of the same friends Molly later had in Fredericton. The letters showed Nicol MacLeod was much bolder in "loving the boys," though, interestingly enough, Molly doesn't comment on what Laura Brandon, Nicol MacLeod's biographer, notes about her many nude self-portraits: "Pegi liked to paint her own sexuality."[36] As she read, Molly found herself transported back "to a better, smaller time — a place where people knew each other in the world of painting." What Nicol MacLeod wrote about the Toronto arts scene during and after the war matched Molly's memory of her own dismissal of the "clever, comfortable people" she found there.[37]

Since she was not a soldier, Nicol MacLeod could not be made an official war artist; still, she painted memorable scenes of CWACs in Canada. She first shows up in Molly's Diary in 1981 when, during a show at the UNB Art Centre (which Nicol MacLeod and painter Lucy Jarvis founded in 1940), Molly wrote that some of Nicol MacLeod's works

bordered on "1930ish stylization." Molly may have had in mind Nicol MacLeod's strong arm in *Pegi with Cyclamens* or her sinuous back in *A Descent of Lilies*, both of which show Nicol MacLeod's familiarity with the Mexican Marxist muralist Diego Rivera. In 1982, Molly is unstinting in her praise of the works she has seen in a show. In 1995, she praises Nicol MacLeod and Jack Nichols for having been able to avoid the "mannered" styles of other Toronto artists, including Jack Bush, the one-time employer of the teenaged Bruno Bobak and a member of Painters Eleven. Nicol MacLeod had gotten so far "into" Molly's head that on 2 April 1999, Molly did something quite unpredictable for her: she took advantage of the early spring day and walked the few blocks to the cemetery where Nicol MacLeod was buried. After a short search, she found her tombstone. While standing before it, Molly thought about how she had outlived Nicol MacLeod by about a half century and how "she produced a lot of good work in a short life."[38]

Ironically, Molly's last major statement about abstraction in her Diary, found in the 15 September 1999 entry, is about Plaskett's work, which Bruno had criticized for decades. A few months before the turn of the millennium, however, Molly finds herself agreeing with Bruno's critique of her friend's work. According to Molly, it was "self-consciously semi-abstract" with a mixture of realism and amounted to "pretty shallow stuff."[39]

On 12 January 2000, Molly began the 236th scribbler or spiral-bound notebook that together make up more than 10,000 pages of her Diary. Because of her deteriorating eyesight, which made painting more and more of a challenge, her cursive hand was larger than normal for her when she recorded that the night before Bruno ranted against women. Two days later, almost as if she knew it would be among the last entries, she and Bruno looked at slides of their work from the 1960s. On 6 February, while Bruno was shopping, Molly, as had been her wont, took advantage of the

good weather and went cross-country skiing as she had hundreds of times along the frozen Saint John River. The last lines of the Diary, written the next morning, read: "When I got home, I pulled in the washing just before a huge and swift blizzard. I felt tired and that night I had a coughing fit."

Sixty years after they were married at All Souls Church in Toronto in 1945, Bruno painted a work called, simply, *Anniversary* (p. 8). Though none of the colours on his face, his now almost bald head, Molly's face, or their hands are unnatural, their organization reminds us that Bruno's was once an Expressionist brush. The greyish skin that bumps up against lighter flesh tones defies both dermatological and photonic logic. White hair, less defined than formed from heavy daubs of paint, emerges unexpectedly from a wave on the left side of Molly's head and pairs itself with the white on the left side of Bruno's head; both areas come close to matching the white of their collars—and thus tie together the forty-five-degree angle formed by their heads in echelon.

The background shares nothing with the contemporaneous *Gary Stairs, Fly-fishing*, in which, above the verdant forest, is a partly cloudy sky formed from alternating patches of white and blue. Instead, Molly and Bruno stand before a dark charcoal (almost black) tonal background that is just light enough so that their black sweaters can be made out. Perhaps the most uninterrupted expanse of colour in Bruno's public *oeuvre*, the black of these sweaters is so complete that were it not for where his hands clasp Molly, we would have no idea where the bend of his (unseen) elbow is. Only after a few moments' study do we notice a thin blue line that delineates her shoulders from his, though even then, since the black of the sweaters is the same, this line flits in and out of our consciousness.

"When we think of Bruno's Expressionist works, we think of strong use of colour, colour which acts [as] a call to or a response to action," says Smith. However strong or complete the colours, here, there is no call to action; indeed, there is no movement or even the intimation of movement. "It's as though they were on stage," says Smith—who is now several years

older than Bruno was when he painted *Anniversary* and, thus, speaks with the knowledge of both his friend's life and his own life well lived—"and the lights are about to go off."[40]

Smith's point isn't that they are about to die, however. Molly lived almost a decade more, and Bruno lived another seven years, during which, despite his many complaints that he had lost confidence and his statements about retiring, he continued to paint. Rather, Smith points to the drama Bruno has, Prospero-like, cast himself and Molly in. "There's a gentleness to how he holds her," says Smith, "that's only partially staged."[41] Time has allowed Bruno to show the harder edges of their tumultuous life as rounder ones, but it would be going much too far to say *Anniversary* rewrites or redeems history. Bruno embraces his wife. Yet, unlike the many lover figures he painted decades earlier, she does not incline toward him. There may not be conflict—the colours forming their faces underscore a deep connection—but they do not, as does the couple in *The Embrace*, merge into each other. The reason is not just that this couple is several decades too old to generate red-hot waves of passion. Rather, the reason is that this couple is isolated by the tonal background and even by the blackness their sweaters share.

Bruno's face is one we've seen before, though perhaps the word *remorseful* fits better here than does *guileless*. His eyes are lidded, but open; however, while he stands more or less fully square before us, those eyes do not engage us. Nor, as the occasion suggests, is he looking at Molly. As so many diagetic Brunos have done in the past, he looks down and away to the left, toward the corner, shyly. Molly's eyes are closed: a metaphor for the fact that without her glasses, and she is without them, she was effectively blind.

At first, Molly's expression seems neutral, oddly, given the painting's name, though a closer look reveals more. Given how remarkably dysfunctional their marriage was and how limited their emotional communication was, Bruno could have created a vengeful Molly (representing how he viewed her or how he felt she viewed him) or a caricature. Hers is, rather, a forlorn face, which is something quite other than depressed or broken.

This Molly, the Bobaks' old friend says, "is created with the recognition (by Bruno) that she has given all she had and can give no more. Here they sit, together, but…not together," says Smith.

J. Bennett Macaulay, the man who objected to *The Artist with Molly* a quarter century earlier, would no doubt have found Molly's arms grotesquely long and her hands and fingers lacking in the definition he expected from art; what he would have made of the vertiginous blackened zones beneath Molly's collar and beneath Bruno's clasped hands and Molly's can only be guessed at. While Molly's unnaturally long fingers could seem to recall the fingers in *A Tender Nude*, which edge into the field of gothic horror, the misshapen knuckle on Molly's right ring finger pulls the hands back from that, back to the endless hours Molly spent holding a paintbrush and the operation she had had some years earlier. This finger makes it impossible not to attend to the thickened, barely delineated left thumb, which in its own way recalls time spent before the easel.

As much as their family romance marks their postures, expressions, even their sweaters, the story Bruno paints in *Anniversary* does not end with the Fall of the House of Bobak. It ends, in a mirror image to how it began, back in the atelier in London's Fairfax House, when Bruno peered around the divider he had set up. It ends with a stunning image of what for both Bruno and Molly was the existential fact of their lives: they were painters. It ends with Bruno's homage to the tools of their trade. It ends with the physical sign of decades of work. It ends with hands that are never going to paint again.

Chapter 13

Quietus

Life is a blank canvas, and you need to throw
all the paint on it you can. — Danny Kaye

On 4 October 2012, the *Telegraph* in London, England, published an obituary for Bruno Bobak, who had died from cancer ten days earlier in Saint John, New Brunswick. Eulogizing him as one of Canada's "most recognized painters," the British paper underscored the fact that he had been the country's youngest war artist in the Second World War. The anonymous newspaper "morgue" writer had something of an eye for art criticism. The writer tied Bruno's sapper training, which taught him to be wary of dead animals because they could be hiding landmines, to *Dead Goats at Empel*. The work, which pictures a number of goats — symbols in Marc Chagall's work as Bruno knew — is characterized as "a powerful allegory of the emotional consequences of war."[1]

The Canadian Press's obituary, carried across the country, began with a more nationalist tone, noting Bruno's training with Arthur Lismer before detailing his military career. Speaking for his province, Premier David Alward said that Bruno had been at the heart of New Brunswick's artistic life for more than half a century. Bernie Riordon, then director of the Beaverbrook Art Gallery, set Bruno's work in context and alluded to how some viewers found it difficult: "He was a very passionate and emotional Expressionistic painter that people grew to love and admire." Inge Pataki spoke of her old friend in both personal and professional terms: "Anything he did with his hands and with his eyes was perfect. He was a

print-maker, he drew incredibly well…he made furniture." Her highest praise, however, was for his paintings, many of which were first exhibited in Gallery 78. "His figurative work is a very strong expression of humanity; his landscapes were just masterful at characterizing or portraying the province" he called home for six decades.[2]

As the Art Gallery of Ontario, where the young Bruno took his first art classes, and the Beaverbrook Art Gallery rushed to hang pictures such as *The Seasons* in memoriam, friends like David Young remembered the last time they saw him. "I saw him a few days before he passed away," Young told me in December 2017. "It was a Friday, and they were going to take him to Saint John for a test or treatment. Bruno was in good spirits. Alex asked him if he was going to get dressed or go in his housecoat. Bruno said he wanted to get dressed. 'Slippers?' Alex asked. 'No, I want my good shoes.'"

As Bruno's son pulled them from the closet, Bruno turned to Young and said, "You know, those are your shoes." "I looked at them," Young said, "and remembered how decades earlier I had bought a pair of Hush Puppies that Bruno thought were lovely. When I realized they didn't quite fit, since we were about the same size, I asked him if he wanted them. He took them and happily wore them" for decades.[3]

A few days before Bruno died, Anny, who had flown in from British Columbia, took him home from the hospital. The next afternoon, he decided to teach her how to make apple jelly. Assembling the sugar, jars, and lemon exhausted Bruno, who was struggling to breathe through a plastic tube in his neck. Though she did not want to, Anny continued making the jelly. When she had finished, he asked for a pad, "and then he wrote out, in a weak and unsteady hand—such a different hand from the one he had only a month earlier when he sketched the poplars by the river at this fishing camp—a few directions, in case I ever wanted to make apple jelly again."[4] The following day, Anny loaded Bruno into a friend's truck to take him to the Grouse and Grilse fishing camp, but halfway there, he was so tired, he asked to go home. The next day, he was sent to Saint John Regional Hospital by ambulance.

When Molly and Anny arrived a day later, Molly asked her husband if he was in pain. He shook his head no. Then he held the breathing tube in his neck and told his wife of sixty-seven years, "Molly, get your soles fixed," a comment Molly was still laughing about when back in Fredericton later that day, as Anny and a friend named Beth were toasting Bruno and telling their favourite stories about him.[5] Before leaving the hospital, Molly had agreed with the doctor's palliative care suggestion to stop Bruno's fluids. The next morning, fittingly, a raw and grey one, the call came to tell them that Bruno had died during the night. That afternoon, while walking on the Green, Molly told her daughter, "He had a good life, considering his sad beginnings."[6]

"I was down in Saint John to see Bruno a few days before he died," recalls Gary Stairs, "and could tell he was very ill and just hanging on. I remember when I was driving home that I suspected I would not see him again."

"A few days later, I was surprised when Bruce Eddy, a close friend of Bruno's and a friend of mine, and Bruno's lawyer, told me that I was co-executor (with his son, Alex) of Bruno's estate." As executor, one of Stairs's first duties was to begin an inventory of Bruno's works. To do this, he had to go into Bruno's studio, which he had been to hundreds of times, on the second floor of their house on Kensington Court. "There were many works leaning up against the walls. But what struck me most was the work on Bruno's easel, a beautiful finished work of flowers on a windowsill beyond which is the frozen, snow-covered Nashwaak River just before it empties into the Saint John River; you can see Fredericton in the background."[7]

Over the years, Bruno and Molly had made annual donations of works that were then auctioned to help fund homeless shelters, such as Transition House in Fredericton and other charities, including, by Bruno, for fishing. Despite his conservative political views, Bruno left a substantial sum to Fredericton homeless shelters. Anny recorded both her surprise and her explanation for her father's largess: "I had never heard him mention homeless people, but I think he had never forgotten the severe poverty his

family experienced when they arrived in Toronto and had to eat restaurant scraps and sleep in boxes."[8] "The sum was enough," Warren C. Maddox, executive director of the shelter told me, "that a few years ago when we were in danger of closing, Bruno's generosity saved the shelter."[9]

On a late August day in 2018, I climbed the steep hillside beside the Miramichi River. Sitting on a bluff some nine metres high is a bench. Beside it is a plaque that reads,

Bruno Joseph Bobak
December 28, 1923-September 24, 2012
'Life is brief but art lasts'

When I sat on the bench, I could see where Stairs and a few close friends scattered Bruno's ashes.

In the year and a half after Bruno's death that Molly had left before she died from the same throat cancer that claimed her husband, Molly's daughter and friends rallied around her.[10] Over these months, Anny made a number of trips back to Fredericton to see her mother. One, providing the title for Anny's memoir, *Last Dance in Shediac*, was to Shediac, New Brunswick. One time they stayed at the Hilton in Saint John. This hotel provided notably comfortable beds, fluffy towels, "a view of the misty sea" from their fifth-floor room, and moments of wonder for Molly, who a lifetime earlier had crawled into her father's house through an organ's air vent, when they opened the door "with a bit of plastic."[11]

Friends worried about Molly living alone in the large house—and about her remembering to put in the eye drops needed to ward off the loss of more of her sight. "Molly wasn't very good about taking her drops," recalls Judy Budovitch. "So, a group of eight or nine of us got together and arranged either to take her to one of our homes for dinner or go to have dinner with her at her home. And, while we were there, following colour-coded instructions that Bruno had left, we made sure she took her

drops: two different drops that had to be taken over a certain period of time."[12]

Anny, who was becoming more and more concerned about Molly living alone, was surprised when her mother told her, "I've finished grieving now. I've decided to go to a home."[13] She was shocked when she heard that her mother had decided to go to the Veterans Health Unit in Fredericton. Although Anny knew Molly had been a uniformed officer during the war, she couldn't quite imagine her in such a predominantly male environment. While cleaning out her home, Molly regaled Anny with an unofficial song the CWACs sang while marching:

> HITLER! The CWACs are on their way!
> HITLER, expect us any day,
> Good girls—we've cut off our curls,
> And the Nazis, the blighters will PAY!
> Da da da-da da da...[14]

John Leroux, who saw Molly two days before she died, recalls that she loved the veterans' home. Though Molly jokingly called it "the Barracks," and told Anny that putting her name on all her clothing was "Just like the army," according to Stairs, Molly's room was quite comfortable. "She was able to put some of her pictures on the walls and even bring in a couple of pieces of favorite furniture."[15] As Anny notes in her book, Molly's friends continued to visit regularly—as did Anny. When Judy Budovitch picked Molly up to take her home for dinner, Molly asked that she pick her up on the building's far side because the other faced the hospital. "I don't like seeing it," Molly told her, "because it reminds me of Bruno's last days and I'm so lonesome for him."[16]

The *Telegraph*'s obituary ran on 13 April 2014, a little over a month after Molly's death. Oddly, its author was more struck by the fact that Molly was one of the last surviving war artists from the Second World War than the fact that she was Canada's only official female war artist. The obituary writer praised her paintings, sketches, and watercolours,

noting, "Her eye for the dignity and determination displayed by women in the army [that] allowed her to capture both the uncertainties of life on the home front and the turmoil behind the front lines in Europe," though their last point incorrectly suggests that Molly was on the continent before the end of hostilities. The obituary went on to praise her War Diary, *Private Roy*, and the "trials and tribulations of CWAC troops living and working on the move in Holland, giving a valuable visual account of an often-forgotten wartime service."[17]

The *Globe and Mail*'s obituary ran on 14 March, two days after Molly died. In it, author Allison Lawlor quoted Laura Brandon pointing out two apparently contradictory aspects of Molly's art that, in fact, reinforced each other: she produced "very personal" works "about shared experiences and sharing those experiences" in an almost conversational manner.[18] Lawlor quotes several people, including Alexander, about Molly's love of meeting with and talking to people.

Molly's ashes were spread in New Brunswick and on her beloved West Coast.

There is no memorial plaque for Molly Lamb Bobak. One of the country's most beloved women artists, and the bestselling one of her era, will always be the nation's first official female war artist.

Coda

But I am 'hors combat,' and am quite content to do work
that people enjoy, even it if it is not making the headlines.
—A.Y. Jackson (in a 1957 letter to Molly)

In 2018, six years after Bruno's death, and four years after Molly's, Gallery 78 mounted a joint retrospective of their work, *People and Places of New Brunswick*. That same year, the Burnaby Gallery mounted *Molly Lamb Bobak: Talk of the Town*, and in 2019 the Ottawa Art Gallery mounted *Molly Lamb Bobak: A Woman of the Crowd*. Eric Klinkhoff organized a retrospective of Molly's work shortly after she died in 2014. There has not, however, been a retrospective in any of the country's major museums since their deaths. Each, in fact, had only one during their lifetimes: Molly's was at the MacKenzie Art Gallery in Regina, Saskatchewan, in 1993, and the retrospective at Concordia that so discomforted Bruno was almost a decade earlier. By contrast, in 1990 and again in 2013, Mary Pratt retrospectives toured the country. A year after Alexander Colville died (2013), the Art Gallery of Ontario mounted a major retrospective of his work; his home on the campus of Mount Allison University is a museum and research centre. Maud Lewis's house in Digby, Nova Scotia, (which belongs to the Art Gallery of Nova Scotia) hosts a permanent exhibition of her work, and she has been the subject of a biopic starring Sally Hawkins and Ethan Hawke.

This lack of recognition would hardly have surprised the Bobaks. In J. Russel Harper's standard history of painting in Canada published in 1977, he merely mentions Molly without giving any information about

her work.[1] Bruno fares a little better. He's listed as "now artist-in-residence at the University of New Brunswick" and merits two sentences in the book's final chapter. The first suggests a rather curious cause and effect: "Bruno Bobak examined canvases by Munch, noted the freedom of Expressionist painters, searched deeper into man's inner psyche, and moved to Fredericton." The second, "There he has continued a somewhat solitary pursuit for meaning," is flat-out wrong, for Bruno was selling works at galleries in Montréal and Toronto at this time and exhibiting at the Beaverbrook Art Gallery.[2] (We also know just how "somewhat solitary" his life in fact was not.) The book's third-to-last illustration is also rather curious: *Saint John Harbour* (1961) is hardly representative of Bruno's oeuvre. As well, Harper completely ignores Bruno's war art.

In Dennis Reid's *A Concise History of Canadian Painting* (2nd edition), published in 1988, the author sandwiches Bruno between Toni Onley and Roy Kiyooka before referencing Bruno's "painterly landscapes...produced in between his extensive travels after retirement as Head of Design at the Vancouver School of Art."[3] Reid skips over the fact that by 1988 Bruno had been director of the UNB Art Centre for more than two decades, not to mention the fact that Bruno *and Molly* had been able to study works in Europe because of her Canada Council support—which is hardly surprising, since Reid completely ignores Molly's substantial body of work.

The book's 2012 edition repeats the above sentence, then grants that his "large expressionist figure paintings are now seen as substantial accomplishments," without describing a single one, before stating that "during the later sixties and the seventies they were not widely shown and had a limited effect on the course of events in the area [the Maritimes]," thus taking away with one hand what had been granted by the other.[4] A chapter later, Reid adds that Bruno produced "still-lifes, figures, and animal studies in his characteristic bold colours and broad handling." The next sentence reads, "His wife, Molly Lamb Bobak enjoyed wider exposure during this period with regular exhibitions....This new work built on her long experience, largely still-lifes in intimate interiors, but as in *Interior with Moroccan Carpet* of 1991...it brought a bolder, broader

development of colour" before going on to list several exhibitions of her work.[5] Somehow Reid missed the works Molly was best known for: flowers and crowd paintings. Reid ignores both Bobaks' contributions as war artists.

Readers of *Canadian Art* in the first two decades after the war would never have expected this neglect, for the Bobaks appeared forty-three times, in either articles about them or that mentioned them or via reproductions of their works. For a few more years, magazines like *Vie des Arts*, *Atlantic Advance*, and *The Fiddlehead* referred to them or carried pictures of their work. Then, with the exception of 1975, when *Saturday Night* published six pieces (articles or pictures) that referred to each Bobak, almost complete silence. There was never another article about either Bobak or a reproduction of their work in *Canadian Art*. In 1985, a decade after *Canadian Art* last covered the Bobaks, Molly cancelled her subscription: "It still fills me with despair, contempt and unhappiness — I was thinking [??] its [*sic*] all so very important and obscure. There is no (real) humility or lack of confidence—really very upsetting—I shall not read it again."[6]

The reason for this silence cannot simply be that Molly and Bruno eschewed Abstract Expressionism, and then Pop Art, Op Art, Minimalism, and several other "isms," and continued to paint figurative works, though their rejection did ensure that they were not seen as au courant. Mary Pratt also ignored these movements, as did her husband, Christopher, and Alex Colville. Since 1972, eight books devoted to Colville have been published, with the latest appearing in 2017. Mary Pratt has been the subject of five biographies, with two on the way and dozens of articles and chapters in books.

Professional and academic critics value difficulty and ambiguity because both require explication. What, for example, is the meaning of the "whiteness of the whale" in *Moby Dick*? What do the intertwining staircases in an Escher work signify? What causes Hamlet's indecision? Why does the figure in *The Scream* scream? As Molly herself noted, editors and critics did not see her and Bruno's work as theoretically interesting

as Mary Pratt's. Works like *Red Currant Jelly* easily lend themselves to discussions of the phenomenology of perception, of light, of optics. Some of Pratt's subject matter, such as the carcass of the deer being held up by the business end of a tow truck in *The Service Station* (1978), disturbs in a way Molly's works do not. As Tom Smart shows, our understanding of this work can be deepened by viewing it through a feminist lens: it "call[s] forward images of 'murder' and 'rape.'" A work that shows fisherman holding up a partially eviscerated salmon they caught presents the "inherent violence of fishing...as a metaphor of sexual violence[7] and rape and dismemberment."[8]

Colville, too, provokes questions. What is the story of the horse running down the tracks toward almost certain death in *Horse and Train*? Is the small-town-bred (Wolfville, Nova Scotia) boy saying something about our increasingly technological world? Given his military background, what are we to make of the many pistols in his works? Why do the oils of the mass graves he saw at Bergen-Belsen pale beside the sketches he did when he visited the death camp?

Even without access to Molly's papers, though, critics could have discussed the phenomenological intricacies of her flowers, the politics of her works done in Israel, the intricacies of Bruno's depictions of men and women in his Expressionist works, how his landscapes deal with time, the development of his portrait of retired Chief Justice Antonio Lamer, and Bruno's examination of the depiction of sexuality in his Fat Ladies series. As we have seen, Molly's Diary and (many of her) letters have allowed a reconstruction of the Bobaks' "life world." Having these documents allows us to see how Bruno's Expressionist broad handling of "bold colours" amounts to an alphabet he used to paint his autobiography. This could be placed in dialogue with Molly's Diary and her works to see, for example, how her flowers and crowds buoy her.

When Molly called her flower paintings "pot boilers," she inadvertently put her finger on the reason why scholars have ignored the Bobaks, save for the one book on Bruno published in 2006 (*Bruno Bobak: The Full Palette*), the catalogue of Molly's retrospective at the MacKenzie Gallery,

and less than a handful of articles. Though no one knew Molly's income and she certainly wasn't showy, everyone in the art world knew that Molly was, as she disparagingly called herself, "a popular painter" — and thus one who could not be, as Mary Pratt was, "first with the critics." Though not as popular as Molly, Bruno continued to sell, and somewhere along the line, the critics came to view Bruno's virtuoso changes in style as evidence that his work was "facile," as Molly put it in a letter. "When you go to look at a Colville," notes Stuart Smith, "you know what to expect. Bruno turned his hand to a number of different styles. And this makes it less easy to speak of a 'Bruno.'"[9] When Bruno asked Molly if artists can ever "get it back," he added his name to the petition that argued his work, too, was rather beneath serious criticism. Popular painters may produce pretty paintings, even pleasurable paintings, but they wield inferior brushes.

Admitting that painters are in the pleasure-creating business should not be overly contentious, however. In museums and galleries, perfect strangers are known to turn to each other and ask, "Do you like it?" The second most common question, "Did you understand it?," is really another version of the first.

The animus against admitting the primacy of pleasure in art has a long pedigree. Two millennia before Joni Mitchell sang about the seductive powers of being a popular songwriter in "Free Man in Paris,"[10] Plato (d. 348/9 BC) disparaged artists. Had Sophocles and Euripides kept their plays hidden in an attic somewhere in Attica, Plato's complaint that they traffic in secondary images, myths, would be interesting but not decisive. So too would be the charge that they show the gods in rather poor light. Though Plato couches his ire in terms of how the uneducated youth are taken in by these second-level creations, what really gets his dander up is that the works of the poets are popular, certainly more popular than Plato's teacher and avatar in the dialogues: Socrates, who famously is sentenced to suicide for corrupting the youth of Athens. Kant was equally concerned with controlling the response to art, validating only one that could be called "disinterested contemplation," a phrase surely not meant to echo how the vast multitudes would explain their response to art, were they to be asked.

Plato and Kant aside, what is wrong with being a popular artist? The young Michelangelo obviously didn't think anything was wrong with being one; otherwise he would not have snuck back into the old St. Peter's to chisel his name on the strap that crosses the Virgin's chest so that people would know who sculpted what became the world's most famous *Pietà*. Van Gogh signed his works, and Picasso, Dali, and Warhol were advertising machines for "Picasso," "Dali," and "Warhol" respectively.

Early in their careers, *avant-garde* artists like Jack Bush, Jean-Paul Riopelle, and Helen Frankenthaler revelled in their rejection of established artistic norms. Yet, however much their *avant-garde* art was difficult to understand, they were hardly re-enacting Samson in the temple. The term *avant-garde*, which comes from the military lexicon, means "before the main force." In other words, *avant-garde* artists are the tip of a spear the purpose of which is to burst through ramparts of the existing art establishment. Rather than tear the temple down, though, the *avant-garde* artists' goal is to capture it and keep it: to establish a new hegemony around their artistic practice and values and to start to collect tribute. No less than in the great age of patronage, the Renaissance, in the world of market capitalism, artists wanted to be understood, appreciated, the key marker being cash on the nail.

Less frightened than his teacher, Plato, about the emotions art generated, Aristotle proposed a psychological theory in which art's chief function is the production of pleasure, not as a secondary effect.[11] In his analysis of tragedies such as *Oedipus Rex*, Aristotle argues that they generate the pleasurable emotion of *catharsis*, the purgation of pity and fear, triggered by watching the fall of a king or prince; the experience is not unlike what teenagers seek when watching horror films. Today, magnetic resonance imaging (MRI) and positron emission tomography (PED) allow researchers to map which parts of the brain light up when a viewer sees an image that they find pleasurable or not. Many images, such as forest scenes with paths or winding rivers that vanish into the distance, light up almost every viewer's brain, which is why they are often put on hotel room walls. Other images depend on the viewers' taste and/or familiarity with different

artistic styles. Klimt's *Woman in Gold* is not everyone's cup of tea, nor would scientists find that Molly's flowers always show the light.

A viewer less than conversant with the theory behind abstract works may still find pleasure in the colours in one of Jean-Paul Riopelle's works or *Voice of Fire*. An educated viewer may enjoy them even more. No amount of art education will get a viewer to like Jackson Pollock's drip paintings if they do not find them pleasurable as visual objects. Presumably, the only way Bruno's *The Artist with Molly* would light up the pleasure centres in J. Bennett Macaulay's brain would be if someone lit it with a match.

Am I suggesting that retrospectives of Molly's and Bruno's art should be mounted? I am. And what would that entail? The mounting of a retrospective usually involves building an exhibit around a core group of works owned by a museum. Borrowing from sister institutions allows curators to fill in gaps in an artist's oeuvre. Then curators turn to private collections, some owned by the rich and famous: for Molly that would include the Irvings, McCains, and Mulroneys; for Bruno, former senator Nöel Kinsella. Finally, with help from either gallerists like Inge Pataki or Alan Klinkhoff, the curator would contact the holders of other private collections held by friends or others who bought pieces.

And there's the rub — and also the reason. If our imagined curator were not careful, they could end up in a real-life version of what might be imagined as a short story by Jorge Luis Borges, in which a curator spends their life searching, ever searching, for the perfect catalogue for retrospective. For, beyond the walls of museums, galleries, and friends' homes, across the length and breadth of the country, thousands of people can walk through their hallways, sit in their living rooms or dining rooms, or look up from reading in their bedrooms and see paintings by Molly and Bruno that give them pleasure.

A Small Financial Note

The secondary art resale market in Canada is dominated by Heffel Fine Art Auction House. Its database includes secondary market sales since before Kenneth G. Heffel founded the company in 1978. Accordingly, it provides a way to gauge the popularity, via sales, of hundreds of Canadian artists.

At the end of 2018, Molly Lamb Bobak stood at number 67 in Heffel's list of 100 top-earning Canadian painters, her works having earned $1,511,899 in the resale market. By contrast, Christopher Pratt occupied the 73rd position, with his works having earned $1.2 million, while Bruno Bobak earned a total of $316,379. On Heffel's watercolour list, Molly occupied the 31st position, having earned $178,930.

If, however, we compare Molly to only those artists active after 1975 (roughly speaking the middle of her career), in order to exclude, for example, Emily Carr's works, which had been sold and resold for decades before Molly was even discharged from the army, her position is significantly different. Of Canadian painters, Molly moves from 67th position to 28th position. Of watercolourists, her works move from being in 31st position to 12th.

Even more impressively, among Canadian female artists active after 1975, only Doris Jean McCarthy's and Kathleen Moir Morris's works have earned more than Molly's: $1.4 million and $5.1 million, respectively. However, both of these painters were already painting when Molly was born, and their most important work was done between 1925 and 1950. Further, both lived long lives: Morris died at ninety-three in 1986 and McCarthy at one hundred years old in 2010. Mary Pratt's death in August of 2018 led to a predictable rise in the value of her works, which showed up in the secondary art market. But by the end of December 2018, her works had earned $806,370, which made her the 97th highest-earning artist among Canadian painters.

Acknowledgements

While working on this book over the past three years, it has been my great pleasure to come to know a number of people. After I called him out of the blue, retired art historian Dr. Stuart Smith, who was a friend of the Bobaks for decades in New Brunswick and a colleague of Bruno's at the University of New Brunswick, warmly welcomed me into his home in Ottawa. Without his memories of the Bobaks, his recall of UNB's politics, and his expert knowledge of art history and of Molly's and Bruno's art, this book would be all the poorer; more than once he has kept me from falling into error by mounting an impromptu Art History 101 class at his kitchen table. Gary Stairs, a student of Bruno's and a decades-long friend of Bruno and the Bobak family, has provided me with a wealth of stories of Bruno the friend, fishing buddy, and artist. In late August 2018, Stairs graciously had my wife and me to lunch at his home in New Brunswick to show me his collection of articles, exhibit catalogues, study shots of Bruno's paintings, and other memorabilia; a few days later, he took me to the Grouse and Grilse fishing camp Bruno helped design and where his ashes were scattered. Gary has helped me date at least ten of the works discussed. The interview that I had planned to last about an hour with artist Donald Andrus, who in 1982 curated a show of Bruno's work at Concordia University in Montréal, lasted most of the afternoon — and resumed at dinner. Andrus filled in many gaps and his artist's eye informs many of the discussions herein. He also supplied me with his collection of letters to and from Molly and Bruno as well as allowing me to take study shots of works in his collection. Dr. Laura Brandon was, in fact, the first person I interviewed and many of my readings are indebted to the introduction she graciously gave me on that frigid January day.

Several other artists have helped me understand how Molly and Bruno solved certain technical questions and how their paintings worked. William Forrestall spent the day with me and my wife in the vaults of the Beaverbrook Art Gallery. His insights into works such as Bruno's studies of retired chief justice of the Supreme Court of Canada Antonio Lamer are testified to many times in this book. Nathalie Mantha, an artist and administrator at the National Gallery of Canada, gave me invaluable help in understanding how Bruno constructed some of his works and the challenges Molly overcame while depicting fireworks. Brigid Toole Grant graciously shared her memories of Bruno and Molly. Several of the insights into Molly's works

are based on what Toole Grant told me about her friend with whom she taught for decades. Additionally, Steven May provided insights into how several of Bruno's paintings worked.

I owe a debt also to John Leroux and Troy Haines, who led me, my wife, and Forrestall through the Beaverbrook Art Gallery's collection of Molly's and Bruno's works; Leroux has also read sections of this book and his comments led to several "oops" moments. Meredith Maclean, collections specialist, Art and Memorials at the Canadian War Museum, allowed me into the museum's vaults, where I saw many of the watercolours discussed herein; her insights into the sequencing of Bruno and Molly's works were invaluable. Maggie Arbour at the Research Centre of the Canadian War Museum worked her usual magic in finding materials for this study. I wish also to thank the research staff at the Library and Archives Canada for their help and for LAC's permission to quote from Molly's Diary. Natania Sherman at the McMichael Gallery graciously made time to show the works the gallery has from each artist. Kathleen Mackinnon at the Confederation Centre in Prince Edward Island also graciously showed me the centre's collection of Bobak works. I wish to thank Marie E. Maltais, director of the UNB Art Centre (and, therefore, a successor to Bruno), who opened the centre's archives to me. Christine Lovelace has twice pulled out everything in the UNB Archives relating to the Bobaks, including fascinating letters from A.Y. Jackson, "Uncle Alex." Peter Larocque at the New Brunswick Museum in Saint John also opened his vaults to me and my wife. Hilary Letwin, who curated the show *Molly Lamb Bobak: Talk of the Town* at the Burnaby Art Gallery, provided me with study photos of some of the pictures in the exhibition. Major Slade G.L. Lerch, regimental major of the Princess Patricia's Canadian Light Infantry, authorized Corporal Andrew Mullett, the collections manager of the Museum and Archives of the PPCLI, to provide me with a study copy of *Trooping the Colours*. J. Neven-Pugh (Nevi), curatorial assistant at the PPCLI Museum & Archives provided the image reproduced in the book. I would also like to thank Miriam Redford at Fasken law firm in Vancouver for providing me both with a study shot of Molly's *Demonstration U.N.B.* and the image reproduced in this book.

Alan Klinkhoff, who runs Galerie Alan Klinkhoff in Montréal, promised me about a half hour of an interview. Surrounded by the beautiful paintings in his gallery, we spent about two hours talking about the Bobaks and the changes in the art gallery business over the decades.

During my research trip to Fredericton in November 2018, I also met with Molly's friend Judy Budovitch, who allowed me to study the works she has and told me about her friendship with Molly and the artist's trip to Israel during which she spent time at Budovitch's uncle's apartment in Caesarea. Marjory and Allan Donaldson shared stories and allowed me to study their collection of Bruno's and Molly's works. Inge Pataki also shared her stories over a wonderful glass of white wine in her living room: the wine, the stories, and the paintings by Bruno and Molly

she has there made me expect the Bobaks to come through the door. Germaine Pataki-Thériault, who now runs Gallery 78, has, as we would say today, "tagged" who is who in many of Bruno's paintings. As well, she has made a number of images available to me to study while writing the book. Fred McElman, a long-time friend of Bruno's and another fishing buddy, not only shared stories and his large collection of Bruno's cartoons, he gave me a copy of the hand-drawn map Bruno made of Northwest Forks Fishing Camp, of which Bruno was a part owner. David Young and Wayne Burley also made time to speak with me and shared their stories of Bruno and Molly. Sheree Fitch and Frances Itani told the most marvellous stories about working with Molly as she illustrated their books.

Dr. Amber Lloydlangston, curator, regional history, at Museum London (Ontario), and the author of "Molly Lamb Bobak Official War Artist (1920-2014)," made time for an interview that was extremely useful. Dr. Devon Smither was kind enough to allow me to read her PhD thesis, "Bodies of Anxiety: The Female Nude in Modern Canadian Art, 1913-1945," which greatly informed my discussion of Bruno's examination of the concept of beauty in his drawings of nudes.

Since writing the acknowledgements always means that a book is about to come out, it is always fun to thank my agent, David Johnston, who was there when the idea was aborning. Likewise, I would like to thank my editor at Goose Lane, James Harbeck, who is the kind of close reader authors hope all their readers are; it was a pleasure sparring and working with you. A hearty thanks to my copy editor, Paula Sarson, for catching a number of loose fish. Goose Lane's creative director, Julie Scriver, has been unfailing in determining which images measure up to supporting the text. Alan Sheppard, my production editor, has kept me sane during the long weeks of COVID shutdown and in navigating the path to permissions. Susanne Alexander, Goose Lane's publisher, has believed in this project from the beginning and has also helped navigate the path to permissions.

I again thank Alexander Bobak for giving me permission to use those images other than Molly and Bruno's war art.

Finally, I would like to acknowledge funding support from the Ontario Arts Council, an agency of the Government of Ontario.

Endnotes

Prelude

1. Smith, interview with the author.
2. The three grades of the Order of Canada are, from highest to lowest, Companion (CC), Officer (OC), and Member (CM).
3. Molly Diary, 10 March 1997.
4. Smith, interview with the author.
5. Molly Diary, February 1996.
6. Molly Diary, 16 March 1995.
7. Molly Diary, 17 March 1995.

Introduction

1. *Montreal Star*, quoted in Des Rochers, Foss, et al., *1920s Modernism in Montreal*, 86.
2. Esther Trépanier, "The Beaver Hall Group: A Montreal Modernity," in Des Rochers, Foss, et al., *1920s Modernism in Montreal*, 214.
3. While the Group of Seven was all male, they often invited female artists such as Emily Carr and Yvonne McKague Housser to exhibit with them.
4. Murray, *The Best of the Group of Seven*, 49.
5. King, *Defiant Spirits*, 87 and 107.
6. Clendinning, "Exhibiting a Nation," 82.
7. Quoted in Murray, *The Best of the Group of Seven*, 16.
8. Clark, "Out from the Canadian Shield," 6.
9. Boyanoski, "Paraskeva Clark: Life & Work," 35.
10. Hughes, "Rare Feast — Charles Comfort's Life and Career," 19.
11. Amos, "Simple Forms of Molly Lamb Bobak," 12.
12. Bell quoted in Smith and Bell, *Kingston Conference Proceedings*, vii.
13. Rosenfeld, *Lucy Jarvis: Even Stones Have Life*, 83.
14. The week-long lapse between Britain's declaration of war and Canada's was because of the time needed to call the Canadian Parliament back into session. Although even before Britain's declaration, the Royal Canadian Navy had begun working in conjunction with the Royal Navy.
15. Carney, *Canadian Painters in a Modern World*, 180.
16. Nurse, "Artists, Society, and Activism," 10.
17. Wrong quoted in Niergarth, "Dignity of Every Human Being," 90. The FCA tried to get around the thorny problem of distinguishing official art from propaganda first by saying that unlike Nazi and Soviet artists, Canadian artists would not concentrate solely on the exploits of workers and heroic soldiers, and second by critiquing the existing centrally planned advertising programs.
18. Scott, "W.L.M.K.," n.p.
19. Brandon and Oliver, *Canvas of War*, 159 and 162. The names refer to Private E.J. Hughes, Sapper O.N. Fischer, and Trooper W.A. "Will" Ogilvie.
20. Stacey quoted in Brandon and Oliver, *Canvas of War*, 162.

21. Stacey quoted in Brandon and Oliver, *Canvas of War*, 162.
22. Molly, letter to Shadbolt, 21 October 1942. Jack Shadbolt Fonds, UBC.
23. Churchill quoted in MacDonald, *Titans and Others*, 89.
24. Dickens, *David Copperfield*, 1.
25. Reid, *Women Between*, 42–43.
26. A reading of Molly's life could be built around the fact that she records doing a tremendous amount of housework—child rearing, cooking, cleaning, and snow shovelling—that takes her away from her art. But to do so would be to misrepresent Molly's presentation of these chores. First of all, they had to be done. So, either they were going to be divided between her and Bruno (and as they got older, their children) or the Bobaks were going to have to pay for them to be done. Had the family divided the chores, biographers would have to examine who did what, and what that division meant. Had they chosen to pay for someone to do these chores, biographers would, rightly, have to inquire about what the Bobaks were like as employers, as well as how this class relationship brought into their home impacted their art.

If we can judge from her rhetoric, Molly's view of these chores is no different from when she has to clean her palette. Indeed, there are times that she revels in cooking, cleaning the kerosene stove, and "scooping snow" as she put it, and, she also points out it "never killed anyone." She had nothing but disdain for labour-saving devices and takes a positive delight in using an old wringer washer and putting her clothes out to dry (even in freezing weather).
27. Unger, *Picasso and the Painting that Shocked the World*, 325–26.

PART ONE: 1920-1945
Chapter 1 Learning Their Trade

1. Though his birth certificate gave his last name as Lamb, Harold used Mortimer-Lamb for his most important writings, his photographs, and his professional letterhead.
2. After arriving in Canada, Alice Slater Price changed her name to Mary Williams for reasons unknown.
3. During the First World War, Babi (Mary) deserted from the Polish Army so she could escape from a drunkard husband, leaving her infant daughter, Carol, to be raised by Mary's parents. When Carol turned twelve, she joined her mother in Canada. Mary's immigration to Canada is somewhat surprising since immigration officials viewed unattached women as likely to become prostitutes and severely restricted their immigration into the country.
4. Bruno quoted in Curtis, "The Early Years," in Riordon, *Bruno Bobak*, 17. Given Bruno's neglect of Babi in her old age, this seems something of an overstatement.
5. Mortimer-Lamb quoted in R. King, *Defiant Spirits*, 18.
6. Mortimer-Lamb quoted in Amos, "The Simple Forms of Molly Lamb Bobak," 2013, 54.
7. Mortimer-Lamb, "No title," 119.
8. Molly Bobak, *Wildflowers of Canada*, 20.
9. Molly Diary, 2 November 1984.
10. Molly Diary, 2 November 1984.
11. Thomas and Znaniecki, quoted in Zahra, *The Great Departure*, 87.
12. Lismer quoted in McLeish, *September Gale*, 129.
13. *Christian Science Monitor* quoted in McLeish, *September Gale*, 147.
14. *Toronto Star* reporter quoted in McLeish, *September Gale*, 151.
15. Bruno quoted in Curtis, "The Early Years," 21.
16. King, *Inward Journey*, 63.
17. Smith, interview with the author.
18. Bruno quoted in Curtis, "The Early Years," 23.

19. Bruno quoted in Curtis, "The Early Years," 23.
20. Smith, interview with the author.
21. Molly Bobak, Lecture at the Robert McLaughlin Gallery, n.p.
22. Molly Bobak, Lecture at the Robert McLaughlin Gallery, n.p.
23. Shadbolt, *In Search of Form*, 57–58.
24. Shadbolt, *In Search of Form*, 59.
25. Shadbolt, *In Search of Form*, 67.
26. Molly Bobak, *Wildflowers of Canada*, 25.
27. To repay Mortimer-Lamb for his kindness, Diamond left behind Duncan Grant's oil *Study for a Ballet Scene* when she and her family returned to England.
28. Molly Bobak, Lecture at the Robert McLaughlin Gallery, n.p.
29. Some years later, Williams married Jack Kingsmill, a friend of the two bachelor brothers who ran the general store near Arbutus Point.
30. In what might be thought of as Bloomsbury on English Bay, in the late 1930s, Mortimer-Lamb paid Varley's rent as he did also for Vera after she left Varley.
31. Molly Bobak, *Wildflowers of Canada*, 32.
32. Molly Bobak, *Wildflowers of Canada*, 32.
33. Molly Bobak, *Wildflowers of Canada*, 32.
34. In addition to the more than 100,000 women who joined the women's divisions of the armed services, almost a million entered the workforce, including 373,000 in manufacturing. Women replaced men as ticket takers on the Toronto transit system and in lumber camps, where they were dubbed "Lumberjills."
35. Molly Bobak, *Wildflowers of Canada*, 37.
36. Lumsden, *The Queen Comes to New Brunswick*, n.p.

Chapter 2 The Education of Two Artists as Young Soldiers

1. Lumsden, *The Queen Comes to New Brunswick*, n.p.
2. Bruno quoted in Brandon, "The War Years," 25.
3. Unfortunately, none of these are available for viewing.
4. Andrus, *Bruno Bobak: Selected Works*, 25.
5. H.O. McCurry to Bruno Bobak, 11 January 1944, National Gallery of Canada, Canadian War Artists, 5.42-B, Bobak, Bruno.
6. H.O. McCurry to A.F. Duguid, 26 January 1944, National Gallery of Canada, Canadian War Artists, 5.42-B, Bobak, Bruno. See also Laura Brandon, "The War Years," 25.
7. A.Y. Jackson to H.O. McCurry, 16 February 1944, National Gallery of Canada, Canadian War Artists, 7.1-B, Lamb, Molly.
8. Molly, letter to Shadbolt, 11 December 1943. Jack Shadbolt Fonds, UBC.
9. Molly Bobak, quoted in Foss, "Molly Lamb Bobak: Art and War," 96.
10. Molly Bobak, quoted in Klinkenberg, "New Brunswick's First Lady of Art," S6.
11. Molly Diary, 7 May 1998.
12. Original held by LAC; 147 folio pages and almost 50 inserts. Can be found at https://www.bac-lac.gc.ca/eng/discover/military-heritage/second-world-war/molly-lamb-bobak/Pages/pages-1-20-molly-bobak.aspx. The published version, *Double Duty* (Dundurn Press, 1992), was edited by Carolyn Gossage.
13. The similarity between some of Molly's drawings and Emily Carr's in *Sister and I from Victoria to London*, which was passed around in manuscript form during Molly's youth, suggests that Molly may also have had Carr's work in mind when she put pen to paper.
14. Twain, *Huckleberry Finn*, 2.
15. Schaap, "'Girl Takes Drastic Step,'" 182.
16. Molly War Diary, 118
17. Schaap, "'Girl Takes Drastic Step,'" 181.
18. Blanchard and Manasses, *New Girls for Old*, 61.
19. Cf. Gossage, *Double Duty*, 63–66.
20. Molly War Diary, 120.
21. Molly War Diary, 107.
22. Molly Bobak, *Wildflowers of Canada*, 57.
23. Molly Bobak, *Wildflowers of Canada*, 57.

24. Molly, letter to Shadbolt, 27 December 1944. Jack Shadbolt Fonds, UBC.

25. Molly Bobak, *Wildflowers of Canada*, 61.

26. I depart here from Foss's view in his seminal essay, "Molly Lamb Bobak: Art and War," that in these and later works we see a "submergence of individual identity in the amorphous life of the crowd," (Foss, "Molly Lamb Bobak: Art and War," 95), which threatens to tip over into Elias Canetti's view of the crowd as a protofascistic formation.

 Molly recognized a kindred spirit in Pegi Nicol MacLeod's portraits of CWACs and in the programmatic statement Nicol MacLeod wrote in a December 1944 letter to Kathleen Fenwick: "When we come to the kitchens and galleys where the foods are prepared for these war-changed girls, we arrive at a group of animated Breughels. In the C.W.A.C. barracks, the colours were his, golden walls with scarlet trim setting off the white aprons wrapped around husky figures, white coifs and aluminum kettles, and rosy khaki cotton for general duty uniform." (Quoted in Brandon, *Pegi by Herself*, 146.)

27. Molly War Diary, 32.

28. Molly War Diary, 144.

29. Molly War Diary, 144.

30. Cf. Bakhtin, *Rabelais and His World*, 10–25.

31. Molly War Diary, 104.

32. King James Version. There are several other examples of Molly's intertextual practice worth noting. Lest her reader miss the echo of Claude Debussy's tone poem in the title "L'Après Midi du Molly," we are told to read it while listening to his "Prélude à l'après-midi d'un faune." When she writes, "When I think of places I have understood / In all seasons, now and once around the year / I know quite simply that the world is good. / I have walked unnoticed and in uniform for war / Down snow banked streets on grey late afternoons / I watched the listless snowflakes vaguely / fall on the square and flurry and follow / And come to rest against the door," Molly riffs between T.S. Eliot's *The Waste Land* and Dr. Seuss's *And To Think That I Saw It on Mulberry Street*. On the lower right of the 19 July 1943 number, *Le déjeuner sur l'herbe À la Jaenicke et Molly* pays homage to Édouard Manet's famous painting, though neither of the two CWACs reclines in the nude in Ottawa's Rockcliffe Park.

33. It is a sign of how small the world of Canadian art was in the early 1940s that unbeknownst to Bruno and Molly, both Lismer and McCurry were members of the jury.

34. McCarthy, "'New Canadian' Soldier Wins Army's Art Prize," *Globe and Mail*, 14 September 1944, 4.

35. Forrestall, interview with the author.

36. Molly War Diary, 82.

37. Molly War Diary, 195.

38. Bruno quoted in Brandon, "The War Years," 30.

39. Composed in 1941 by bandleader Gene Krupa and trumpeter Roy Eldridge, "Drum Boogie" was a boogie-woogie jazz standard sung by, among others, Barbara Stanwyck and Ella Fitzgerald.

40. Oliver and Brandon, *Canvas of War*, 167.

41. Brandon, "The War Years," 28.

42. Canadian War Artists Selection Committee, Minutes of 2 June 1943, National Gallery of Canada, 5.41-C, file 2.

43. Molly Bobak, "I Love the Army," 148.

44. Owen, "Dulce et Decorum Est," n.p.

45. Molly War Diary, 19.

46. Molly Bobak, "I Love the Army," 149.

47. Smith, interview with the author.

48. Mantha, interview with the author.

Chapter 3 War Artists

1. Molly Lamb, letter to H.O. McCurry, 5 November 1945, National Gallery of Canada, 5.41-C, file 3.

2. Marinetti, "Manifesto of Futurism," n.p.

3. On 10 April Bruno twice survived being strafed—by the Royal Air Force. In the days that followed, Bruno saw V-1s overhead.

4. Bruno Bobak Fonds, Canadian War Museum.

5. Bruno quoted in Andrus, *Bruno Bobak: Selected Works*, 27.

6. Brandon, "The War Years," 28.

7. Andrus, *Bruno Bobak: Selected Works*, 27.

8. "Comfort's ability to portray shell bursts realistically drove fellow war artist Lawren P. Harris Jr., who was in Italy with him, to distraction," recalls Stuart Smith, who studied with Comfort at the University of Toronto after the war. "During one bombardment, Harris lost sight of Comfort. Then he heard from a shell crater, 'One, two, three, wumph.' He crawled over and saw Comfort sitting there, counting and then whipping his brush down toward the page," Smith said in an interview with the author. The cadence gave Comfort the spread of the shells while the paint hitting the page pushed paint into the weave, where it then spread out like the light of an exploding shell.

9. Quoted in Brandon, "Veracity and Expectation," 55.

10. Following the referendum in 1942 that released Mackenzie King's government from its pledge not to invoke conscription, some 60,000 men were conscripted. Only 13,000 conscripts were sent overseas, with 2,500 reaching the front lines before Germany surrendered. In effect, the Canadian Army was an all-volunteer force, as were the Royal Canadian Navy and Royal Canadian Air Force.

11. For example, the literary sociologist René Girard argues in *Violence and the Sacred* that one of the chief functions of ancient dramas like *Oedipus Rex* was to contain violence by foregrounding its

effect while simultaneously keeping it safely offstage.

12. Smith, interview with the author.

13. Halliday, "Interview with Bruno Bobak," n.p.

14. Halliday, "Interview with Bruno Bobak," n.p.

15. Halliday, "Interview with Bruno Bobak," n.p.

16. "Letter from Deputy Minister of Defence to Editor," 22 June 1945, *Canadian Art* 2, no. 4 (April-May 1945) reported that Lamb had been appointed as an official war artist.

17. On 26 January 1945, Bruno wrote in his War Diary that, "Since Vught Concentration camp was close by, I thought I would wander over, as it interested me." Military authorities at Herzogenbusch concentration camp in Vught, Holland, which had been liberated by Canadian and Scottish troops three months earlier, prevented him from entering because he did not have the required pass. He did, however, see the men and women accused of being collaborators being held there, many of whom "were at work on the grounds pushing heavy wheelbarrows"; among those behind barbed wire were children, presumably of the female prisoners.

18. Molly Bobak quoted in Lumsden, *The Queen Comes to New Brunswick*, 17.

19. Though there are some paintings that show postal sorting frames in the American Old West, Molly's work is the only one I have been able to find that shows postal clerks sorting mail into one. In a style reminiscent of Brittain, Reginald Marsh's 1936 mural *Sorting the Mail* in the Ariel Rios Federal Building in Washington, DC, depicts burly men hauling sacks of mail to and from chutes but not placing letters into sorting frames.

20. Three years later, Grierson came to Canada to be the founding director of the National Film Board.

21. Molly quoted in Murray, "Joan Murray Speaking with Molly Bobak," 7.

22. B. Bobak, memo to Shadbolt, Bruno Bobak Fonds, Canadian War Museum.

23. Save for the *Dead German on the Hitler Line*, which he considered pardonably "lugubrious," Captain Comfort also refrained from depicting dead soldiers. His picture of a desiccated corpse of a German soldier lacks the realism of his portraits of Lieutenant-General Guy Simonds or Captain S.H.S. Hughes, the historical officer of Comfort's unit. The German's sunken cheeks that have pulled so far back as to reveal the German's front top teeth recall Otto Dix's work.

24. The pencil sketch this oil is based on has the confusing title *Battle of Oldenburg and Advance Thru Meppen*. Since Bruno executed a different oil using this second title, I shall refer to the oil based on the sketch as *Battle of Oldenburg*, the name that the Canadian War Museum has assigned to it.

25. Hynes, *On War and Writing*, 28.

26. Molly angled the other painting of Emmerich further to the right; the words "WATER RATS" can easily be read on the wall. The two figures have been removed.

27. Benjamin, *The Origin of German Tragic Drama*, 178.

28. Jackson, *A Painter's Century*, 166.

PART TWO: 1945-1973
Chapter 4 Painters Two

1. Smith, interview with the author.

2. Brandon, interview with the author.

3. Brandon, interview with the author.

4. Nelson, *Representing the Black Female Subject*, 29.

5. Molly Diary, 24 September 1998.

6. Nelson, *Representing the Black Female Subject*, 29.

7. Brandon on a panel at Ottawa Art Gallery occasioned by the book launch of Michele Gerwurtz's *Molly Lamb Bobak: Life and Work* on 9 November 2018.

8. Schaap, "'Girl Takes Drastic Step,'" 176.

9. As distasteful as it is to read today in Molly's 11 December 1943 letter to Shadbolt and see the cartoon in Molly's War Diary in which her avatar dons blackface and sings "I'm the Lamb from Alabama," Molly indicates a consciousness of race and respect for the talents of African American performers. For, however much she told Shadbolt that the skit was the "sort of thing that you used to laugh at, anyway," in her Diary (11 December 1943), part of Molly's joke is the (ridiculous) prediction that her "tenor" timbre represents a "grave threat to Marian Anderson." Molly knew well that African American contralto famously sang before an integrated crowd of 75,000 at the Lincoln Memorial on 9 April 1939 (Easter Sunday) after the Daughters of the American Revolution refused her permission to sing at Constitution Hall.

10. Molly Diary, 23 November 1984.

11. Bruno War Diary, Canadian War Museum Archives.

12. Smith, interview with the author.

13. Molly quoted in Smith, "The Vancouver Years," 47.

14. Several scribbler pages of Bruno's notes in possession of the author; gift of Fred McElman.

15. Lumsden, *The Queen Comes to New Brunswick*, 9.

16. Looking back almost five decades later, Molly agreed with Emily Carr's assessment of her early works as being marred by "ugly, foul colour and imitations of Jack [Shadbolt]" and that they were saved "only barely by [her] sense of humour." Carr was scarcely less critical of Bruno, whom she dismissed as a "slick version of Carl Schaefer." (Molly Diary, 21 October 1991).

17. Guilbaut, *How New York Stole the Idea*, 97.

18. Prospectus, Vancouver School of Art, 1954.
19. Bruno quoted in Andrus, *Bruno Bobak: Selected Works*, 39.
20. The mural was demolished when the now-named Emily Carr University built a new fine arts building.
21. Shakespeare, *As You Like It*, 2.1.563–64.
22. Leroux, interview with the author.
23. Bruno quoted in "Bruno Bobak Does a Mural in Concrete," 164.
24. *Varsity*, Vancouver School of Art, 25 January 1954.
25. Hynes, *On War and Writing*, 183.
26. Guilbaut, *How New York Stole the Idea*, 97.
27. Gabriel, *Ninth Street Women*, xii.
28. Smith, interview with the author.
29. Bruno quoted in Andrus, *Bruno Bobak: Selected Works*, 67.
30. In 1954, Bruno won the Montréal Museum of Fine Arts' Jessie Dow Prize for graphic arts and a year later the C.W. Jefferys Award for graphic arts from the Canadian Society of Graphic Art. In 1956, he received the K.B. Baker Memorial Purchase Award of $100 ($940) from the Seattle Art Museum, a recognition not only of his skill as a graphic artist but also of the affinities his work had with artists in the American Pacific Northwest such as Morris Graves. The following year, he won the Monsanto Art Competition in Montréal.
31. Bruce, "They Share Art Career," 24.
32. Molly, letter to Shadbolt, 29 November 1956. Jack Shadbolt Fonds, UBC.
33. Lewis, *Demon of Progress*, 63.
34. Lewis, *Demon of Progress*, 63.
35. Lewis, *Demon of Progress*, 64
36. Fulford, "Molly Lamb Bobak," 14.
37. The presence of a horizon line beyond the black, grey, and yellow smudges that mount up on the right-hand side of Bruno's *English Coast* (one of three nautical-themed works painted at about the same time) keeps the painting from tipping over into Abstract Impressionism. This line provides just enough balance for the browns on top of the black smudge to feel like an English castle above a storm-tossed sea in what painter William Forrestall calls a "metaphorical landscape." Though interesting, in the broad sweep of Bruno's work, *English Coast*, *Atlantic Coast*, and *Gurnard's Head* (this last in Cornwall) seem almost like experiments, attempts to see just how far he could push his work, for they do not announce a direction he will follow.
38. Greenberg, quoted in Danto, *After the End of Art*, 120–21.
39. Andrus, *Bruno Bobak: Selected Works*, 48.
40. Molly Bobak, "Leisure to Paint," 103.
41. Molly Bobak, "Leisure to Paint," 105.
42. Mantha, interview with the author.

Chapter 5 Putting Down Roots

1. A.Y. Jackson, letter to Molly, 2 November 1959 and 10 January 1960, UNB Fonds.
2. A.Y. Jackson, letter to Molly, 15 September 1960, UNB Fonds.
3. Bruno quoted in Sabat, "Bruno Bobak's Creativity Results in Newest Exhibition," 1986.
4. At some point, Bruno learned that one of Jimmy Pataki's childhood friends was the same Gerald Budner who invited Bruno to the AGT. Budner apparently never mentioned Bruno to Jimmy or vice versa.
5. Molly, letter to Shadbolt, 30 December 1966, Jack Shadbolt Fonds, UBC.
6. Lawren P. Harris Jr., letter to Bruno 8 February 1960, UNB Fonds.
7. Pacey, "Bruno Bobak at U.N.B.," 140.
8. Matthiesen Gallery, letter to Bruno, 20 November 1961, UNB Fonds.
9. Beaux Art Gallery, letter to Bruno from, 19 June 1962, UNB Fonds.
10. Bruno, "The Artist in Canada," 11.
11. Berland, "Marginal Notes," 517.
12. Massey, *On Being Canadian*, 3 and 23.
13. Cavell, *Love, Hate, and Fear*, 6.

14. Claxton File, n.d., Brooke Claxton Fonds, LAC.
15. Gabriel, *Ninth Street Women*, 197.
16. Dondero quoted in Hofstadter, *Anti-Intellectualism in American Life*, 14–15.
17. Dondero quoted in Saunders, *Who Paid the Piper?*, 253.
18. Tucker, "European from Canada," 14.
19. Danto, and Goehr, *After the End of Art*, 67.
20. Denis quoted in Unger, *Picasso*, 271.
21. Pacey, "Bruno Bobak at U.N.B.," 141.
22. Oliver, "First Show in Britain," n.p.
23. Bruno quoted in Andrus, *Bruno Bobak: Selected Works*, 68.
24. *Listener*, "Did You Hear That?," 369.
25. *Listener*, "Did You Hear That?," 369.
26. Only a few years earlier, Bruno's portrayal of the couple's embrace might have seemed out of place among the famously phlegmatic English. A year before Bruno painted *Happy Reunion*, however, in the most famous sex-related trial since Oscar Wilde's in 1895, the Crown lost the obscenity case of *R. v. Penguin Books* and *Lady Chatterley's Lover* became a bestseller.
27. Edward Kaplan, letter to Bruno, 9 November, 1962, Bruno Bobak Fonds, UNB.
28. Though the catalogue for *Talk of the Town*, an exhibit at the Burnaby Art Gallery (2018), lists the date of the work as "c. 1961," this letter dates *Venice* to after 26 April 1962.
29. Cf. Moyle, *The Extraordinary Life*, 395–96.
30. Merleau-Ponty quoted in Meyers, *Impressionist Quartet*, 77.
31. A.Y. Jackson, letter to Molly, 15 September 1962, Molly Bobak Fonds, UNB
32. J.B. Macaulay, letter to Robert Percival, n.d., Bruno Bobak Fonds, UNB.
33. Robert Percival, letter to J.B. Macaulay, n.d., Bruno Bobak Fonds, UNB.
34. Robert Percival, letter to J.B. Macaulay, n.d., Bruno Bobak Fonds, UNB.
35. Robert Percival, letter to J.B. Macaulay, n.d., Bruno Bobak Fonds, UNB.
36. Quoted in Bischoff, *Edvard Munch, 1863-1944*, 10.
37. Forrestall, interview with the author.
38. Rombout, "Bruno Bobak," 41.
39. Tucker, "European from Canada," 15.
40. Bruno quoted in Rosenfeld, "Works on Paper," 136–37.
41. Andrus, interview with author.
42. Forrestall, interview with author.
43. At a typical key party, the male members of couples would toss the car/house keys into a hat. At the end of the evening, the women would draw out a set of keys and go home with that male.
44. Molly Diary, 4 April 1972.
45. Rovers, interview with the author.
46. According to Andrus, the probable source for this pairing is one of Gustav Vigeland's works. Bruno had a well-thumbed booklet of black-and-white photos of this Norwegian sculptor's works, likely purchased in 1961 when the Bobaks were in Oslo. In 2002, before curator John Leroux went to Oslo, Bruno told him how influenced he had been by Vigeland and that Leroux had to go see his works.
47. Murray, "Joan Murray Talking with Bruno Bobak," 6.
48. See chapter 7 for more on the taboo on pubic hair and the break from it, starting in the 1970s.
49. Andrus, interview with the author.
50. Molly Diary, 6 October 1969.
51. Mural Committee quoted in Leroux, *1967: New Brunswick's Centennial Building Murals*, 2017, 41.
52. The *Cartoon for the Saint John Tuberculosis Hospital Murals* depicted scenes of poverty and calls for affordable housing. The mural was never executed.
53. *United Mine Workers' Journal*, 15 December 1937 quoted in Seager, "Minto, New Brunswick," 81–82.

Chapter 6 Who's Afraid of Virginia Woolf on the Saint John River

1. Molly Diary, 18 October 1998.
2. Murray, "Interview with Molly Lamb Bobak," 8.
3. Canetti, *Crowds and Power*, 18.
4. Canetti, *Crowds and Power*, 35.
5. Molly's loose brushwork ensures that in none of her various works that depict CWACs marching in Ottawa and London, England, are they tightly arrayed or even suggestive of fascistic order.
6. They also hark back to a small, funny work Molly painted in the early 1960s in which a habitué of Paris cafés is depicted as half an umbrella.
7. Le Bon, *The Crowd*, 32.
8. Molly Bobak, "Letter from the Maritimes," 48.
9. Molly Bobak, "Letter from the Maritimes," 48.
10. Molly was an indefatigable letter writer. Her Fonds at Library and Archives Canada contains letters from, among others not named above and below, Mrs. Roland Michener (from 1968 when her husband was Governor General), the Right Honourable Judge Bora Laskin (thanking Molly for her letter congratulating him on his appointment to the Supreme Court), and Claude Ryan, then editor of *Le Devoir*.
11. Some months earlier, Strax had been arrested at an anti-war protest at Columbia University in New York City.
12. One of the city's major yearly events, which thousands turned out to watch, the university's commencement procession flowed down the hill from UNB to University Avenue and then to the Lady Beaverbrook Rink, and ran on streets just a few blocks from where the Bobaks lived.
13. Austin, *How to Do Things with Words*, 5, 6–7, 46, 62.
14. Twelve years later, on 11 March 1980, Molly sketched a similarly sympathetic version of the protest at the New Brunswick Legislature against the Point Lepreau nuclear plant.
15. Molly Diary, 15 May 1970.
16. Andrus, interview with the author.
17. Andrus, interview with the author.
18. Bruno, undated note, UNB Archives, MG H173 Box 12, Jerome and Christina Sabat Collection.
19. In fact, the federal budget for 1969 saw the NFB's budget increase by $1.2 million to $10.5 million, so it is unclear what Molly meant by a budget cut.
20. Molly Diary, 25 August 1969.
21. Molly Diary, 20 November 1969.
22. Molly Diary, 28 November 1969.
23. Molly Diary, 18 October 1970.
24. Molly Diary, 20 May 1969.
25. Molly Diary, 16 September 1969.
26. Molly Diary, 28 January 1970.
27. Molly Diary, 8 February 1970.
28. Molly Diary, 8 July 1970.
29. Molly Diary, 28 November 1970.
30. Molly Diary, 5 July 1986.
31. Berman, "Body and Body Politic," 80.
32. *Aftenposten* (Oslo, Norway), 15 April 1944, quoted in Knausgaard, *So Much Longing*, 197.
33. Bruno taught Gordienko how to do woodcuts. "I saw some of these," recalls Andrus, "and was struck by the sensitivity of these prints on rice paper. You would not have believed those massive and brutalized hands to have been capable of such delicacy of touch" (Andrus, interview with the author).
34. Molly Diary, 10 April 1971.
35. Stuart Smith quoted in Leroux, "On Bobaks and Fredericton Downtown," n.d., n.p. I thank the author for providing me with a copy of this essay.
36. Jane Jacobs and Stuart Smith quoted in Leroux, "On Bobaks and Fredericton Downtown," n.d., n.p.
37. Molly Diary, 23 July 1969.
38. Molly Diary, 20 February 1971.
39. In October 1969, Molly flew to British Columbia to see her mother and her ailing father. Mortimer-Lamb died a year later. Molly's mother died in November 1971.
40. Smith, interview with the author.
41. Smith, interview with the author.
42. Andrus, interview with the author.

43. In commemoration of UNB's bicentennial in 1985, the New Brunswick Telephone Company put the work on its 1985/86 telephone directories.

44. See for example *La Grenouillère*, his picture of a riverside restaurant near Bougival, France, considered by art historian Kenneth Clark to be among the first Impressionist paintings.

45. Smith, interview with the author.

PART THREE: 1973-1990
Chapter 7 Picturing Desire

1. Metcalf, interview with author.

2. Molly Diary, 4 March 1973.

3. Molly Diary, 14 September 1973.

4. Molly Diary, 5 January 1975.

5. Molly Diary, 10 August 1976.

6. Murray, "Joan Murray talking with Bruno Bobak," 1979, 11.

7. Molly Diary, 24 June 1975.

8. Molly Diary, 19 February 1973.

9. Molly Diary, 8 June 1974.

10. Molly also made a number of trips to Britain, to see her half-brother Abby and Europe. During her 1974 trip to Britain, she saw an exhibit of Helen Lessore's paintings at the Tate. While they were different from hers in almost every way, Molly liked Lessore's paintings, perhaps because her "kitchen-sink realism" was not dissimilar to Molly's War Diary. Molly also liked the works by Lucian Freud she saw on that visit.

11. Molly Diary, 30 April 1978.

12. Murray, "Joan Murray talking with Bruno Bobak," 1979, 1.

13. Bruno quoted in Andrus, *Bruno Bobak: Selected Works*, 61.

14. Given the importance of these faces, it is interesting to note that they were usually the last element of his pictures that Bruno completed.

15. Forrestall, interview with the author

16. Forrestall, interview with the author.

17. Matthew Arnold, "Dover Beach," n.p.

18. Hughes, *The Shock of the New*, 288.

19. Morehead, "The Untimely Face of Munch," 22.

20. Smither, "Bodies of Anxiety," 149–51.

21. Gewurtz and Lamb Bobak, *Molly Lamb Bobak: Life & Work*, 40.

22. Molly Bobak, *Wildflowers of Canada*, 30.

23. Molly Diary, 3 March 1973 and 4 March 1974.

24. Smith, interview with the author.

25. Molly Bobak, Lecture at the Robert McLaughlin Gallery, 18.

26. Gewurtz and Lamb Bobak, *Molly Lamb Bobak: Life & Work*, 64.

27. Huneault quoted in George, *Sexuality and Women's Writing, 1760-1830*, 59.

28. Mastin, "Beyond 'the Artist's Wife,'" 3. Both Smith and Andrus heard others deride Molly's flower paintings as "kitchen art," as revealed in interviews with each.

29. Molly Diary, 27 August 1997.

30. Murray, "Joan Murray speaking with Molly Bobak," 11.

31. Smith, interview with the author.

32. Molly Diary, 9 August 1987; Bauer, "Molly Lamb Bobak," 35.

33. Itani, interview with the author.

34. The term denotes the social matrix that seems natural but is in reality produced by language, cultural institutions, and the political and economic structures of society.

35. Joe Plaskett, "Introduction," 8.

36. Molly quoted in Toole Grant, "An Interview with Molly Bobak," 37.

37. Huneault, *I'm Not Myself at All*, 185.

38. Andrus, interview with the author.

39. Benjamin, Thesis VII, "On the Concept of History," n.p.

40. Amos, "The Simple Forms of Molly Lamb Bobak," 12.

41. Merleau-Ponty, "Cézanne's Doubt," 278.

42. Molly added that she was by no means an expert on Eastern art. Interestingly, however, more than a few of the people conversant with art that I have shown Molly's flower paintings to

have commented on how much they are reminded of Japanese paintings of flowers. And, indeed, in August 1974 Molly writes in her Diary that after visiting the Louvre, she had fallen "under the influence of Japanese prints."

43. Lumsden, *The Queen Comes to New Brunswick*, 13.

44. These "blue/black" shapes, perhaps not surprisingly, recall Merleau-Ponty's discussion of how shadows affected Cézanne's white paper. When viewed "analytical[ly]," the shadows on the page become less an effect of blocked light than "a grey or steely blue substance, thick and not definitely localized." (Merleau-Ponty, "Cézanne's Doubt," 278.)

45. Toole Grant, interview with the author.

46. Barthes, *Camera Lucida*, 96.

47. Woolf, *To the Lighthouse*, 157–58; and Molly Diary, 20 May 1997.

48. Molly Diary, 21 March 1972.

49. Molly Diary, 5 June 1972. Molly's sniffy objections to Bruno's "pornographic" works and the film may sound odd coming from the woman who swam *au naturel* in the Saint John River in front of family and friends (and did so until she was in her seventies) and who herself drew some risqué cartoons.

50. Andrus, interview with the author.

51. Gombrich and Kris, *Caricature*, 26.

52. Dolnick, *The Forger's Spell*, 136.

53. Clark, *The Nude*, 133.

54. Nead, *The Female Nude*, 2

55. Aristotle, *The Complete Works*, vol. 2, 36.

56. Nead, *The Female Nude,* 26.

57. Andrus, interview with the author.

58. Murray, "Joan Murray talking with Bruno Bobak," 6.

59. For a discussion of the "male gaze" see Griselda Pollock, *Vision and Difference*, 2015.

Chapter 8 "The Fall of the House of Bobak"

1. Molly Diary, 5 August 1973.

2. Molly Diary, 11 December 1975. Between 1952 and 1972, William (Bill) Bennett's father, W.A.C. Bennett, was the Social Credit premier of British Columbia. The "Socreds" were British Columbia's equivalent of the Progressive Conservative Party.

3. "John" was John Saunders, who at the time was a senior official in the New Brunswick Department of Tourism, Culture and Heritage. Though she did not share their political leanings, Molly counted both Saunders and Hatfield (whom she often referred to as Dick or Dickie Hatfield in her Diary and who came to dinner on 20 December 1976) as friends. Since both men were gay, Molly jokingly referred to the painting as *The Three Queens*.

4. Molly Diary, 20 May 1980.

5. Molly Diary, 12 November 1977.

6. Curious because at the Battle of Agincourt (25 October 1415), the English army decisively defeated the French. It was not, therefore, an obvious

moniker for a diptych showing English and Acadians marching together in celebration of the occupant of the throne Henry V once sat on. Molly knew that in *Henry V*, Shakespeare gave King Henry the speech that began, "Once more unto the breach, dear friends, once more" and ends with "Cry 'God for Harry', England and St. George" (3.1.1092–11.25) as well as the famous St. Crispin's Day speech with its line about "Band of brothers."

7. Rilke, *Letters to Cézanne*, 75.

8. Molly Diary, 24 March 1976.

9. Molly Diary, 11 February 1977.

10. Molly Diary, 27 January 1978.

11. Molly Diary, 19 May 1976.

12. Molly Diary, 27 August 1976.

13. Molly Diary, 19 November 1977.

14. Molly Diary, 2 December 1977.

15. Molly Diary, 16 December 1978.

16. Molly Diary, 25 April 1976.

17. Molly Diary, 22 November 1977.

18. Molly Diary, 5 December 1977. Writing in her Diary on 17 October 1986, Molly's son, Alexander, confirmed

Grant's dating of Bruno's decline. "Sash remarked that he saw a great change come about fifteen years ago when Bruno stopped going sketching, skiing, travelling, etc.—into the bottle and out of energy."

19. Molly Diary, 31 July 1977.
20. Molly Diary, 21 November 1977.
21. Molly Diary, 25 November 1977. As we will see, Molly was not quite as sanguine about her place in Canadian art as she tells herself here. Nor is her claim that she ceased trying to be famous all it seems; for one thing, she was famous. For another, appearances on CBC shows such as Peter Gzowski's *Morningside*, and the memoir she was writing for publication in 1978 were hardly designed to keep her name out of the news.
22. Molly Diary, 19 December 1990.
23. Bruno may have had some inkling that while the bridge between his and Molly's emotional lives had all but collapsed, she was drawn to others, including Ron Thom and Saskatchewan artist George Wood. In January 1977, Molly met with Thom in Toronto: "We talked and held hands and should have made love. Someday I really must" (Molly Diary, 24 January 1977).
24. Like many of Bruno's paintings, dating this one is difficult. Its owner, however, believes it to date to 1977.
25. Molly Diary, 14 April 1978.
26. *Arts Atlantic*, vol. 1, no. 3 (Summer/Fall 1978), 14.
27. Molly Diary, 23 February 1992.
28. Molly continued thinking harshly of her work: "I think of the paintings I've left in my studio—not one escaped the silly, meaningless subject, from cineraria's to skiers."
29. Molly Diary, 31 January 1979.
30. Molly Diary, 1 June 1976.
31. Molly Diary, 1 June 1976.
32. Alice James was the younger sister of novelist Henry and psychologist William.
33. Molly Diary, 15 September 1980.
34. Molly Diary, 16 December 1978.
35. Molly Diary, 6 August 1978.

36. Molly Diary, 23 November 1978.
37. Molly Diary, 20 June 1976.
38. Molly Diary, 12 September 1976.
39. Molly Diary, 16/18 August 1979.
40. Molly Diary, 30 November 1978.
41. Molly sold so well, in fact, that in addition to quarterly income tax payments, she had to pay $28,000 ($93,000) when she filed her 1978 income taxes, and her income prompted her to say she and Bruno had become "big nasty capitalists" (Molly Diary, 3 July 1979).
42. Molly Diary, 29 May 1980. In the letter, she told Shadbolt, "My work is to be sold—the danger is that quite innocently, unless one is really alert, that one paints for the dealer—a commodity—even an investment. I'm not being moral about this—but just the same I seem to think I can see why things [recent trends in art] are going that way." (Molly, letter to Shadbolt, 14 February 1980, Jack Shadbolt Fonds, UBC.)
43. Molly Diary, 29 May 1980.
44. Itani, *Linger by the Sea*, n.p.
45. Itani, interview with the author.
46. Fitch, interview with the author.
47. Itani, *Linger by the Sea*, n.p.
48. Quoted in Wylie, "Narrative Space," 174.
49. Itani, *Linger by the Sea*, n.p.
50. Molly Diary, 18 May 1979.
51. Molly Diary, 27 May 1979.
52. Molly Diary, 29 May 1979; 17 June 1979; 3 July 1979; 22 June 1979.
53. Molly Diary, 30 May 1979.
54. Molly Diary, 16 August 1979.
55. Molly Diary, 2 October 1980.
56. In addition to *Kent's Punch*, the novel consists of *After the Concert*, *Jimmy Pataki*, and the 1985 oil, *Snooker*. Since *After the Concert* and *Jimmy Pataki* are similar works, I discuss *After the Concert* only.
57. Molly Diary, 31 November 1977.
58. Molly Diary, 14 August 1977.
59. Andrus, interview with the author.
60. Forrestall, interview with the author.
61. Cf. Girard, *Violence and the Sacred*.

Chapter 9 A Sense of Place

1. Molly Diary, 5 January 1981.
2. Molly Diary, 16 September 1986.
3. Molly Diary, 16 September 1986.
4. Molly Diary, 15 February 1981.
5. Molly Diary, 25 April 1981.
6. Molly Diary, 17 July 1981.
7. Molly Diary, 31 July 1981.
8. Smith, interview with the author.
9. Molly Diary, 1 February 1980.
10. Molly Diary, 31 March 1981.
11. Bruno's love of shopping at Walmart greatly annoyed Molly. Donald Andrus, by contrast, recalls that when he would visit them in Fredericton, Bruno would invite him to go shopping at Walmart, where Bruno would often purchase bits and pieces that he would later use in artwork or to decorate things he made. David Young recalls Bruno mocking himself for buying a case of Campbell's tomato soup, even though he prepared the soup only a couple of times a year.
12. Molly Diary, 23 November 1984.
13. Molly Diary, 19 June 1984.
14. He also complained about her cooking, which a number of friends agreed was not good—but he still left it to her to do.
15. Molly Diary, 25 September 1983.
16. Molly Diary, 7 May 1983.
17. Molly Diary, 3 September 1982.
18. Molly Diary, 20 June 1982.
19. Molly Diary, 19 November 1983.
20. Molly Diary, 13 February 1984.
21. Molly Diary, 14 February 1984.
22. Molly Diary, 11 February 1982.
23. Molly Diary, 26 January 1982.
24. Molly Diary, 26 January 1982.
25. Burnett and Schiff, *Contemporary Canadian Art*, 167.
26. Molly Diary, 14 January 1998.
27. Lismer, "Canada at War: A Symposium," 90.
28. Bishop-Gwyn, *Art and Rivalry*, 89.
29. Molly Diary, 23 July 1997.
30. Donaldson, "The Fredericton Years," 96.
31. Smith, interview with the author.
32. My detailed digital photograph of the work revealed that Molly had originally intended there to be a couple watching the revellers through the second window on the right. In the final form, the bright light coming from the window has blanched the figures out of the scene.
33. Forrestall, interview with the author.
34. Richmond, "Molly Lamb Bobak" 48.
35. Since at least the 1961 painting *Oslo Street*, Molly had been experimenting with using shadows to increase the number of "figures" in a crowd scene without filling the narrative space with so many figures that the sense of movement was lost.
36. Letwin quoted in Letwin and Molly Bobak, *Molly Bobak: Talk of the Town*, 4.
37. Molly Diary, 7 June 1993 and passim.
38. In *Skaters* the sense of movement is generated by the skater-like poses of the figures and the stark difference between the white background, representing the ice surface as seen from above, and the black figures that seemingly glide across it.
39. Mantha, interview with the author.
40. Sylvester, *Looking at Giacometti*, 35–36.
41. Molly Diary, 6 January 1983.
42. Zola made Lantier enough like Cézanne that after reading the novel, Cézanne ended the friendship that had begun when they were young boys.
43. Zola, *The Masterpiece*, 175.
44. Molly Diary, 19 February 1983.
45. Andrus, interview with the author (email).
46. Molly Diary, 23 September 1982.
47. Molly, letter to Shadbolt, 2 April 1984, Jack Shadbolt Fonds, UBC.
48. Molly Diary, 24 April 1983.
49. Molly Diary, 15 June 1983.
50. Molly Diary, 10 November 1985.
51. Molly Diary, 20 March 1981.
52. Molly Diary, 27 September 1983.
53. Keat, "Victoria's Sympathy for Captain Dreyfus," 28 January 1901.
54. Molly Diary, 28 July 1986.
55. Molly Diary, 10 April 1991
56. After a particularly upsetting anti-Semitic outburst by Bruno on 1 April 1993 that verged on Holocaust denial, Molly asked, "How did this damnable

thing come about?" before answering, "I wonder if 'God's' chosen people was too much for other tribes. Now I think it is purely an excuse for self hate, shift it to the other's shoulders."

57. Molly Diary, 24 March 1990.
58. Molly Diary, 8 February 1991.
59. Molly Diary, 1 October 1990.
60. Molly Diary, 26 August 1979. Mary's letter is also interesting because of the way she refers to the Irish Republican Army's recent assassination of Lord Louis Mountbatten. While Mary's equation of the IRA with the "fascist Croatian Ustaše" (the Croatian fascists who sought to ally with Hitler) may be a historical stretch, the fact that she writes it indicates both her detailed knowledge of history and Molly's.
61. Molly Diary, 9 February 1984.
62. Molly, letter to Shadbolt, 27 July 1984, Jack Shadbolt Fonds, UBC.
63. Molly Diary, 20 June 1984.
64. Budovitch met Molly in 1969 and they quickly became close friends, despite the fact that Molly was Budovitch's mother's age. They took innumerable strolls on the Green, walking Molly's various dogs.
65. Budovitch, interview with the author.
66. Toole Grant, interview with the author.
67. Molly, letter to Shadbolt, 19 December 1985, Jack Shadbolt Fonds, UBC.
68. Event held on 24 October 2018, Ottawa Art Gallery, with the author in attendance. Molly records Bruno saying he's "retired" on 3 October 1986. In a letter to Donald Andrus in 1988, Molly reports Bruno saying that he has retired and wants to fish.
69. Smith, interview with the author.
70. Molly found these times trying because, while she liked Ernie, she thoroughly disliked Ernie's wife, Elma; even worse were Molly's and Bruno's visits to Ernie and Elma in southern Ontario, which Molly loathed.
71. Young, interview with the author.
72. Greif, interview with the author.
73. Smith, interview with the author.
74. Molly Diary, 10 March 1985.
75. Gay, *Art and Act*, 49.
76. Berger, *Landscapes*, 24.
77. Botton and Armstrong, *Art as Therapy*, 19.

Chapter 10 Two People Who Have Outworn Each Other

1. As Philip Kokotailo showed in John Glassco's *Richer World: Memoirs of Montparnasse*, Glassco's book is a case of literary subterfuge.
2. Molly Diary, 2 January 1986.
3. Molly Diary, 2 January 1986.
4. Molly Diary, 4 January 1986.
5. Molly Diary, 15 February 1986.
6. Molly Diary, 8 March 1986.
7. Interestingly, at about the same time, Christopher Pratt suffered a similar crisis in confidence. "How did I get so far from the meat and sinew of things?...What has killed the poetry and left me arranging lines and tone; is there nothing beneath the surface of the pond, behind the wall, through the window, in the room, on the mind of a model." (Pratt quoted in Gwyn, *Art and Rivalry*, 136.)
8. Molly Diary, 6 April 1986.
9. Molly Diary, 25 April 1986.
10. Molly Diary, 26 May 1986.
11. Molly Diary, 13 June 1986.
12. Fitch, interview with the author.
13. Wylie, "Narrative Space," 172.
14. Fitch, interview with the author.
15. Molly Diary, 15 October 1986.
16. Despite her claims that she did not really understand the paperwork, seven years earlier Molly also ended up holding a mortgage for a friend. In January 1977, she lent a female friend $10,000 ($35,000) so she could buy her soon-to-be ex-husband's share of their house. Ironically, five months earlier, he had borrowed $1,000 ($4,000) from Molly. Molly's claim to being a financial ingenue is belied by the fact she insisted that he tell his wife he had used their

house as collateral. Humorously, Molly ended up part owner of the house that she later financed the purchase of.

17. Donald Andrus, letter to Bruno, 9 January 1982, in the possession of the author; Bruno, letter to Donald Andrus, 29 January 1982, in the possession of the author.
18. Molly Diary, 20 May 1988.
19. Molly Diary, 16 January 1986.
20. Lambert strongly supported Abstract Expressionist artists. She was responsible for getting the abstract artist Mark Rothko to paint the murals in the Seagram Building in New York. At times, Molly was not above being somewhat unkind, as evidenced by her characterization of Lambert as "mannish" (Molly Diary, 22 August 1986.)
21. Molly Diary, 13 February 1987.
22. Molly Diary, 18 November 1988.
23. Molly Diary, 13 February 1987.
24. Molly Diary, 7 August 1986.
25. Molly Diary, 12 August 1986.
26. *Gleaner*, 1986, Clipping, UNB.
27. Molly Diary, 2 December 1986.
28. Among the thirty-five or so composers mentioned in her Diary are Dvořák, Haydn, Mahler, Chopin, Barber, Debussy, Ravel, Schubert, Elgar, Tchaikovsky, and Shostakovich. Her observation that Anton Bruckner's 8th Symphony was "so Germanic" was shared by Nazi propaganda chief Joseph Goebbels, who had it played at the Nuremberg Rallies.

 Molly was an early supporter of both Holly Cole and Measha Gosman (later Brueggergosman). She saw the latter perform in the 1993 Fredericton High School production of *The Wiz*.
29. Molly Diary, 10 August 1987.
30. Molly, letter to Shadbolt, 26 October 1987, Jack Shadbolt Fonds, UBC.
31. Lawrence quoted in Hyman, *The World New Made*, 134.
32. Molly Diary, 26 Sept 1987.
33. Molly Diary, 3 October 1987.

34. For a complete discussion of Lawrence's fascistic beliefs see Guttman, "Sacred, Inspired Authority."
35. Molly's disinterest in depicting the male nude (and, indeed, her praise of Bruno's nudes in his *Tired Wrestler* period) also makes her interest in Lawrence surprising, for, as Allen Guttmann shows in "Sacred, Inspired Authority," Lawrence upheld precisely the view of the triumphant male body that Molly eschews in works like *Trooping the Colours*.
36. Lawrence quoted in Guttman, "Sacred, Inspired Authority," 176.
37. The Royal 22nd Regiment, nicknamed the "Vandoos," the anglicized version of *le Vingt-deuxième*, 22nd, the only French-speaking regiment in the First World War.
38. The PPCLI's regimental major, Slade G.J. Lerch, told me, referencing the marchers, "I'm one of those blobs."
39. McFee and Tomlinson, "Riefenstahl's Olympia," 93.
40. By contrast, in *Triumph of the Will*, to achieve her desired effect—an evocation of Nazi Germany's gestalt—Riefenstahl's camera is both omniscient and hidden.
41. Molly Diary, 14 January 1998
42. Molly Diary, 26 July 1989.
43. Plumly, *Elegy Landscapes*, 27.
44. Molly Diary, 16 January 1970.
45. Molly Diary, 22 April 1991.
46. Molly Diary, 22 April 1991.
47. Molly Diary, 22 April 1991.
48. Molly Diary, 28 May 1987.
49. Molly Diary, 7 April 1989.
50. Molly Diary, 18 October 1981.
51. Molly Diary, 6 September and 27 October 1992.
52. Molly Diary, 10 February 1992.
53. One such example of Bruno's record keeping is a letter to Andrus dated 26 November 1971, referencing his purchase of a painting for $1,000 in $100 installments. In the letter, Bruno writes,

"Your records correspond with mine," before adding, "You still owe $100."

54. The window, which shows a group of graduands wearing the mortar boards, is interesting because it is the only one of Molly's major works that could be said to owe a debt to Cubism. Characteristically, while we see the graduands' faces, none is individuated.

55. On 20 April 1993, Molly recorded Bruno asking, "'Why do you paint, you don't need the money.'" She responds in the same entry, "He has a point, have not done much good lately."

56. The exception to this was Walter Klinkhoff's. From the very beginning of

the firm's relationship with the Bobaks, it had a 33/66 per cent division. "My father," Eric Klinkhoff told me, "felt the artists should be receiving the large end of the sale price, as he had such respect for their talent."

57. Molly Diary, 24 February 1990.
58. Molly Diary, 28 July 1988.
59. Molly Diary, 30 June 1989.
60. Molly Diary, 13 January 1989.
61. Molly Diary, 29 March 1989.
62. Molly Diary, December 7 1989.
63. Molly Diary, 13 March 1990.
64. Rovers, interview with the author.
65. Molly Diary, 18 August 1990.

PART FOUR: 1990-2014
Chapter 11 The Compleat Angler

1. Among other commissioned portraits Bruno painted was one of Senator Noël Kinsella. Additionally, he painted one of Ian Lumsden on the occasion of his thirtieth anniversary of being director of the Beaverbrook Art Gallery.

2. Forrestall, interview with the author.
3. Forrestall, interview with the author.
4. Soussloff, *Subject in Art*, 42.
5. Soussloff, *Subject in Art*, 44.
6. Molly Diary, 9 December 1990; and 10 October 1990. Judge Lamer was one of many political and business leaders who stopped in unannounced to see Molly. Some years earlier, when upon returning from a visit to Paris, Molly realized she had forgotten her chequebook in Joe Plaskett's apartment, she called Wallace McCain, who she knew was soon going to Paris, to go pick it up for her.

7. Molly Diary, 29 November 1980.
8. Molly Diary, 6 and 11 January 1991.
9. Molly Diary, 16 January 1991.
10. Molly Diary, 18 January 1991.
11. Molly Diary, 5 March 1991.
12. Molly Diary, 31 January 1991.
13. Molly Diary, 31 January 1991.
14. Molly Diary, 23 April 1995.
15. Molly Diary, 18 May 1995.
16. Molly Diary, 26 September 1996.
17. Molly Diary, 30 October 1995.

18. Molly Diary, 25 October 1995.
19. Molly Diary, 6 November 1995.
20. Molly Diary, 13 November 1995.
21. Merleau-Ponty, "Cézanne's Doubt," 276.
22. Molly Diary, 3 February 1992.
23. Molly Diary, 14 March 1992.
24. Molly Diary, 20 March 1992.
25. Molly Diary, 5 April 1992.
26. Molly Diary, 18 January 1992.
27. Paddie, "Cool Distance," 47.
28. Auden quoted in Jacobs, *The Year of Our Lord 1943*, 67. Molly's militant atheism would have prevented her from following Auden on the path he charted in "Unicorn Among the Cedars," which ends with the Latin "O da quod jubes, Domine," which comes from St. Augustine's Confessions and means, "O give what you command, Lord."

29. Molly Diary, 23 February 1991.
30. Molly Diary, 26 July 1995.
31. Molly Diary, 4 September 1995.
32. Molly Diary, 10 September 1996.
33. Molly Diary, 11 June 1996.
34. McElman, interview with the author.
35. Stairs, interview with the author.
36. Young, interview with the author.
37. Walton, *The Compleat Angler*, 71–72.
38. McElman, interview with the author.
39. Bruno also created the label, which has a sketch of McElman wearing his

beloved New York Yankee's baseball cap, for "Ted and Fred's Magic Fly Dressing." The dressing, a clear gel, is applied to the dry flies at the riverside to keep them from absorbing water and sinking. Though he graciously gave me a sample squeeze bottle of dressing, when, in the interest of research, I asked what was the main ingredient in it, like an angler keeping secret a favourite pool, McElman gave me a Cheshire Cat grin.

40. Hazlitt, *The Literary World*, 23.
41. Chiasson, "Introduction," 14.
42. McElman, interview with the author.
43. For example, on 23 September 1995, "Bridge set off against Italian fresco blue sky"; on 16 May 1997, "Sky dunned sullen all day. Blazing oranges and yellows"; while on New Year's Day 2001, "I see millions of canvases. White snow/dramatic sky with fat blue-grey clouds—a bit of gold."

44. McElman, interview with the author.
45. Burley, interview with the author.
46. McElman, interview with the author.
47. McElman, interview with the author.
48. Bishop-Gwyn, *Art and Rivalry*, 49.
49. Lumsden, *The Queen Comes to New Brunswick*, 13.
50. Molly Diary, 23 November 1995.

Chapter 12 "I Belong to Myself"

1. Molly Diary, 5 May 1995.
2. Molly Diary, 29 January 1992.
3. Molly Diary, 24 October 1992.
4. Over the decades Molly had had a number of dogs. The two favourites were Baby and Daisy. After Daisy bit a woman in April 1994, Molly came under pressure from both Bruno and Alexander to get rid of the dog. The standoff between the two Bobak men and Molly was one of the most rancorous ones she recounts, though her view that Daisy was more sinned against than sinning seemed wilfully blind. In the end, a compromise was worked out whereby Daisy was shipped to Anny, who had a farm on Galiano Island. Molly heartily resented the loss of "sweet," "dear" Daisy.
5. Andrus, interview with the author.
6. Bergson, "Laughter," n.p.
7. Molly Diary, 31 March 1994.
8. Molly Diary, 2 April 1994.
9. Molly Diary, 10 September 1996.
10. Molly Diary, 20 December 1998.
11. Her view on a possible third referendum is reflected in her noting that on 20 August 1998 the Supreme Court of Canada ruled the federal government was not required to negotiate with Quebec on secession unless the "Yes" was to a clear question.

12. Molly Diary, 9 March 1998.
13. Molly Diary, 20 April 1997.
14. Molly Diary, 21 February 1998.
15. Molly Diary, 22 February 1998.
16. Molly Diary, 22 July 1998.
17. Molly Diary, 23 July 1997.
18. Molly Diary, 22 July 1998.
19. This explains her pique at Bruno's agreement in 1983 with Jerome Sabat's idea for an article showing them as a "team." She noted caustically that decades earlier Bruno was so opposed to this idea taking hold that he wanted Molly to sign her works "Lamb."
20. Molly Diary, 5 February 1997.
21. Molly Diary, 25 April 1997.
22. Reid, *Women Between*, 135.
23. Bishop-Gwyn, interview with the author.
24. Perhaps the one exception to this—and the settling is confined to Molly's Diary—concerns not Carolyn Cole, whom Molly came to pity, but rather Christina Sabat. Time and again, Molly criticizes that "Sabat woman." After Christina Sabat's funeral (she was killed in an automobile accident in March 1998), Molly wrote that the funeral was all a "show" and that Sabat's art criticism had "had lots of big words and little content."

25. Grant, "An Interview with Molly Bobak," 37.
26. Given that she says Christopher Pratt's work only "emulated Edward Hopper" (18 January 1995), Bruno would likely be very happy about this.
27. Molly Diary, 5 February 1997.
28. Molly Diary, 27 October 1999.
29. Bruno's fascination with the light effects of snow and ice forms the basis of one of the few stories I was told in which the two artists publicly discussed an artistic challenge. At a dinner party, recalls Inge Pataki, "Bruno was talking about how difficult it was to render the thin layer of ice that had formed on a river. When Molly said it could not have been that difficult, Bruno said, 'You try it.'" (Pataki, interview with the author.)
30. Molly Diary, 8 November 1981.
31. Molly Diary, 19 June 1984.
32. Molly Diary, 20 July 1974.
33. Molly Diary, 3 June 1977.
34. Molly Diary, 8 May 1993.
35. Molly Diary, 24 November 1996.
36. Brandon, *Pegi by Herself*, 85. In 1935, Nicol had an abortion and started a long affair with Bill Graham, with whom she shared an apartment for a short while.
37. Molly Diary, 18 January 1999.
38. Molly Diary, 21 January 1999.
39. Molly Diary, 1 September, 1999.
40. Smith, interview with the author.
41. Smith, interview with the author.

Chapter 13 Quietus

1. "Bruno Bobak," *Telegraph*, 4 October 2012.
2. Canadian Press, "Canadian War Artist Bruno Bobak Dies in New Brunswick at Age of 88," *Globe and Mail*, 26 September, 2012.
3. Young interview with the author.
4. Scoones, *Last Dance in Shediac*, 107.
5. Scoones, *Last Dance in Shediac*, 109.
6. Scoones, *Last Dance in Shediac*, 110.
7. Stairs, interview with the author.
8. Scoones, *Last Dance in Shediac*, 131.
9. Maddox, interview with the author.
10. Anny Scoones did not write about her brother, Alexander, in her memoir of Molly. Alexander Bobak's decision not to be interviewed about his parents explains the lack of first-hand information about his dealings with both his father and his mother toward the end of their lives. However, the fact that Bruno named him co-executor (with Gary Stairs) of Bruno's estate speaks for itself, as does Molly's decision to name her son executor of her estate. Molly assigned the rights to her correspondence at Library and Archives Canada to her daughter.
11. Scoones, *Last Dance in Shediac*, 75.
12. Budovitch, interview with the author.
13. Scoones, *Last Dance in Shediac*, 111.
14. Scoones, *Last Dance in Shediac*, 116.
15. Leroux, interview with the author.
16. Budovitch, interview with the author.
17. "Molly Lamb Bobak—Obituary," *Telegraph*, 13 April 2014.
18. Lawlor, "Molly Lamb Bobak was First Canadian Woman Sent Overseas as War Artist," *Globe and Mail*, 14 March 2014.

Coda

1. Harper, *Painting in Canada*. The mention is in the "Biographies" section of the book.
2. Harper, *Painting in Canada*, 354.
3. Reid, *A Concise History of Canadian Painting*, 2nd ed., 287–88f.
4. Reid, *A Concise History of Canadian Painting*, 3rd ed., 338.
5. Reid, A Concise History of Canadian Painting, 3rd ed., 446.
6. Molly Diary, 28 September 1985.
7. It is worth noting in passing that when Molly writes of gutting a deer Bruno had shot while hunting and of cleaning fish he caught, she does so in a matter-of-fact way that cannot be interpreted as coded

references to Bruno's verbal violence and the emotional battles between them. Perhaps this difference is due to the fact that having seen the devastation of Europe, whatever bloodletting occurred while turning a deer or fish into food was small beer indeed.

8. Smart, *The Art of Mary Pratt*, 85.
9. Smith, interview with the author.
10. One hopes that Mitchell had a taste for irony. Shortly after being released in July 1974, "A Free Man in Paris" climbed to no. 22 on the Billboard Chart and no. 2 on the Easy Listening Chart, helping to drive the album *Court and Spark* to no. 2 in the United States and no. 1 in Canada; the album went double platinum, with two million sold. Mocking the creator of a popular song, it would seem, made for a very popular song.
11. Aristotle's books on comedy and his writing on painting and sculpture are lost. Nevertheless, *The Poetics*, which in ancient Greek means "the making of something that did not exist before," gives a clear idea of Aristotle's psychological view of art.

Bibliography

Abbreviations
LAC Library and Archives Canada
UNB University of New Brunswick

Interviews with the author were conducted between November 2017 and October 2019.
Carol Bishop-Gwyn (Toronto)
Laura Brandon (Ottawa)
Judy Budovitch (Fredericton)
Wayne Burley (Fredericton)
Marjory and Allan Donaldson (Fredericton)
Brigid Toole Grant (Fredericton)
William Forrestall (Fredericton)
John Leroux (Fredericton)
Warren C. Maddox (Fredericton)
Nathalie Mantha (Ottawa)
Fred McElman (Fredericton)
Inge Pataki (Fredericton)
Bernard Riordon (Fredericton)
Martin Rovers (Ottawa)
Stephen Scott (Fredericton)
Stuart Smith (Ottawa)
Gary Stairs (Fredericton)
David Young (Fredericton)

Writings by Bruno Bobak
Bobak, Bruno. Fonds. UNB Archives.
———. Fonds. UNB Art Centre.
Bobak, Bruno. Military reports and letters. CWM Archives DU MCG. Textual Records 58A1 284.2-4. Canadian War Museum, Ottawa.
———. "The Artist in Canada." *Leeds Arts Calendar*, 1962. Bobak Fonds, UNB Archives.
———. "The Best of Contemporary Art." Jerome and Christina Sabat Fonds, UNB Archives.

Writings on Bruno Bobak
Baster, Victoria, ed. *Bruno Bobak Drawings*. Edmonton: Southern Alberta Art Gallery, 1983.
Bobak, Bruno. *Bruno Bobak: Selected Works 1943-1980*. Curated by Donald Andrus. Montréal: Sir George Williams Art Galleries and Concordia University, 1983.
Brandon, Laura. "The War Years." In Riordon, *Bruno Bobak*, 25–44.
Bruce, Fraser. "They Share Art Career." *Vancouver Sun*, 11 April 1953, 24.

"Bruno Bobak." *Telegraph*, 4 October 2012. Accessed 4 April 2019. https://www.telegraph
.co.uk/news/obituaries/culture-obituaries/art-obituaries/9587983/Bruno-Bobak.html.

"Bruno Bobak Does a Mural in Concrete," *Canadian Art* 10, no. 4 (Summer 1953): 164.

Canadian Press. "Canadian War Artist Bruno Bobak Dies in New Brunswick at Age of 88."
Globe and Mail, 26 September, 2012. Accessed 4 April 2019. https://www.theglobeandmail
.com/arts/art-and-architecture/canadian-war-artist-bruno-bobak-dies-in-new-brunswick
-at-age-of-88/article4568713/.

Chiasson, Herménégilde. "Introduction." In Riordon, *Bruno Bobak*, 11–16.

Curtis, Herb. "The Early Years." In Riordon, *Bruno Bobak*, 17–24.

"Did You Hear That." (Review of 1962 exhibit of Bruno's work in Leeds, UK.) *Listener*, 1
March 1962, 369.

Donaldson, Marjory Rogers. "The Fredericton Years." In Riordon, *Bruno Bobak*, 71–110.

Fry, George. "Bruno Bobak: University of New Brunswick." n.p., n.d. UNB Archives
Clippings.

Fulford, Robert. "Bruno Bobak." *Canadian Art* 71 (January-February 1961): 12–13.

Halliday, Hugh. "Interview with Bruno Bobak." September 1980. Bruno Bobak Fonds. 31d 5,
Bobak, Bruno. Canadian War Museum, Ottawa.

Larisey, Peter. "Enriching the Spiritual Life." *Canadian Art* 23, no. 38 (July 1966).

Leroux, John. *New Brunswick's Centennial Building Murals, 1967*. Fredericton: New Brunswick
Museum, 2017.

———. "On Bobaks and Fredericton Downtown." n.d. Essay in possession of the author.

McCarthy, Pearl. "'New Canadian' Soldier Wins Army's Art Prize," *Globe and Mail*, 14
September 1944, p. 4.

Murray, Joan. "Joan Murray Talking with Bruno Bobak at 72 Landsdowne, Fredericton, Sept.
28/79." Bruno Bobak Fonds. LAC, Ottawa.

———. *The Versatile Art of Bobak*. (Exhibition, November 1983.) Oshawa: Robert McLaughlin
Gallery, 1983.

Newton, Eric. "Two Commonwealth Artists." *Guardian* (London, UK), 18 September 1964,
n.p. UNB Archives Clippings.

Oliver, W.T. "First Show in Britain by a Canadian Artist." *Yorkshire Post*, February 1, 1962.

Pacey, Desmond. "Bruno Bobak at U.N.B." *Canadian Art* 28 (March-April 1961): 140–44.

Riordon, Bernard, ed. *Bruno Bobak: The Full Palette*. Fredericton: Goose Lane Editions and
Beaverbrook Art Gallery, 2006.

Robson, John. "Letter from London." *Canadian Art* 23 (January-February 1963): 62–63.

Rombout, Luke. "Bruno Bobak." *Vie des Arts* 53 (Winter 1968-1969): 40–43.

Rosenfeld, Roslyn. "Works on Paper." In Riordon, *Bruno Bobak*, 111–50.

Sabat, Christina. "Bruno Bobak's Creativity Results in Newest Exhibition." *Daily Gleaner*, 13
May 1974, 9. UNB Archives Clippings.

———. "Visual Arts in Review." *Daily Gleaner*, 15 March 1980, 4–5. UNB Archives Clippings.

———. "Visual Arts in Review." *Daily Gleaner*, 1986, n.p. UNB Archives Clippings.

———. "Visual Arts in Review." *Daily Gleaner*, 23 May 1987, n.p. UNB Archives Clippings.

Shadbolt, Doris. "Molly and Bruno Bobak." *Canadian Art* 9, no. 3 (1952): 125–26.

Simmons, Richard B. "B.C. Man and Wife Portray Life and Nature Intimately." *Leader Post*
(Regina). 1 January 1954, 9.

Smith, Gordon. "The Vancouver Years." In Riordon, *Bruno Bobak*, 45–70.

Tucker, Anthony. "European from Canada." *Manchester Guardian Weekly*, 8 February 1962,
14–15. UNB Archives Clippings.

Varsity. Vancouver School of Art, 25 January 1954.

Writings by Molly Bobak

Bobak, Molly. Fonds. Diary: 1969-2000, MG30-D378. LAC, Ottawa. All references to Molly Bobak's Diary are indicated in the text or in an endnote.

———. Letters to Jack Shadbolt, Jack Shadbolt Fonds, University of British Columbia.

———. Letters. Fonds. UNB Archives. (All references to Molly Bobak's letters to and from her father [Harold Mortimer-Lamb] and A.Y. Jackson are indicated in the text or in an endnote.)

———. Letters to (and from) Donald Andrus, in possession of Andrus. (The author wishes to thank Andrus for allowing him to copy the letters.)

Published Works

Bobak, Molly. "I Love the Army." *Canadian Art* 2, no. 4 (April-May1945): 147ff.

———. "Leisure to Paint." *Canadian Art* 16, no. 2 (May 1959): 101–17.

———. "Letter from the Maritimes," *artscanada* 25, no. 118–19 (June 1968): 48–49.

———. *Wildflowers of Canada: Impressions and Sketches of a Field Artist.* Toronto: Pagurian Press, 1978a.

———. Lecture at the Robert McLaughlin Gallery. Oshawa, Ontario, 9 November 1978b. Molly Bobak Fonds. LAC, Ottawa.

———. *Molly Bobak: Retrospective Loan Exhibition*, (exhibition 26 April–10 May 2014), edited by Eric Klinkhoff. Montréal: Galerie Eric Klinkhoff, 2014.

———. *Molly Bobak: Talk of the Town.* (Exhibition 19 January–8 April 2018.) Edited by Hillary Letwin. Burnaby: Burnaby Art Gallery. 2018.

———. War Diary, 1942-1945 LAC, Ottawa. Last accessed 26 December 2019. https://www.bac-lac.gc.ca/eng/discover/military-heritage/second-world-war/molly-lamb-bobak/Pages/pages-1-20-molly-bobak.aspx.

Bobak, Molly, and Sheree Fitch. *Toes in My Nose and Other Poems.* Toronto: Doubleday, 1987.

Bobak, Molly, and Carolyn Gossage. *Double Duty: Sketches and Diaries of Molly Lamb Bobak, Canadian War Artist.* Toronto: Dundurn Press, 1992.

Bobak, Molly, and Frances Itani. *Linger by the Sea.* Fredericton: Brunswick Press, 1979.

Writings on Molly Bobak

Bauer, Nancy. "Molly Lamb Bobak: A Painter of Silent Space." *Arts Atlantic* 33 (1989): 35–38.

Bell, Peter. "Bobak Makes Crowds Speak." n.p, 1977. Clippings UNB Archives.

Brandon, Laura. "Interview with Molly Bobak." Canadian War Museum Fonds. 12 May 2000.

Bruce, Fraser. "They Share Art Career." *Vancouver Sun*, 11 April 1953, 24.

Donaldson, Marjory. *Themes of Molly Bobak.* Fredericton: UNB Art Centre.

Foss, Brian. "Molly Bobak: Art and War." In Richmond, Foss, and Lamb Bobak, eds., *Molly Lamb Bobak.* 92–139.

Fulford, Robert. "Molly Lamb Bobak." *Canadian Art* 71 (January-February 1961): 14–15.

———. "Survey of the Work of 24 Young Canadian Artists." In *Documents in Canadian Art*, edited by Douglas Fetherling, 221–22. Peterborough: Broadview Press, 1987.

Gewurtz, Michelle, and Molly Lamb Bobak. *Molly Lamb Bobak: Life & Work* (e-book). Toronto: Art Canada Institute, 2019. https://aci-iac.ca/art-books/molly-lamb-bobak.

Grant, Brigid Toole. "An Interview with Molly Bobak." *Arts Atlantic* 12, no. 3 (Winter 1995): 37.

Klinkenberg, Marty. "New Brunswick's First Lady of Art," *Telegraph Journal*, 25 September 2010, S6.

Lawlor, Allison. "Molly Lamb Bobak was First Canadian Woman Sent Overseas as War Artist," *Globe and Mail.* Accessed 4 April 2019. https://www.theglobeandmail.com/news

/national/molly-lamb-bobak-was-first-canadian-woman-sent-overseas-as-war-artist/article
17505200/.

"Letter from Deputy Minister of Defence to Editor." *Canadian Art.* 22 June 1945. NGC 5.42-L
Canadian War Artists, Lamb.

Lloydlangston, Amber. "Molly Lamb Bobak Official War Artist (1920-2014)." *Canadian
Military History* 23, no. 2, article 6 (2015): 119–27. https://scholars.wlu.ca/cmh/vol23/iss2/6.

Lumsden, Ian. *The Queen Comes to New Brunswick: Paintings and Drawings By Molly Lamb
Bobak.* (Touring exhibition 1977-79.) Fredericton: Beaverbrook Art Gallery, 1977.

"Molly Lamb Bobak—Obituary." *Telegraph*, 13 April 2014. Accessed 4 April 2019. https://
www.telegraph.co.uk/news/obituaries/10763764/Molly-Lamb-Bobak-obituary.html.

Murray, Joan. "Joan Murray Speaking with Molly Bobak." 5 September, 1977. Molly Bobak
Fonds. LAC, Ottawa.

———. "Interview with Molly Lamb Bobak." *The Canadian Collector* 13, no. 5 (September-
October 1978): 40–43.

———. "Joan Murray and Molly Lamb Bobak." 28 March 1983. Molly Bobak Fonds. LAC,
Ottawa.

Nowlan, Alden. "Learning about the Bobaks: Note on Two Personal, Confessional Artists."
Saturday Night 90, no. 5 (October 1975): 23–28.

———. "Molly Bobak: A Gift for Finding Joy." *Atlantic Insight* (November 1981): 72–77.

Richmond, Cindy, Brian Foss, and Molly Lamb Bobak, eds. *Molly Lamb Bobak: A Retro-
spective/Une Rétrospective.* Regina: MacKenzie Art Gallery, 1993.

Richmond, Cindy. "Molly Lamb Bobak." In Richmond, Foss, and Lamb Bobak, *Molly Lamb
Bobak,* 24–91.

Riordon, Bernard, ed. *Bruno Bobak: The Full Palette.* Fredericton: Goose Lane Editions and
Beaverbrook Art Gallery, 2006.

Schaap, Tanya. "'Girl Takes Drastic Step': Molly Lamb Bobak's 'W110278 – Diary of a CWAC.'"
In *Working Memory: Women and Work in WW II*, edited by Marlene Kadar and Jeanne
Perreault, 171–190 Waterloo: Wilfrid Laurier University Press, 2015.

Scoones, A. *Last Dance in Shediac: Memories of Mum, Molly Lamb Bobak.* Victoria:
TouchWood Editions, 2013.

Shadbolt, Doris. "Molly and Bruno Bobak." *Canadian Art* 9, no. 3 (1952): 125–26.

Simmons, Richard B. "B.C. Man and Wife Portray Life and Nature Intimately," *Leader Post*
(Regina), 1 January 1954, 9.

Smith, Sheila. "Artist Teaches Painting to Inland Groups." *Globe and Mail.* 6 February 1960,
10.

Smith, Stuart, A. "Molly Bobak." *Canadian Art* 22, no. 5 (November-December 1965): 36–37.

Wylie, Andrea Schwenke. "Narrative Space in Sheree Fitch's Merry-Go-Day and Night Sky
Wheel Ride: Picture Book Poesis." In *More Words About Pictures: Current Research on Picture
Books and Visual/Verbal Texts for Young People*, edited by Perry Nodelman, Naomi Hamer,
and Mavis Reimer, 171–88. London: Routledge, 2017.

Canadian Art History

Amos, Robert. "The Simple Forms of Molly Lamb Bobak." *Times Colonist.* 29 October 2000, 12.

———. *Harold Mortimer-Lamb: The Art Lover.* Victoria: TouchWood Editions, 2013.

Bishop-Gwyn, Carol. *Art and Rivalry: The Marriage of Mary and Christopher Pratt.* Toronto:
Knopf, Canada, 2019.

Boyanoski, Christine. "Paraskeva Clark: Life & Work." Art Canada Institute – Institut De
L'art. Accessed 15 February 2019. https://www.aci-iac.ca/art-books/paraskeva-clark/credits.

Brandon, Laura. *Pegi by Herself: The Life of Pegi Nicol MacLeod, Canadian Artist*. Montréal: McGill-Queen's University Press, 2005.

———. "Veracity and Expectation in Charles Comfort's War Art, 1940–1948: The Hitler Line Perspective." In *Take Comfort: The Career of Charles Comfort / La Carrière de Charles Comfort*, edited by Mary Jo Hughes and Rosemarie L. Tovell, 53–56. Winnipeg: Winnipeg Art Gallery, 2007.

Burnett, David, and Marilyn Shiff. *Contemporary Canadian Art*. Edmonton: Hurtig, 1983.

Carney, Lora Senechal. *Canadian Painters in a Modern World, 1925-1955: Writings and Reconsiderations*. Montréal and Kingston: McGill-Queen's University Press, 2017.

Carr, Emily. *Sister and I: From Victoria to London*. Victoria: Royal British Columbia Museum, 2011.

Cavell, R. *Love, Hate, and Fear in Canada's Cold War*. Toronto: University of Toronto Press, 2004.

Clark, Paraskeva. "Out from the Canadian Shield," *New Frontier* (April 1937): 16-17.

Clendinning, Anne. "Exhibiting a Nation: Canada at the British Empire Exhibitions, 1924-1925." *Social History* 39, no. 77 (2006): 79–107.

Comfort, Charles. *Artist at War: Charles Comfort*. Pender Island, BC: Remembrance Books, 1995.

Harper, J. Russell. *Painting in Canada: A History*. 2nd ed. Toronto: University of Toronto Press, 1970.

Hughes, Mary Jo. "Rare Feast—Charles Comfort's Life and Career." In Hughes and Tovell, 11–29.

Hughes, Mary Jo, and Rosemarie L. Tovell, eds. *Take Comfort: The Career of Charles Comfort / La Carrière de Charles Comfort*. Winnipeg: Winnipeg Art Gallery, 2007.

Huneault, Kristina. *I'm Not Myself at All: Women, Art, and Subjectivity in Canada*. Montréal and Kingston: McGill-Queen's University Press, 2018.

Jackson, A.Y. *A Painter's Century: The Autobiography of A.Y. Jackson*. Toronto: Clark, Irwin, 1958.

King, J. *Inward Journey: The Life of Lawren Harris*. Markham: Thomas Allen, 2013.

King, R. *Defiant Spirits: The Modernist Revolution of the Group of Seven*. Vancouver: Douglas & McIntyre, 2011.

Lismer, Arthur. "Canada at War: A Symposium." *Maritime Art* 2, no. 3 (February-March 1942): 90.

Mastin, Catherine Margaret. "Beyond 'the Artist's Wife': Women, Artist-Couple Marriage and the Exhibition Experience in Postwar Canada." PhD thesis, University of Alberta, 2012.

McLeish, John A.B. *September Gale: A Study of Arthur Lismer of the Group of Seven*. Toronto: J.M. Dent & Sons, 1973.

Mortimer-Lamb, Harold. "No title." *The Studio* 77 (August 1919): 119.

Murray, Joan, ed. *Daffodils in Winter: The Life and Letters of Pegi Nicol MacLeod, 1904-1949*. Moonbeam, ON: Penumbra Press, 1984.

———. *The Best of the Group of Seven*. Edmonton: Hurtig, 1984.

Nead, Lynda. *The Female Nude: Art, Obscenity, and Sexuality*. London: Routledge, 1992.

Nelson, Charmaine. *Representing the Black Female Subject in Western Art*. London: Routledge, 2010.

Niergarth, Kirk. *"The Dignity of Every Human Being": New Brunswick Artists and Canadian Culture between the Great Depression and the Cold War*. Toronto: University of Toronto Press, 2015.

Nurse, Andrew. "Artists, Society, and Activism: The Federation of Canadian Artists and the Social Organization of Canadian Art." *Southern Journal of Canadian Studies* 4, no. 1 (June 2011): 1–24.

Oliver, D.F., and Laura Brandon. *Canvas of War: Painting the Canadian Experience, 1914 to 1945*. Vancouver: Douglas & McIntyre, 2005.

Reid, Dennis. *A Concise History of Canadian Painting*. 2nd ed. Toronto: Oxford University Press, 1988.

———. *A Concise History of Canadian Painting*. 3rd ed. Toronto: Oxford University Press, 2012.

Reid, Verna. *Women Between: Construction of Self in the Work of Sharon Butala, Aganetha Dyck, Mary Meigs and Mary Pratt*. Calgary: University of Calgary Press, 2008.

Rochers, Jacques Des, and Brian Foss, eds. *1920s Modernism in Montreal: The Beaver Hall Group*. Montréal: Montréal Museum of Fine Arts, 2015.

Rosenfeld, Roslyn. *Lucy Jarvis: Sketches and Letters*. Fredericton: UNB Art Centre, 2014.

———. *Lucy Jarvis: Even Stones Have Life*. Fredericton: Goose Lane Editions, 2016.

Shadbolt, Jack. *In Search of Form: Jack Shadbolt*. Toronto: McClelland and Stewart, 1968.

Smart, Tom. *The Art of Mary Pratt: The Substance of Light*. Fredericton: Goose Lane Editions, 1995.

Smith, Frances K., and Michael Bell. *The Kingston Conference Proceedings*. Kingston: Agnes Etherington Art Centre, 1991.

Smither, Devon. "Bodies of Anxiety: The Female Nude in Modern Canadian Art, 1913-1945." PhD thesis, University of Toronto, 2016.

Tippett, Maria. *Emily Carr: A Biography*. Markham: Penguin Books Canada, 1982.

Young, Kathryn A., and Sarah M. McKinnon. *No Man's Land: The Life and Art of Mary Riter Hamilton*. Winnipeg: University of Manitoba Press, 2017.

General Art History

Alison, Jane, and Coralie Malissard. *Modern Couples: Art, Intimacy and the Avant-Garde*. New York: Barbican, 2018.

Armstrong, Carol. *Cézanne's Gravity*. New Haven: Yale University Press, 2018.

Bell, Julian. *What Is Painting?* London: Thames & Hudson, 2017.

Berger, John. *About Looking*. New York: Vintage Books, 1991.

———. *Landscapes: John Berger on Art*. Edited by Tom Overton. London: Verso Books, 2016.

———. *Portraits: John Berger on Artists*. Edited by Tom Overton. London: Verso Books, 2017.

Berman, Patricia. "Body and Body Politic in Edvard Munch's Bathing Men." In *The Body Imaged: The Human Form and Visual Culture since the Renaissance*, edited by Kathleen Adler and Marcia R. Pointon, 71–104. Cambridge: Cambridge University Press, 1994.

Bischoff, Ulrich. *Edvard Munch, 1863-1944: Images of Life and Death*. Translated by Michael Hulse. Köln: Taschen, 2017.

Botton, Alain de, and John Armstrong. *Art as Therapy*. London: Phaidon Press, 2016.

Cernuschi, Claude. "Defining Self in Kokoschka's Self-Portraits." *The German Quarterly* 84, no. 2 (2011): 198–219. https://doi.org/10.1111/j.1756-1183.2011.00111.x.

Clark, Sir Kenneth. *The Nude: A Study of Ideal Art*. London: John Murray, 1956.

Curtis, Cathy. *A Generous Vision: The Creative Life of Elaine de Kooning*. New York: Oxford University Press, 2017.

Danto, Arthur Coleman. *After the End of Art: Contemporary Art and the Pale of History*. Princeton: Princeton University Press, 2014.

Dijkstra, Bram. *Georgia O'Keeffe and the Eros of Place*. Princeton: Princeton University Press, 1998.

Dutton, Denis. *The Art Instinct: Beauty, Pleasure, and Human Evolution.* New York: Bloomsbury, 2010.

Gabriel, Mary. *Ninth Street Women: Lee Krasner, Elaine de Kooning, Grace Hartigan, Joan Mitchell, and Helen Frankenthaler, Five Painters and the Movement that Changed Modern Art.* New York: Little, Brown, 20018.

Gay, Peter. *Art and Act: On Causes in History—Manet, Gropius, Mondrian.* New York: Harper and Row, 1976.

Guilbaut, Serge. *How New York Stole the Idea of Modern Art Abstract Expressionism, Freedom, and the Cold War.* Translated by Arthur Goldhammer. Chicago: University of Chicago Press, 1983.

Gombrich, E.H. "Kokoschka in His Time": Lecture Given at the Tate Gallery on 2 July 1986. Tate Modern Masters Series. London: The Gallery, 1986.

Gombrich, E.H., and Ernst Kris. *Caricature.* Harmondsworth: King Penguin, 1940.

Hughes, Robert. *The Shock of the New.* London: BBC Books, 1980.

Hyman, Timothy. *The World New Made: Figurative Painting in the Twentieth Century.* London: Thames & Hudson, 2016.

Kimmelman, Michael. *The Accidental Masterpiece: On the Art of Life, and Vice Versa.* New York: Penguin Press, 2006.

Knausgaard, Karl Ove. *So Much Longing in So Little Space: The Art of Edvard Munch.* Translated by Ingvild Burkey. New York: Penguin Books, 2019.

Lewis, Wyndham. *Demon of Progress in the Arts.* London: Methuen, 1954.

Marinetti, F.T. "Manifesto of Futurism," *Le Figaro,* 20 February 1909. Reproduced at *Art Theory* (website). Accessed 4 April 2020. http://theoria.art-zoo.com/futurism-manifesto-marinetti/.

McFee, Graham, and Alan Tomlinson. "Riefenstahl's Olympia: Ideology and Aesthetics in Shaping of the Aryan Athletic Body." In *Shaping the Superman: Fascist Body as Political Icon, Aryan Fascism,* edited by J.A. Mangan, 86–106. London: Frank Cass, 1999.

Meyers, Jeffrey. *Impressionist Quartet: The Intimate Genius of Manet and Morisot, Degas and Cassatt.* New York, Harcourt, 2005.

Milton, Andrew. *Turner and the Sublime.* London: British Museum, 1980.

Morehead, Allison. "The Untimely Face of Munch." In *Edvard Munch: Between the Clock and the Bed,* edited by Gary Garrels, J.-O. Steihaug, S. Wagstaff, Karl Ove Knausgaard, P.G. Berman, and A. Morehead. New York: Metropolitan Museum of Art, 2017.

Moyle, Franny. *The Extraordinary Life and Momentous Times of J.M.W. Turner.* London: Viking, 2016.

Nielsen, Trine Otte Bak, ed. *Vigeland Munch: Behind the Myths.* Antwerp: Mercatorfonds, 2015.

Plumly, S. *Elegy Landscapes: Constable and Turner and the Intimate Sublime.* New York: W.W. Norton, 2018.

Pollock, Griselda. *Vision and Difference: Feminism, Femininity and the Histories of Art.* London: Routledge, 2015.

Rilke, Rainer Maria. *Letters to Cézanne.* Translated by Joel Agee. New York: Fromm International Publishing, 1985.

Saunders, Frances S. *Who Paid the Piper?: The CIA and the Cultural Cold War.* London: Granta, 2000.

Soussloff, Catherine M. *Subject in Art: Portraiture and the Birth of the Modern.* Durham: Duke University Press, 2006.

Sylvester, David. *Looking at Giacometti.* New York: Henry Holt, 1994.

Unger, M. *Picasso and the Painting that Shocked the World.* New York: Simon & Schuster Paperbacks, 2019.

Wolfe, Tom. *The Painted Word*. New York: Farrar, Straus and Giroux, 1975.

General and Military History
Berland, Jody. "Marginal Notes on Cultural Studies in Canada." *University of Toronto Quarterly* 64, no. 4 (1995): 514–25.
Blanchard, Phyllis, and Carolyn Manasses. *New Girls for Old*. New York: The Macaualy Company, 1930.
Canetti, Elias. *Crowds and Power*, translated by Carol Stewart. London: Penguin, 1973.
Claxton File, Brooke Claxton Fonds, LAC
Dolnick, Edward. *The Forger's Spell: A True Story of Vermeer, Nazis, and the Greatest Art Hoax of the Twentieth Century*. New York: Harper, 2008.
Gossage, Carolyn. *Greatcoats and Glamour Boots: Canadian Women at War (1939-1945)*. Rev. ed. Toronto: Dundurn Press, 2016.
Hofstadter, Richard. *Anti-Intellectualism in American Life*. New York: Alfred A. Knopf, Vintage Books, 1963
Keat, Wes. "Victoria's Sympathy for Captain Dreyfus," *Los Angeles Herald*, vol. 28 (119), 28 (January 1901): n.p. https://cdnc.ucr.edu/cgi-bin/cdnc?a=d&d=LAH19010128.2.44&e=-------en--20--1--txt-txIN--------1.
Le Bon, Gustave. *The Crowd: A Study of the Popular Mind*. New York: Viking, Press, 1960.
MacDonald, Malcolm. *Titans and Others*. London: Collins, 1972.
Mangan, J.A. "Blond, Strong and Pure: 'Proto-Fascism', Male Bodies and Political Tradition." In *Special Issue Shaping the Superman Fascist Body as Political Icon—Aryan Fascism*, edited by J.A. Mangan, 108–29. London: Frank Cass, 1996.
Massey, Vincent. *On Being Canadian*. Toronto: J.M. Dent and Sons, 1948.
Seager, Allen. "Minto, New Brunswick: A Study in Class Relations between the Wars." *Labour / Le Travailleur* 5 (Spring 1980): 81–132. https://www.jstor.org/stable/25139949?seq=1.
Zahra, Tara. *The Great Departure: Mass Migration from Eastern Europe and the Making of the Free World*. New York: W.W. Norton, 2017.

Philosophy, Literature, and Literary Criticism
Aristotle. *The Complete Works of Aristotle*. 2 vols. Edited by Jonathan Barnes. Princeton: Princeton University Press, 1984.
Arnold, Matthew. "Dover Beach." Poetry Foundation. [1867?]. Accessed 12 December 2019. https://www.poetryfoundation.org/poems/43588/dover-beach.
Austin, John. *How to Do Things with Words*. 2nd ed. Cambridge: Harvard University Press. 1975.
Bakhtin, Mikhail. *Rabelais and His World*. Translated by Hélène Iswolsky. Bloomington: Indiana University Press, 1984.
Barthes, Roland. *Camera Lucida: Reflections on Photography*. Translated by Richard Howard. New York: Hill and Wang, 1981.
Benjamin, Walter. *The Origin of German Tragic Drama*. Translated by John Osborne. London: New Left Books, 1977.
———. "Thesis VII: On the Concept of History." [1940]. Translated by Dennis Redmond, 2005. Accessed 28 November 2019. https://www.marxists.org/reference/archive/benjamin/1940/history.htm.
Bergson, Henri. "Laughter: An Essay on the Meaning of Comic." Authorama.com. Accessed 28 December 2019. http://www.authorama.com/laughter-6.html.
Dickens, Charles. *David Copperfield*. (Project Gutenberg e-book #766). http://www.gutenberg.org/files/766/766-h/766-h.htm#link2HCH0001.

Doyle, Roddy. *The Woman Who Walked into Doors*. London: Jonathan Cape, 1996.

George, Sam. *Sexuality and Women's Writing, 1760-1830: From Modest Shoot to Forward Plant*. Manchester: Manchester University Press, 2007.

Girard, René. *Violence and the Sacred*. Baltimore: Johns Hopkins University Press, 1977.

Guttman, Allen, "Sacred, Inspired Authority: D.H. Lawrence, Literature and the Fascist Body." *The International Journal of the History of Sport* 16, no. 2 (1999): 169–79. https://doi.org/10.1080/09523369908714076.

Hazlett, William. *The Literary World* no. 7 (7 August 1847). https://www.the-tls.co.uk/articles/public/izaak-waltons-complete-compleat-angler/.

Heitman, Danny. "The Messy Genius of W.H. Auden." *Humanities* 39, no. 3 (Summer 2018). https://www.neh.gov/humanities/2018/summer/feature/the-messy-genius-w-h-auden.

Hynes, Samuel. *On War and Writing*. Chicago: University of Chicago Press, 2018.

Jacobs, Alan. *The Year of Our Lord 1943: Christian Humanism in the Age of Crisis*. New York: Oxford University Press, 2018.

Mendelson, Edward. *Early Auden*. Cambridge: Harvard University Press, 1983.

———. *Later Auden*. New York: Farrar, Strauss and Giroux, 2000.

Merleau-Ponty, Maurice. "Cézanne's Doubt." In *Maurice Merleau-Ponty: Basic Writings*, edited by Thomas Baldwin, 276–78. London: Routledge, 2004.

Owen, Wilfred. "Dulce et Decorum Est." Accessed 3 February 2019. https://www.poetryfoundation.org/poems/46560/dulce-et-decorum-est.

Paddie, Dennis. "Cool Distance: W. H. Auden's 'Gay' Version of Christian Spirituality." In *W.H. Auden: A Legacy*, edited by David G. Izzo, 47–59. Portland: Locust Hill Press, 2002.

Schiwy, Marlene A., and Marion Woodward. *A Voice of Her Own: Women and the Journal Writing Journey*. New York: Simon and Schuster, 1996.

Scott, F.R. "W.L.M.K." From *The Eye of the Needle: Satire, Sorties, Sundries*. Montréal: Contact Press, 1957. Canadian Poetry Online. University of Toronto and University of Toronto Libraries, 2000. https://canpoetry.library.utoronto.ca/scott_fr/poem5.htm.

Shakespeare, William. *As You Like It*. 2.1.563–64. Open Source Shakespeare. https://www.opensourceshakespeare.org/views/plays/play_view.php?WorkID=asyoulikeit&Act=2&Scene=1&Scope=scene.

———. *Henry V*. 3.1.1092–1125. Open Source Shakespeare. https://www.opensourceshakespeare.org/views/plays/play_view.php?WorkID=henry5&Act=3&Scene=1&Scope=scene.

Twain, Mark. *The Adventures of Huckleberry Finn, Part I* (Project Gutenberg e-book #7100). http://www.gutenberg.org/files/7100/7100-h/7100-h.htm.

Walton, Izaak. *The Compleat Angler*. [1635]. Gloucester: Dodo Press, n.d.

Woolf, Virginia. *To the Lighthouse*. [1927]. New York: Harcourt Brace, 1989.

Zola, Émile. *The Masterpiece*. Translated by Roger Pearson. Oxford: Oxford University Press, 1993.

Index